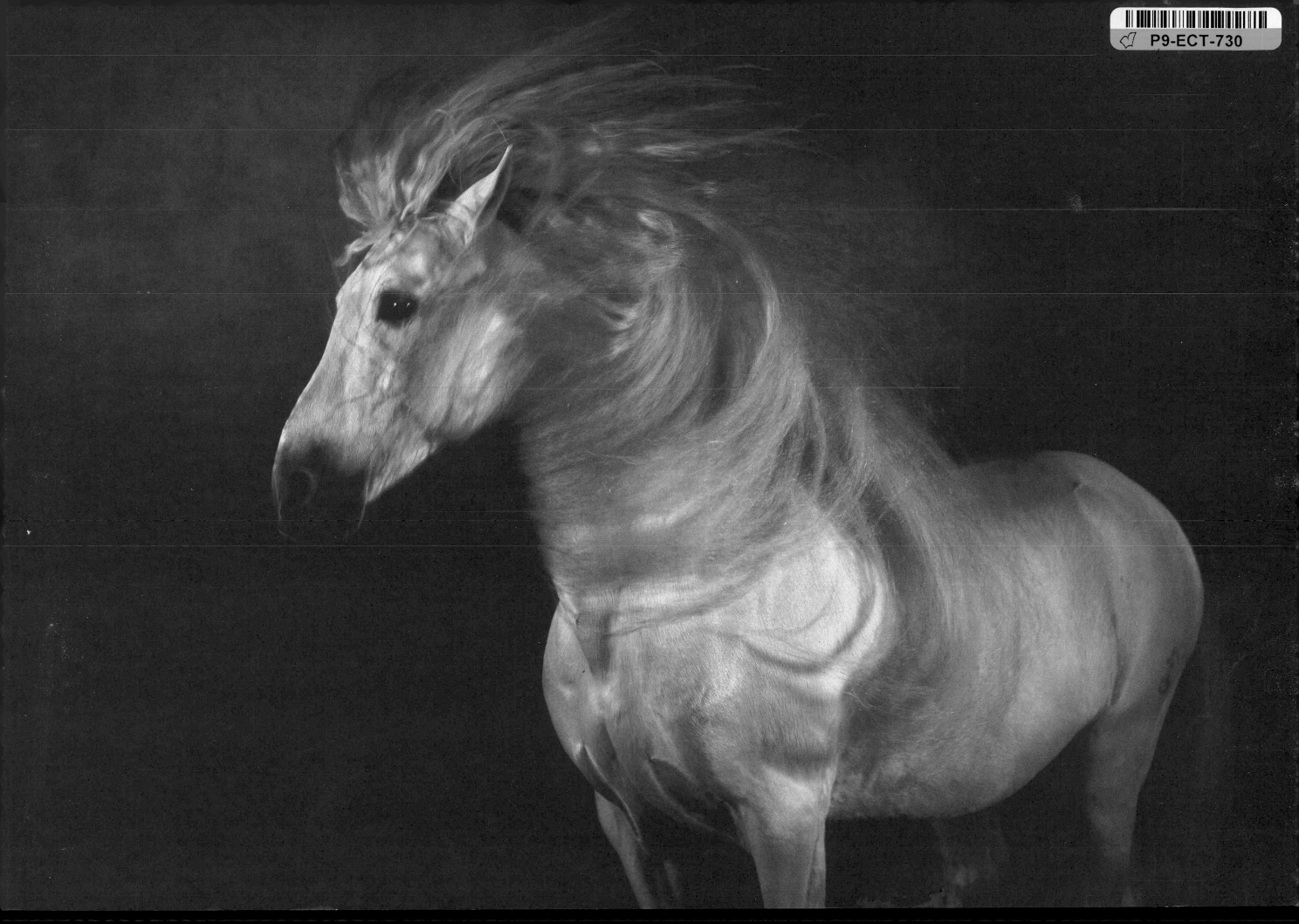

Contents

Front endpapers: *Templado*, an eighteen-year-old Lusitano stallion by *Perdigon V* (a purebred Spanish horse born in Spain) out of *Léquina* (a Lusitano mare bred by the Delgado [PSL] stud farm), owned by Frédéric Pignon.

This book is not designed and presented like a well-kept stable, with the horses neatly contained in perfectly aligned stalls. It is more like a cavalcade, a headlong gallop, a *fantasia* of horses from around the world. So how do you pick your way through this assortment of different breeds? Rather than a simple list of contents, these are some directions for use.

This book is dedicated to all the owners, trainers, riders and horsemen and -women—whether or not they are featured in this book—who, together with their horses, have given up their time to share their great passion.

Preface

Yann Arthus-Bertrand does not spend his entire life in helicopters taking aerial photographs of the earth below, as his renowned "earth-from-the-air" photographic work would have us believe. He does touch down occasionally to ply his trade in a more conventional fashion on terra firma. In the 1990s, Arthus-Bertrand became the first person to photograph ordinary animals such as cows, sheep, pigs, cats and dogs in a studio, against a plain background, paying great attention to details such as lighting and shade, and of course to finding the perfect pose to show off his subjects.

Arthus-Bertrand always makes a point of attending the Salon de l'Agriculture international agricultural show, which is held every March in Paris and brings together the finest examples of animals from France and around the world. For him, the event is rather like a pilgrimage: having set up his tent and all his equipment, including projectors, convectors and lighting reflectors, he lives, eats and sleeps on the site, spending the entire week photographing some of the finest examples of the most magnificent breeds of animals. He has been doing this for almost twenty years and, as you can imagine, has learned a great deal about animals—and people—during this time.

One of his key discoveries has been the realization that horses really are unlike any other animal. Why are they more difficult to photograph? The beauty of a bull lies in its contained strength, that of a cow or a sheep lies in its very placidity and therefore immobility. In the case of the horse, the opposite is true because the essence and beauty of the horse is revealed when it moves. This poses a problem for the photographers whose job it is to portray that movement: how do you capture such beauty in a split second and fix it for eternity in a two-dimensional photographic image?

Arthus-Bertrand's success at solving this problem bears testament not only to his skill as a photographer but also to his courage in deviating from the sacrosanct conventions of equestrian portraiture. Traditional shots of the horse are in profile, with it standing squarely on all four legs, front legs parallel, hind legs slightly offset, head held high to be clearly visible and highlight the neck, with mane laid to the side away from the camera. Arthus-Bertrand flouts all these rules. He does not want his photographs to resemble criminal mug shots for police records, nor does he favor a clinical style of approach of the kind typified by stud managers' identification sheets. His aim is to show horses as they really are: creatures that are lively, high-spirited, mettlesome, animated, prancing, supple and even ethereal—a quality that should appeal to a man who has spent hours in the sky in pursuit of his profession.

The photographs in this book are the result of fifteen years' work and several journeys around the world. Even though he took more than a thousand photographs, possibly even tens of thousands, it is still not an exhaustive collection. Nor does it claim to be an encyclopedia or a technical reference. The idea was to compile a lovingly crafted atlas of the horse. Loving because this is a personal selection. Arthus-Bertrand included only the photographs and horses that appeal to him, with scant regard for official or scientific criteria. He did not feel obliged to include any shots he did not like, a Barb here or a Nonius there, simply to give the impression that he was compiling a definitive catalog. And he did not photograph a particular breed in order to appear well informed and above expert criticism.

Personally, I endorse this approach wholeheartedly. Even if he had wanted to, Arthus-Bertrand would have been unable to produce a complete photographic catalog of all the horse breeds in the world because most of the horses on earth (one hundred and sixty-seven million according to the 1980s census) belong not to clearly defined "breeds" but to countless regional types, subdivided into an infinite number of local varieties. Add to this a problem that has not been widely publicized, perhaps out of a sense of shame or sheer ignorance: the reality is that large numbers of breeds have unfortunately become "redundant" and will probably die out altogether in the next few decades.

For instance, what do you do with the Don, the horse that was ridden by the Cossacks for at least two hundred years? It is neither fast enough for racing nor powerful enough for jumping. It could, of course, be used for recreational purposes, but horse riding in southern Russia has to come second to the struggles of the people. This one example shows how closely the horse's destiny is linked to that of mankind. When you point out that the horse has been used and abused by man throughout history, many people reply—and rightly so—that without human intervention and protection, the equine species may well have died out long ago. Indeed, by creating and promoting the development of different types of "breeds" with various aptitudes, man has fashioned the horse, if not in his own image, at least in accordance with his desires and needs.

The horse's intertwined existence with man appears to have escaped the notice of most of those who have turned the spotlight on the horse before Yann Arthus-Bertrand. In the text that accompanies the photographs, I have not so much tried to prove as to give examples of the way in which each breed that originates in a particular part of the world is also a reflection of a culture and civilization. Just as Arthus-Bertrand's photographs capture the movement of the horse in space, I have tried to place the horse within the context of time, by presenting his work in an order that, without being strictly chronological or rigidly geographical, does have a certain logic. I have tried to show that, although the horse is now spread throughout the world, the majority of horses—both large and small*—are descended from the horses that lived in Eurasia, North Africa and the Asia. Though this may be an incomplete and unscientific approach, and one that is open to criticism, you cannot deny that the horse is a truly beautiful creature, and nobody has ever produced such a charming book about such a wonderful animal.

I can see its creator fidgeting impatiently: like the horse, he needs to be continually active. He has other fish to fry, other horses to photograph and new shots to take. He is on the move again, somewhere between land and sky. According to an Arab legend, Allah created the horse from a handful of the South Wind. If that legend is true, he must have created Yann Arthus-Bertrand from a puff of smoke.

* Many thanks to Alain Gouttman and Marion Scali, who agreed to write the sections devoted to large horses and ponies.

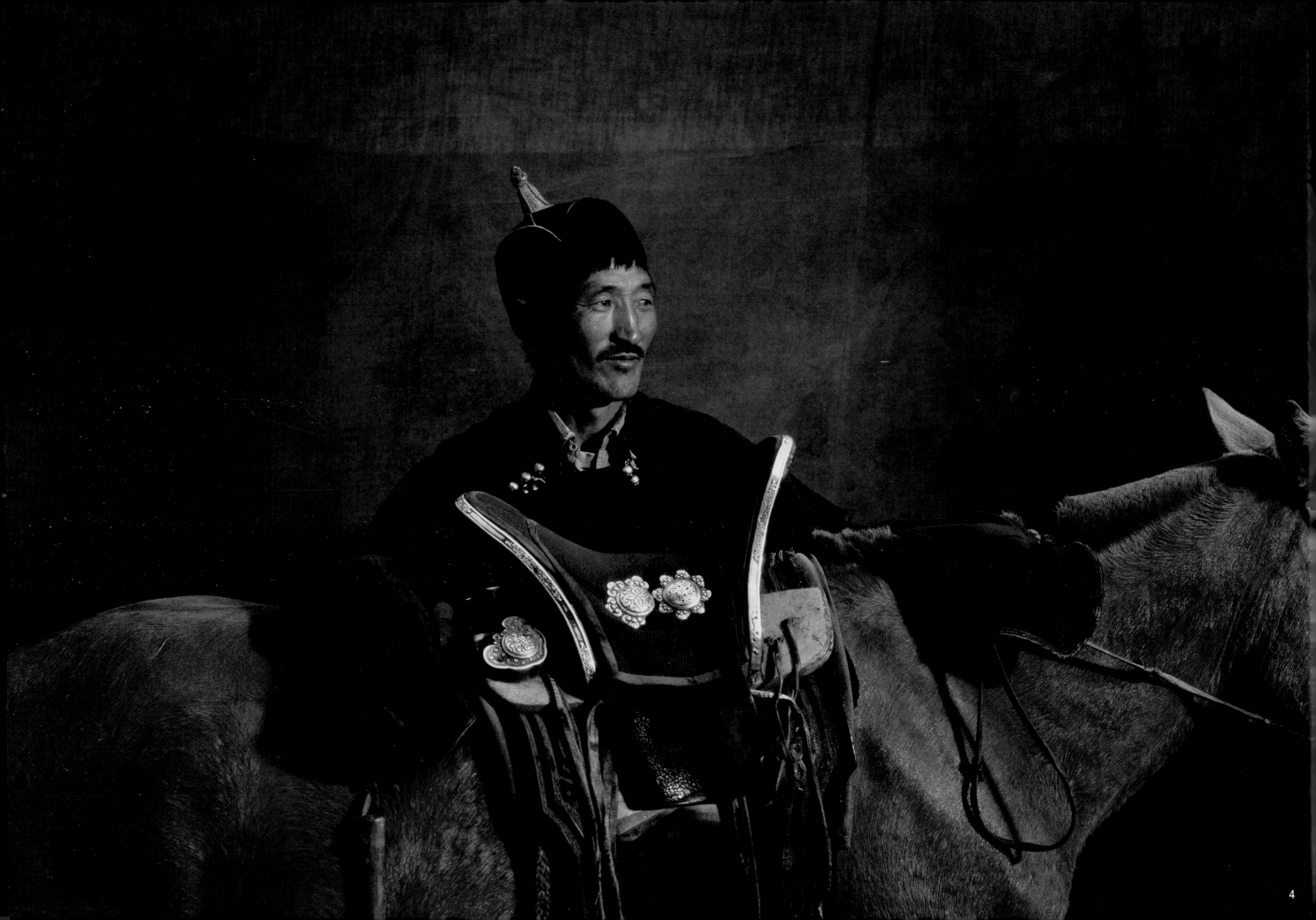

Eurasia: birthplace of the horse

Although surrounded by countless tales and legends, our history of the horse can begin with a few scientific facts. The Bible does not tell us whether there were horses in the Garden of Eden or in Noah's Ark, but we do know that the origin of the species dates back approximately seventy million years.

According to paleontologists, the horse's early ancestors were creatures no bigger than a dog that lived on the continent of America, known appropriately enough as *Eohippus* ("the dawn horse") and also as *Hyracotherium*. One day, around three to four million years ago, these small horses became dissatisfied with their homeland for some reason and began to move westwards, crossing the isthmus (later to become the Bering Strait) into Asia. They entered a vast stretch of land that suited them so well that they decided to stay there.

They flourished in the broad expanses of Eurasia, growing ever larger in size until they developed into the species known as *Equus* (the horse as we know it today) and the rest, as they say, is history.

In 1995, magnificent cave paintings, dating back to *c.* 30,000 B.C., were discovered in the Chauvet Cave in the Ardèche region of southern France, which pinpointed the appearance of the horse in Western Europe to the Upper Paleolithic era. They picture animals that look amazingly similar to the small wild horses described by Nikolay Mikhaylovich Przhevalsky (1839–88) during his third voyage in central Asia (1879–80), on "the harshest terrain in the Dzungarian desert," a region of Mongolia (now part of China) between the Altai and Tien Shan Mountains.

Called *takhi* by the Mongols, and *kertag* by the neighboring Kyrgyz, this distant descendant of the prehistoric horse is now known as Przewalski's horse, after its discoverer. The examples of Przewalski's horse that can currently be seen in the majority of the world's zoos have all been born and raised in captivity. Unfortunately, therefore, even if the attempts to return them to the wild in Mongolia and Europe one day prove successful, they can never again be described as truly wild horses. The last *takhis* and *tarpans*—their European counterparts, which lived wild without any interference from man—died out at the beginning of the twentieth century.

The three million horses that are spread throughout Mongolia—the only country in the world where horses outnumber humans—are not the direct descendants of Przewalski's horse as their cells do not carry the same number of chromosomes, but they are certainly related.

The principal quality required of a Mongolian pony is endurance. It is therefore selected by means of grueling races over distances of up to 25 miles (40 km). The most spectacular are run each year in July, at the annual Naadam festival of the Three Games of Men that is now celebrated nationwide. In order to judge the ability of the horses, rather than the skill of the riders, they are ridden in the races by children—both girls and boys, sometimes very young.

4. A winning **Mongolian** and its proud owner Grubazar Baatartsogt.

6–7. A **Mongolian** presented by Mr. Enkhree and his seven-year-old son Bat-Erdenne, winners of a Naadam organized in September 2002 in the Khan Khenti region near Mongon Moor ("silver horse"), at an altitude of 5,905 ft (1,800 m).

If any one place can be named as the origin of the horse and the scene of its early domestication, it has to be **Eurasia**. The vast expanses of the steppes—stretching, broadly speaking, from Mongolia to Hungary—have seen the small prehistoric ancestor of the horse evolve into the animal we know today. Even if it is not known exactly when (perhaps four or five thousand years ago) or how man finally succeeded in domesticating this beautiful creature, it is almost certain that this important event took place to the north of the Black Sea, probably in present-day Ukraine.

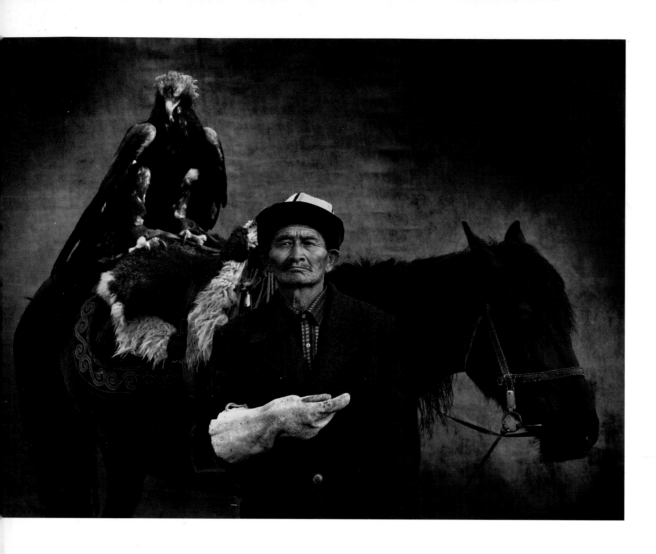

Mongolian and Kyrgyz horses: one large family

Rarely more than 12.3–13.1 hh (51–53 in), Mongolian horses are actually ponies, strictly speaking. Since they are small, stocky and "strong-limbed," some people think they look coarse, or criticize them for lack of grace and finesse. One such critic was French writer and diplomat Saint-John Perse (1887–1975), who was not only a great poet—winning the Nobel Prize for Literature in 1960—but also a fine horseman. In a letter to his mother in 1919, he described the Mongolians as "misshapen offspring of the equine race" and "large rats on wheels."

However, even the Mongolian's staunchest critics are obliged to admit that its physical "defects" are outweighed by some extraordinary qualities, and Saint-John Perse was no exception: "On the credit side, one has to recognize a number of good qualities: robustness, endurance, sobriety and courage proceeding from an astonishing vitality that maintains in them a sort of gaiety, playfulness, and zest."

As there is not a Mongolian breed as such but thousands of single types, it is impossible to generalize. The millions of horses in Mongolia may look very much the same, but they are all different, if only in the color of their manes, tails and coats. In fact, the Mongols have more than five hundred terms to describe their horses' coats. This does not stop local breeders giving off mixed messages about these horses: some will tell you that a certain region is renowned for the quality of its horses, others that a specific valley produces particularly fast horses, but it is all rather vague and confused. At most, it is possible to distinguish certain differences between horses from the Gobi Desert and those from the Altai Mountains, for example, but it would be inappropriate to classify them as two distinct breeds.

The typically Western concept of a "breed" was introduced only very recently into central Asia, where all the horses seem to belong to one large family. Dividing them into categories and precise ethnic groups would be impossible. How can you measure the degree of crossbreeding within populations of horses that have lived for centuries, and even millennia, in these vast, boundless expanses? How do you ascertain the purity of a "breed" if you cannot guarantee its total isolation from other "breeds"?

Although this is contrary to the Western penchant for classification, you simply have to accept the idea that the equine populations of most of Asia belong to the same huge family, whose branches and subdivisions stretch far beyond its region of origin. To the east, Mongolian horses can be found as far afield as Korea and northeastern China (the historic region of Manchuria), to the north as far as Siberia, and to the west in Kyrgyzstan and Kazakhstan, among the Turkic-speaking neighbors of the Mongols.

Although they now have a tendency to lead a more sedentary lifestyle, the mountain-dwelling Kyrgyz people are still very attached to their traditions. One of these, hunting with eagles, was outlawed during the Communist era but has since been reinstated. Efforts are also being made to revive the local breed of horses, the purebred Kyrgyz, which Soviet zootechnicians corrupted by creating a "new breed," the New Kyrgyz.

8. The **Kyrgyz** horse *Kara Jorgo*, presented by proud owner Alymkul Obolbekov with his eagle.
9. The **Kyrgyz** horse *Jeerde*, ridden by Narguiza Kashkoroeva and held by her brother Toktobek Orozaliev, who is holding the hand of Narguiza's son Uchgun.
10–11. The **Kyrgyz** horse *Kyzyl At*, ridden by At Almas Dosmanbetov.
Photographs 8, 9, and 10–11 were taken near the village of Barskoon, in the region of Jety Oguz (in the province of Issyk-Kul).

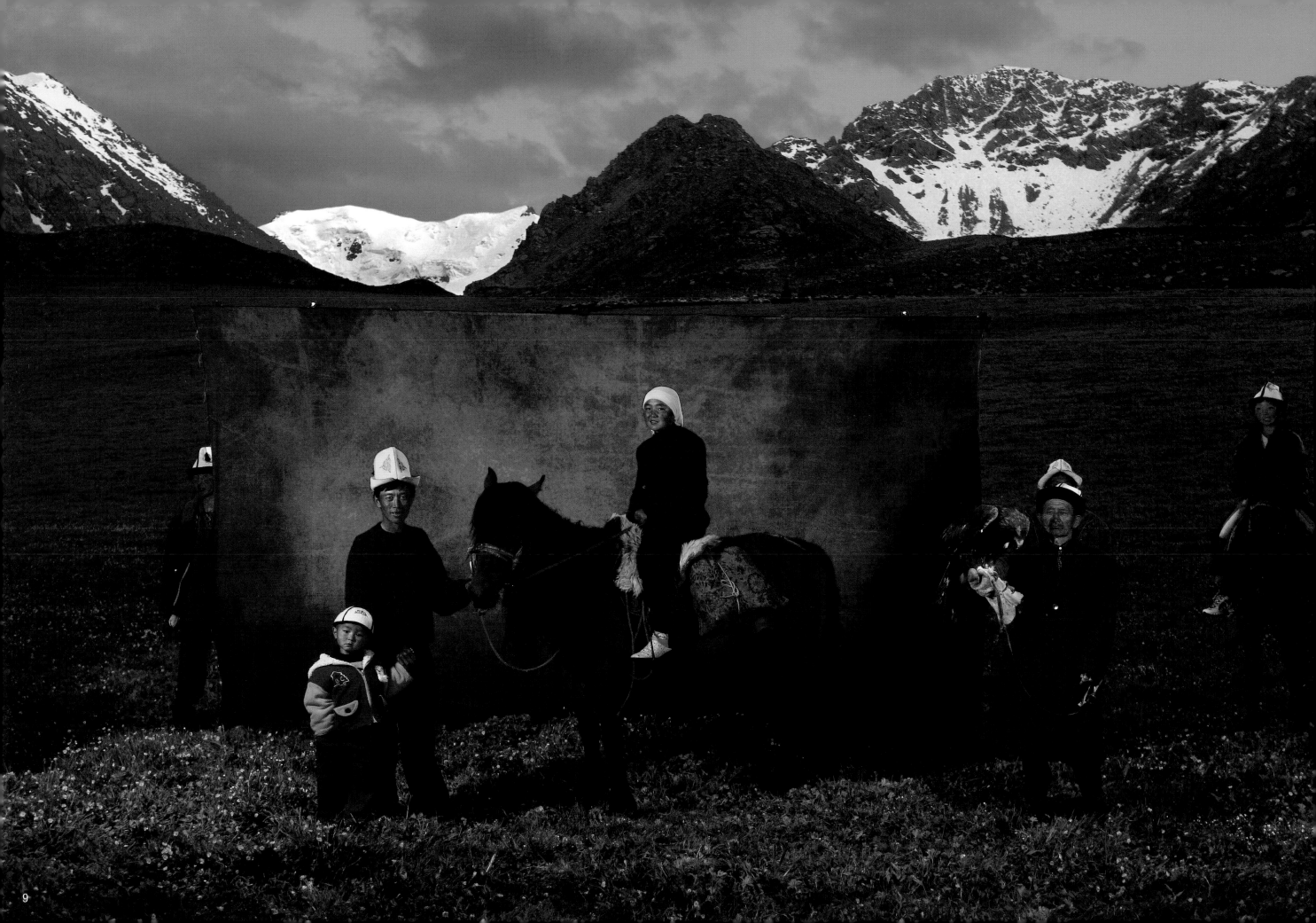

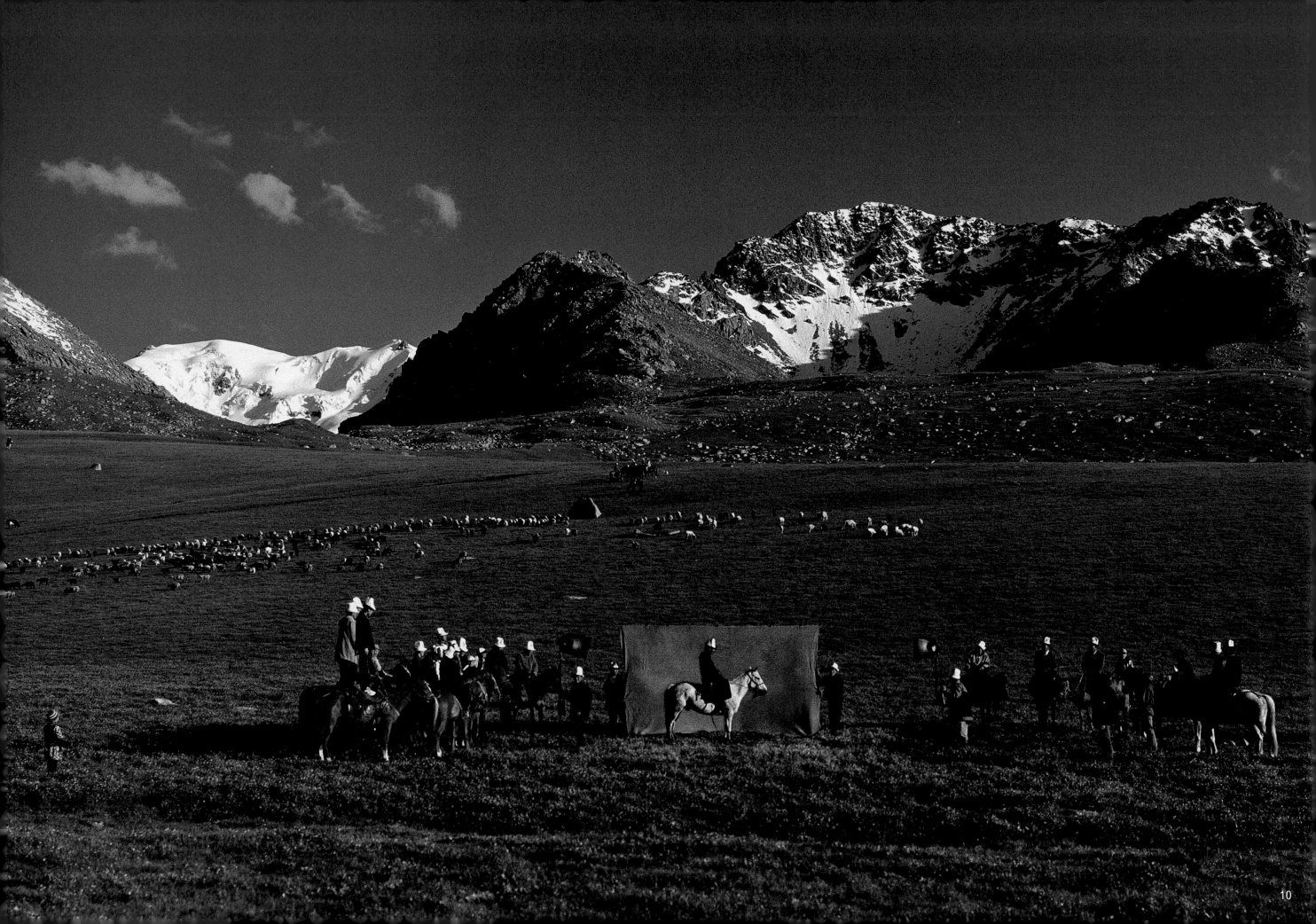

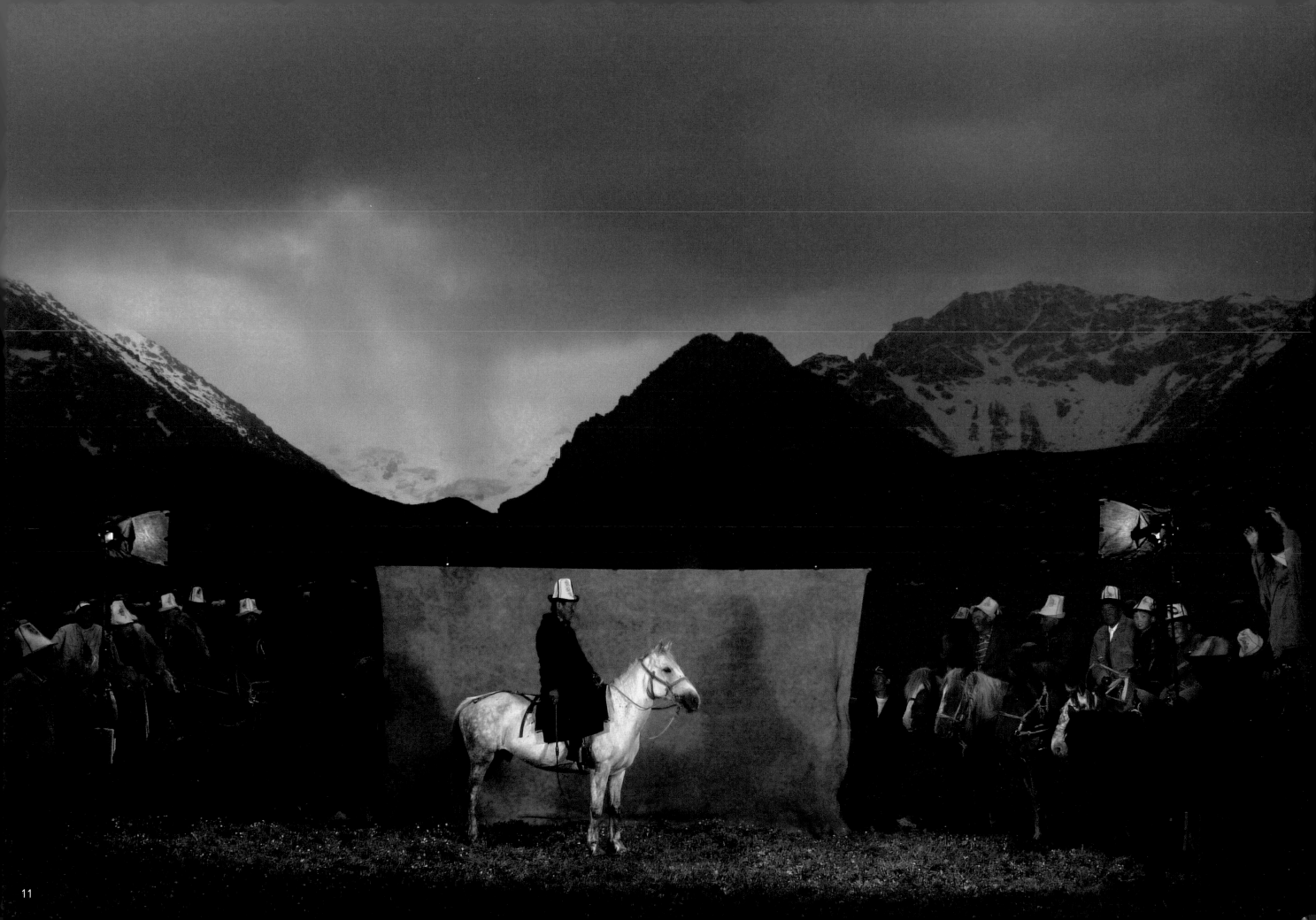

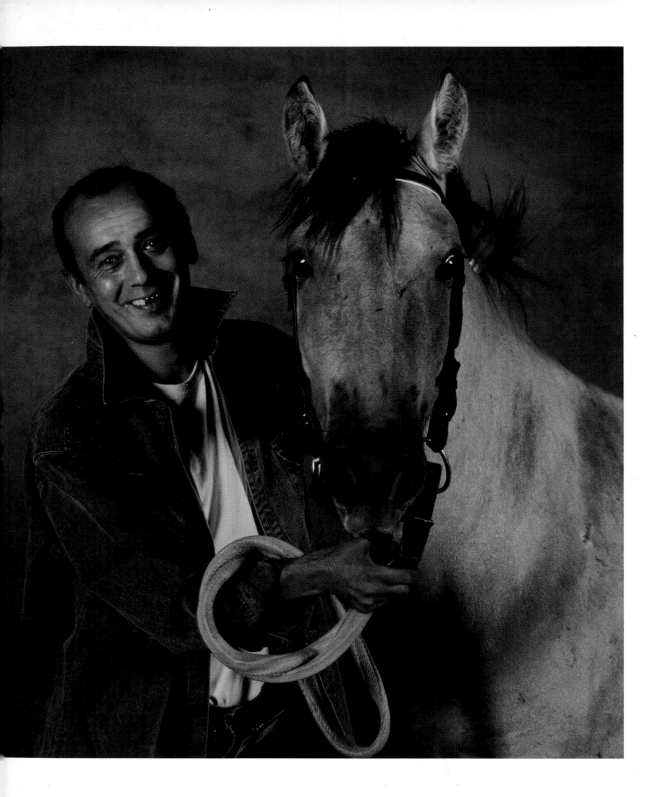

The Bashkirsky: fallen from grace

For many years, the peoples who emerged from the far reaches of the Asiatic steppes, or descended from the impregnable ranges of the Tien Shan, Altai and Caucasus Mountains, have been grouped together under one name—the Tartars (or Tatars). This name has sent shivers down many a spine, evoking at once images of the Barbarian hordes and the mythological underworld of Tartarus into which Zeus is said to have flung those who offended him.

The Mongolian-speaking Kalmycks (Buddhists) and Turkic-speaking Kazakhs, Persian-speaking Tajiks and Caucasian-speaking Cherkess (Muslims) were all called "Tartars" quite indiscriminately. However, the real Tartars were a dynamic, Turkic-speaking Muslim people whose spread was halted on the banks of the Volga, in 1552, by Ivan the Terrible (1530–84), the first Russian prince to bear the title of *tsar*.

In much the same way, the Russians have tended to group together the many different types of horses from the regions beyond the Volga and Don Rivers under the generalized, vague designation of the "steppe-type horse." This naturally includes the Kyrgyz and Bashkirsky horses.

The Bashkirsky horses belong to a people who are ethnically, linguistically and religiously very similar to the neighboring Tartars. Originally nomadic, they settled in the southern Urals in the tenth century, at the confluence of the Volga and its tributary the Kama. Here they developed a "breed" of robust, docile and extremely adaptable ponies, with an average height of 14.3 hh (59 in). They must have been quite remarkable animals as they were used by the Cossacks of the Urals in the nineteenth century and inspired the great Russian novelist and moral philosopher Leo Tolstoy (1828–1910).

Tolstoy, who was also a great horse lover, prided himself on his knowledge of farming and breeding, and owned several stud farms. On one of these farms, in the province of Samara, he crossed English horses and Russian trotters with the best Bashkirsky horses to create a new breed of saddle horse, intended for use as a cavalry horse. However, the count was a better writer than he was horse breeder and did not achieve the results he had hoped for. He finally abandoned the project and had to make do with ordinary horses for the daily excursions that constituted his favorite pastime until his death.

As for the Bashkirsky pony, it continued to perform tasks that, while they may have been less glorious, were certainly just as useful. Employed as a riding pony by the Bashkir herdsmen, and as a harness or light draft animal, it was gradually relegated to the role of milk producer.

Koumiss—slightly fermented mare's milk and the traditional drink of the people of the steppes—had been rediscovered by Soviet scientists and upgraded to the status of a "product beneficial to the health of working people." As a region of cures and health resorts, the tiny Bashkir republic of Bashkortostan—a member of the Russian Federation, with Ufa as its capital—became one of the main regions for the production of this magic potion.

Although most of the *kolkhoz* (collective farms) specializing in the production of *koumiss* have now disappeared, a few private breeders perpetuate the tradition. A good mare, milked seven or eight times a day, can produce a daily yield of 5–7 pints (3–4 liters) of milk.

12. The three-year-old **Bashkirsky** mare *Aïsseloy* (by *Sultan* out of *Aïssou*), winner of a gold medal (Kazan) and bronze medal (Saint Petersburg) in 2002, accompanied by the golden smile of Gennady Timofeyev.
13. The **Bashkirsky** mare *Anessa*, born at the Ufa Stud Farm (1993) and winner of a gold medal (Kazan) and a silver medal (Moscow) in 2001, presented "with foal at foot" by Grigori Arkadiev, a breeder from Olkhovoye. Her foal is held by Gulnar Gainodinova, who has a bucket of *koumiss* on her arm.

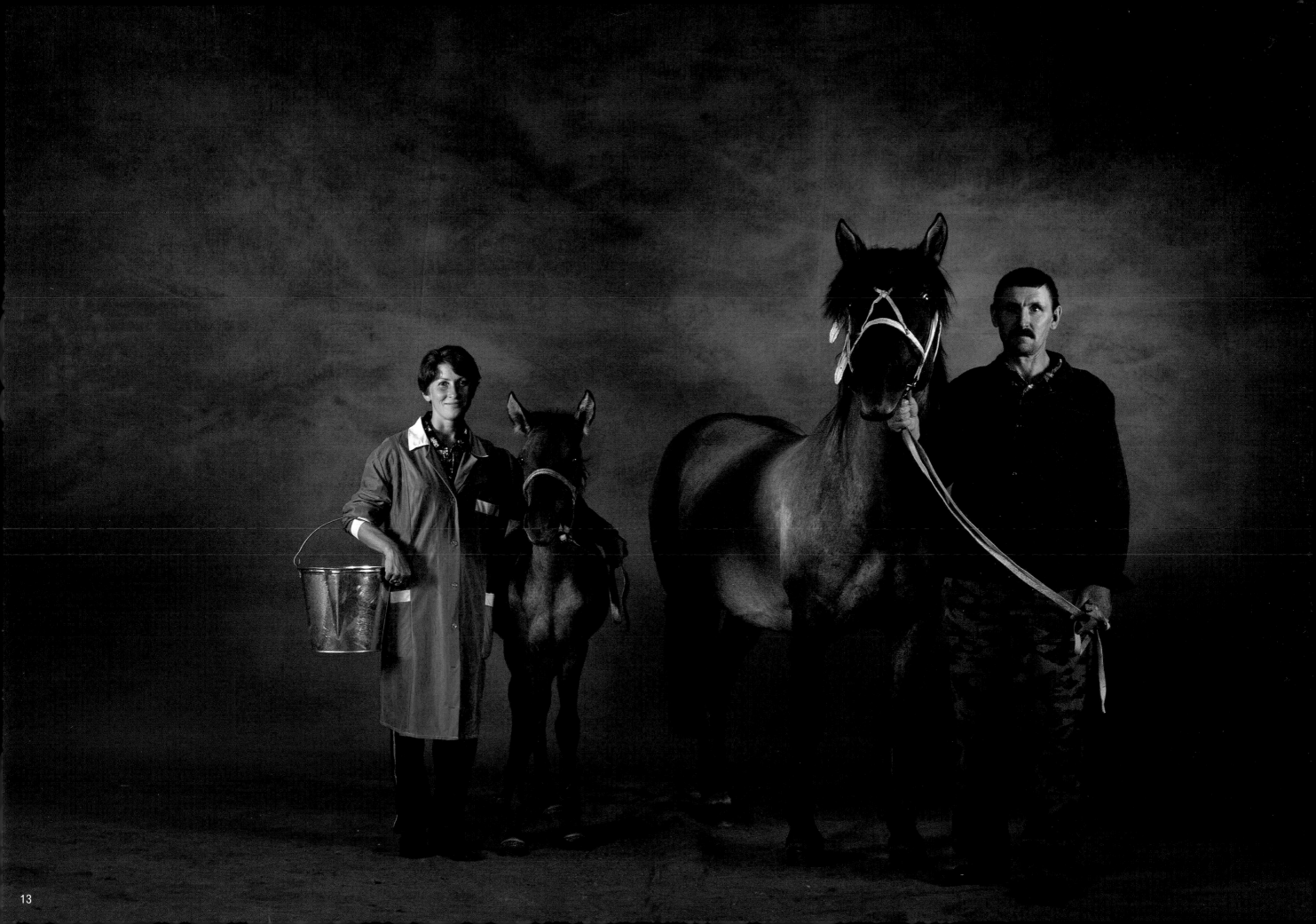

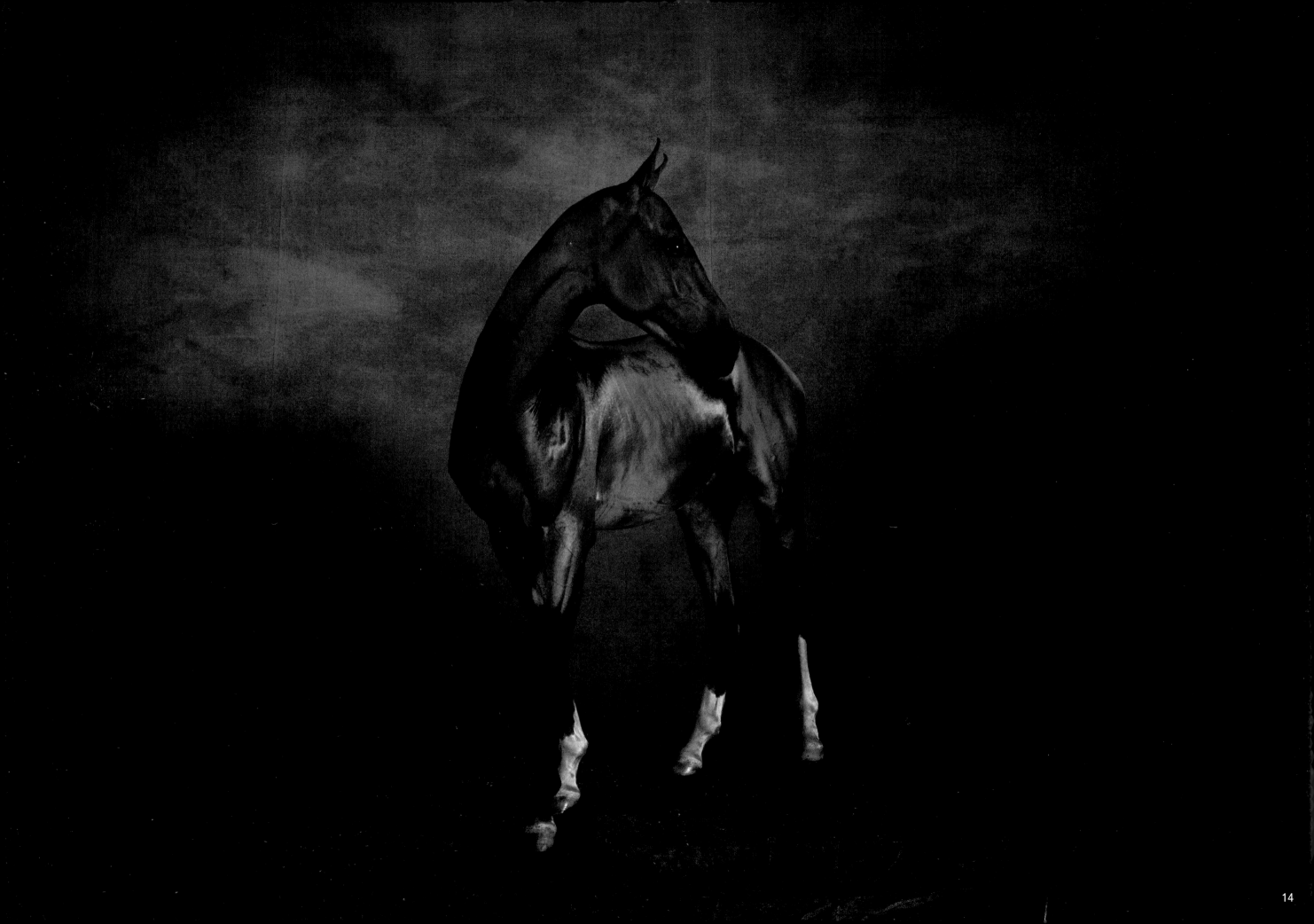

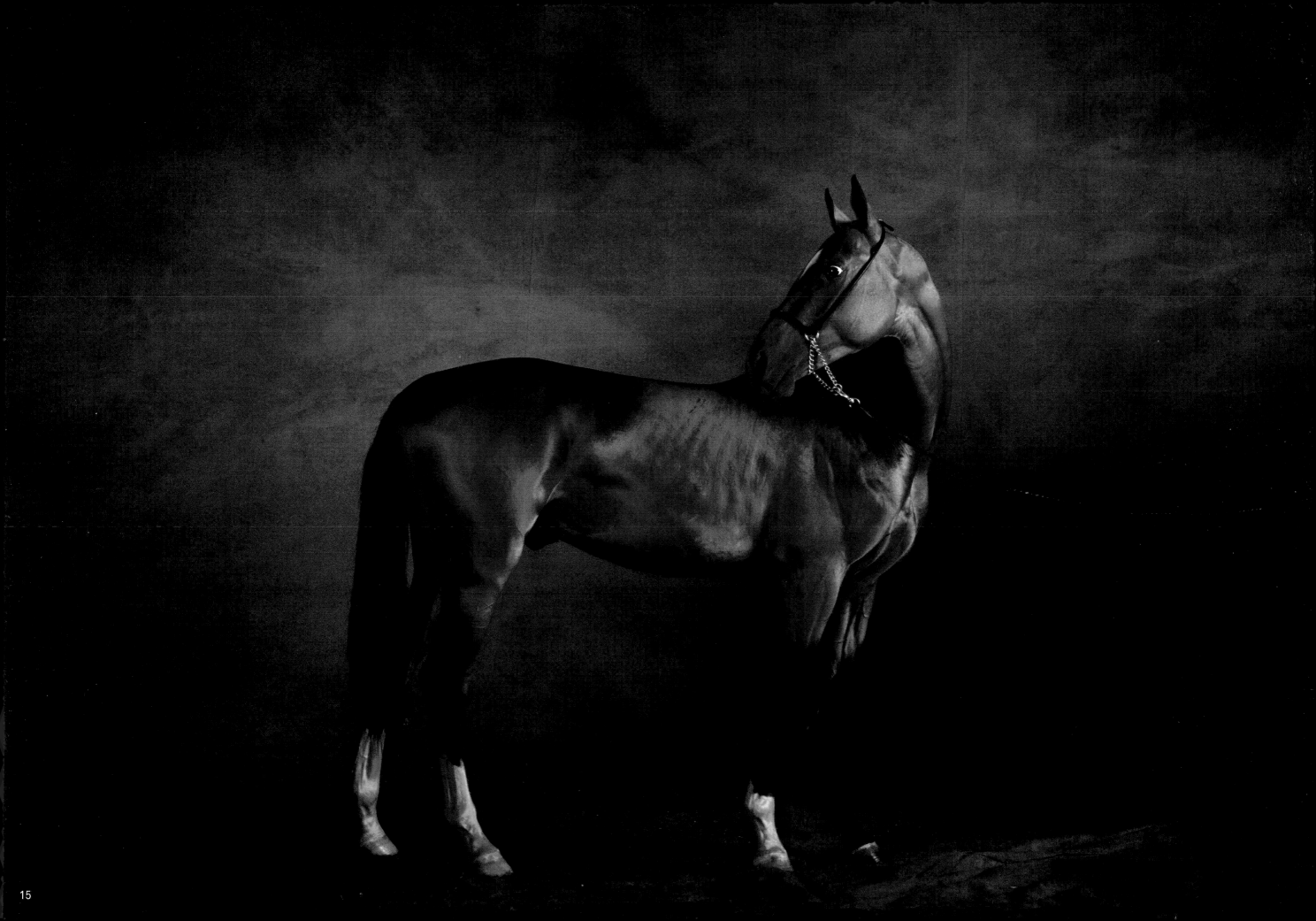

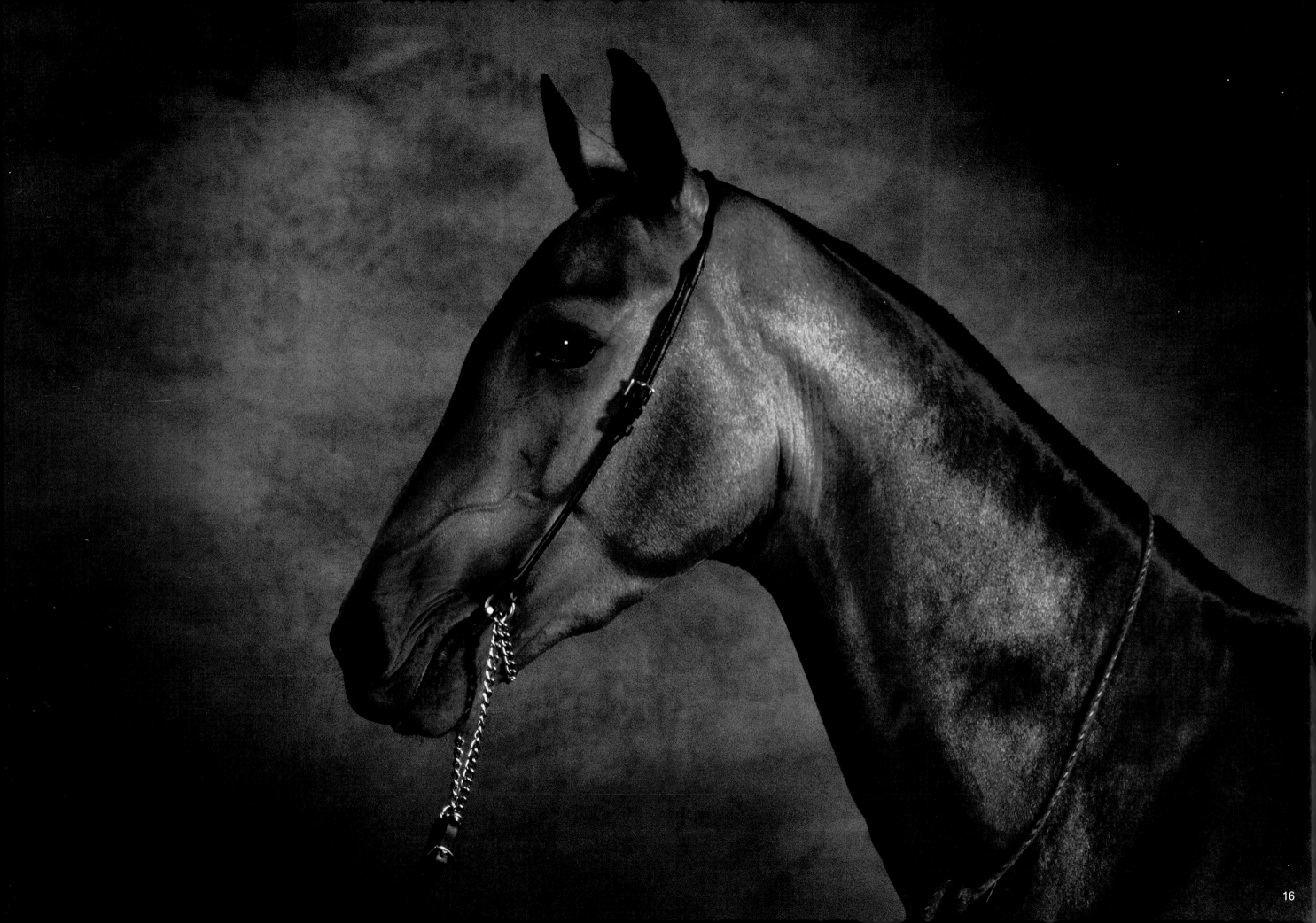

The majestic Akhal-Teke: a world apart

"Golden," "silken-coated," "the only purebred horse that is really pure," "the most beautiful horse in the world"—it is impossible to describe the Akhal-Teke without using superlatives. It is a truly exceptional animal, as different from other horses as the greyhound is different from other dogs.

The Akhal-Teke comes from Turkmenistan, a former Soviet republic in central Asia rich in vast natural gas reserves, which lies between the Caspian Sea and Afghanistan, bounded by Uzbekistan to the north and Iran to the south. The Akhal-Teke originated in the Akhal Valley, a prosperous oasis in the middle of the Karakum Desert. This paradise is the home of the Teke Turkmens, who are famous for the quality of their embroidery, jewelry and carpets.

However, the Teke Turkmens' greatest success is not a traditional craft product but a horse. Not particularly large, it stands between 15.3 and 16.1 hh (63–65 in) and is slender, fine, graceful and aristocratic, with a silken coat that has a metallic bloom, and long, slender legs that give it "plenty of air under its belly." It has a soft, gliding and elastic stride, a high-set neck, an expressive head and sometimes virtually no mane or forelock. It was described as "a horse that commands respect" by Maria Cherkesova, a Russian national living in Ashgabat, and known as the "mother of the Akhal-Teke," since she devoted her entire life (she died in 2003) to protecting this magnificent breed. It had become an endangered species under the combined threat of natural disasters—Ashkhabad was destroyed by violent earthquakes in 1924 and 1948—and sheer human blundering. Having decided that the horse should be replaced by machinery, in the 1950s the Soviet authorities decreed that the Akhal-Teke should be slaughtered for meat!

What a sorry end this would have been for such a magnificent animal, a horse with such a prestigious past. As far as the Turkmens are concerned, there is no doubt whatsoever that their horse, which today features in their national coat of arms, is the ancestor of all horses. They are quite convinced that the Scythians, the Parthians and even the Amazons were mounted on Akhal-Tekes; indeed that Bucephalus, the legendary horse of Alexander the Great (356–323 B.C.), or the famous "heavenly horses" of the emperors of China, were also Akhal-Tekes.

The breed would probably have become extinct had it not been for the courage of dedicated specialists like Maria Cherkesova or the French-born Soviet zootechnician Vladimir Chamborant, who opposed its slaughter. With an estimated total world population of just over three thousand, the Akhal-Teke is a rare animal. Fortunately, many people today appreciate and value it, not only in its homeland but also in neighboring countries (especially in European Russia), Germany and, more recently, the United States.

Highly prized for many years for its great endurance and stamina, the horse of the Turkmens has proved to be extremely adept at dressage. One of the top medal winners in the history of the Olympic Games was an indigenous Akhal-Teke from the famous Lugovsky Stud Farm, in Kazakhstan. *Absent*—whose name has sometimes been translated as *Absinthe*—won a gold medal at the Rome Olympics in 1960, and bronze medals in Tokyo (1964) and Mexico City (1968).

This aptitude for *haute école*, combined with its great beauty, has also made the Akhal-Teke much sought after by circuses throughout the world.

14–15, 16. *Murgi*, an **Akhal-Teke** stallion born in 2000 (by *Gayaz* out of *Almagul*), at the Chamborant Stud Farm in the region of Vladimir, near Moscow.

The Orlov trotter: the count's finest creation

"In the mid-eighteenth century, there were no good carriage horses in Russia, even though there was an obvious need for them since this was the only possible means of transport within such a vast country. The steppe-type horses, although excellent saddle horses, were often too small, while European horses did not have enough stamina over long distances." This was how eminent Soviet horse expert Igor Bobilev—professor of veterinary medicine and, until his death in December 2000, the permanent representative of the USSR and then Russia on the Fédération Équestre Internationale (International Equestrian Federation)—explained his country's determined attempts to create various types of light draft horse.

The most successful and most beautiful of these was produced by Count Aleksey Grigoryevich Orlov (1737–1808). His conduct may have been reprehensible at times—he may even have been behind the assassination of the Emperor Peter III (1728–62), which enabled Catherine the Great (1729–96) to become empress—but he was a brilliant horse breeder. He built the magnificent Khrenovsky Stud on the broad expanses of pastureland in the Voronezh region, given to him by the grateful empress, about 310 miles (500 km) south of Moscow. Here, by skillfully crossing Arab, Danish, Dutch and English blood, he created the Orlov trotter, a breed of powerful and fast-moving horses.

This new breed was a great success. Of average height—about 15.3 hh (63 in)—with a roomy chest, strong loins and hard legs, for over two hundred years it has proved ideal for pulling the many types of carriages that travel the length and breadth of Russia. No self-respecting *troika* would have anything other than an Orlov between the shafts. The Orlov trotter, usually dapple gray, even became something of a national symbol—so much so that, thirty years after the count's death, Emperor Nicholas I (1796–1855) decided to "nationalize" the Khrenovsky Stud, which is still breeding Orlov trotters today.

18. The **Orlov trotter** mare *Pika* (by *Quartet* out of *Pepa*), from the Khrenovsky Stud, held by the director of Russian National Stud Farms Alexander Timchenko.

19. *Indikator*, a four-year-old **Orlov-Rostopchin** (by *Intrigan* out of *Delyana*), held by Maria Pozhilkova. Count Orlov also helped to create a breed of Russian riding horse that, combined with the horses produced on the stud farm of another enthusiast, Count Rostopchin, gave rise to a breed of very elegant black horses: the Orlov-Rostopchin. After almost dying out during the Communist era, the breed is once again being promoted by the Russian government, especially at the Starojilov National Stud, about 155 miles (250 km) southeast of Moscow.

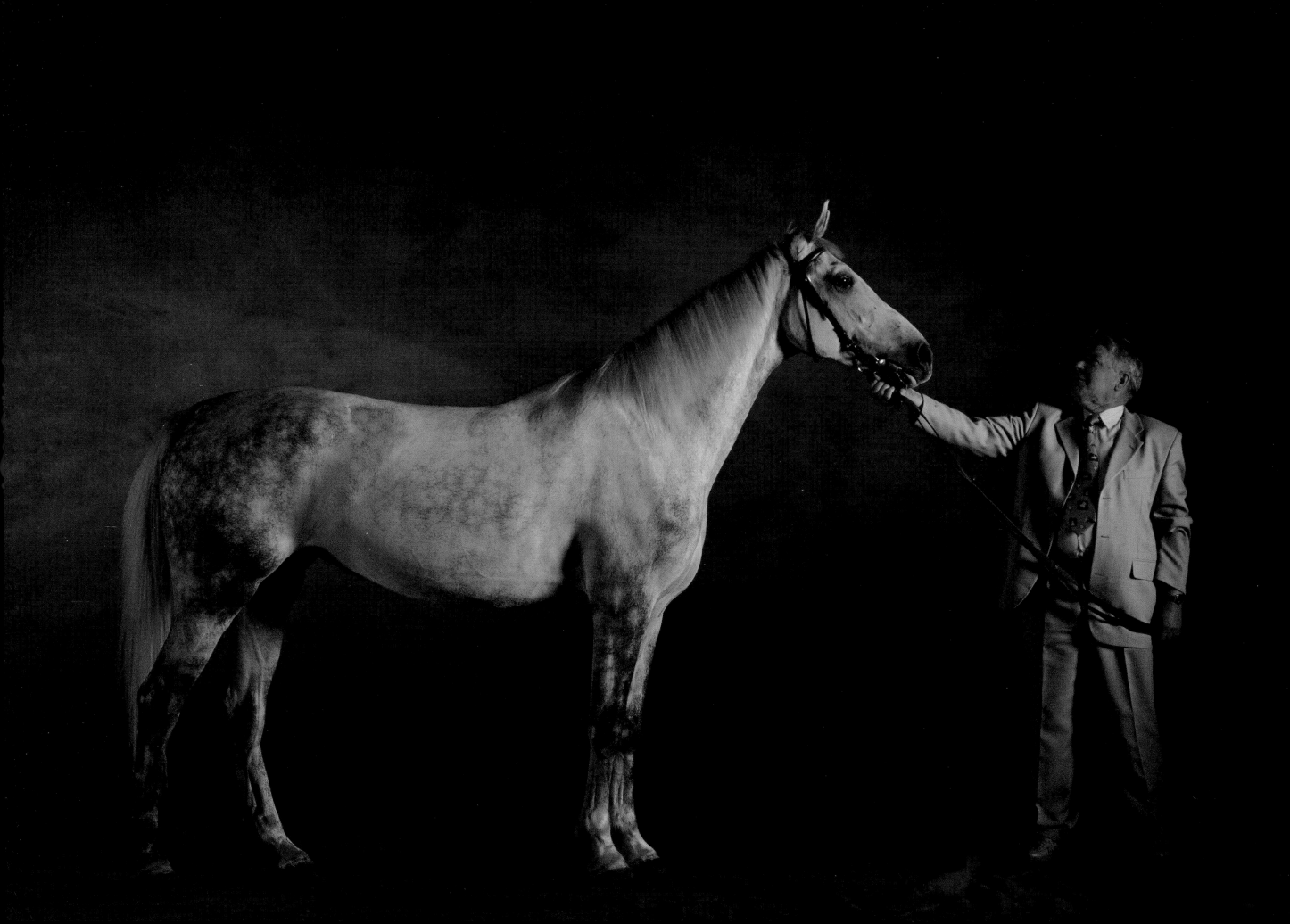

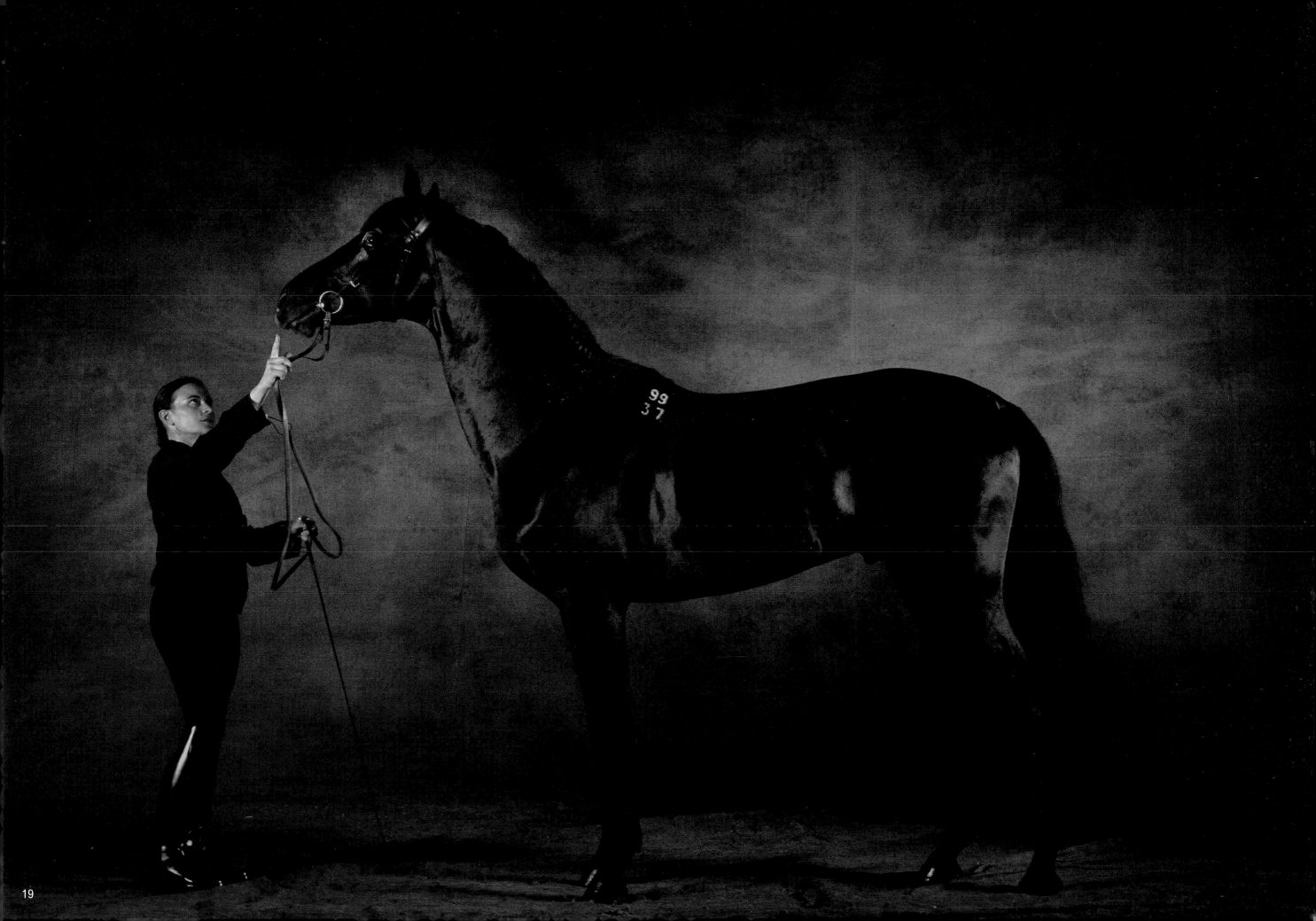

Heavy and light draft horses: enjoying the limelight

Russia has had a plentiful supply of saddle horses, descended from the "breeds" created by the nomads of the steppes of central Asia and the warrior-herdsmen of the Caucasus Mountains. However, it has always found it more difficult to develop animals well suited to agricultural and heavy draft work.

Peter the Great (1672–1725) had encouraged the creation of a type of draft horse known as the Bityug (or Bitjug), crossing imported Dutch stallions with mares from the Voronezh region, but results proved disappointing. It was not until the mid-twentieth century that more satisfactory results were achieved with the Vladimir Heavy Draft and the Russian Heavy Draft. The former, at 16.1 hh (65 in) and about 1,675 lb (760 kg), was developed in the 1940s using French (Percheron), Belgian (Ardennais) and Scottish (Clydesdale) stallions. The 15.3 hh (63 in) Russian Heavy Draft, created by crossing Brabant stallions with Russian mares, carries more weight (1,720 lb or 780 kg) and was officially registered as a distinct breed in 1952.

The "light draft" horse comes midway between the trotter, now used for racing, and the heavy draft horse, which unfortunately tends to be used for meat. The "light draft" has become popular in Russia owing to the recent development of harness racing, a sporting discipline that was previously little known.

24, 25. *Pingouin*, a **Belorussian Draft** (a light draft horse from Belarus) born in 1991, presented by his handler Andrei Letunov.

20. The **Vladimir Heavy Draft** stallion *Tulak*, born in 1993, held by Yuri Laptenko.
21. The **Vladimir Heavy Draft** mare *Galatea*, born in 1988 at the Yuriev-Polsky Stud Farm (in the region of Vladimir) and descended from a long line of breed champions, lovingly presented by Slava Kiceliov.
22. The **Russian Heavy Draft** stallion *Jar*, born in 1991 at the Mordova Stud Farm and breed champion in 1996.
23. The **Russian Heavy Draft** stallion *Kourière*, born in 1998 at the Pochinkovsky Stud Farm, presented by Alexander Morozov.

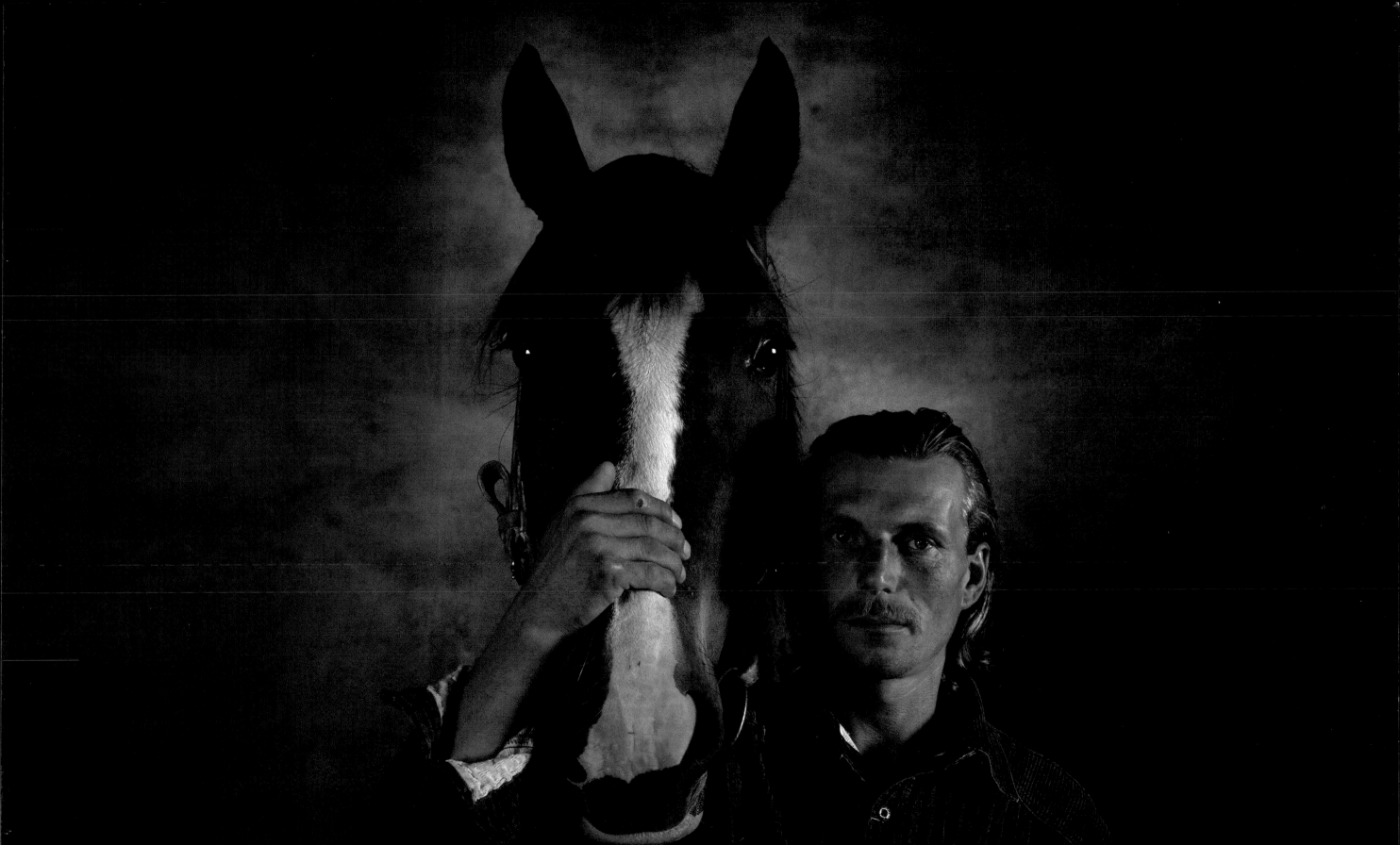

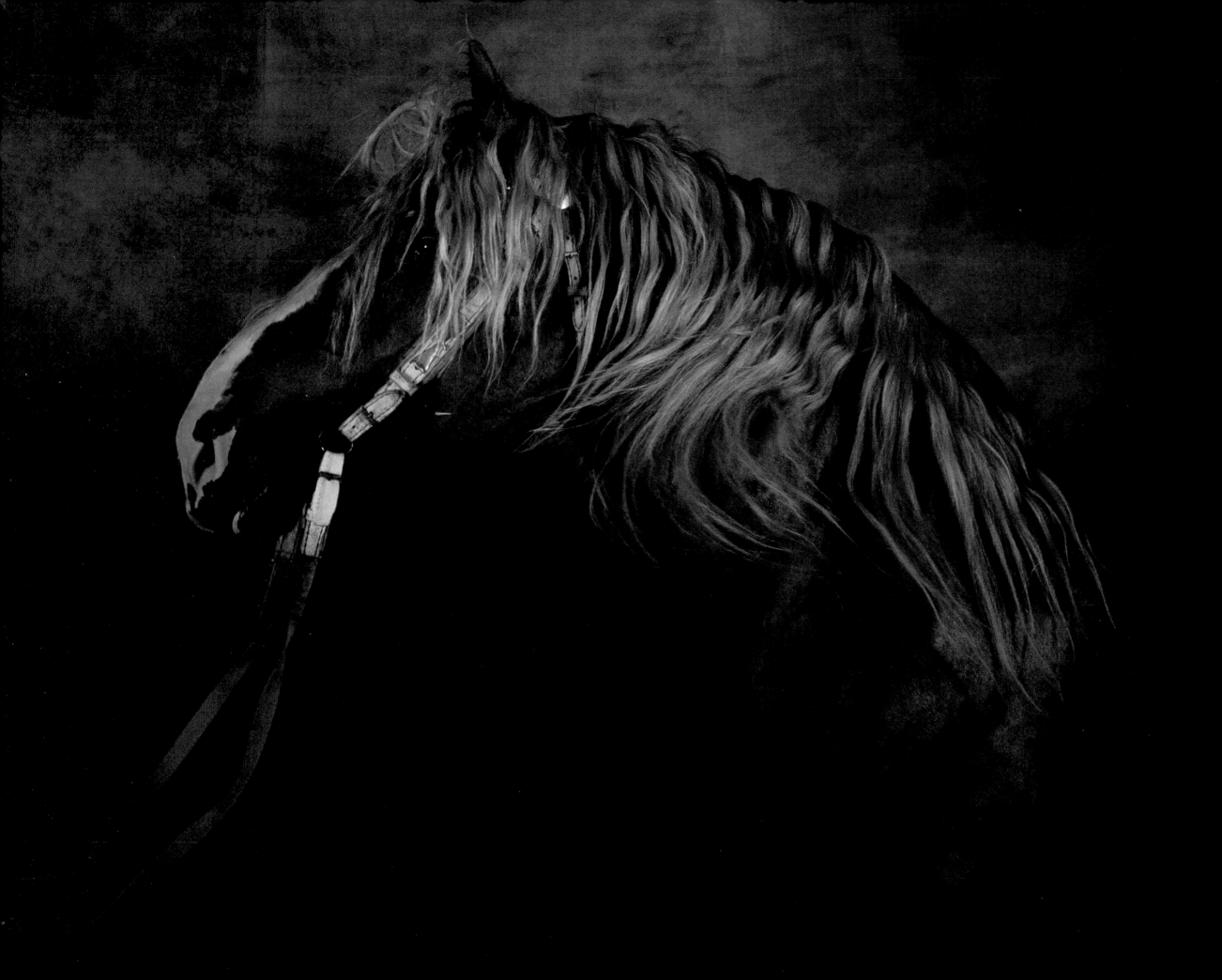

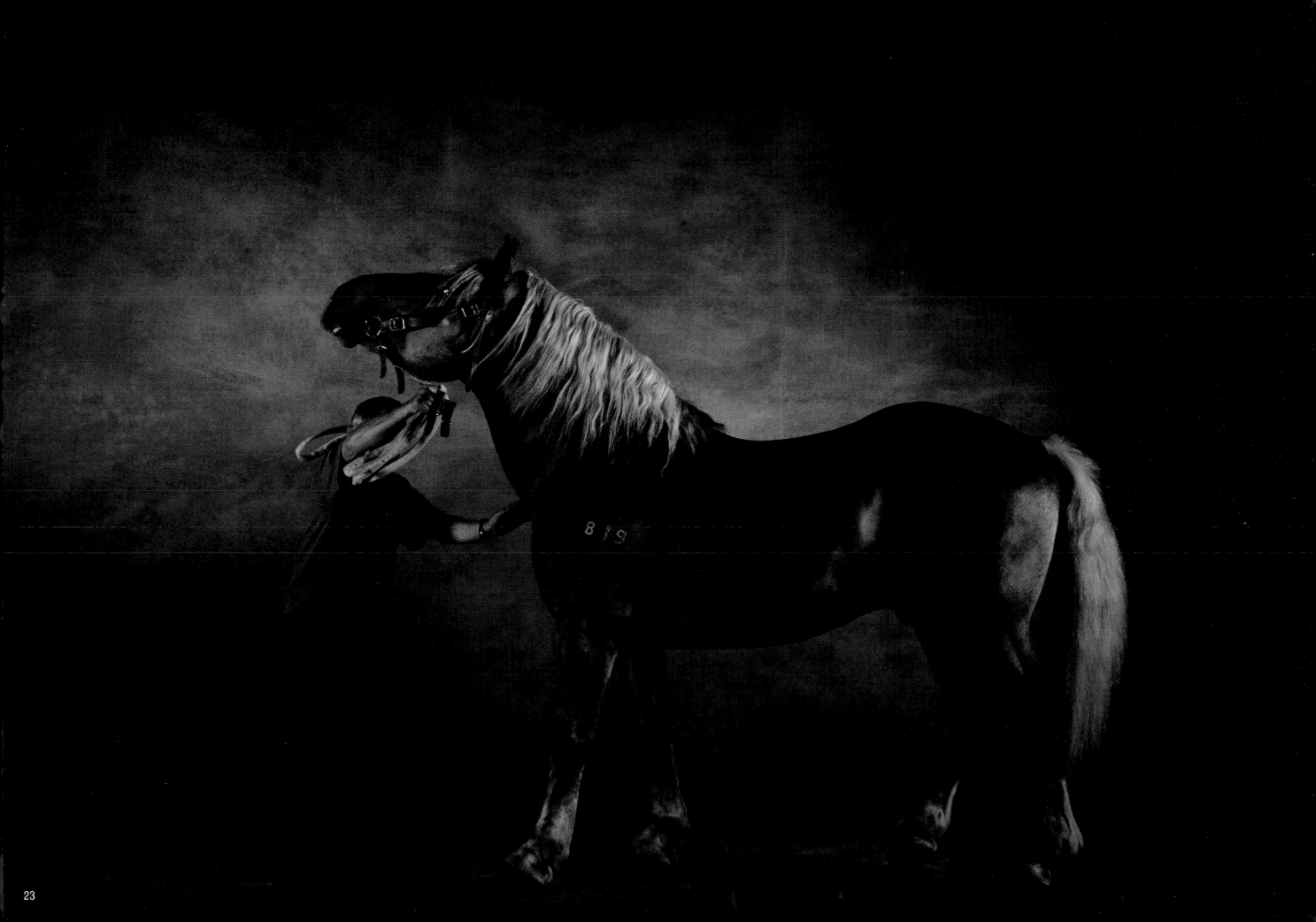

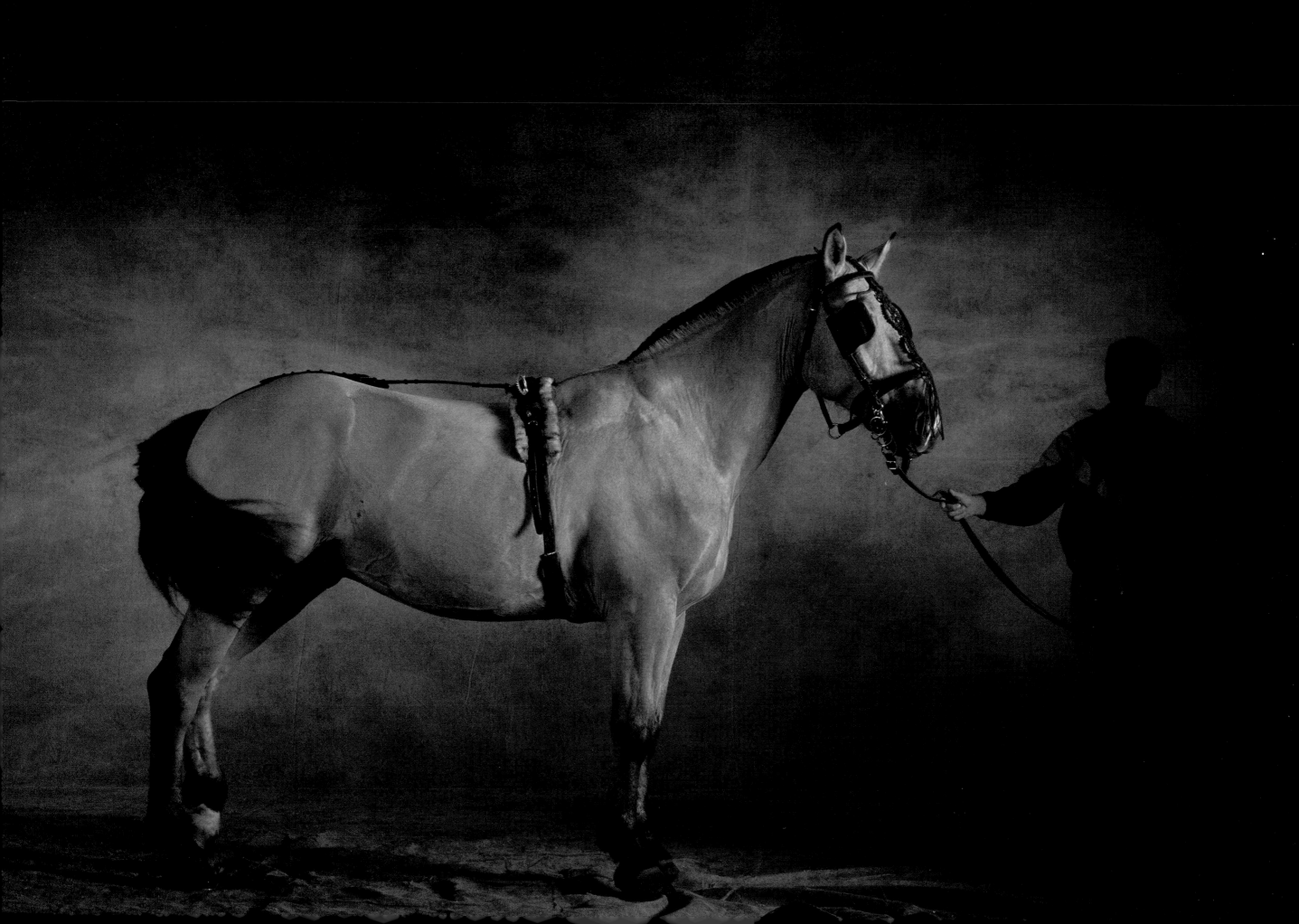

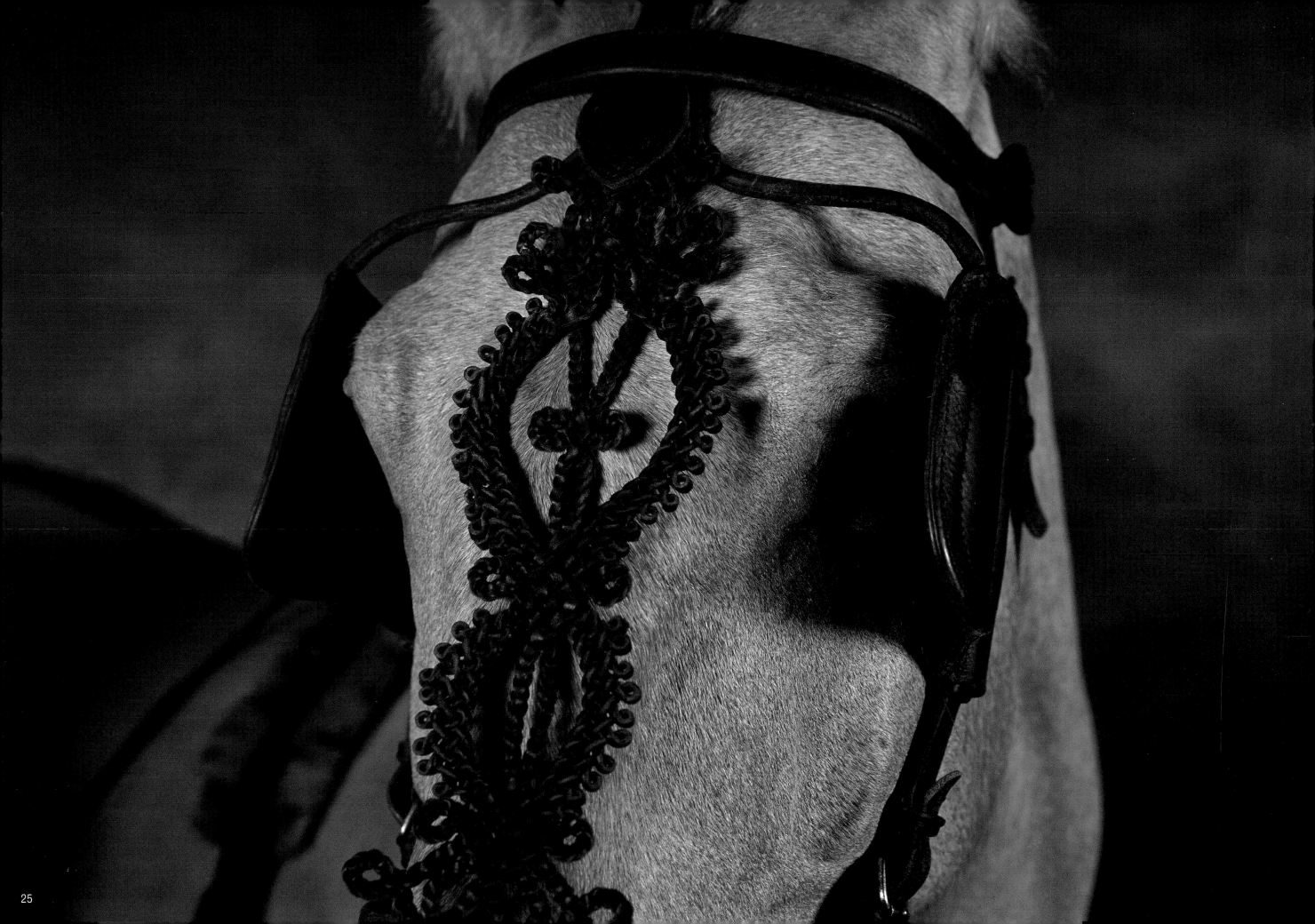

The Caucasus is a land of legend. Famed for its beautiful women, it appears to have been a favorite source of concubines for the Ottoman sultans. It is also renowned for its unusually high number of centenarians. The region is an incredible mélange of many different ethnic groups and a wide assortment of totally unconnected languages, which bear no resemblance to one another and are totally incomprehensible from one valley to the next. The Chechens do not understand the Cherkess, who do not understand the Ossetes, and so on.

There is, of course, a legend that explains this strange phenomenon. Some time after God had created mankind, He realized that something was wrong: He had forgotten to give them language. So He hurriedly piled a number of different languages into His heavenly chariot and began distributing them around the world. When He reached the Caucasus, one of the chariot wheels hit Mount Elbrus which, at 18,480 ft (5,633 m), is the highest peak in the Caucasus Mountains. The chariot jolted so violently that a pile of languages slipped through the slatted sides and fell to earth. Having made sure He had enough languages to complete His task, God decided to leave them where they had fallen.

Another legend links the region's horses to the creation of the Caucasus Mountains. Long, long ago, it was said that the mountains had the power to move. One day, as they traveled between the Caspian and Black Seas, they saw herds of splendid wild horses. These horses were so magnificent that the mountains were rooted to the spot for eternity, forming the Caucasus Mountains.

There is an element of truth in this legend, in that the vast plains on the foothills of the Caucasus Mountains provide grazing for an amazing variety of horses. The Russians have established a number of stud farms here, some of which have become internationally renowned. One example is the Tersk Stud, founded in 1889 by Count Alexei Stroganov on the outskirts of the delightful spa town of Pyatigorsk ("Five Mountains"), which was popular in summer with Muscovite high society. Today Tersk is one of the most prestigious stud farms in the world for the production of purebred Arabs. A few miles away, the Stavropol Stud produces the best Akhal-Tekes bred outside their region of origin, as well as excellent Terskys, which—as their name suggests— were first developed on the Tersk Stud. Terskys are small gray horses with a strong Arab influence, but much more affordable.

On the vast expanses of the northern Caucasus, the Soviet regime also perpetuated the tradition by creating several top-quality state stud farms between the cities of Stavropol and Krasnodar. In 1920, they founded the Voskod ("dawn") Stud, which produced some of the best English Thoroughbreds in the USSR, including the famous champion *Aniline*. In the 1960s, a stud farm for sporting horses (especially Trakehners) was set up within the Krasnoarmeiski (Red Army) model *sovkhoz* (state farm). It was much admired by not only the great apparatchiks Nikita Sergeyevich Khrushchev (1894–1971) and Leonid Ilyich Brezhnev (1906–82), who visited the stud, but also by eminent specialists such as Olympic dressage champion and silver medalist Elena Petushkova.

Arabs, English Thoroughbreds and Turkomans, the breeds raised so successfully in the northern Caucasus, are obviously not indigenous to the region. The real Caucasian horses are found in the mountains, in the small republics bordering Georgia, where the herdsmen still (although probably not for much longer) use horses to round up their flocks of goats and sheep. It is here, deep in the mountains around Mount Elbrus, that you will find the pearl of the Caucasus: the Kabardin. According to yet another legend, this horse is the perfect product of centuries of interbreeding between all the breeds of the region, as well as those brought in during numerous invasions. The Kabardin is said to combine all the qualities but none of the defects of the breeds that have produced it. Although in reality it may not possess all the qualities of its constituent breeds, it certainly has a great many. It is sturdily built, usually standing at about 14.3 hh (59 in), and its slightly Roman nose and bay, dark-brown or black coat give it an air of elegance. It stands squarely on strong, well-positioned legs, and has a roomy chest and short croup, which makes it an excellent pack and saddle animal. The mountain dwellers of the Caucasus have always used it for both purposes, and, before the advent of motor vehicles, it was the equine equivalent of the Jeep.

Born and bred in the mountains—at an altitude of 8,200–11,480 ft (2,500 and 3,500 m)—it has the respiratory and vascular systems of an equine athlete, which, combined with its hard legs and feet, make it an indefatigable climber. Calm, hardy and courageous, able to withstand wide variations in temperature, and extremely surefooted, the Kabardin was once much sought after by the Cossacks of the Terek and Kuban Rivers. These days, for many people, this beautiful animal no longer serves any "useful" purpose and is in danger of disappearing forever. However, given the chance, it would undoubtedly do well in the field of endurance riding.

The Karachai, of similar size and coloring, is closely related to the Kabardin and shares the same characteristics and qualities. In fact, the only real difference is its name, derived from the tiny republic in which it is bred: the Kabardin is bred in the republic of Kabardino-Balkari; the Karachai is bred in KarachayCherkessi.

27. The **Kabardin** stallion *Djenal*, born in 1999 at the Nalchik Stud Farm, held by Azamat Khazimov.
28–29. The **Karachai** stallion *Paruss*, born in 1995 and the pride of an equestrian center near Borodino, about 62 miles (100 km) west of Moscow, ridden by Ruslan Liskanich.

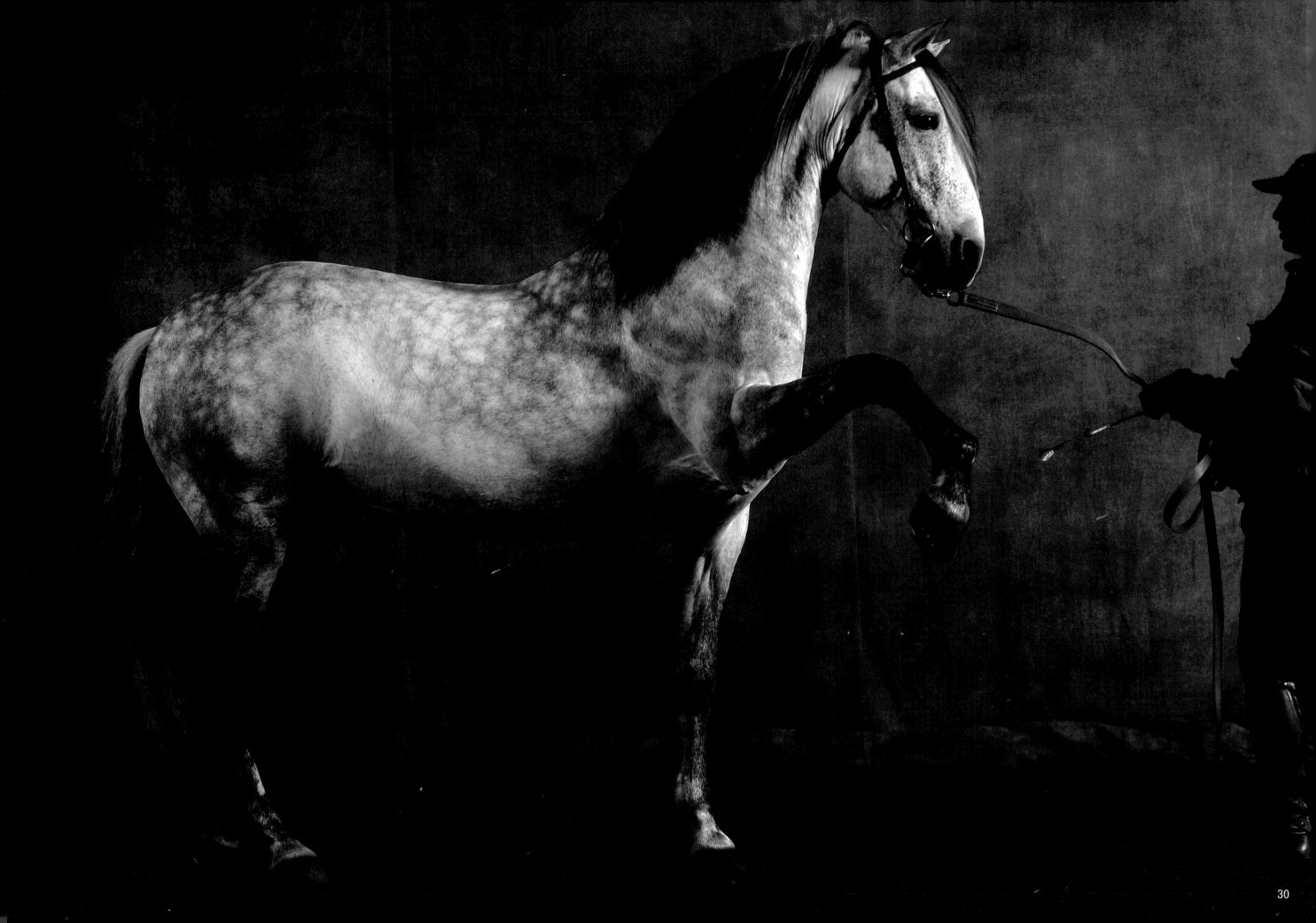

Barbary:
a center for world expansion

The horse has existed in Africa for thousands of years, proven by its depiction in the Tassili rock paintings discovered at Tassili n'Ajjer, in southern Algeria. Of the thousands of engravings and paintings discovered there in the 1950s by French ethnologist Henri Lhote, the earliest date from 5000 B.C. For Lhote there was no doubt that the first horses to arrive on the continent of Africa came from the distant lands of Eurasia.

This is thought to have occurred twenty-five thousand years ago, during the last Ice Age, when vast numbers of animals migrated southwards to escape the cold. These animals included wild horses—or rather, according to certain experts, onagers (an Asian variety of wild ass) and even quaggas with their sandy-brown coats and zebralike stripes, but *Equidae* nonetheless. They are believed to have reached Africa via central Asia and the Near East, only to die out during the Neolithic Age, about 5000 B.C.

It was only much later, around 1200 B.C., that the mysterious invaders known as "the Sea Peoples" arrived from Asia or Europe (their origins are uncertain) accompanied by domesticated horses, including some in harness as depicted in the Tassili rock paintings. It is quite likely that these warriors mixed with the indigenous population to form the people known today as the Berbers. It is also quite possible that their horses were the ancestors of the modern Barb "breed."

Whatever the case, we do know that the horses used a thousand years later by the great Carthaginian general Hannibal (247–183 B.C.) in his campaign against Rome were the ancestors of the horses found in North Africa today. The horses depicted on mosaics discovered in Carthage (in modern-day Tunisia)—at about 15.1 hh (61 in), with a strong head, a slightly Roman nose, short loins and small, hard feet—leave little room for doubt.

Such continuity is extremely rare in the history of the horse. Those who praise a particular breed or breeds are often obliged to turn to legend and fable to trace their supposed origins. The Barb's history can be traced, with little need for embellishment, over a period of two thousand years.

About one thousand years after the death of Hannibal, the Muslims used the same type of horse to invade Spain and part of Mediterranean Europe; and a thousand years after that, the same type was again encountered, this time by the French when they turned the tables and invaded Algeria. In 1847, General Oudinot (1767–1847), a French marshal during the Napoleonic Wars, described the Barb as "docile, calm, swift, patient, agile and indefatigable, combining the greatest number of qualities required by fighting men." The French army adopted the Barbs immediately, using them primarily as mounts for the famous *spahi* regiments, the French army's native cavalry corps.

One hundred and fifty years later, modern tourists visiting North Africa (especially Morocco) are able to admire these same horses in the spectacular and incredibly noisy *fantasias* (equestrian displays).

Although they have been confined to their homeland for many years, the breeding of Barb horses is now gaining a foothold in Europe. The great qualities of this little horse "with a sound temperament and strong back" are being rediscovered, especially in outdoor disciplines such as endurance riding and ecotourism.

30. The twelve-year-old **Barb** stallion *El Ouassal*, by *Ouassal* (by *Nedjed*) out of *Assila*, owned by Madame Elgosi and presented by David Jollivet at the Haras du Pin stud farm (Normandy).
32, 33. *Guerrouan*, a palomino **Arab-Barb** (with light mane and tail) born in Morocco in 1995 and the pride of the stud farm owned by Susanne Geipert in Laubach, Germany. The crossing of Barb and Arab horses, especially in Morocco, created a type known as the Arab-Barb, which is finer than the purebred Barb.

Another of the regions from which some breeds of horse are said to have originated is **Barbary**, a former region of North Africa that stretched from western Egypt to the Atlantic coast. It was from here that the Barb horses of the Berbers spread southwards, giving rise to most of the African "breeds," and northwards, where they contributed to the creation of the Spanish and Portuguese breeds. Taken across the Atlantic by the Conquistadors, these horses were also introduced to the Americas. It makes quite a history and it does not end there: Barb blood is also present in the English Thoroughbred, the Neopolitan, the Lipizzaner and the Friesian.

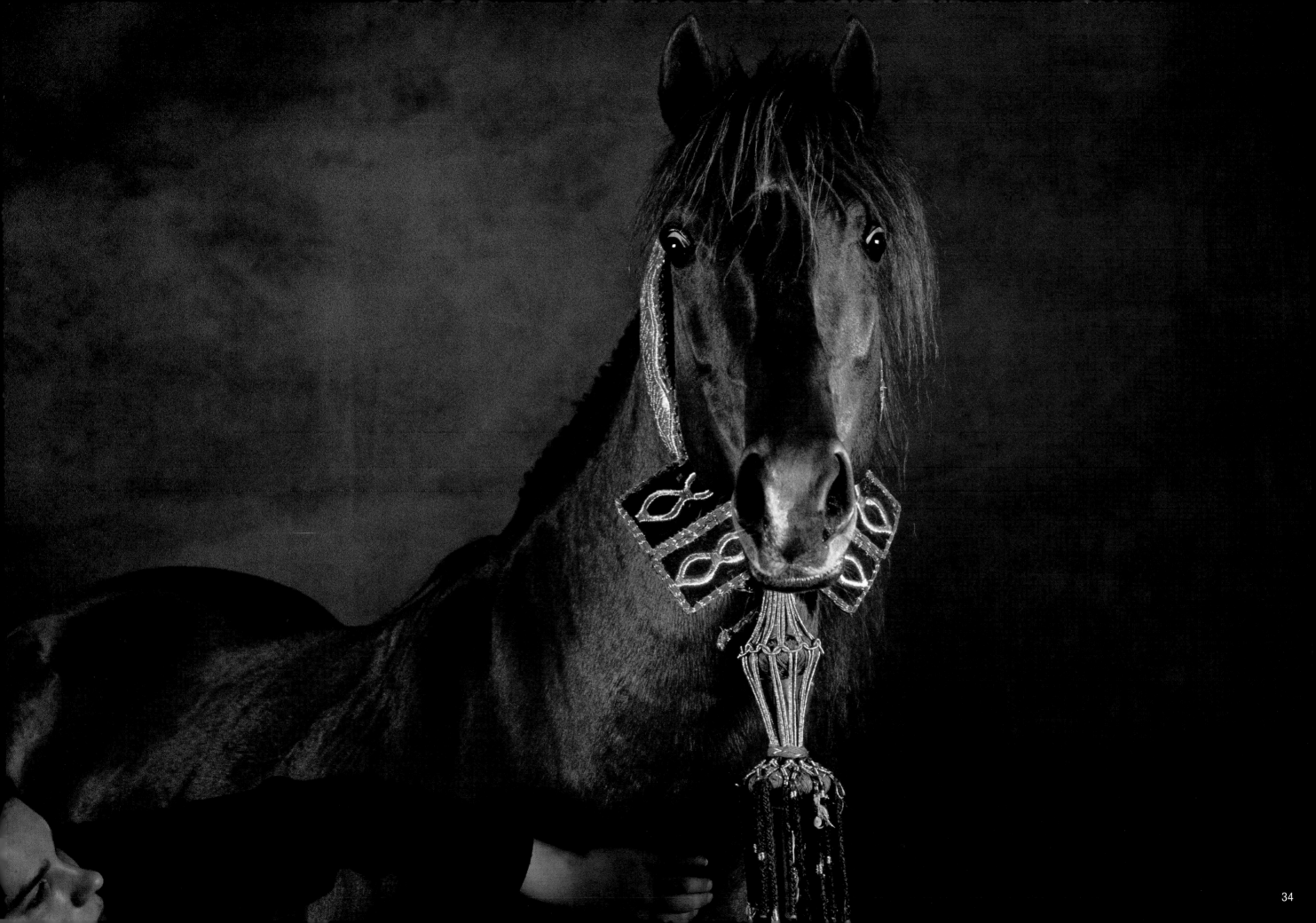

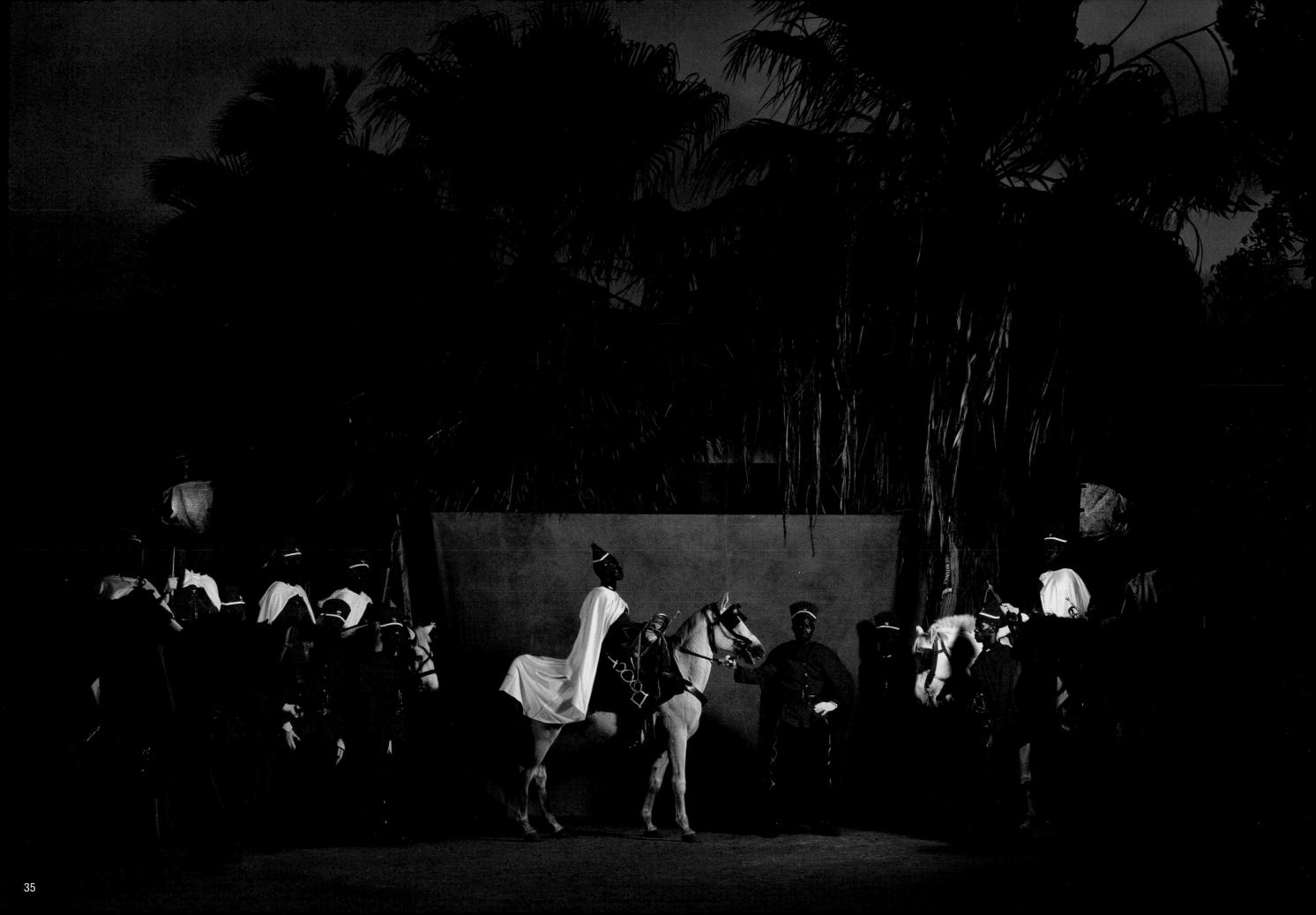

35

From the Maghrib to the Sudan: military stalwarts

On June 14, 1830, Charles X (1757–1836) of France sent an expeditionary force of thirty-eight thousand troops and four thousand horses to Algeria. It was a "punitive" expedition against Algeria, initiated on the pretext that the dey of Algiers had insulted a French ambassador.

The occupying army soon realized that these four thousand big *afrandjis* (French) horses were totally unsuited to the climate and terrain of North Africa, and replaced them with local Barb horses. In October of that year, General Clauzel (1772–1842), commander in chief of the expeditionary force, decided to create a native cavalry regiment that became known as the *spahis*.

Thirteen years later, when France wanted to strengthen its presence in Africa, the governor of Senegal, Commander Bouët-Willaumez, was authorized to "borrow" some of these famous *spahis* from his colleague in Algeria.

On February 6, 1843, twenty-six "Algerian" cavalrymen (half were European, half Maghribis) landed at Saint-Louis in Senegal. "I am reinforcing them with twelve black cavalrymen," the governor wrote to the French colonial minister a week later, and then proceeded to send his small cavalry on missions of "pacification." Their first feat of arms was to rout two thousand Tukulor warriors (a Muslim people from northern Senegal) on August 4, 1843.

As a result of this exploit, the colonial authorities decided to create a full squadron—and then a regiment—of exclusively Senegalese *spahis*, who went on to achieve glory in every corner of the French Empire. "The sands of Mauritania, the banks of the Niger, the region of Timbuktu, the distant lands of Chad and Central Africa and . . . Morocco can bear witness to their heroic deeds," proclaimed General Jung, commander of West African troops, in December 1927.

By the time Senegal gained independence in 1960 and after more than a century of loyal service, this prestigious cavalry regiment had almost been disbanded. However, the first president of the new Republic of Senegal, the poet Léopold Sédar Senghor, decided to retain a mounted squadron that would become part of the national police force. Despite Senegal's new-found republican status, the squadron's colonial past continued to be reflected in its spruce uniforms and its Barb horses, although these no longer came from Algeria but from Morocco, a country with much closer links to Senegal, both geographically and politically.

Resplendent in red tarbooshes, burnooses and jackets, and black baggy trousers, this parade unit is called the Red Guard. Today it is the only one of its kind in Africa, with the exception of the much smaller guard of honor created by the president of Togo, between 1975 and 1980, quite simply because he did not know what to do with the horses given to him by his northern neighbor, the president of Niger. Its only function is to parade through the streets of the capital once a year during the national festival.

34. *Naïm*, a 15-year-old **Barb** stallion, born in Algeria, owned by Eckehard Pöppel, from Süstedt (Germany).

35. Mounted on **Barb** and **Arab-Barb** horses, the Senegalese Red Guard, photographed at their barracks in Dakar, in May 2003. *Saphir*, ridden by Sambou Diouf of the 1st troop of the Red Guard, is flanked by members of the 1st and 2nd mounted squadrons of the Senegalese national police force under the command of Captain Djiby Tine.

37. Barb and **Arab-Barbs**. Captain Djiby Tine holding *Tango*, from the band of the Red Guard, ridden by Warrant Officer Abdoulaye N'Diène and flanked by members of the 2nd troop.

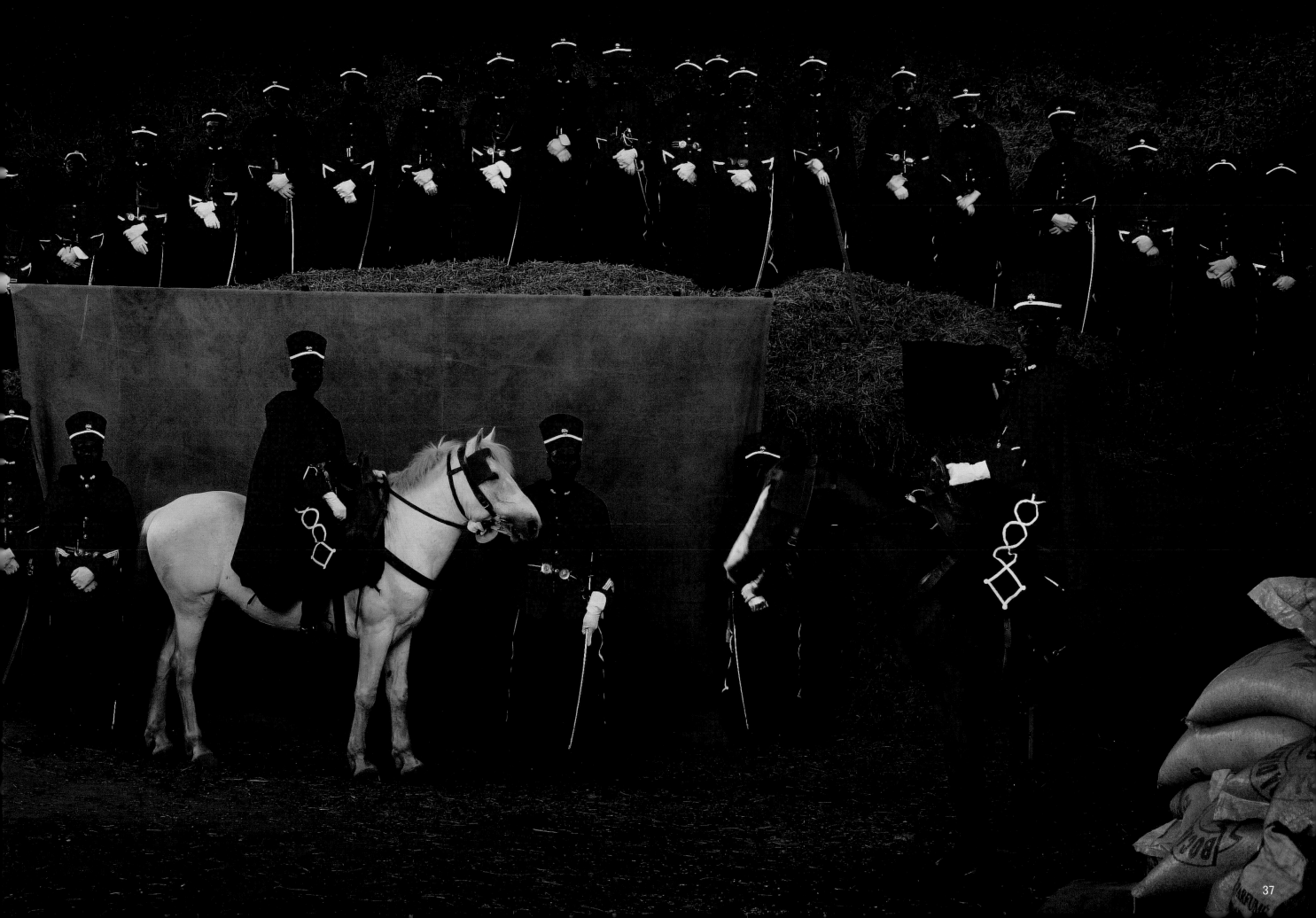

Barbs and Dongolas: trading places

Although separated by one of the largest deserts in the world, North Africa and sub-Saharan Africa—the Maghrib (from the Arabic for "west") and the Sudan (from the Arabic *bilad as-sudan* meaning "land of the black peoples")—have maintained trading links for thousands of years. Twentieth-century French ethnologist Henri Lhote was able to prove this ancient link when he found evidence that the "Sea Peoples" had traveled from Tripoli (the capital of present-day Libya) to Gao (to the east of Mali). Three to four thousand years ago, a "chariot route" linking the shores of the Mediterranean and the banks of the Niger was already in existence. Far from being an insurmountable barrier, the Sahara has always been a region of trade and trafficking—some trades more honorable (salt) than others (slaves).

Of course, horses were also part of this vast trading network, which still continues today. The horse drinks large quantities of water and did not adapt well to the arid climate of the Sahara. Nor did it fare any better in the humid climate of the tropics, which favors the proliferation of the tsetse fly—a bloodsucker that transmits a deadly parasite causing sleeping sickness in humans and a similar disease (nagana) in domestic animals. It was a different story in the vast expanses of the Sahel, a broad belt of savanna between the desert and the tropical forest that roughly covers northern Senegal, the whole of Mali and Burkina Faso, the north of Togo, Benin, Nigeria and Cameroon, and the whole of Niger and Chad. Here, the horse adapted and even flourished, establishing a bloodline and developing numerous indigenous varieties that colonial vets attempted to describe, but which were mostly of Barb origin. They are smaller and a little narrower on the forehand than their North African ancestors, but they have nevertheless retained the general appearance that makes them easily identifiable.

The Dongola is another type of horse that is fairly widespread in sub-Saharan Africa, recognized primarily by its strangely shaped head and very pronounced Roman nose. Its ancestry is obscure and unproven, although its champions maintain that it originated in Nubia and possibly even Yemen.

The horses of sub-Saharan Africa (pages 38, 39, 40, and 41) are descended from Barbs and Dongolas.
38. *Ndjirou Balewou*, a six-year-old *fantasia* horse owned by the *lamido* ("lord") of Maroua, presented by Ibrahim, a dignitary from the lamidate of Mindif (Cameroon).
39. *Balewou* (whose name means "black"), a five-year-old from Bornu (Nigeria), presented by Souleyman, a "warrior" from the lamidate of Mindif (Cameroon).
40. His Majesty, Oumarou Maigari, the *lamido* ("lord") of Mindif/Moulvoudaye (Cameroon), surrounded by his dignitaries.
41. *Bidi Bridji*, a six-year-old *fantasia* horse—winner of the "1,500 meters" at the "festival of the sheep" and of the race held on February 11, ("the festival of youth")—presented by Abdulwahabou, a dignitary from the lamidate of Maroua (Cameroon).

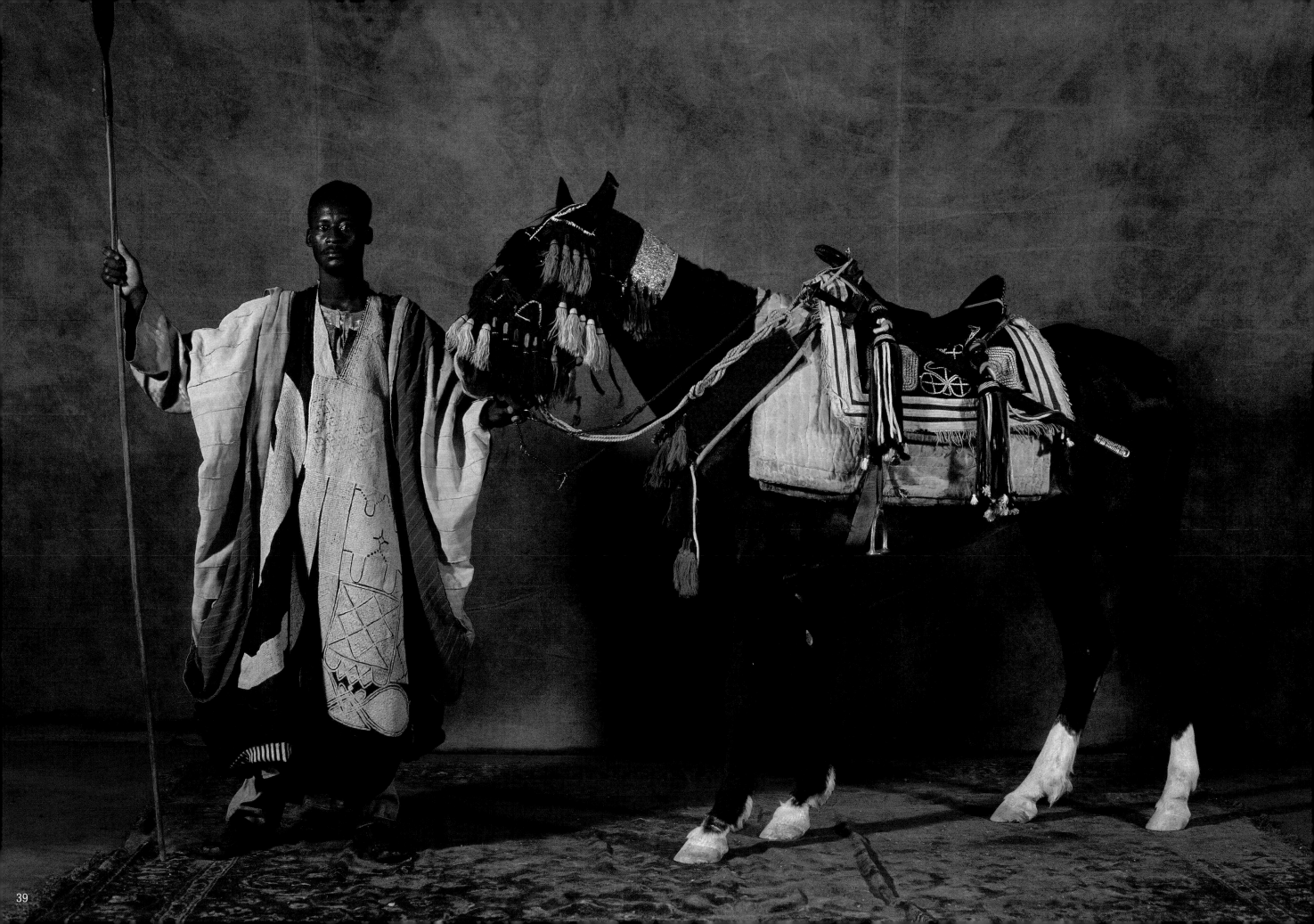

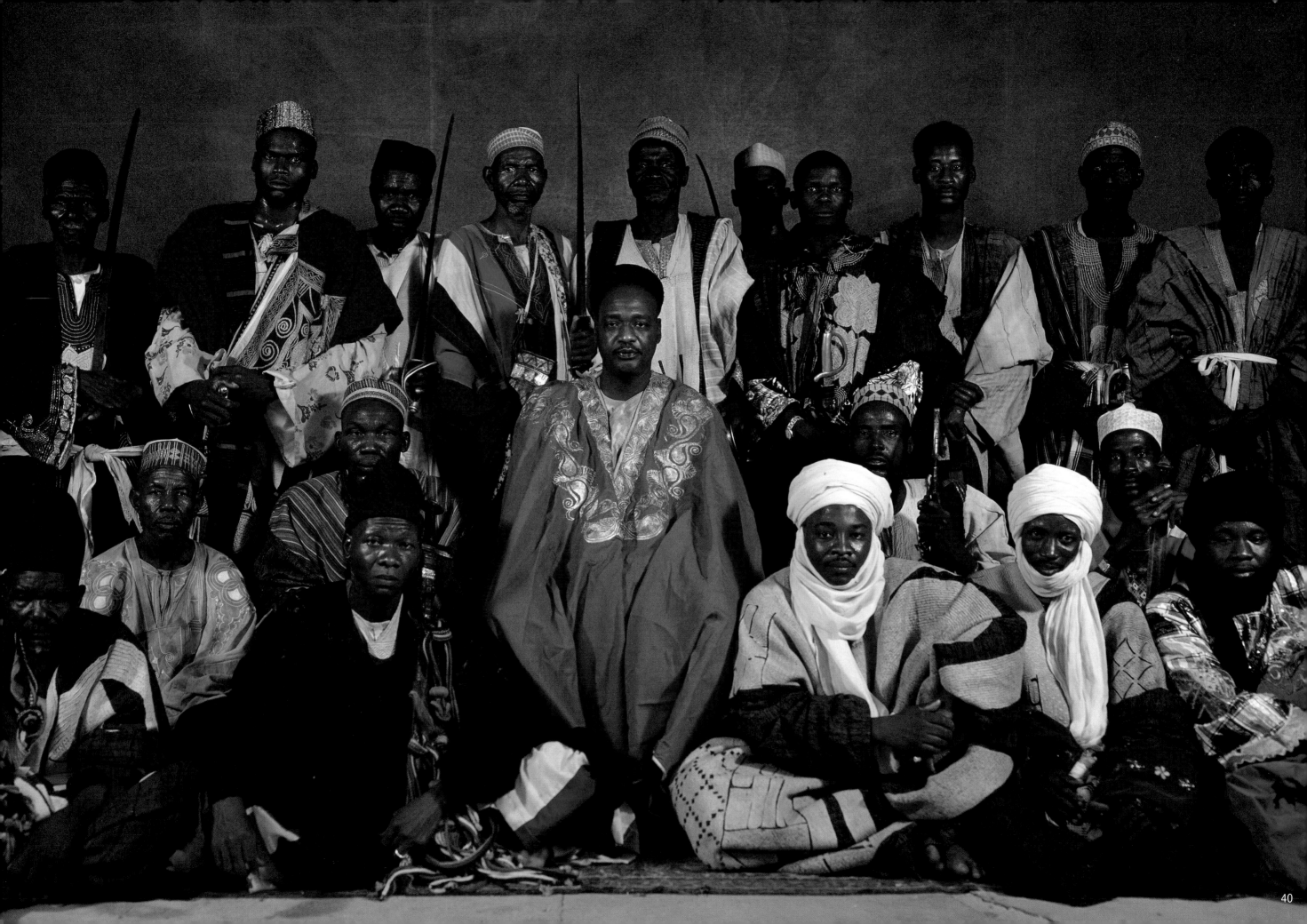

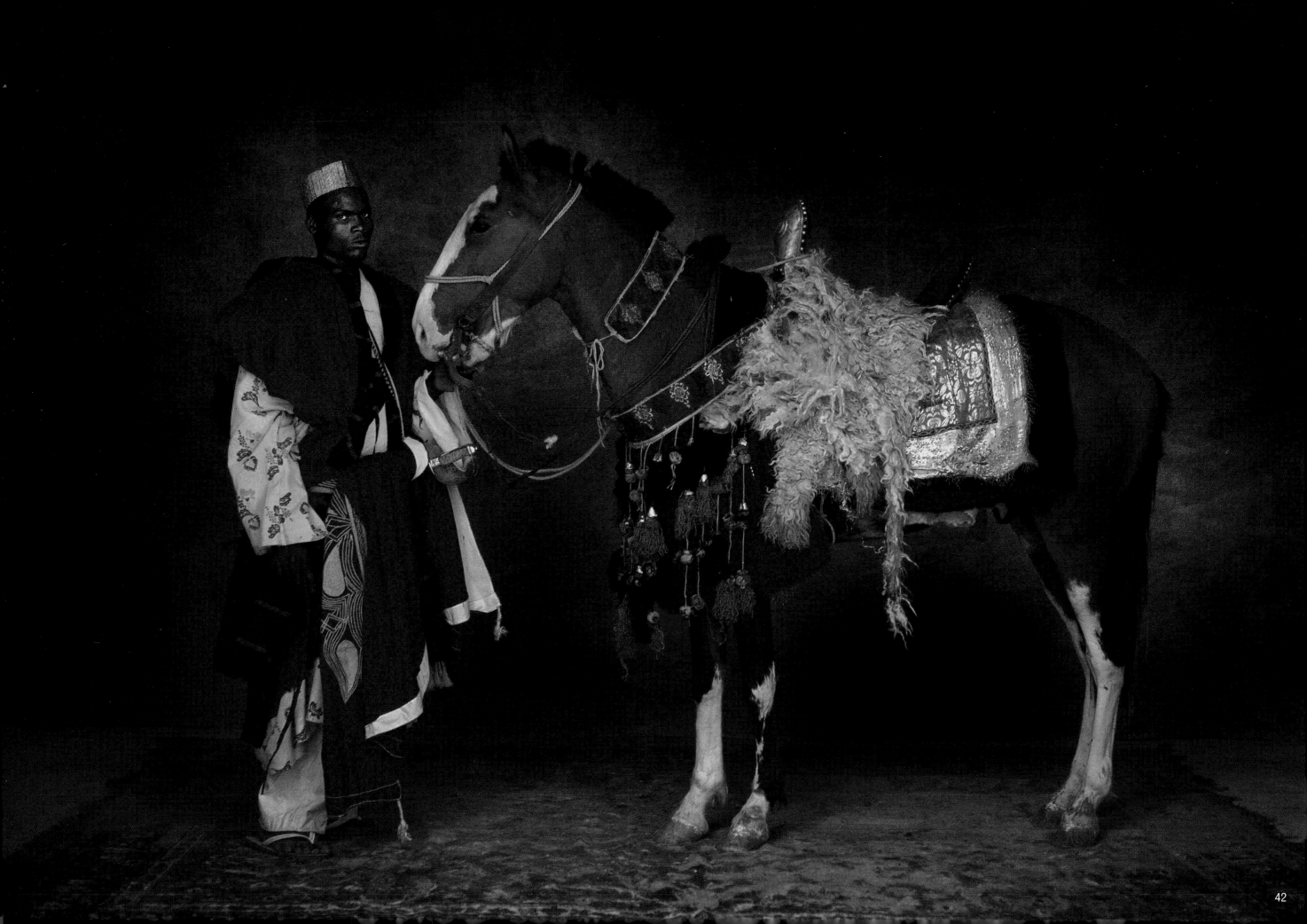

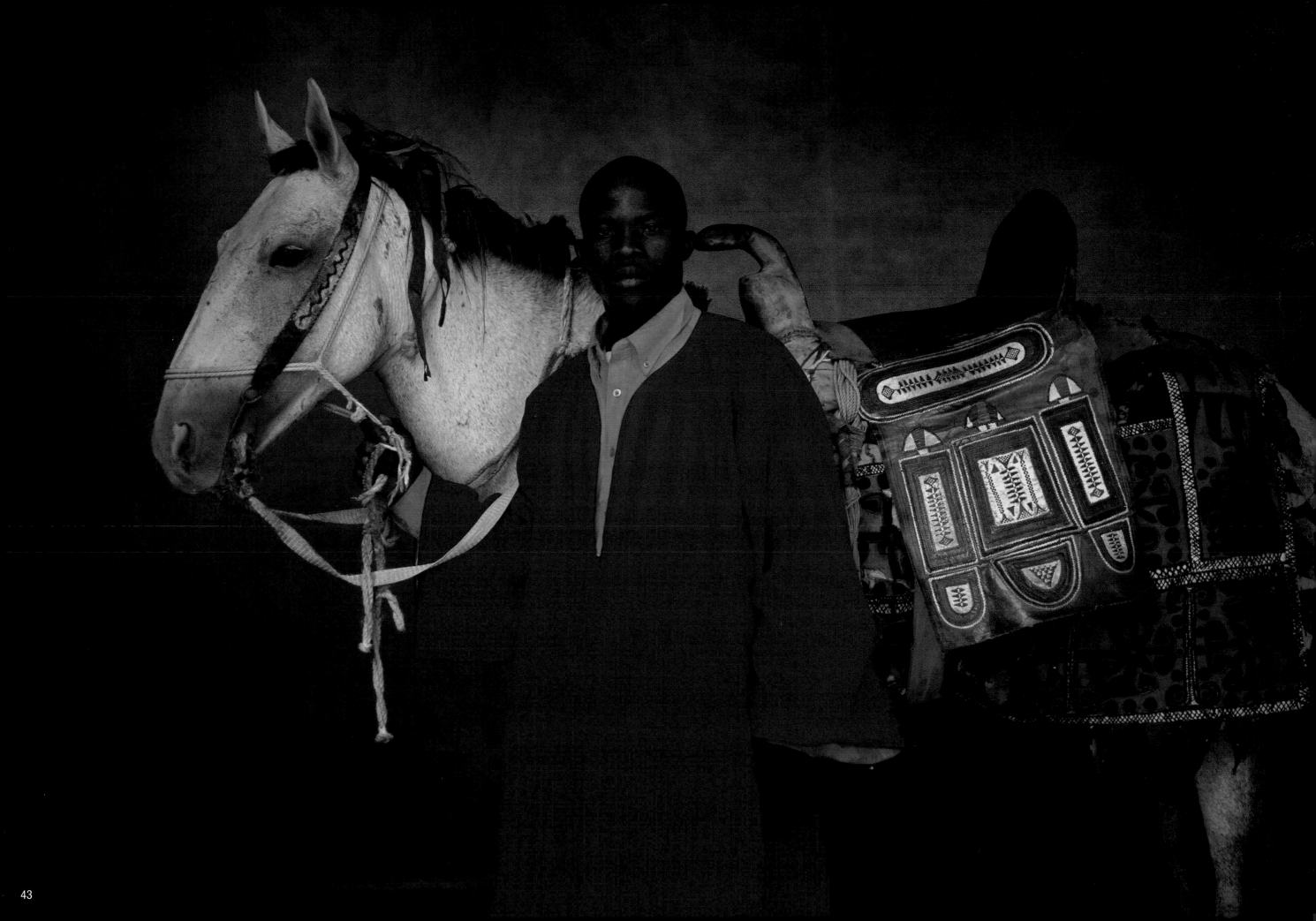

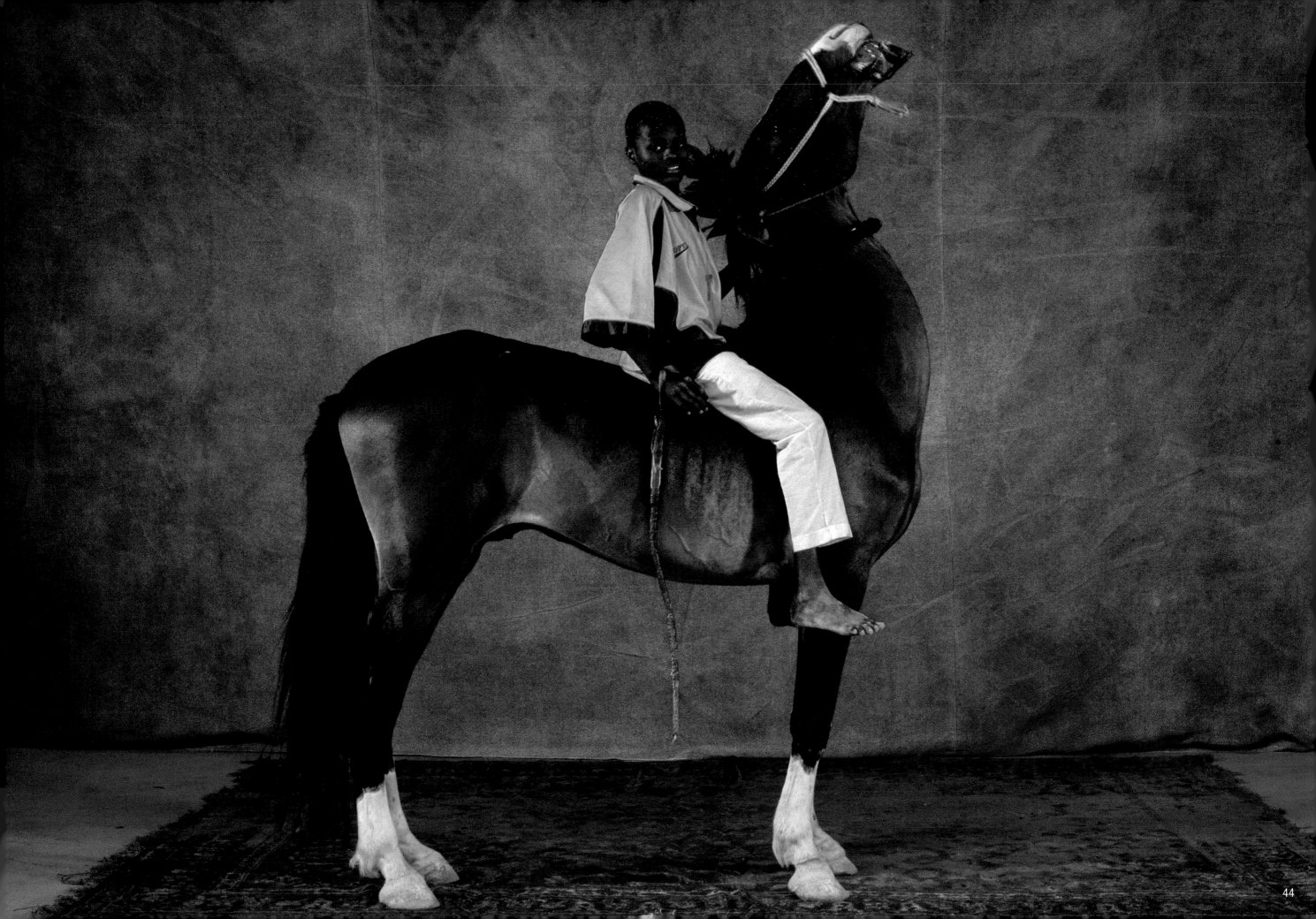

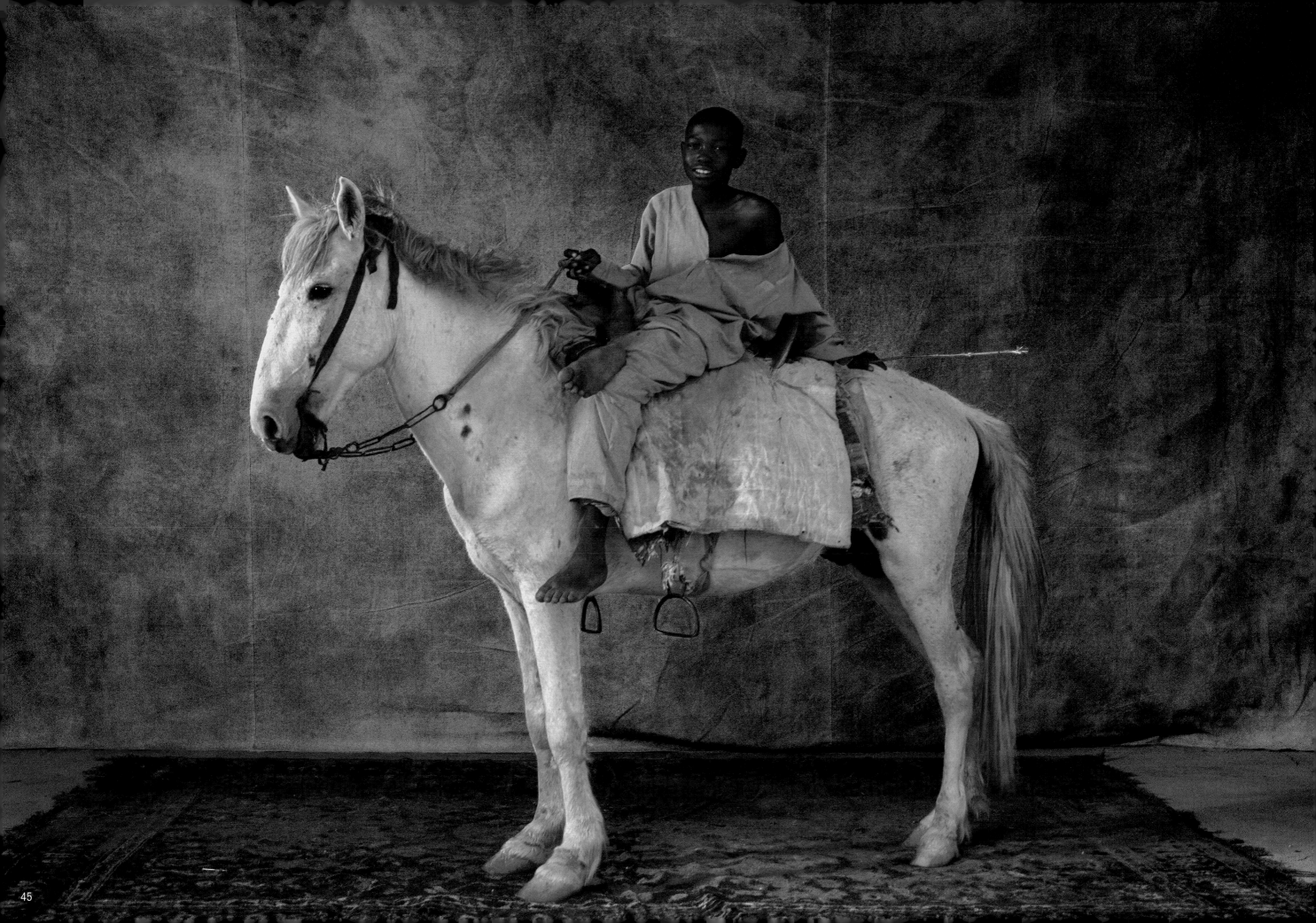

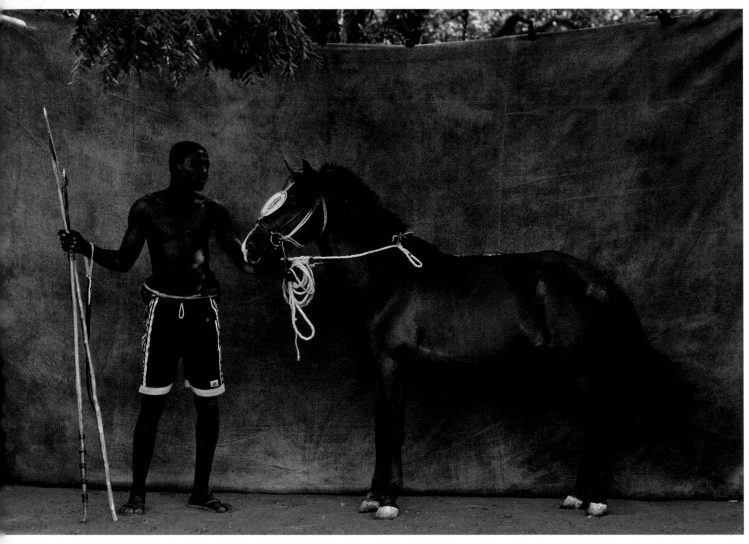

The Musey: hidden strengths

Long before Africa's colonization, vast empires—often ruled by gallant black knights—had been established south of the Sahara. Among these was the Mali empire, whose great ruler Mansa Musa (1307–32) devalued his kingdom's gold reserves by liberally handing out the precious metal during his famous pilgrimage to Mecca in 1324. Then there was the Songhai empire of Sonni 'Ali (1464–92) and his successor Muhammed Askia (1494–1529), and the empire of Kanem-Bornu, on the shores of Lake Chad, whose horsemen, clad in their thick padding, resembled knights in a European jousting tournament.

In the early nineteenth century, the Fulanis of Adamawa (a region situated in present-day Cameroon) created religious and military "commanderies" by the juxtaposition of neighboring states. With the advent of the Europeans at the turn of the nineteenth and twentieth centuries, these became known as "lamidates," quite simply because the local overlords bore the title of *lamido* ("lord").

After colonization, these local "sultans," as they were sometimes also known, retained their religious and social authority but lost much of their warrior status. However, their horses—and especially their stallions—remained the symbol of their power.

Today, horses are still the prerogative of chieftains and the *lamido* continues to entrust his horses to vassals known as *lawan* (chiefs of large villages), whose grand-sounding titles are now largely redundant and devoid of any real significance. These *lawan* are obliged to feed and care for the horses, and keep them at their lord's disposal—not, as in the past, for use in military campaigns, but for the festivals, ceremonies and *fantasias* that are reminiscent of former splendors.

These horses, the distant descendants of the horses that came from the Maghrib, Egypt and possibly the Arabian Peninsula, "are of mixed character, somewhere between the Barb, Dongola and Arab," explains French researcher Christian Seignobos, who is a top specialist in the field.

Seignobos, who is also a geographer, ethnologist, linguist and zoologist, has a particular interest in a small member of the horse family. At 11.3–12.1 hh (47–49 in), with uncertain origins, it is with "trypano-tolerant" (i.e., immune to the tsetse fly) and well adapted to swampland (see *Le Poney du Logone*, 1987). It is still used today by the Musey, a non-Muslim people living on either side of the Chad-Cameroon border, on the flood plains of the River Logone. According to certain historians, this is where an ancestor of the great Russian poet Aleksandr Pushkin (1799–1837) was born in the late seventeenth century.

"Ridden bareback and in a makeshift bridle, Musey ponies were for a long time used for hunting and raiding," says Christian Seignobos. "The Musey invested them with human characteristics and their lives, like the lives of their human masters, followed a ritual pattern. When they died, they were buried and mourned."

The horses of sub-Saharan Africa (pages 42–47) are descended from Barbs and Dongolas.

42. A three-year-old *fantasia* horse, whose name, *Ndjirou Balewou*, is in fact a reference to its color—squirrel gray, i.e., reddish-gray. He is presented by Abdoul Karim, the dignitary responsible for the caparisons and other harness of the local *lamido*, and the official in charge of "administrative affairs."

43. The five-year-old *Pourou Balewou Koppi* (whose name literally means "flecked black-gray"), owned by the *lamido* of Mindif.

44. *Bodewou* (i.e., "red" or "chestnut"), an eight-year-old ridden by Harun, the son of a dignitary from Maroua, an important lamidate in northern Cameroon.

45. *Pourou* (which means "tobacco flower," i.e., gray or blue-gray), a seven-year-old of unmistakable Barb origin, ridden by Abba, the son of the dignitary who is looking after the horse for the local lord, the *lamido* of Mindif.

46, 47. Two **Musey** ponies. Right: *Gofna*, ridden by Marcus Jimanga. The photograph was taken beneath the sycamore figs near the concession of the chief of the province of Gobo (northern Cameroon).

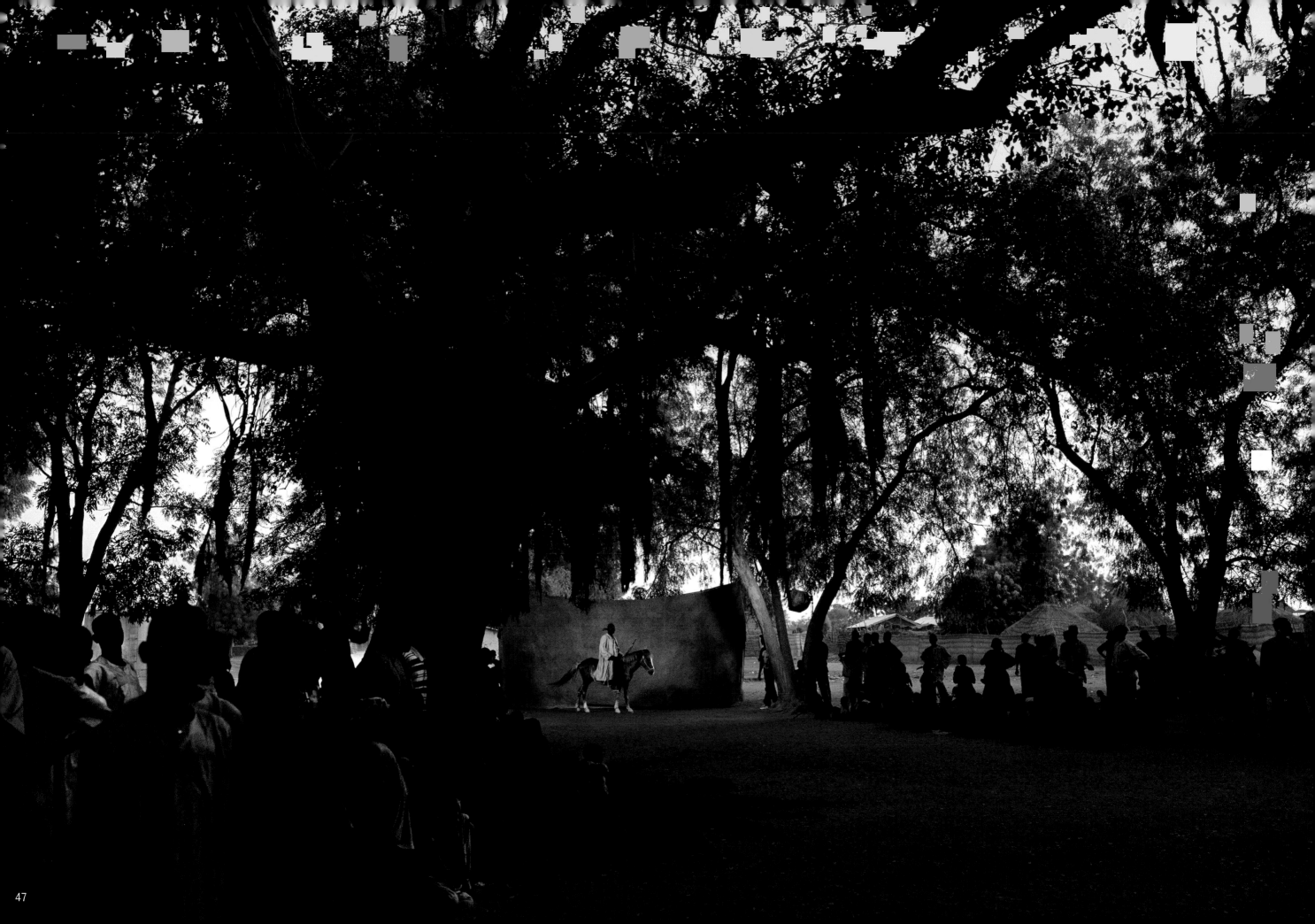

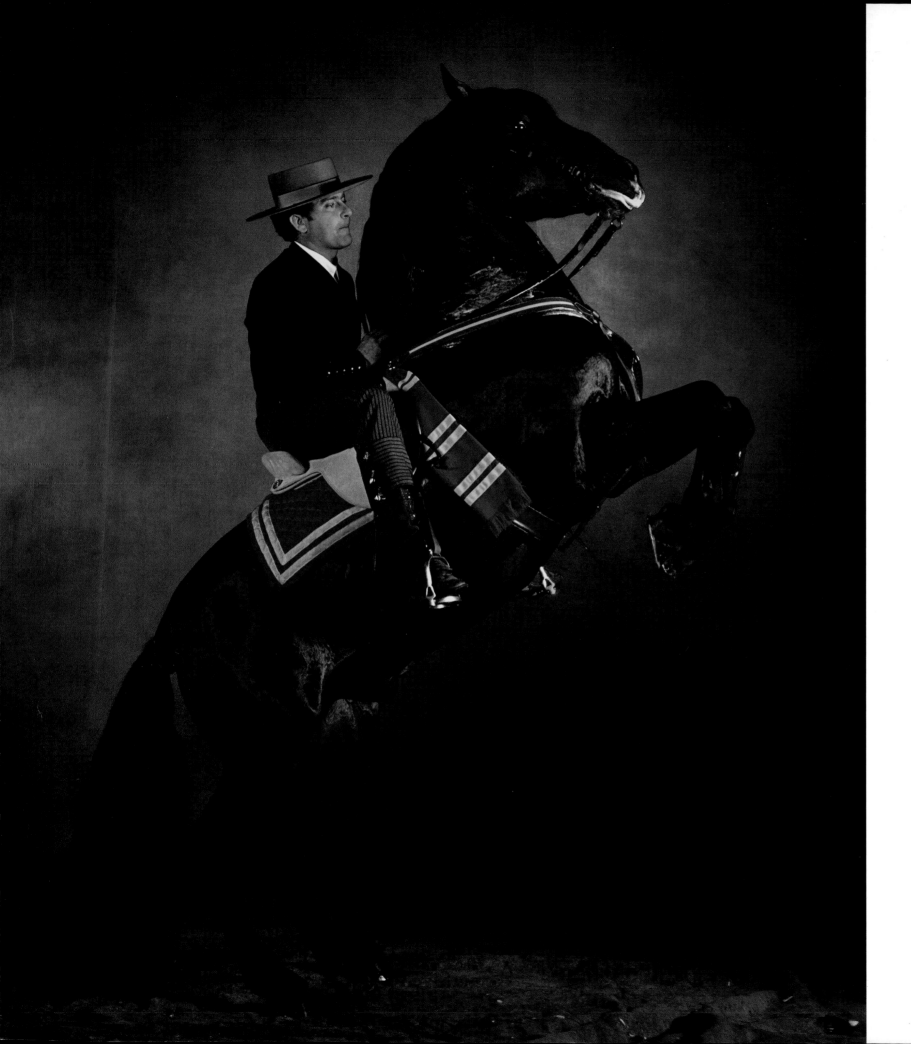

Jennets and Andalusians: in a league of their own

Never tell a *rejoneador* (mounted bullfighter) that his horse has North African blood in its veins. He is certain to deny it, even though certain historical events leave little room for doubt. About 200 B.C., Numidian (and therefore Berber) horsemen crossed the Iberian Peninsula during the Carthaginian expedition against Rome. They were followed by Zenete (and therefore Berber) horsemen eight hundred years after the birth of Christ, and the Almoravid and then Almohad (and therefore Berber) dynasties, which ruled Andalusia for more than eight centuries and gave rise to one of the most brilliant civilizations in the Mediterranean world. Supporters of the breed are just as adamant: the Spanish horse is not related to the Berber horse, and the Iberian breeds have not been modified in any way since they were first introduced by the Iberians during the Neolithic Period. If you insist, however, some people will admit that perhaps there could have been some degree of foreign influence, but in the opposite direction. It was the invaders' horses that were improved by the native breeds.

To keep everyone happy, it was decided that the existing names and classifications had to be changed. In the 1960s, the extremely fashionable eighteenth-century term "Spanish Jennet" was abolished, probably because it evoked the North African influence—according to linguists, the term "Zenete" gave rise to *jinete* (the Spanish word for "rider") and, consequently, "jennet." It was also decided to stop using "Andalusian," since it could apply to a horse bred in Spain or Portugal. The two countries eventually established their own stud books and new names for their horses. In references to Iberian breeds, it is now *de rigueur* to refer only to the PRE—Pura Raza Española (purebred Spanish horse)—and the PSL—Puro Sangue Lusitano (purebred Lusitano).

This all seems a bit clinical. Fortunately, however, a few enthusiasts continue to perpetuate the tradition (possibly inherited from the Berbers) of singing their horses' praises. Angel Peralta (b. 1926)—a famous Spanish breeder of bulls and horses, brilliant horse breaker and remarkable horseman—does not let a day go by without composing a poem dedicated to the horse.

48, 49. The **purebred Spanish** stallion *Tejedor VII* (by *Pegador* out of *Tejedora V*), ridden by Juan Antonio Martinez Ruzafa, technical director of the Peña de Bejar Stud Farm.
50–51. The remarkable horseman and breeder Angel Peralta on his **purebred Spanish** horse *Capricio*, photographed in the Plaza de Toros de la Real Maestranza (Seville).

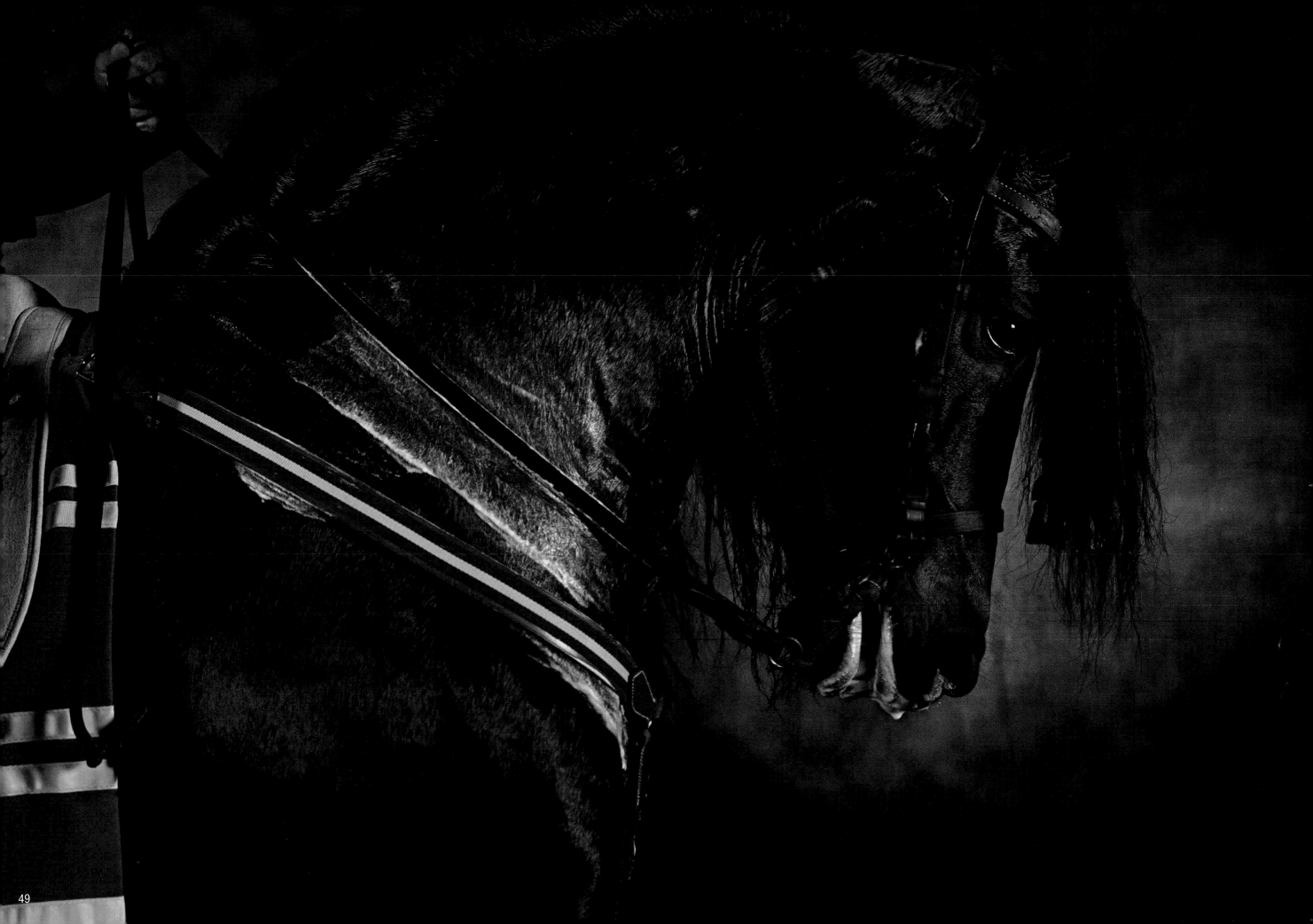

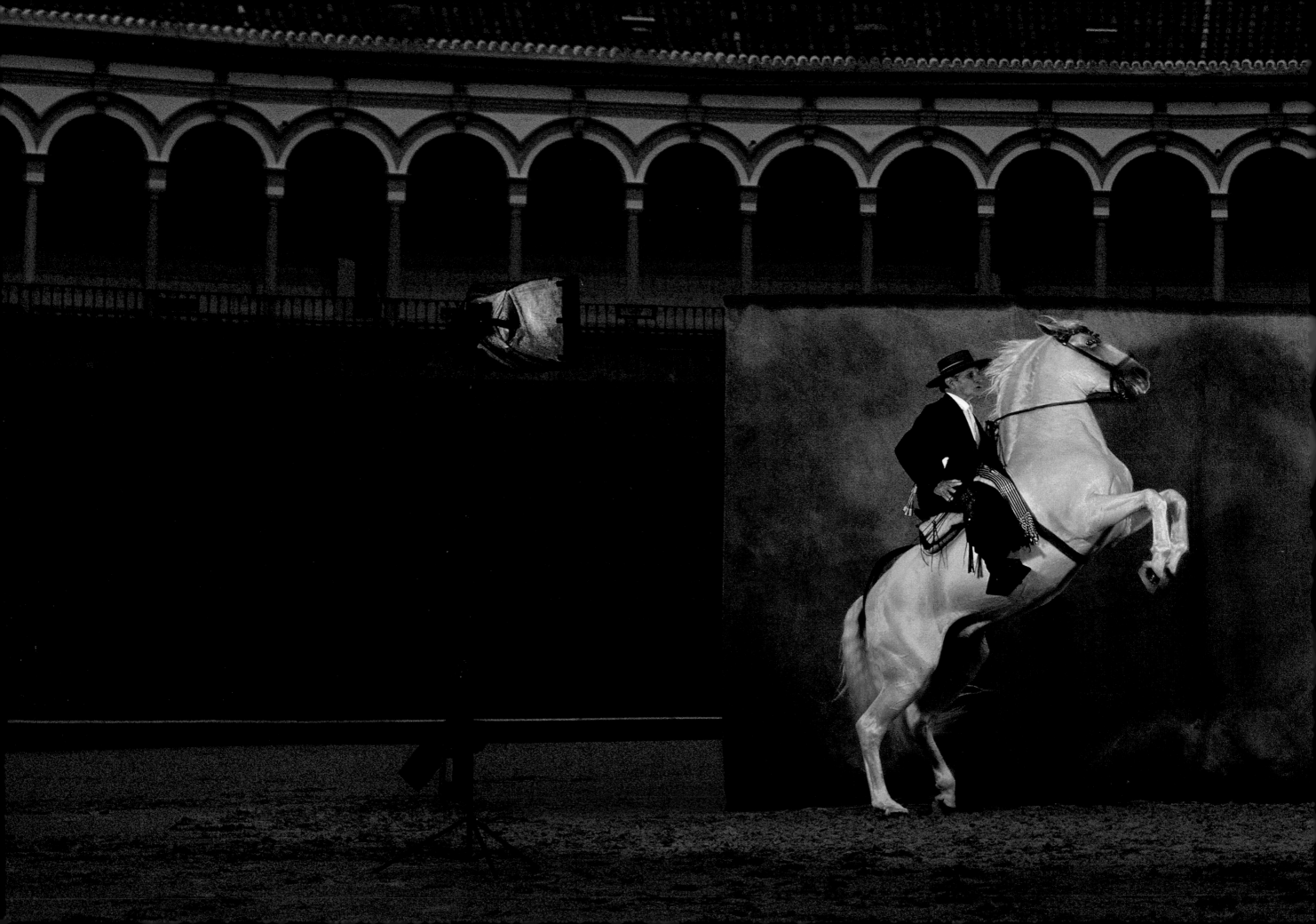

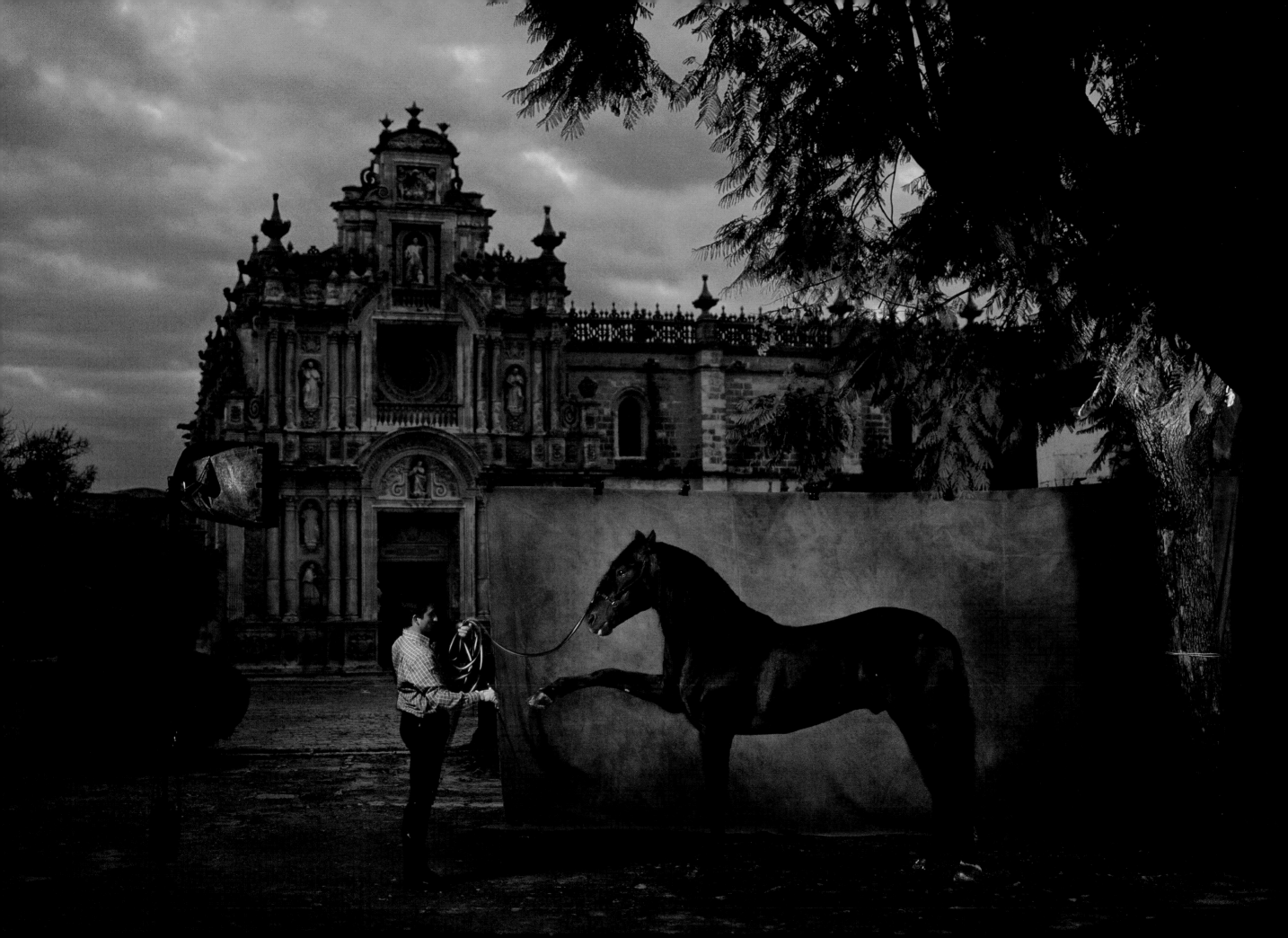

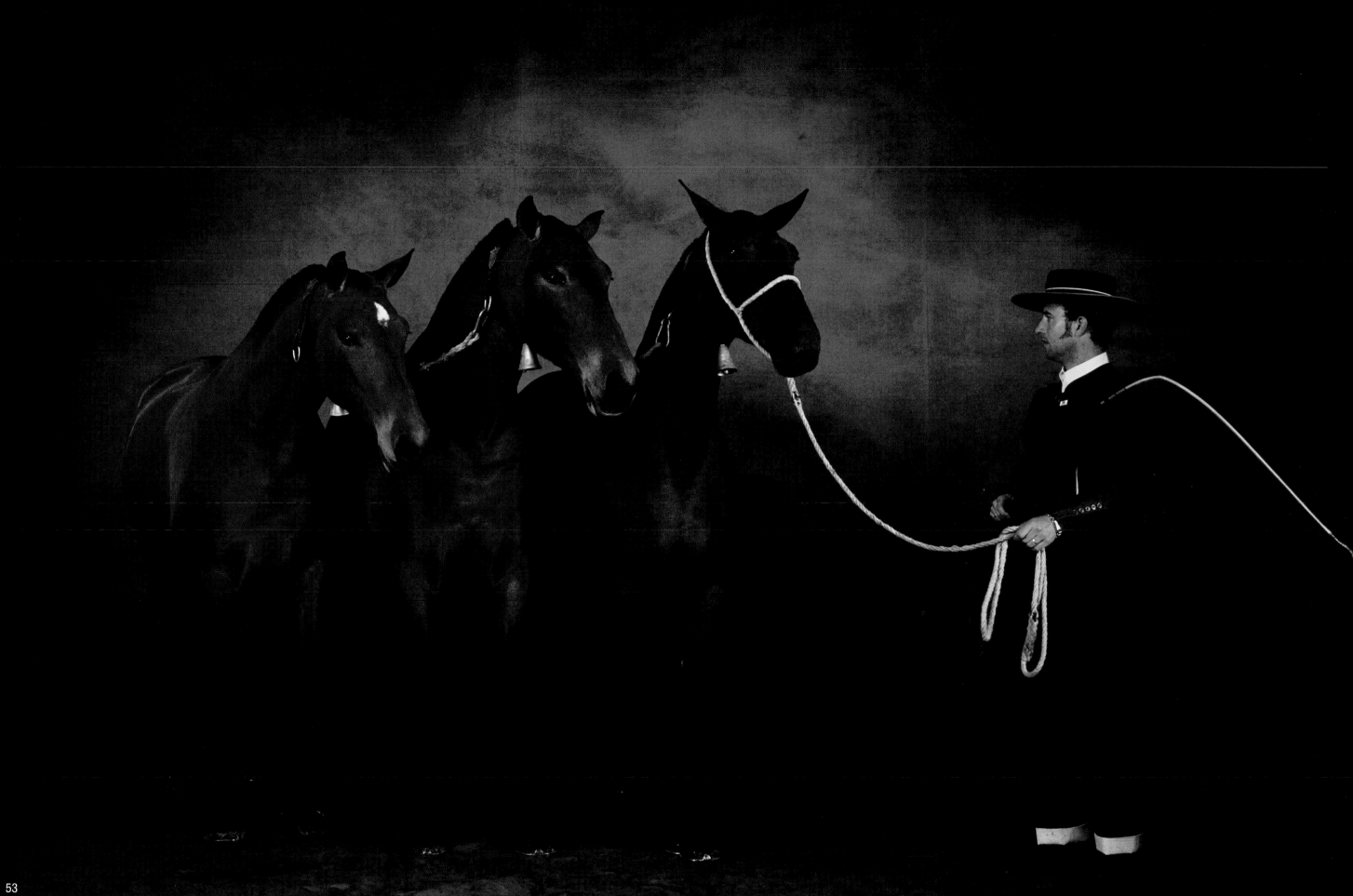

The purebred Spanish horse: master of *haute école*

Whatever you call it—Iberian, Andalusian, Spanish Jennet or PRE (Pura Raza Española)—the Spanish horse is one of the jewels of the equine race. Enthusiastic testimonies to the qualities of the breed abound in the—often extremely literary—treatises on the art and practice of horse riding that proliferated from the sixteenth century onwards. In 1593, a certain Salomon de La Broue (1530–1610), equerry in the royal stables of the French king Henri III (1551–89), wrote: "I put the true Spanish horse in first place, giving it my vote as the most beautiful, the most noble, the most graceful, the most courageous and the most worthy of a King."

Its conformation is so perfectly proportioned that it never fails to captivate even those who admit to knowing nothing about horses. Whether gray or black—all colors are accepted, except piebald and chestnut, according to the official standard for the PRE—it is certainly a magnificent animal. Yet there is also something very reassuring about it. It is not particularly large—14.3–15.3 hh (59–63 in)—and has a beautifully curved outline, from its aquiline nose, its powerful, arched neck and its broad back to its rounded hindquarters.

All these flowing curves undoubtedly help to create the impression of the placid and even temperament that people find so appealing. Those who have anything to do with the Spanish horse stress that this is not just a matter of appearances; these horses are incredibly kindly disposed towards their peers as well as their riders. Even the stallions (in Spain, the colts are not gelded) are docile, generous and cooperative.

This unique combination of physical attributes and "moral" qualities has long been recognized by the masters of the world of equestrian arts. In France, François Robichon de la Guérinière (1688–1751)—riding master by royal appointment (1715) and director of the royal manège of the Tuileries (1730–51)—wrote (1731): "All writers [on the subject] have given preference to the Spanish horse and regarded it as the best breed for schooling, because of its agility, its scope and a cadence naturally suited to pomp and ceremony, because of its proud bearing, gracefulness and nobility."

The breed is so closely linked to the development of the equestrian art that it is tempting to ask which came first. Was it the use of this beautiful animal with its extraordinary natural abilities that gave rise to *haute école*? Or was it the Spanish horse that provided horsemen with the ideal tool and enabled them to develop and perfect their art? Today, the Spanish horse remains the preferred choice for *haute école* riding (with its "airs above the ground") and equestrian displays.

52. The **purebred Spanish** horse *Cañamon*, presented in front of the monastery (La Cartuja) of Jerez de la Frontera by Antonio J. Diaz Porras, a former student of the Real Escuela Andaluza del Arte Ecuestre, in Jerez. The purest purebred Spanish horses are known as *Cartujanos* (Carthusians) because they are descended from a line of magnificent horses bred by Carthusian monks in Seville (from 1393) and Jerez (from 1478).

53. Three **purebred Spanish** brood mares from the Marques de Velilla Stud Farm, in San Pedro de Alcantara (near Málaga). The photograph was taken in Germany, at Equitana 2003, a biennial equestrian event that shows breeds from all over the world.

54. The **Andalusian** horse (from the south of the Iberian Peninsula) *Peruano*, "ridden" by his owner Camilla Naprous. The photograph was taken at the Horse of the Year Show 2001, held at Wembley Arena, London (England).

55, 56, 57, 58, 59. Two **purebred Spanish** horses, trained to perform by the famous stuntman and trainer Mario Luraschi—*Toreo* (aged eleven), performing "circus tricks" (sitting down, bowing and rearing), and *Rimbaud* (aged nine), ridden by Joëlle Balland.

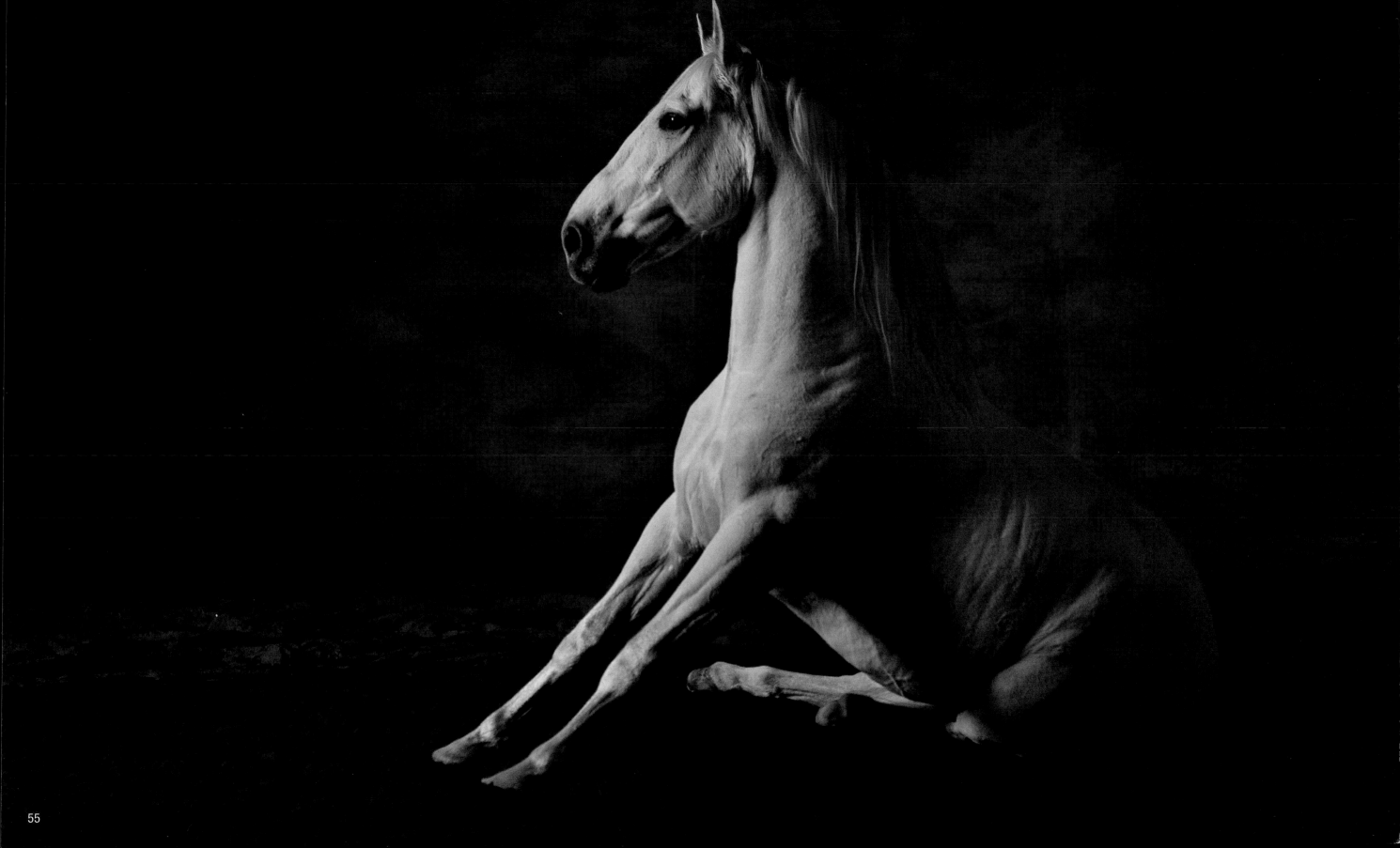

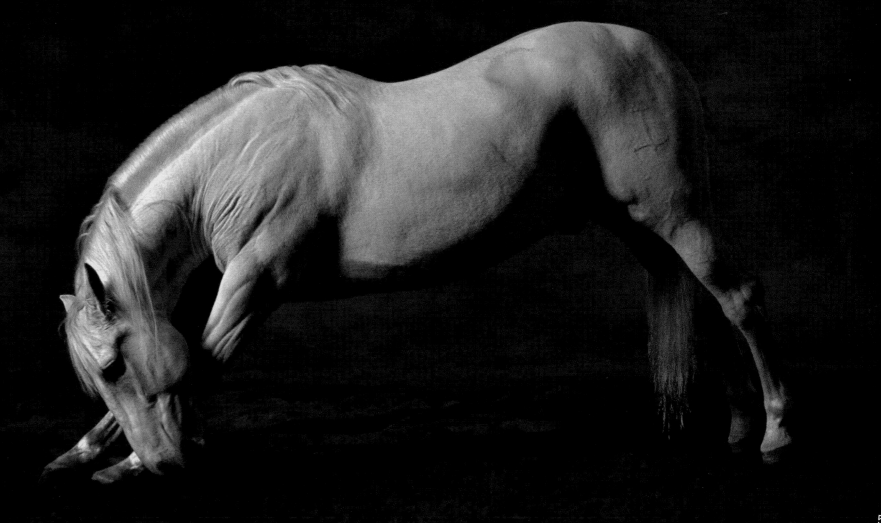

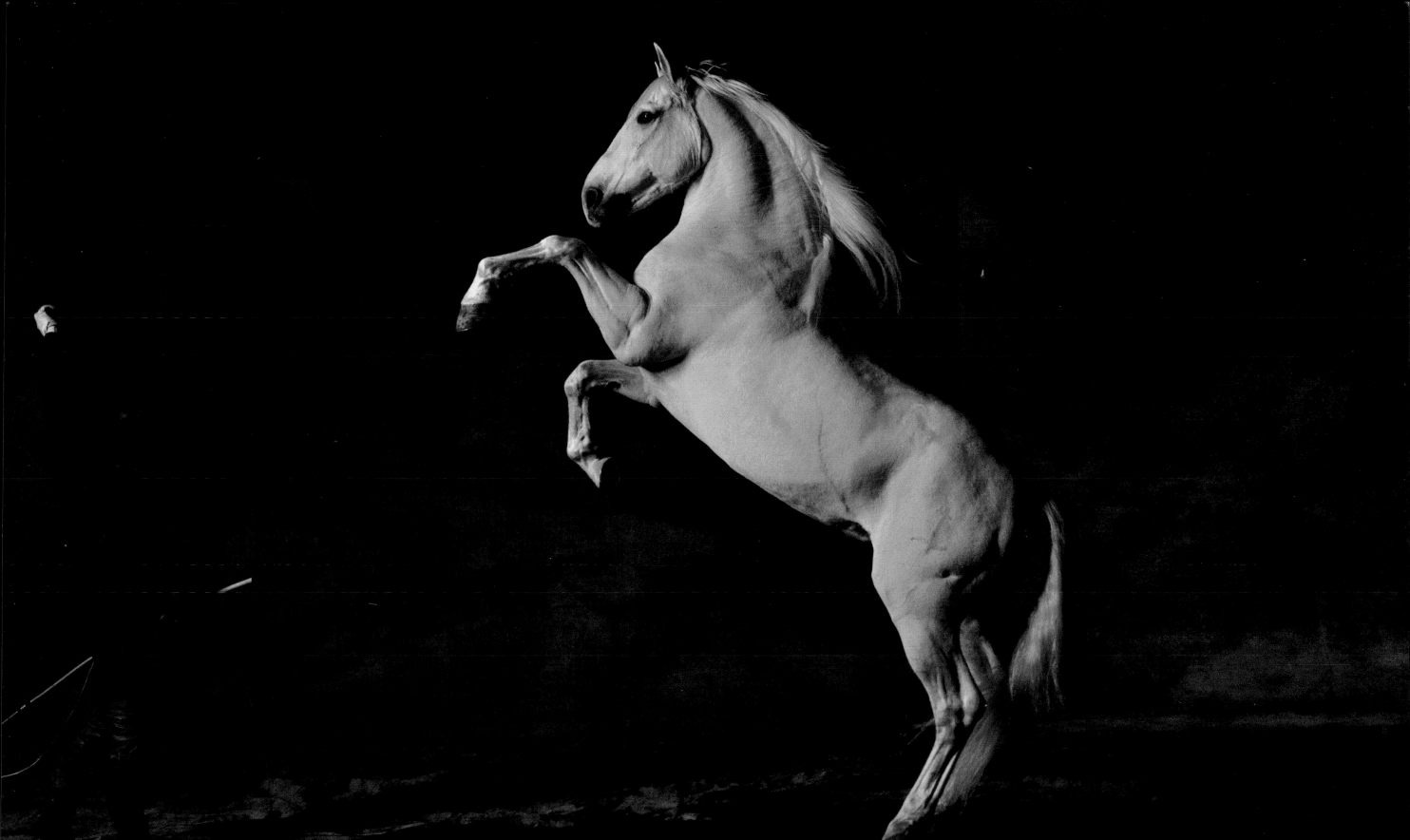

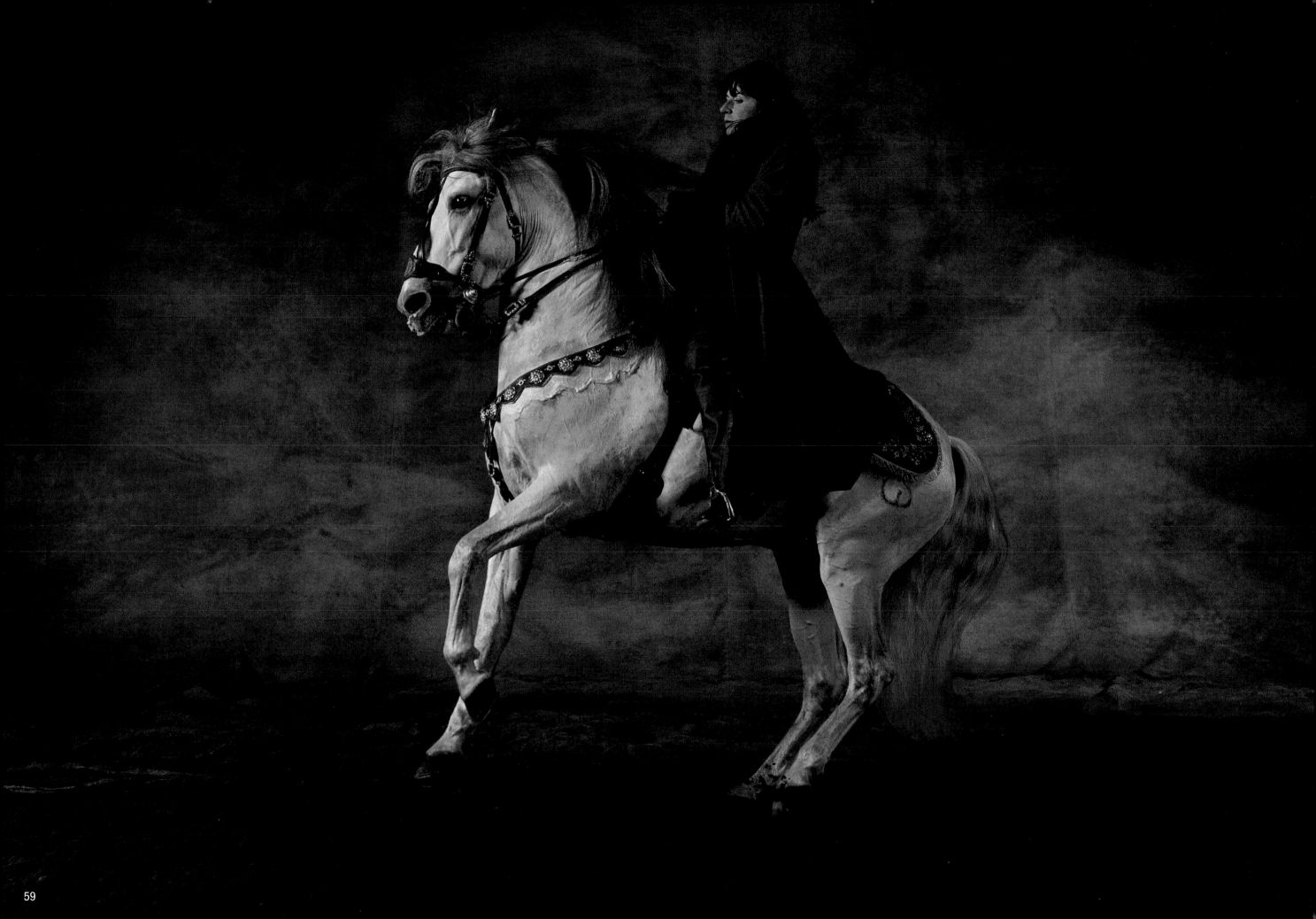

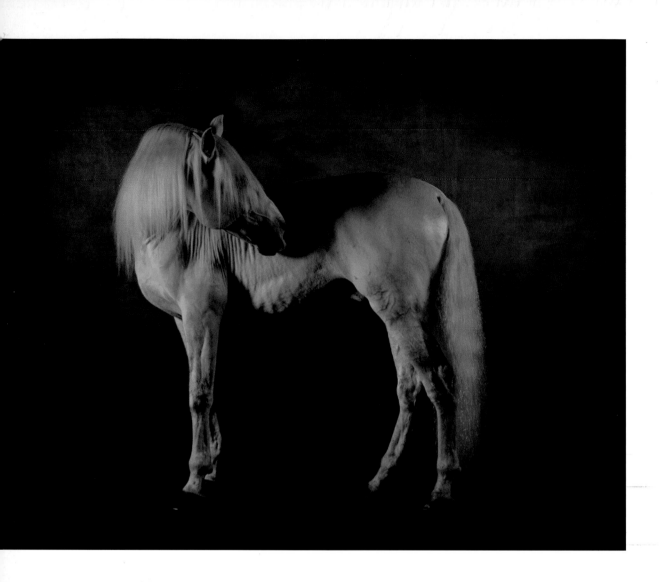

The purebred Lusitano: a star in the making

Another jewel of the Iberian Peninsula, the Portuguese horse, or Lusitano, is as deserving of praise as is the Spanish horse. These horses are descended from the same Andalusian stock and have the same qualities, to the extent that, until recently, little distinction was made between these two branches of the same "breed."

The Portuguese branch became the Lusitano in 1966 and then the Puro Sangue Lusitano (purebred Lusitano), or PSL, in 1990. Like its Spanish counterpart, it enjoyed its golden age with the development of the equestrian academies and *haute école*, a discipline in which it shows a particular aptitude. Between the sixteenth and eighteenth centuries, it was the darling of the royal courts of Europe.

In the nineteenth century, however, the crowned and titled heads of Europe suddenly became infatuated with Oriental (Arab, Turkoman and Persian) horses and their finest Western offshoot, the English Thoroughbred. They lost interest in academic equitation and the beautiful *pirouettes* and *caprioles* performed by the Iberian horses, and turned their attention to flat racing and steeplechasing—i.e., sport and the turf—or, to use the terms coined by French author Jérôme Garcin in *Perspectives cavalières* (2003), "horizontal" rather than "vertical" equestrian disciplines.

This infatuation with Arabs and English Thoroughbreds all but sounded the death knell for the horses still classified as "Jennets" and "Andalusians." It also threatened the future of the academic equitation they had helped to develop, a style of riding that the Portuguese horseman Diogo de Braganca called (in a work published in 1975) "riding in the French style," even though it was first developed and subsequently revived in Portugal.

The first European treatise on the equestrian art was in fact written by an eminent Portuguese horseman—King Duarte of Portugal (1391-1438)—who, in around 1434, wrote a training treatise entitled *O Livro da Ensynnança de Bem Cavalgar Toda Sella (A Book That Teaches How to Ride Well on All Types of Horse)*.

Five centuries later, after a long period of unpopularity and relative obscurity, the Iberian horse and the beautiful light, floating style that it executes so perfectly finally enjoyed a revival of interest. This was due to the brilliance of the Portuguese riding master, Nuno Oliveira (1925–89), described as "the most remarkable horseman of the twentieth century" by his disciple and friend, Michel Henriquet, who has done so much to promote Oliveira's international reputation.

Used in Portugal for what are modestly referred to as bullfighting spectacles, the Lusitano is a true performer, well suited to the circus ring and footlights. Its color is more varied than that of the Spanish horse and it often has a much fuller mane and tail, which merely add to its charm, not to say its "femininity." Today the Lusitano is much sought after by circuses, equestrian theaters, horse operas and equestrian "academies," which, in the wake of Bartabas's carefully choreographed "Zingaro" horse shows, are becoming increasingly popular throughout the world.

60. The ten-year-old **Lusitano** *Jardineiro*, owned by the Rahmatallah family (England).
61. The **purebred Lusitano** *Pintor*, ridden by Portuguese rider Rodrigo Brito de Moura Coutinho Torres, demonstrating a classic movement from *Doma Vaquera*—a form of riding inspired by the *vaqueros* (herdsmen) of southern Spain, open to all horses of Andalusian origin, i.e., Spanish horses and Lusitanos.
62, 63. The twelve-year-old **purebred Lusitano** *Dao de Courenne*, from the Delgado Stud Farm (one of the best known in France), which also produced *Templado*, the world-famous star of equestrian theater, magnificently trained and presented by Frédéric Pignon and Magali Delgado.

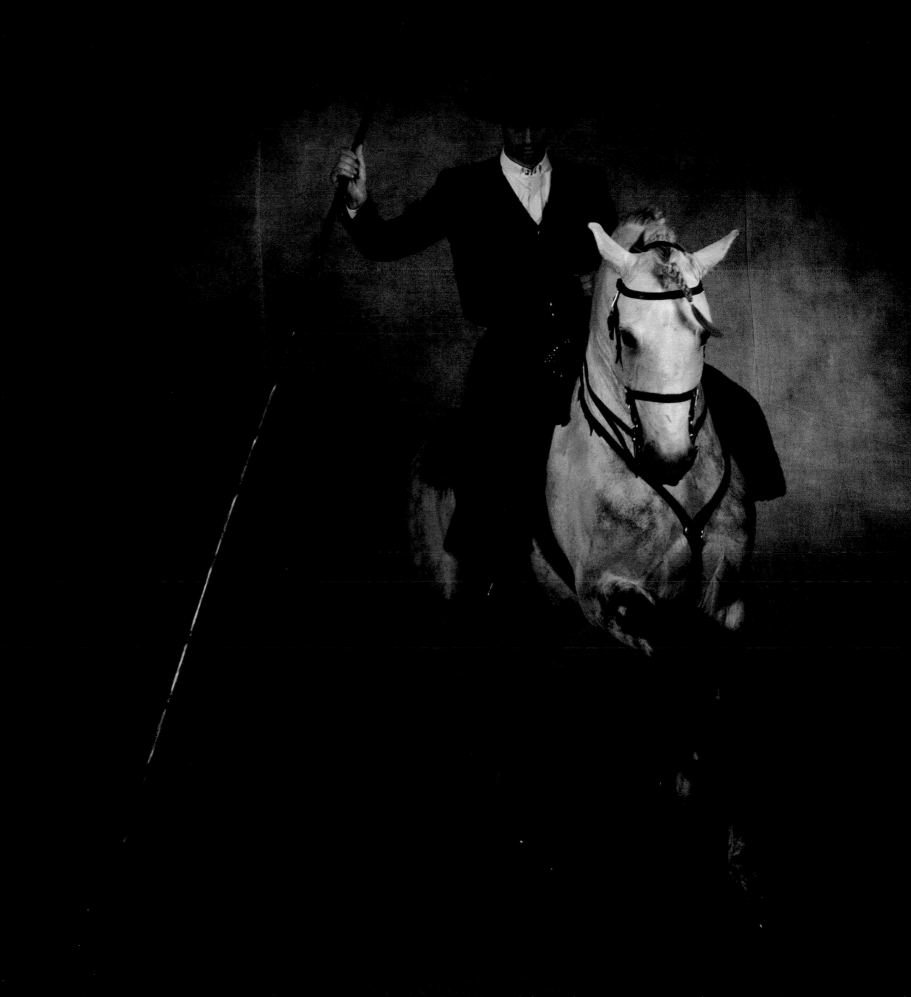

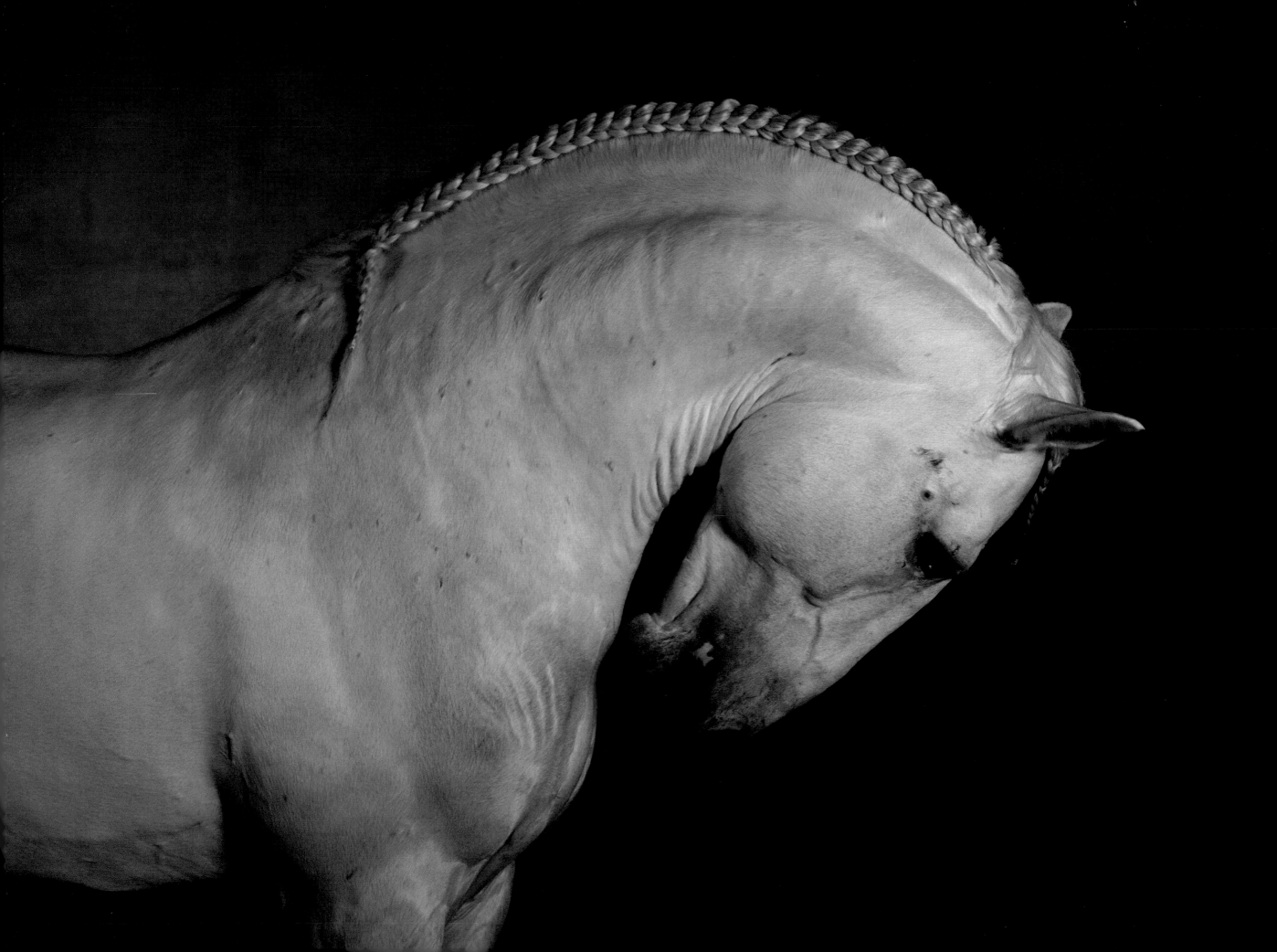

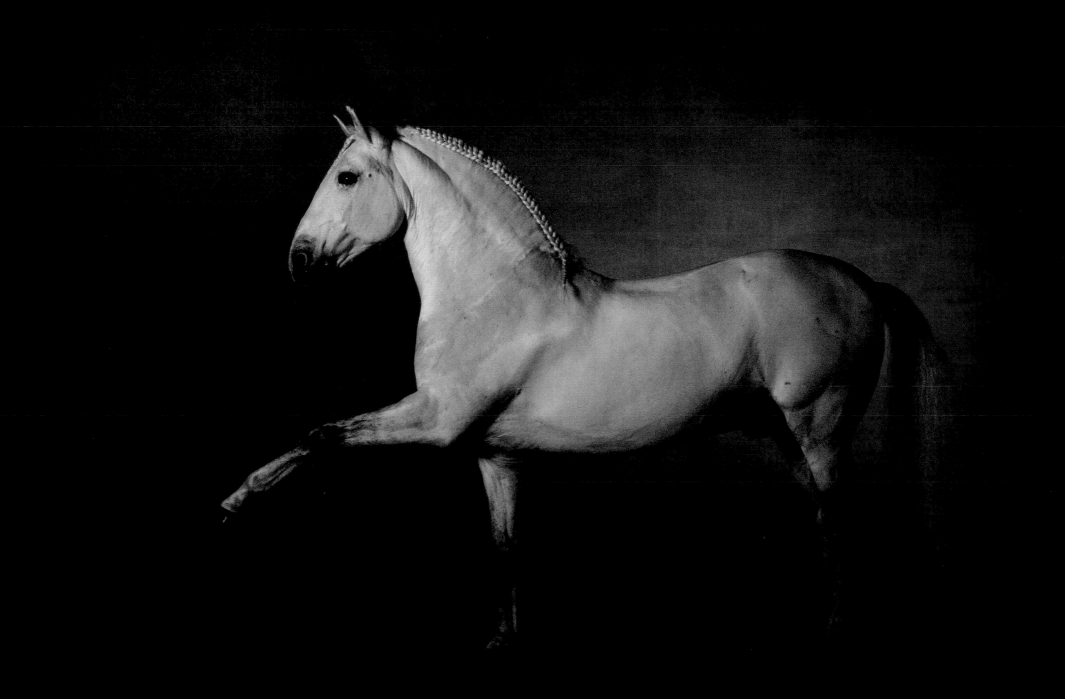

The Camargue: wild at heart

The Camargue, the vast marshy delta formed by the Rhone River as it flows into the Mediterranean, is famous for its *manades*—the Provençal term for the herds of wild horses that seem to thrive in the region's suffocating summer heat and bitter winter cold. Picking their way through the marshes, the occasional snowy-white egret perched on their backs, Camargues, the small white ponies native to the region, seem locked in a time warp.

To their enthusiastic supporters, Camargues are virtually identical to the horses that early man drove over a cliff to the death in the hundreds at Solutré in Mâcon—apparently so their flesh could be eaten, although this has not been proven conclusively. Standing between 13.1 and 14.1 hh (53–57 in), sturdily built (660–880 lb/300–400 kg), robust and compact, the Camargue is not totally dissimilar to the early prehistoric horses that were painted on cave walls, such as the Lascaux caves in the Dordogne region of France.

However, it would be unrealistic to deny the possibility of any later influences, since there is evidence of Barb blood in the Camargue. This may have been introduced initially during the Roman period when Numidian horsemen, traveling from Carthage to Rome via Spain, must have passed through the region, but it was almost certainly injected later, during the Muslim conquest in the eighth century.

The question is purely academic. Whether they are the result of having evolved in a vacuum, isolated from any form of external influence or, on the contrary, of being crossed with some exotic breeds, today's Camargue ponies are unmistakable and well established as a type. They are also a protected species that is found nowhere else in the world—over three thousand wild horses living in an area of less than 247,000 acres (100,000 hectares) whose boundaries coincide roughly with those of the Camargue Nature Reserve.

Between May and October this "Garden of Eden" can become a living hell, with horseflies, ticks, flies and mosquitoes. This does not seem to deter the thousands of tourists who make the annual pilgrimage to the land of *Crin Blanc (White Mane)*, the cult film by Albert Lamorisse which, since winning an award at the Cannes Film Festival in 1953, has captivated the hearts of millions of children worldwide.

64. Traditionally, all **Camargue** ponies bear the brand of their *manade* (herd) on their left hindquarter.

65. The eight-year-old **Camargue** stallion *Gitan du Mas II*, presented by his owner Jean-Marie Nègre.

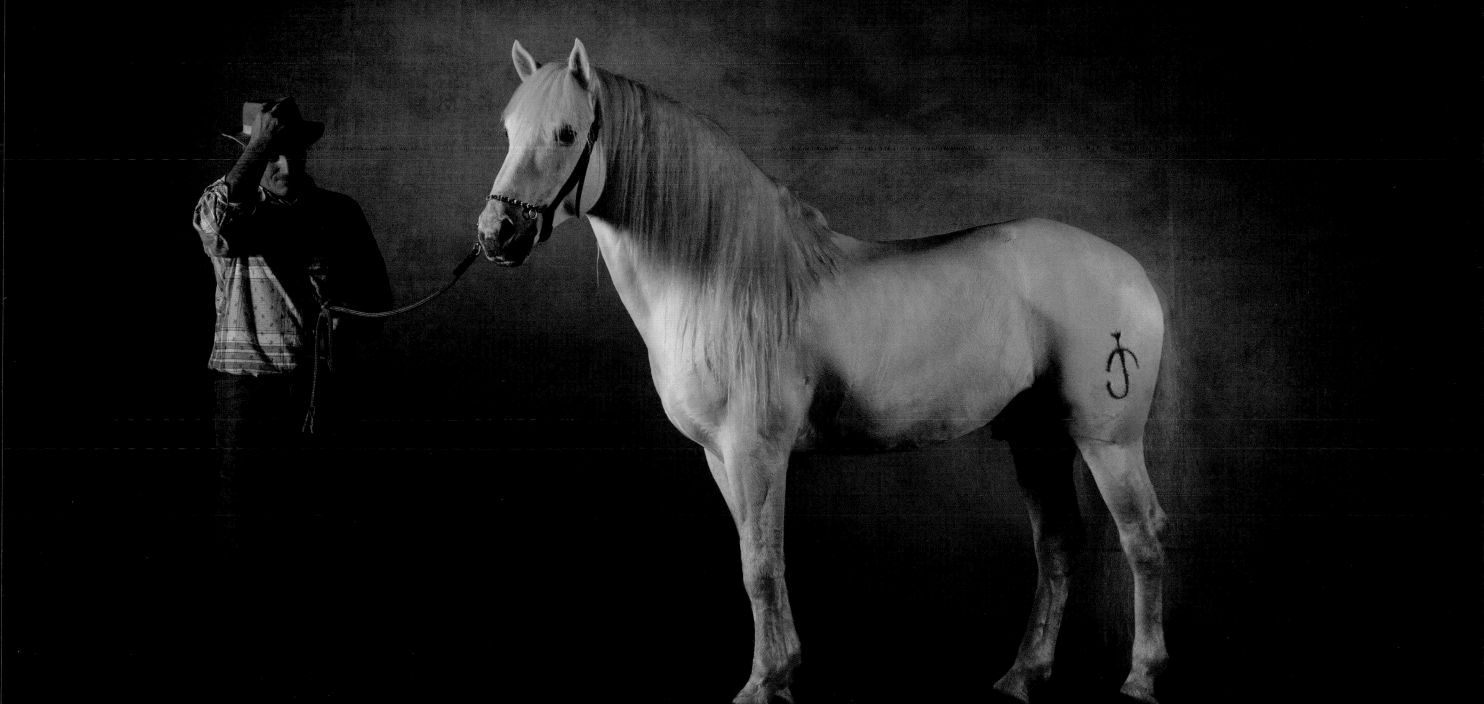

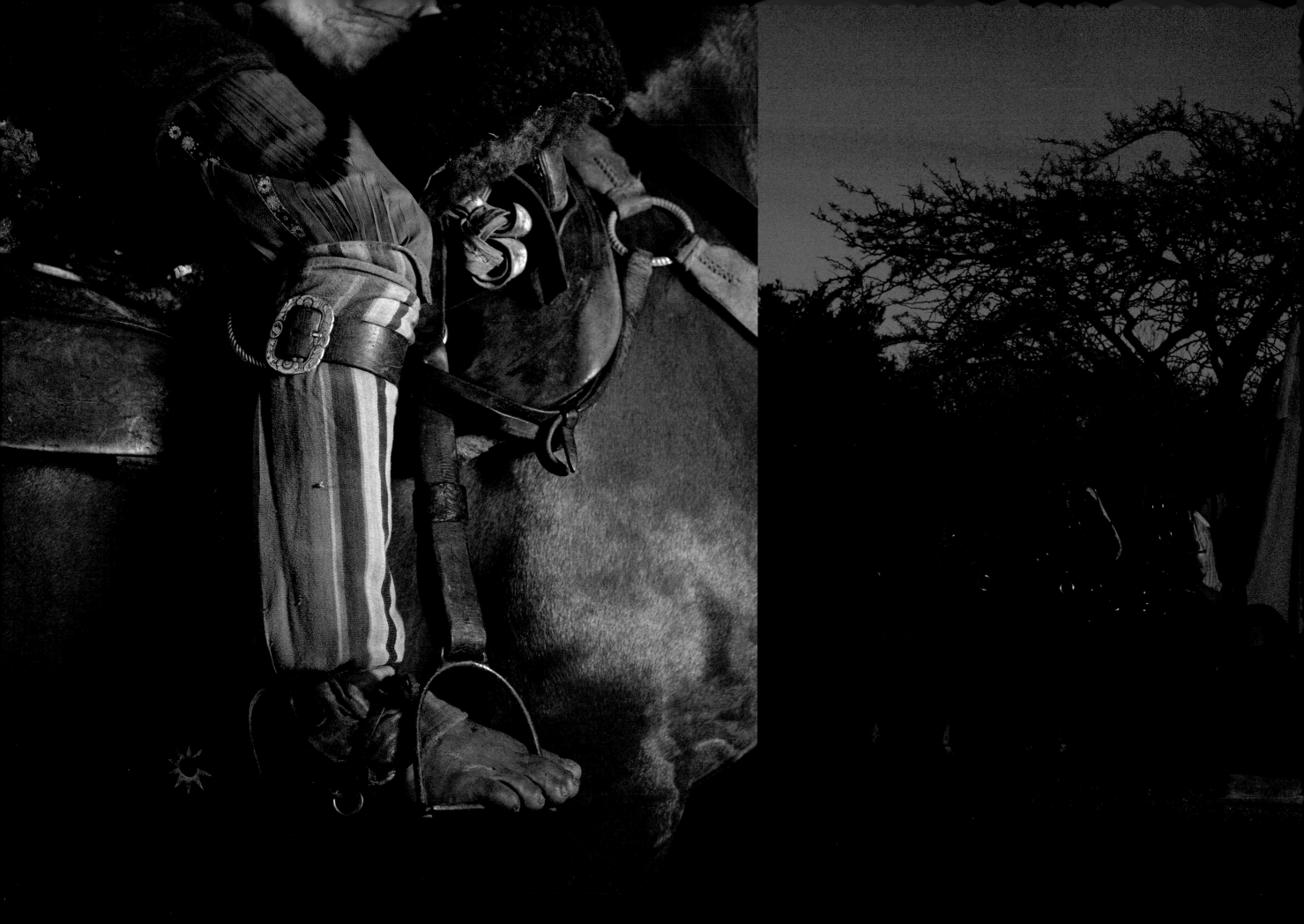

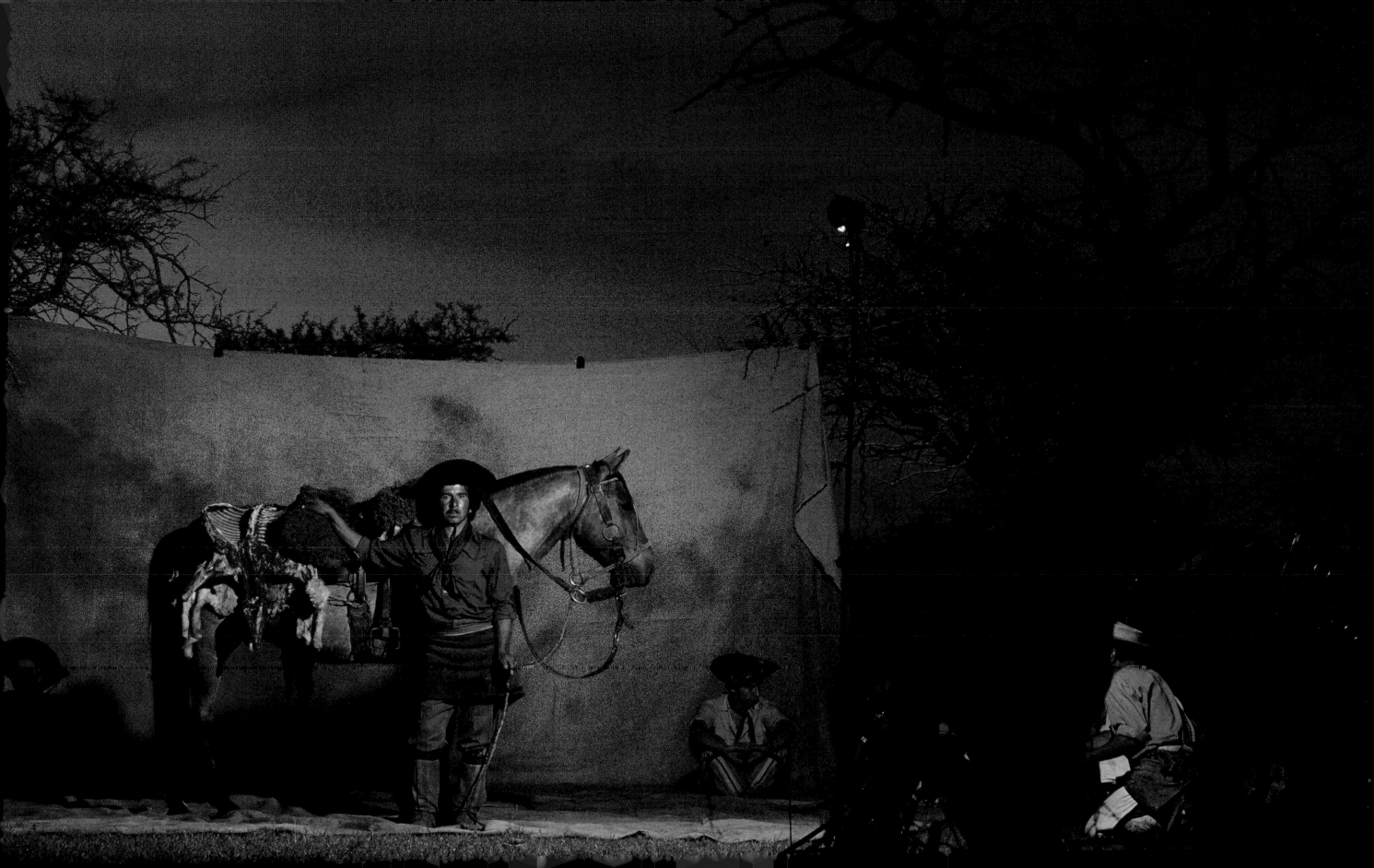

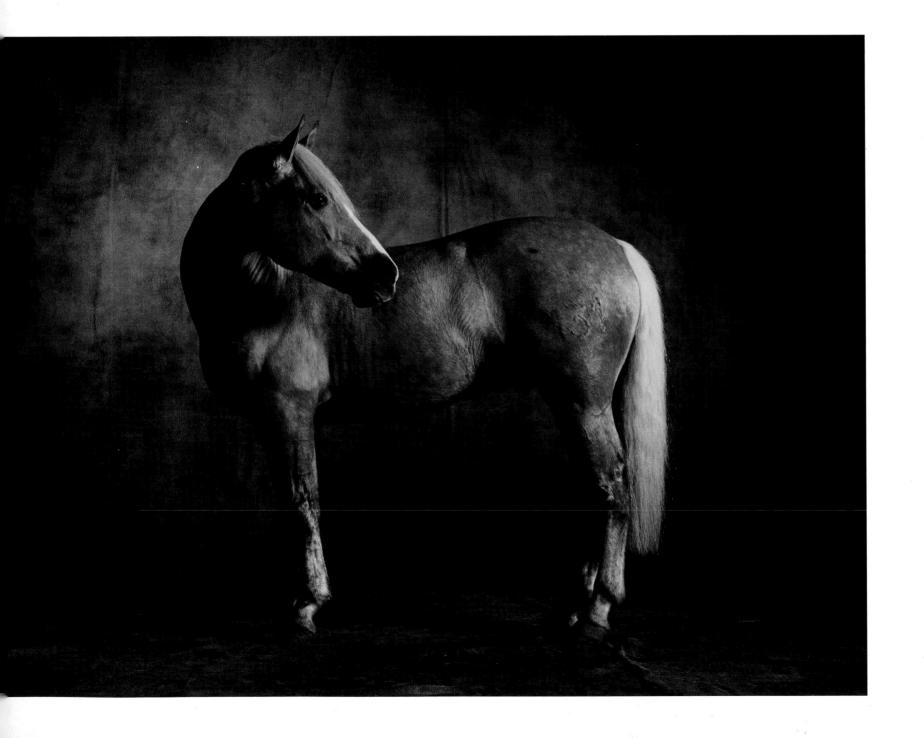

The Criollo: living the American dream

Paradoxically, the American continent, home of the Western—where horses appear (at least in films) to be galloping off into the distance all day long, and where men seem to have been born in the saddle—was in fact the last continent to have been colonized by *Equus*, or the horse as we know it today. According to the accepted history of the horse, millions of years ago, a small animal no bigger than a dog (30 cm/1 ft high), with four toes on its forefeet and three on its hind feet, was widespread throughout the continent of America. Known as *Eohippus*, it evolved gradually over the millennia, losing some of its toes as it developed into *Mesohippus*, *Parahippus* and *Merychippus* successively, finally disappearing from the American continent to pursue its evolution in Eurasia, where it assumed the "definitive" appearance of the modern horse. It was not reintroduced into its distant land of origin until a few thousand years later—by the Conquistadors.

Paleontologists were more or less unanimous on these points until March 2003, when a research team in Peru discovered the complete skeleton of a horse, a "proper" horse of the *Equus* type, that appeared to be three hundred thousand years old. If and when confirmed, this discovery would not only overturn the accepted theories on the subject, but also provide yet another example of the shaky foundations on which some of our knowledge is based.

Certain episodes in the history of the horse are rooted more firmly in legend than science, but there are a few incontrovertible historical facts. Having found America devoid of horses on his first expedition to the New World, when Christopher Columbus embarked on his second voyage he took some horses with him. He originally thought he had discovered India (which is why its inhabitants were originally known as Indians), but he had in fact landed on the Caribbean island of Hispaniola (now Haiti and the Dominican Republic). Although the exact number of horses he took with him on the caravels (the small, fast ships on which he made the voyage) is not known, it is thought to have been about twenty. It is recorded that Columbus landed on Hispaniola on November 28, 1493. The first horses to step onto the soil of the New World were with him.

Five years later, the island's horse population had evolved into a breeding stock comprising some sixty or so brood mares. Stallions were regularly brought in from Spain, and breeding was soon extended to the Caribbean islands of Cuba and Jamaica and the nearest regions of Central America. Even so, horses continued to be imported—into Panama in 1514, Mexico in 1519, Argentina in 1534 and Florida in 1538.

As top Argentine horse expert Angel Cabrera explained in his book on American horses (*Caballos de America*, 1945), the breeding program was extremely successful owing to the excellent climatic conditions and quality of the grazing in the newly conquered lands. It was also helped by the traditional Spanish practice of allowing mares and foals to run free, which meant that the horses that escaped or were simply abandoned eventually formed semi-wild herds that interbred. This was how an indigenous "breed," a creole horse (i.e., born in the country), a truly American horse was created: the Criollo.

66. Left: José Ismael Britez, wearing spurs but no boots.
66, 67. A **Criollo** from the La Estrella *cabaña* ("cattle ranch"), presented somewhere on the Argentinian pampas by José Ismael Britez.
68. The seven-year-old **Argentine Criollo** *Miriju Noche Mala*, owned by Señor Duchini ("La Margarita," Ranchos, Argentina).
69, 70, 71. The **Argentine Criollo** *Ayacucho Coscorron* with his trainer Martin Hardoy.

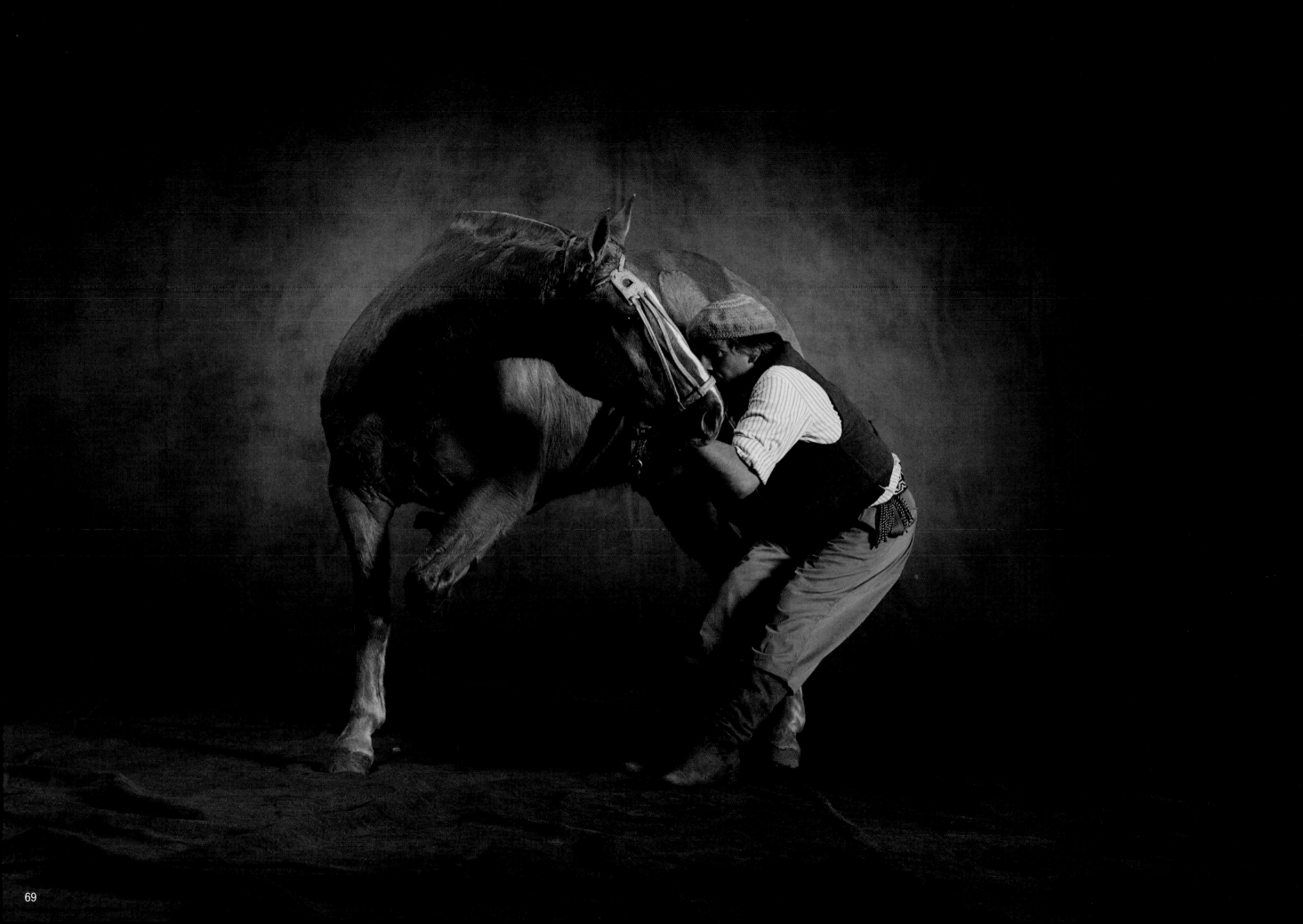

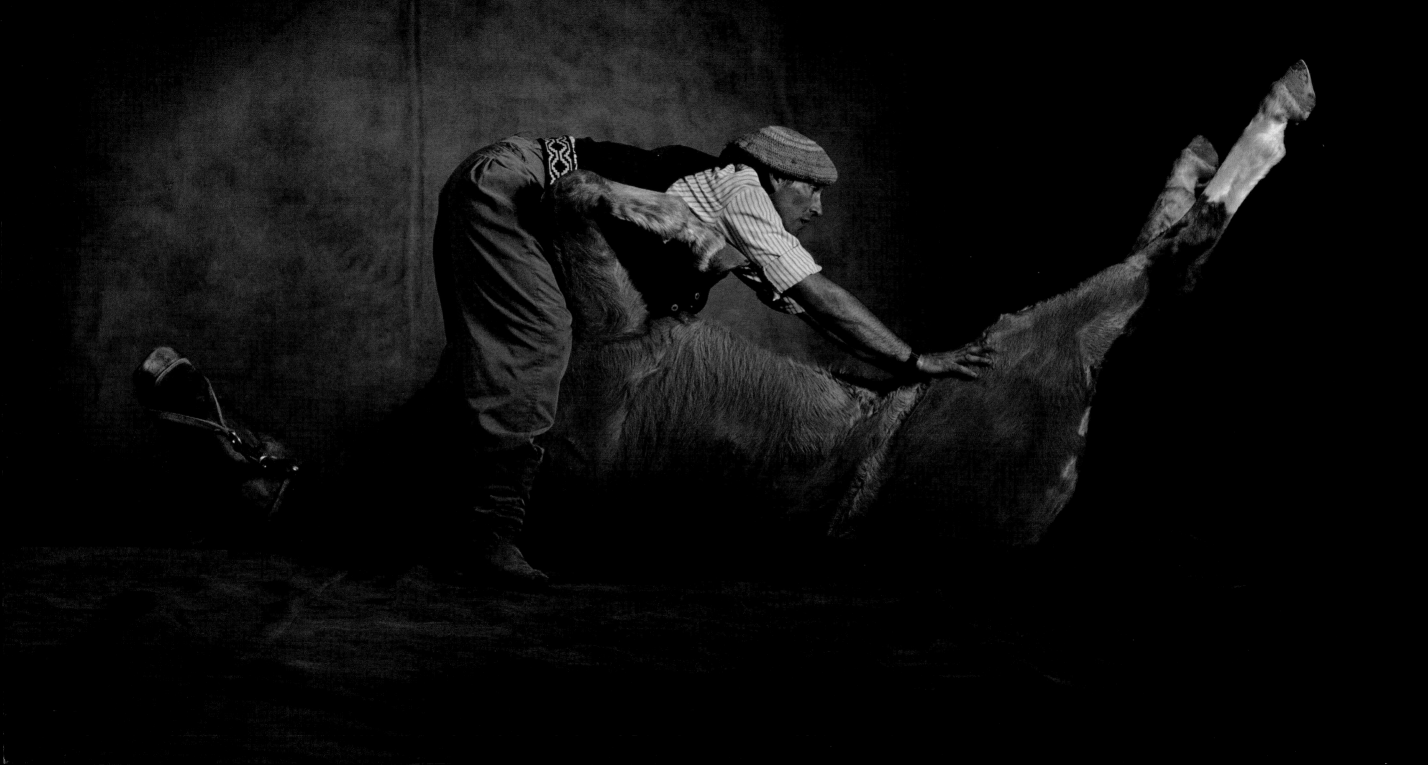

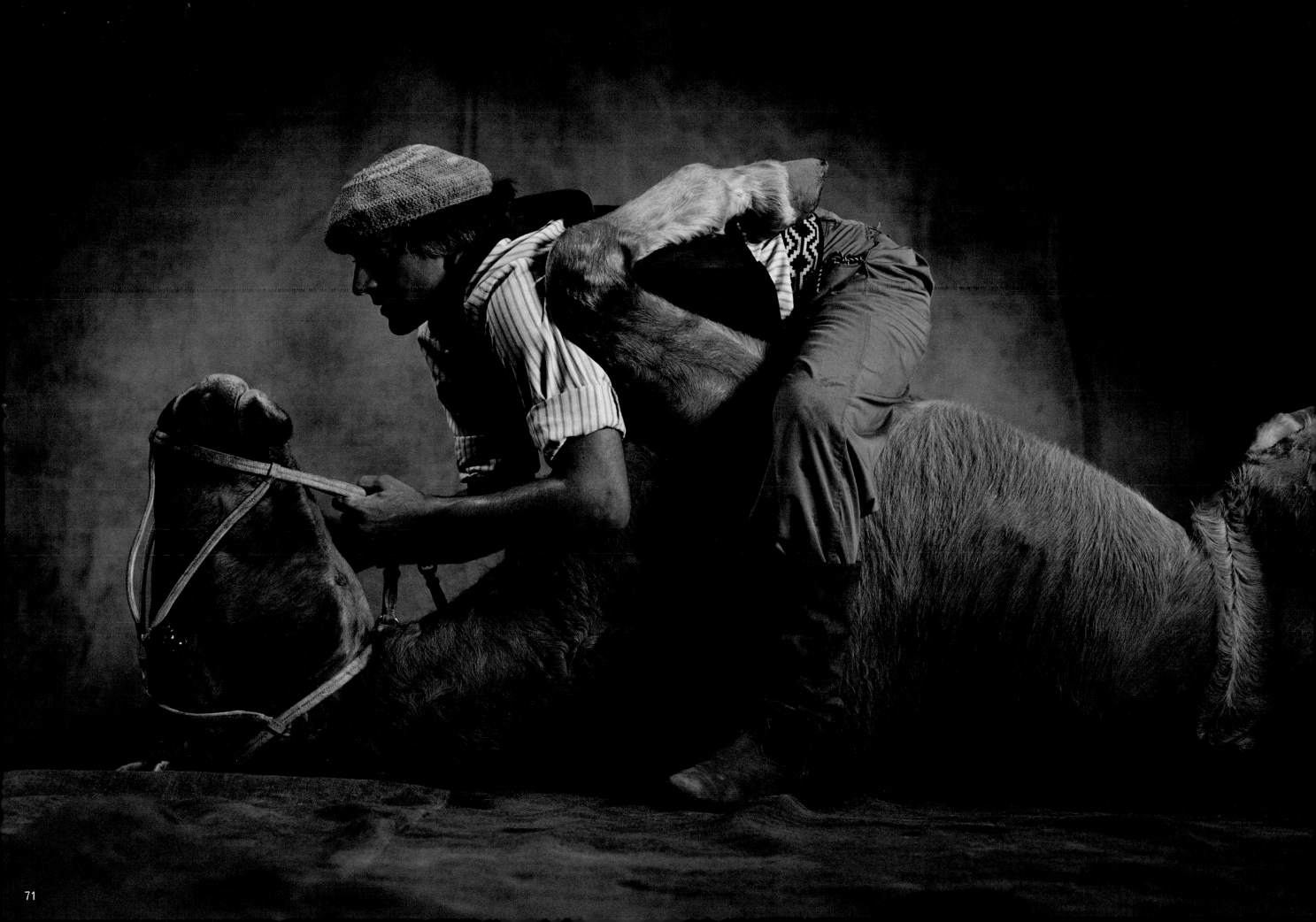

The Argentine Criollo, Polo pony and Petiso: born survivors

Aimé Tschiffely was instrumental in discovering and publicizing the qualities of the Argentine Criollo, helping it to become a kind of national symbol for the Argentine. A Swiss teacher, he was educated in England but lived in Argentina. He had been teaching in a secondary school in Buenos Aires for nine years when, in 1925, he decided to give up his job and travel. Tschiffely resolved that if he were going to travel he would do it properly. He decided to cross the Americas from south to north, from Buenos Aires to Washington, D.C. Originally he had intended to finish the journey in New York but decided to change his final destination after two fairly serious accidents.

To make the journey more interesting, the young Tschiffely (he was thirty-three years old) decided to avoid populated areas: "Remote from cities and seaports—far from white men's haunts—ran much of my lonely trail. One night camp might be pitched far from any human habitation; again, I ate and slept with ancient Indian tribes in stone villages older than the Incas" (*Tschiffely's Ride*, 1933).

The only means of transport suited to such an undertaking was the horse. Many people thought he was quite mad to attempt such a thing, but Tschiffely proceeded with his plan and contacted a dedicated horse breeder. Dr. Emilio Solanet applauded his project and recommended the virtues of the Criollo, explaining that they were "the descendants of a few horses brought to Argentina in 1535 by Don Pedro Mendoza, the founder of the city of Buenos Aires. These animals were of the finest Spanish stock, at that time the best in Europe, with a large admixture of Arab and Barb blood in their veins." Furthermore, Dr. Solanet had just what Tschiffely needed—two Criollos, *Mancha* and *Gato*, sixteen and fifteen years old respectively, an advanced age for an ordinary European saddle horse but not for a Criollo.

Mancha and *Gato*, who stood about 14.3 hh (59 in), had belonged to a Patagonian Indian chief named Liempichun ("I Have Feathers"). They had recently arrived in Buenos Aires with a batch of horses from Patagonia and were still half wild. A European horse lover would have found them curious to look at, to say the least. *Mancha* ("the Spotted One") was reddish-brown (chestnut) with large, irregular white markings (i.e., skewbald). He had a white face and a white stocking on each leg. *Gato* ("the Cat") was more or less the color of milky coffee (dun), what Americans call "buckskin." Tschiffely wrote: "Their sturdy legs, short thick necks and Roman noses are as far removed from the points of a first-class English hunter as the North Pole from the South. 'Handsome is as handsome does,' however, and I am willing to state my opinion boldly that no other breed in the world has the capacity of the Creole for continuous hard work."

It was on these fairly unprepossessing horses that the quiet and unassuming schoolmaster achieved one of the greatest equestrian exploits in history. He left Buenos Aires in 1925 and arrived in Washington, D.C. three years later, completing a journey of 9,940 miles (16,000 km) that took him across frozen deserts and through tropical swampland, across the Andes and the Panama Canal, through half of Argentina, Bolivia, Peru, Colombia, the republics of Central America, Mexico and finally the United States. Incredible as it may seem, at the end of this amazing journey, *Mancha* and *Gato* were bursting with health.

Returning home (by boat), *Mancha*, *Gato* and Tschiffely were given a hero's welcome and a place in the history books. People who still harbored reservations about the Criollo, which they regarded as too rough and ready, common and coarse, suddenly discovered all kinds of qualities in the breed. It was used, most notably, to "create" a new breed of horses that today dominates the world of polo—the famous Argentine Polo pony.

Obtained by crossing English Thoroughbreds from North America (Anglo-Americans) and Criollo mares, and then recrossing the results with Anglo-Americans, standing at 14.3 hh (59 in), the Argentine Polo pony inherited the finesse and speed of the Thoroughbred, while retaining the stamina and resilience of the Criollo.

Another Argentine "breed," the Petiso, is also the result of the skilful crossbreeding of European ponies and Criollos.

73. The four-year-old **Argentine Criollo** *Bonito*, presented by Angel Gonzalez, his wife and their children.
74, 75. The three-year-old **Argentine Polo pony** *Ombucito Impacto* (by *Infidente* out of *Loca*), presented (on the left) by Carlos Ulloa and (on the right) by Hilario Ulloa.

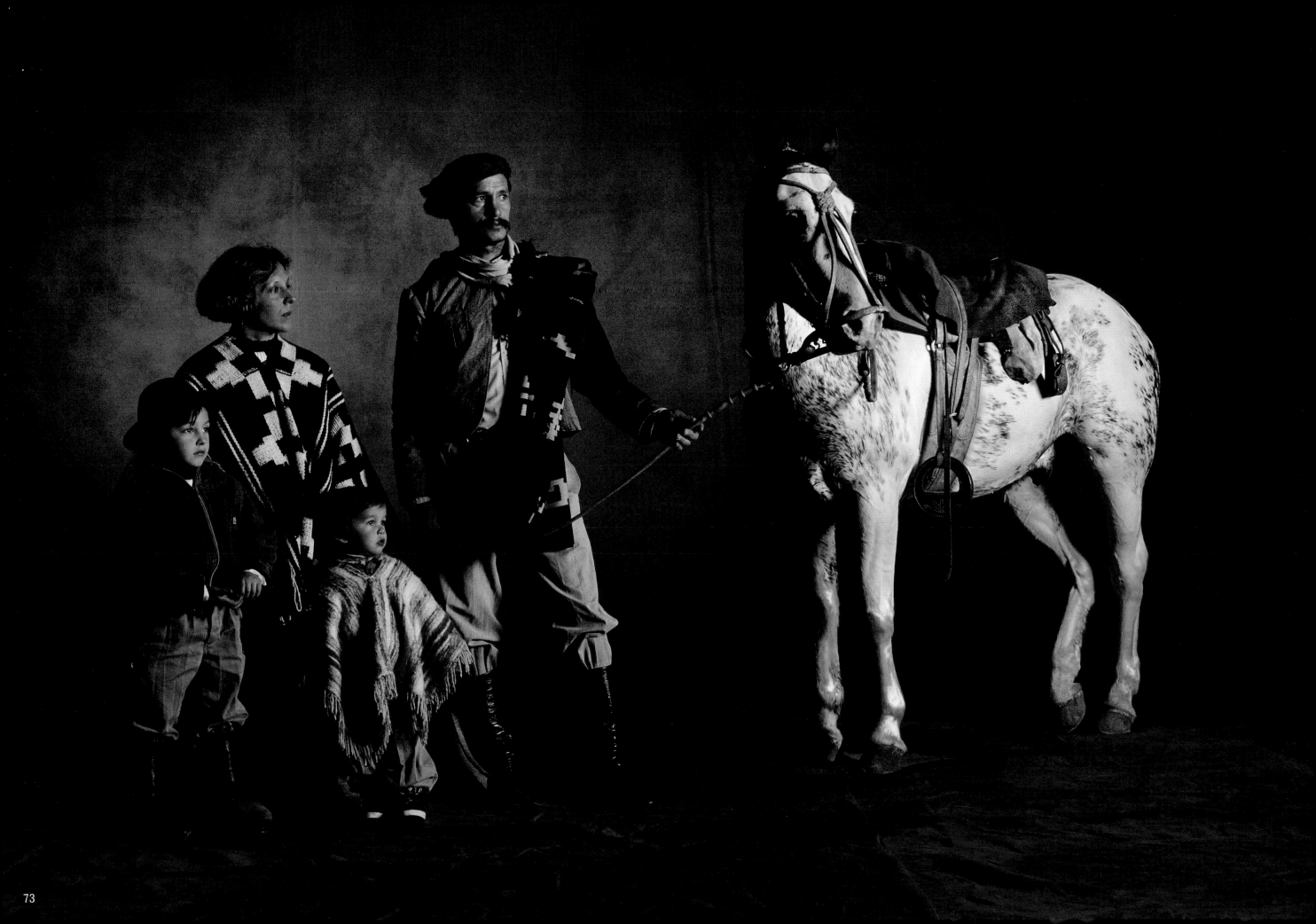

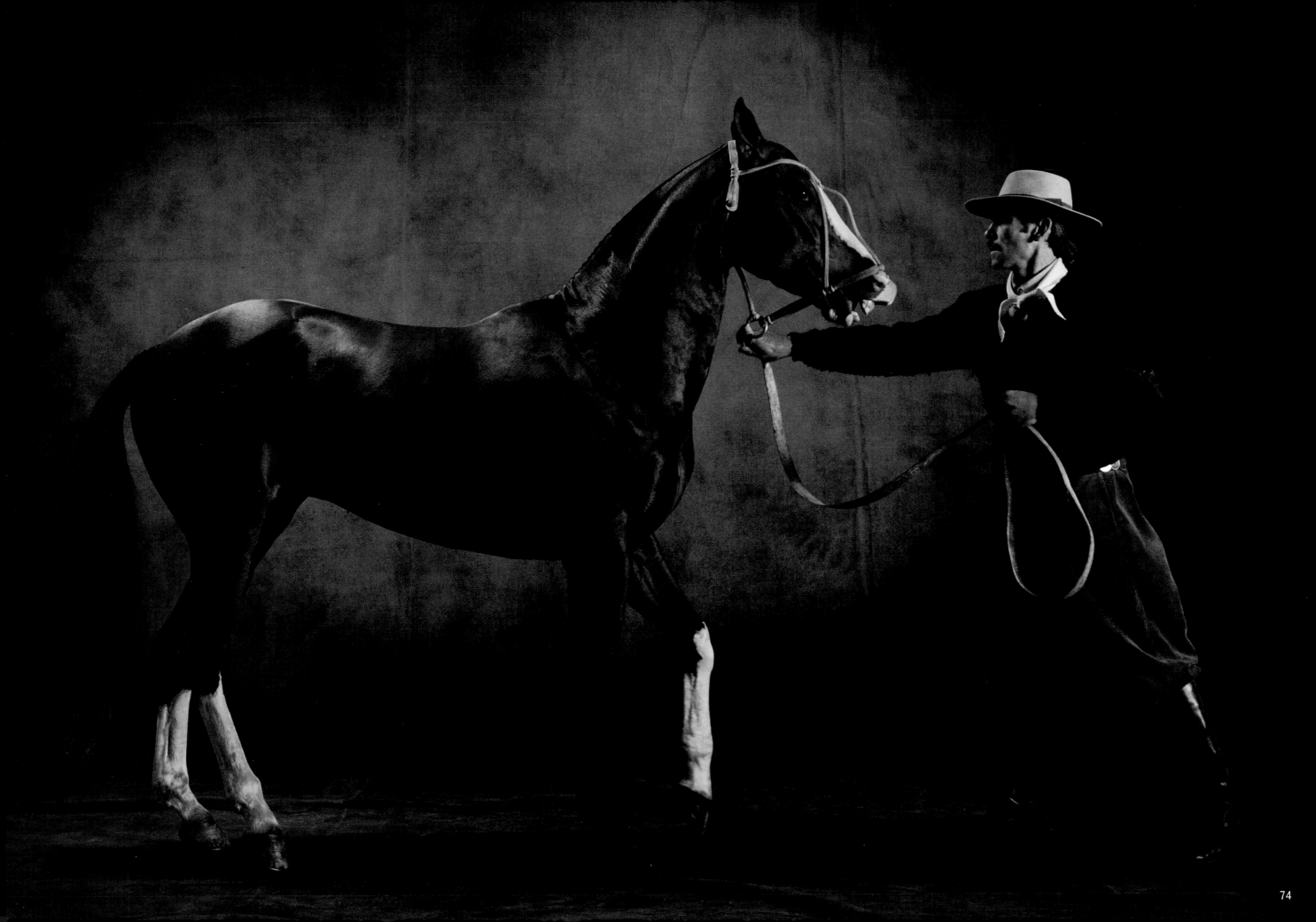

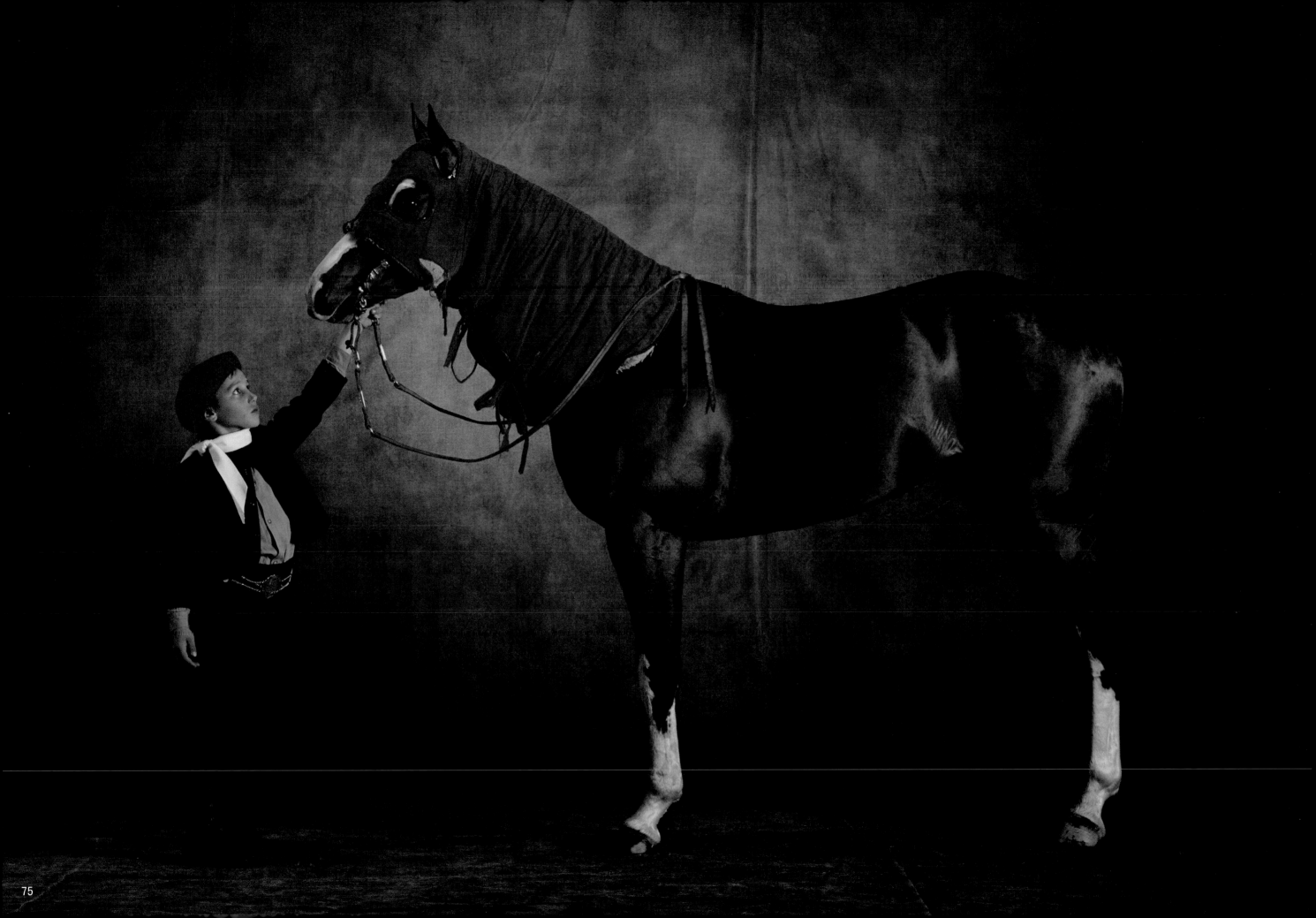

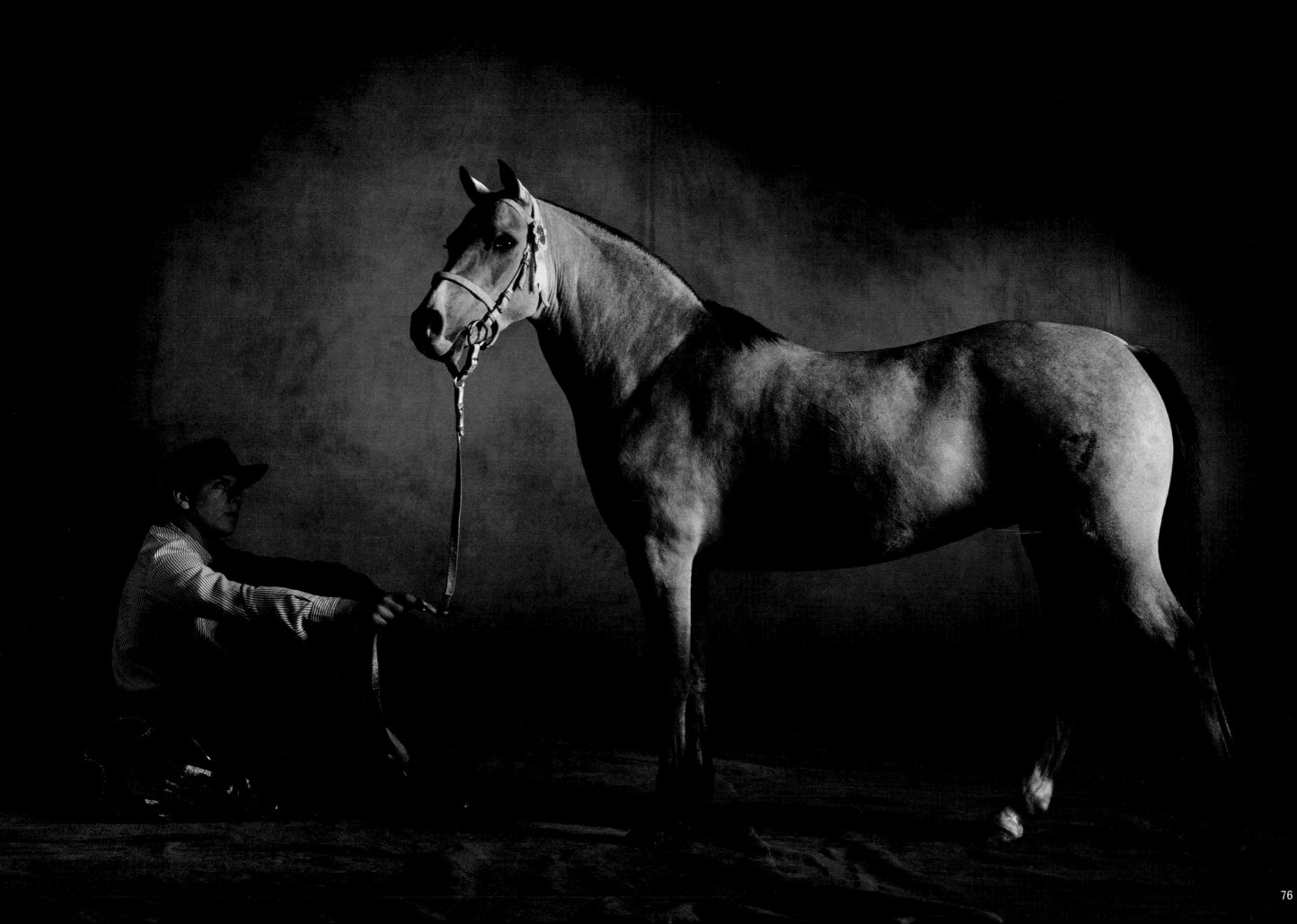

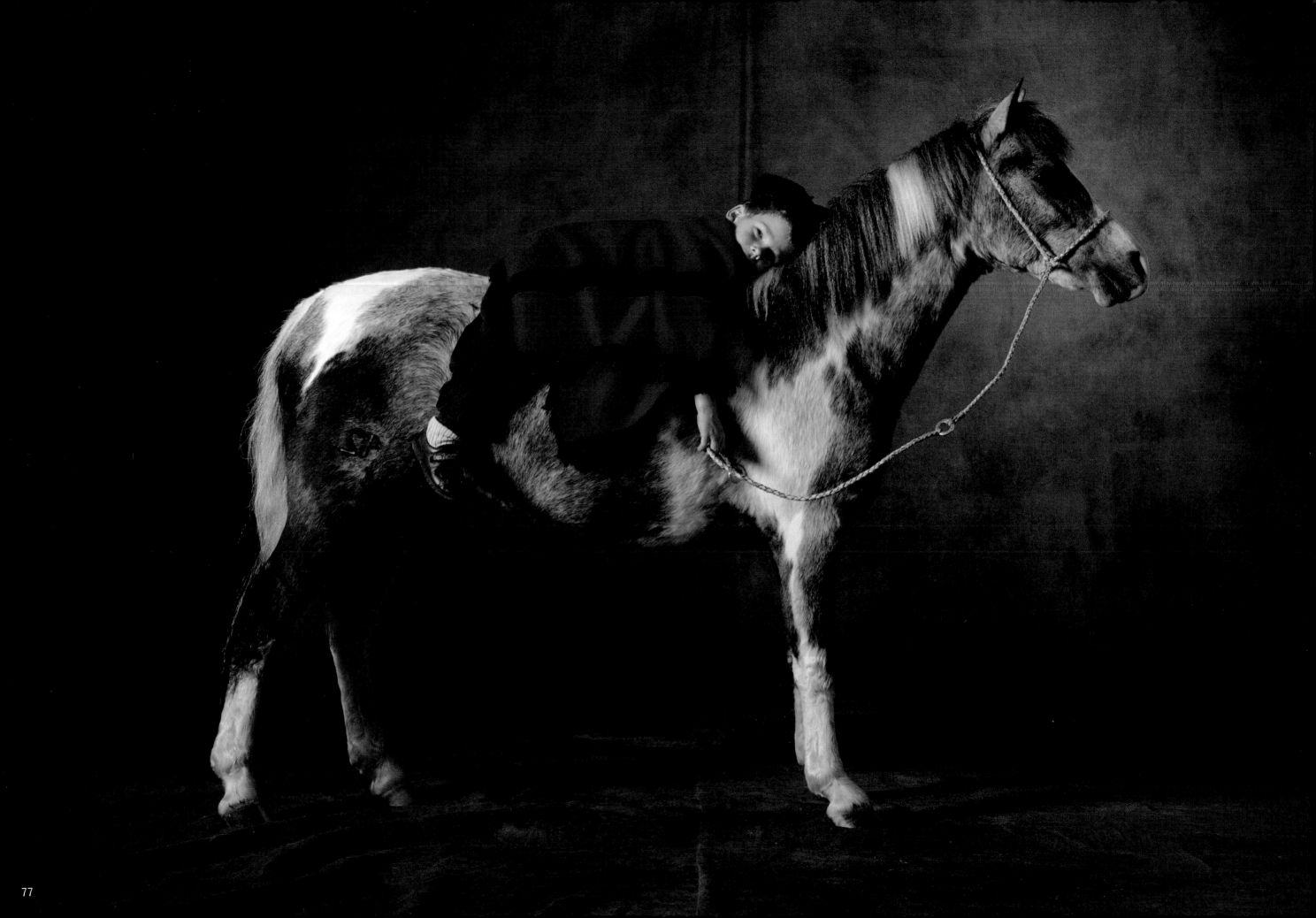

Chile, Peru and Mexico: adding a touch of flamboyance

As additional proof of the Spanish and, even more distant, Berber influence on anything and everything related to horses in Latin America, much of the tack and equipment still used by modern cowboys (stirrups with a broad tread, bits fitted with curb chains and roweled spurs) bear a striking resemblance to that found in North Africa. The Zenetes—one of the Berber tribes to go to Spain during the Muslim conquest—rode with short stirrups, a style of riding that became known as *a la jineta*. In his account of the conquest of Peru, in *The Royal Commentaries of the Inca* (1609), Garcilaso de la Vega ("El Inca"), the son of a royal Inca woman and a Spanish nobleman, wrote that his land was conquered *a la jineta*.

"The modern Chilean Criollo originated in Peru, when it was still known as the viceroyalty of Castilla La Nueva (New Castile)," explains French enthusiast Gérard Barré, who has dedicated an entire Website to the Criollo (www.justacriollo.com). "The journey from Peru to the valleys of central Chile was so arduous that only the best and most robust horses reached their destination.

These horses founded a line of Criollos that were among the most popular in South America. It was also one of the most isolated from outside influences due to the nature of the terrain, but also due to the wily local breeders who created a form of stud book in 1893, at a time when the concept of pure-bred horses was not particularly widespread in America."

The Chilean Criollo has an aptitude for herding cattle and performs well as a rodeo horse. It also has great endurance, speed and beauty, with a thick mane and tail. Despite its relatively small stature (13.3 hh/55 in), it has great capacity for hard work and is surefooted with elegant paces.

It was these flamboyant, and sometimes highly elevated, paces that other Latin American countries tried to develop and accentuate in their own horses, not only for aesthetic reasons but also for increased rider comfort. By carefully selecting the horses most gifted at this type of dancing gait (*paso*)—which should not be confused with the traditional paces of "ordinary" horses, the airs of *haute école* (e.g., *piaffe*, *passage*) or the extravagant movements (e.g., the *pas espagnol* or "Spanish step") developed by European riders—they finally created such "breeds" as the Paso Fino (Puerto Rico, Colombia), the Peruvian Paso (or Stepping horse) and, more recently (1972), the Mexican Azteca.

76, 77. Two **Argentine Petiso** ponies. Left: The mare *Bragadense Celosa* (by *Labra Careta* out of *Bettina*), owned by Ernesto J. Figueras and presented by Daniel Meaca.
Right: *Martin Fierro Mancho* (by *Charina Pacaflor* out of *Brava Lenteja*), owned by Anna Renata Hahn de Schultz and "ridden" by her son Ferdinand.
78. *Zafiro*, a young **Peruvian Paso** gelding (by *Galante* out of *Gloria*), presented by his owner Laurence Bouteiller from Arces-Dilo (France).
79, 80, 81. The **Chilean Criollo** *Malulo*, presented and ridden by rodeo rider Marcello Rivas. *Malulo* belongs to Italo Zunino, the owner of the *fundo* San Lorenzo, at the foot of the Andes, in the Bío-bío region of Chile.

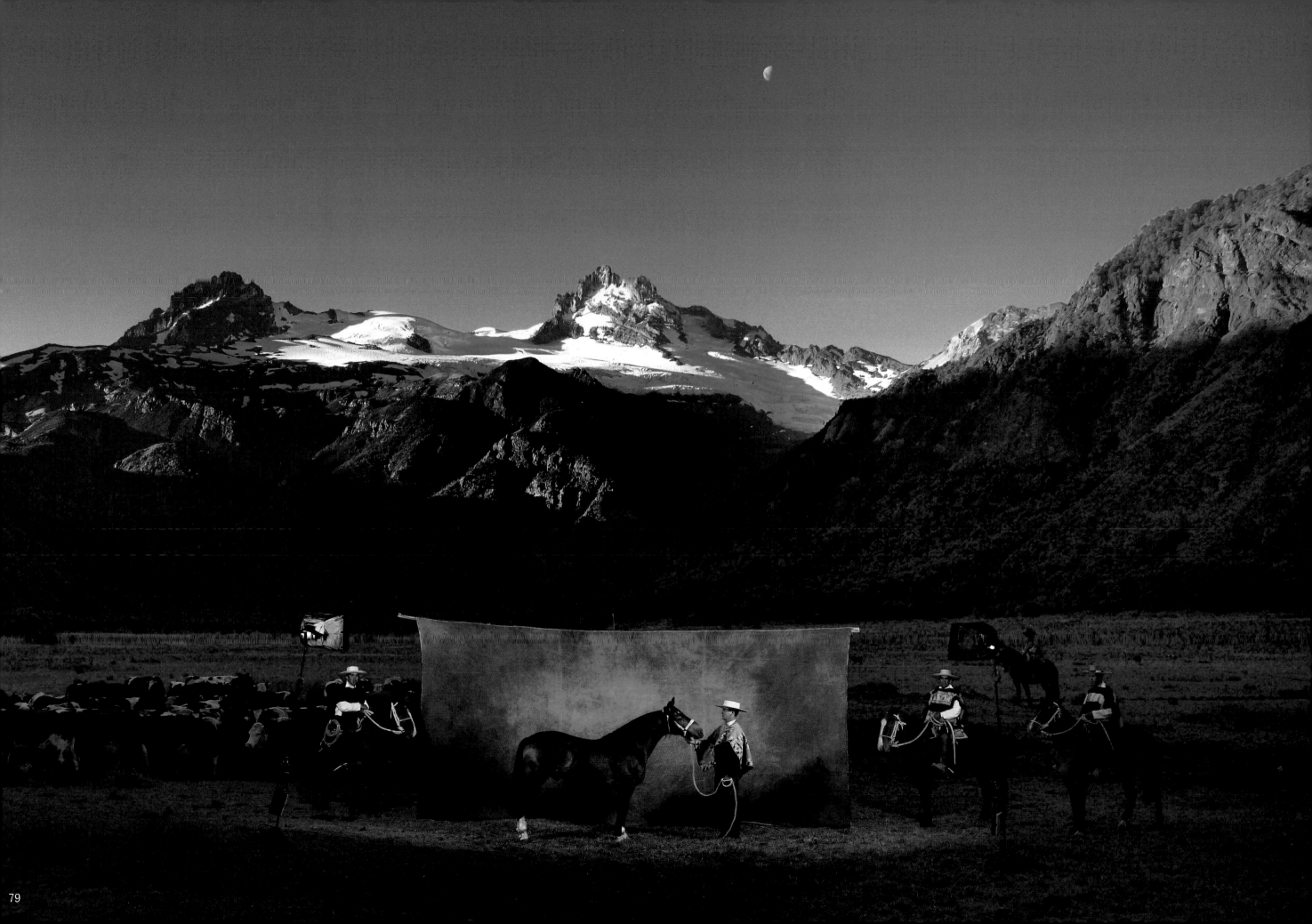

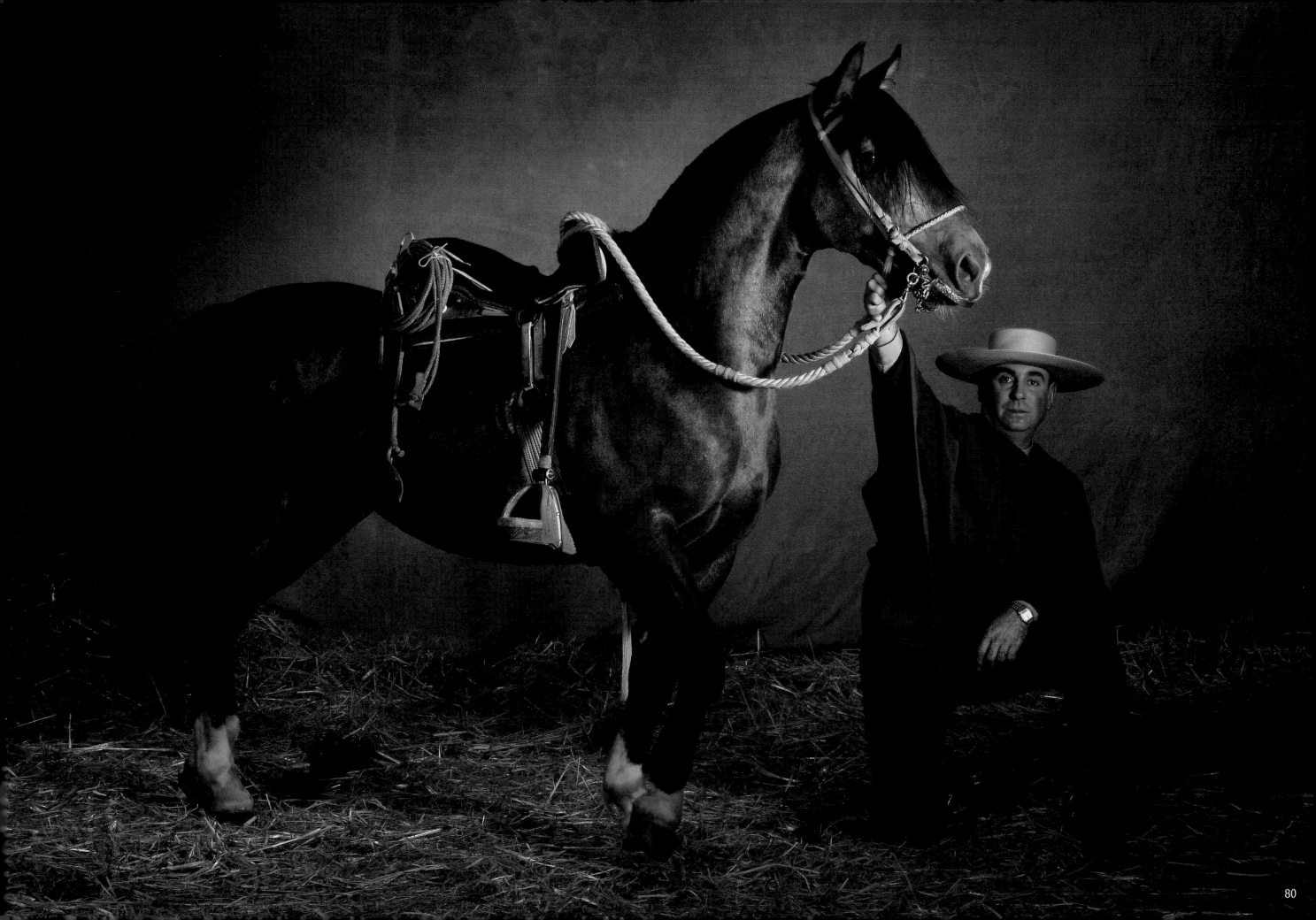

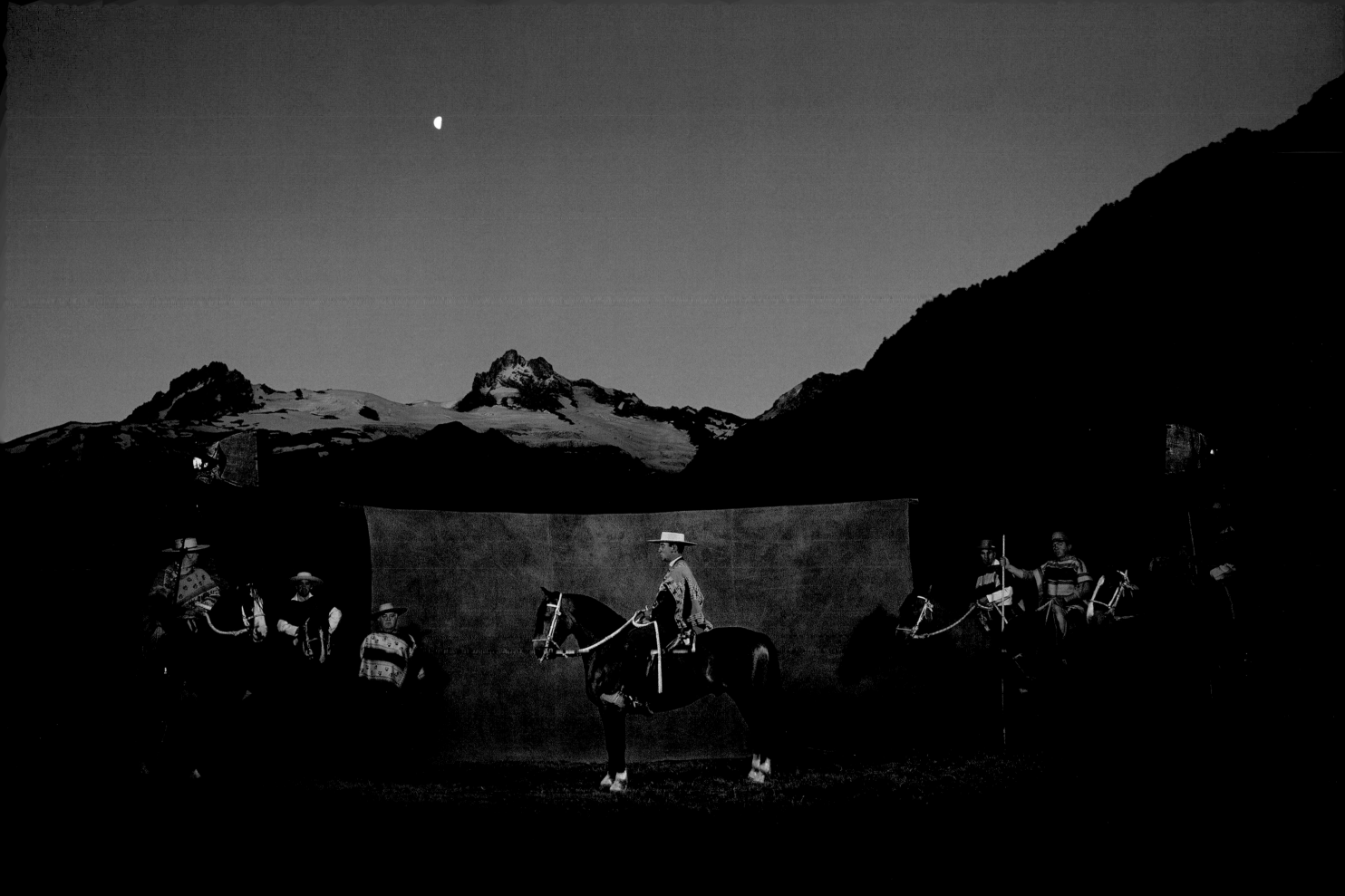

Native American horses: the mysterious Appaloosa

In Native American culture, there are all kinds of legends to explain the first appearance of the horse in America. According to a Kiowa legend, for example, this extraordinary animal was born of the dream of an old medicine man, while the Apache and Blackfeet peoples attribute its paternity to the sun and water—or rather the spirit of the sun and the spirit of water. A Hopi legend tells the story rather differently: "On the day that humans emerged from the bowels of the earth, the Great Spirit, in the form of a bird, gave each one a language and a race." The white men, "always impatient," began to walk towards the south. When they were exhausted, "a woman tore off pieces of her skin and fashioned them into horses."

The interesting thing about this legend, apart from the fact that it attributes the origin of the horse to a woman, is that it identifies the white man as the first to own this legendary creature.

Italian-born researcher Maria Franchini has gathered together many different stories recounting the first encounters of many Native Americans with the white man and therefore their very first contact with the horse (*Les Indiens d'Amérique et le cheval*, 2001). A Comanche tale is particularly vivid—"One day, the Comanche, at the time when they traveled on foot with their dogs, noticed some strange animals in the distance. They were almost as big as a buffalo and had long necks and a hump on their back that reflected the light of the sun." The large humps in question were, of course, the amor-clad Conquistadors. The strange animals approached and one of them suddenly began to make sounds. "As it began to speak, the animal split in two. The large hump that reflected the light detached itself from the animal's body and took a human form. The other part now looked like a large dog...."

The story continues in this vein for several hours and ends, after a great many twists and turns, with the following episode: "One night, as the 'humps-that-reflect-the-light' were sleeping, the Comanche stole their large dogs.... The Comanche learned to ride these animals and became one of the most powerful tribes of horsemen in the West. As for the white men, they learned to walk."

The reaction of the native peoples on their first contact with horses was not always as humorous. Most accounts of the conquest of the New World indicate that, for the most part, the South American Indians were terrified when they came across these huge, unfamiliar animals.

The incident most often recounted tells how a single Spanish horseman succeeded in routing the entire Inca army without doing a thing—he simply appeared in front of them on his horse. This happened in Peru, in 1534, more than forty years after the first European horses had arrived in America.

However, as the conquering forces and settlers advanced, penetrating farther inland, sometimes preceded by whole herds of runaway horses that had returned to the wild, the Indians became accustomed to them and soon learned how to use these large animals to their own advantage.

The peoples of North America did not discover the horse until much later, but it took only another fifty years for the use of the horse to spread to the Plains Indians, and by 1650 the Apache had become formidable horsemen. They were followed by the Comanche, Navajo and Shoshone who, during their extensive travels, passed on this new "weapon" in their armory to the Cayuse. The latter must have proved particularly skilled at breeding horses, since, by the nineteenth century, all Native American ponies were known as "Cayuse ponies."

The Cayuse Indian pony proper is relatively small—about 13.1 hh (53 in)—and can be any color. It has a full mane and tail, and a heavy head that is almost too large for its body, but it has an intelligent eye and, above all, amazing stamina and endurance. According to the journal (1867) of Colonel Philippe Régis Denis de Keredern de Trobriand—a French aristocrat and volunteer general in the Army of the Potomac, who came to the United States in 1841—"the Indian pony can cover distances of 110–130 km (70–80 miles), from dawn to dusk, without stopping, while most of our horses are exhausted after 55–65 km (35–40 miles)."

For a long time it was believed that Native American ponies were all descended from the escaped horses that the Spanish referred to as *mesteño* ("wild" or "untamed"), a word that mutated into the term "mustang." However, this theory is contested today, since it has been proven that the Native Americans acquired most of their horses fully broken, either by trading or quite simply by stealing entire herds.

As for the Cayuse Indian pony, one school of thought is that it was the result of haphazard crossbreeding between horses from South and North America—Spanish horses with Barb blood and French carriage horses brought to Canada by the early settlers.

The only thing known for certain is that, in the past, the Native Americans—like the Americans and an increasing number of Europeans today—were very keen on what are known as Pinto (painted) horses in the United States and colored horses in Europe, i.e., piebalds, skewbalds and horses with spotted, speckled, marbled or flecked markings.

One of the most sought-after types of marking is the "leopard" pattern, one of the six characteristic patterns of the Appaloosa horse, attributed to the Nez Percé Native Americans whose territory was crossed by the River Palouse (hence *Palousa* and Appaloosa). Since 1938, when The Appaloosa Horse Club was first established, the Appaloosa has been regarded as a "breed" in its own right in the United States, and more recently in certain European countries—even though its distinctive markings have existed in a number of other breeds for centuries, such as in Mongolia, Russia and Denmark. Several works of art bear this out, such as *The Piebald Horse* (Getty Museum, Los Angeles)—in fact an Appaloosa—by Paulus Potter (1625–54), the Dutch artist famous for his paintings of animals, and the lithograph produced by Jean-Baptiste Oudry (1686–1755) to illustrate the chapter on horses in the comprehensive *Histoire naturelle* by the French naturalist Georges-Louis Leclerc de Buffon (1707–88).

83. The ten-year-old **"English"** Appaloosa *Spottie Dot Com*, ridden by Sophie Broome, daughter of the owner and niece of the famous show jumper David Broome.

84. Two **"German"** Appaloosas, *Coco* (age eight) and *El Lobo* (age seven), owned by Herbert Fischer and presented by Paul Herrada.

85. The three-year-old **"Canadian"** Appaloosa mare *Wyalta Kamia*, presented by her owners Donna and Syd Wyatt.

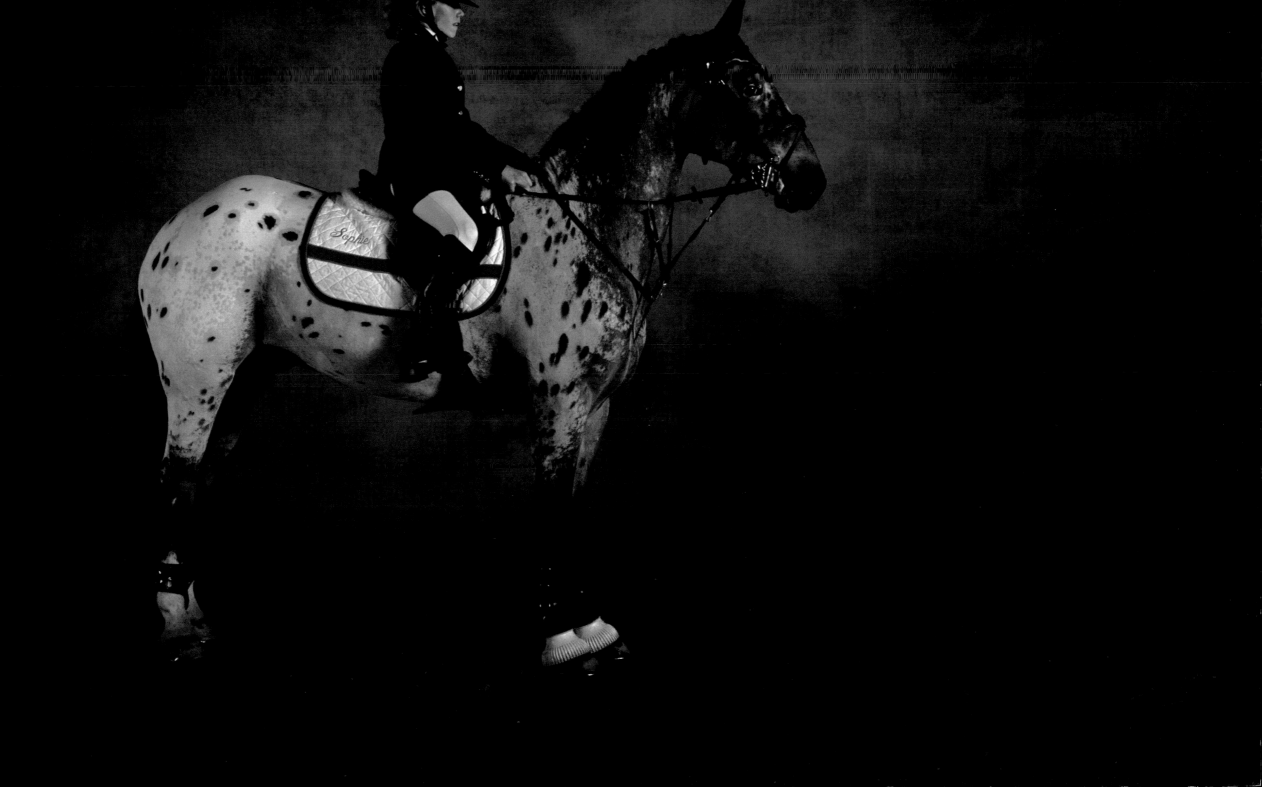

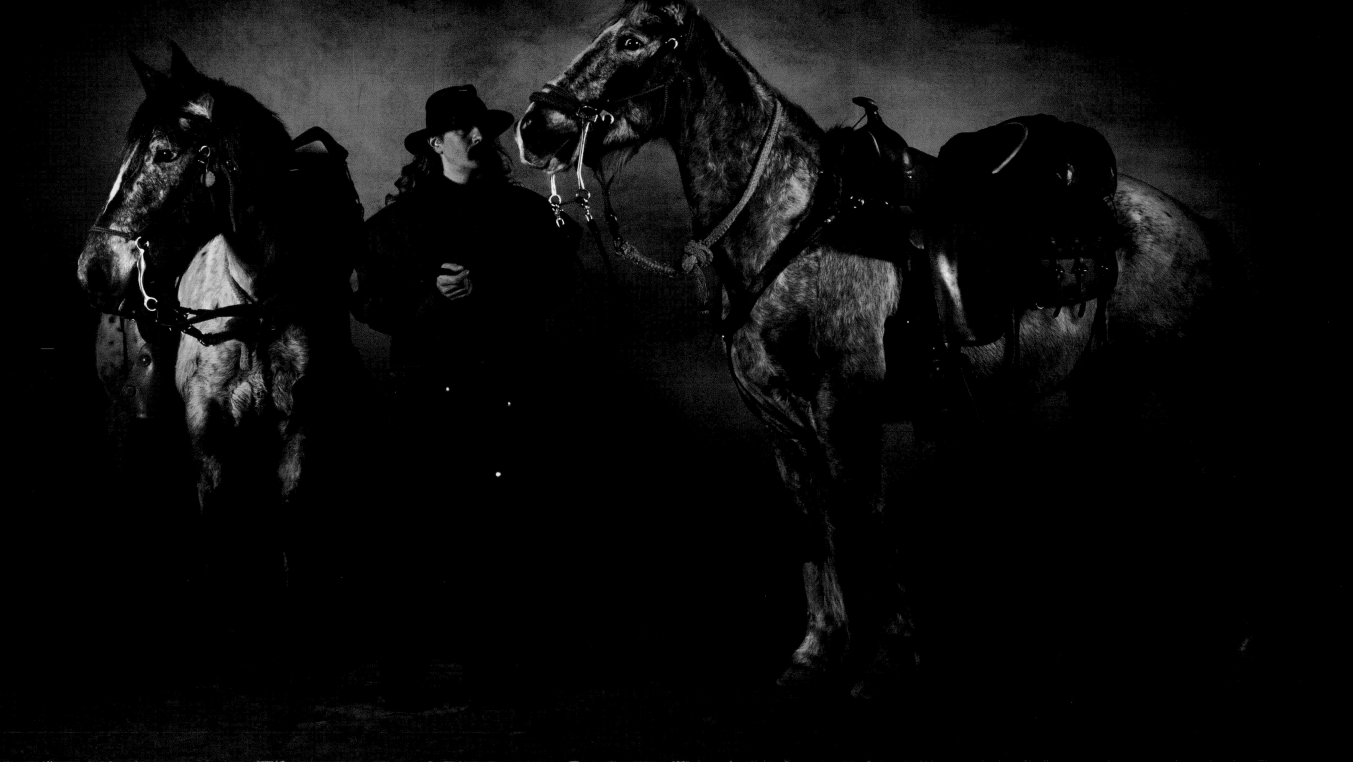

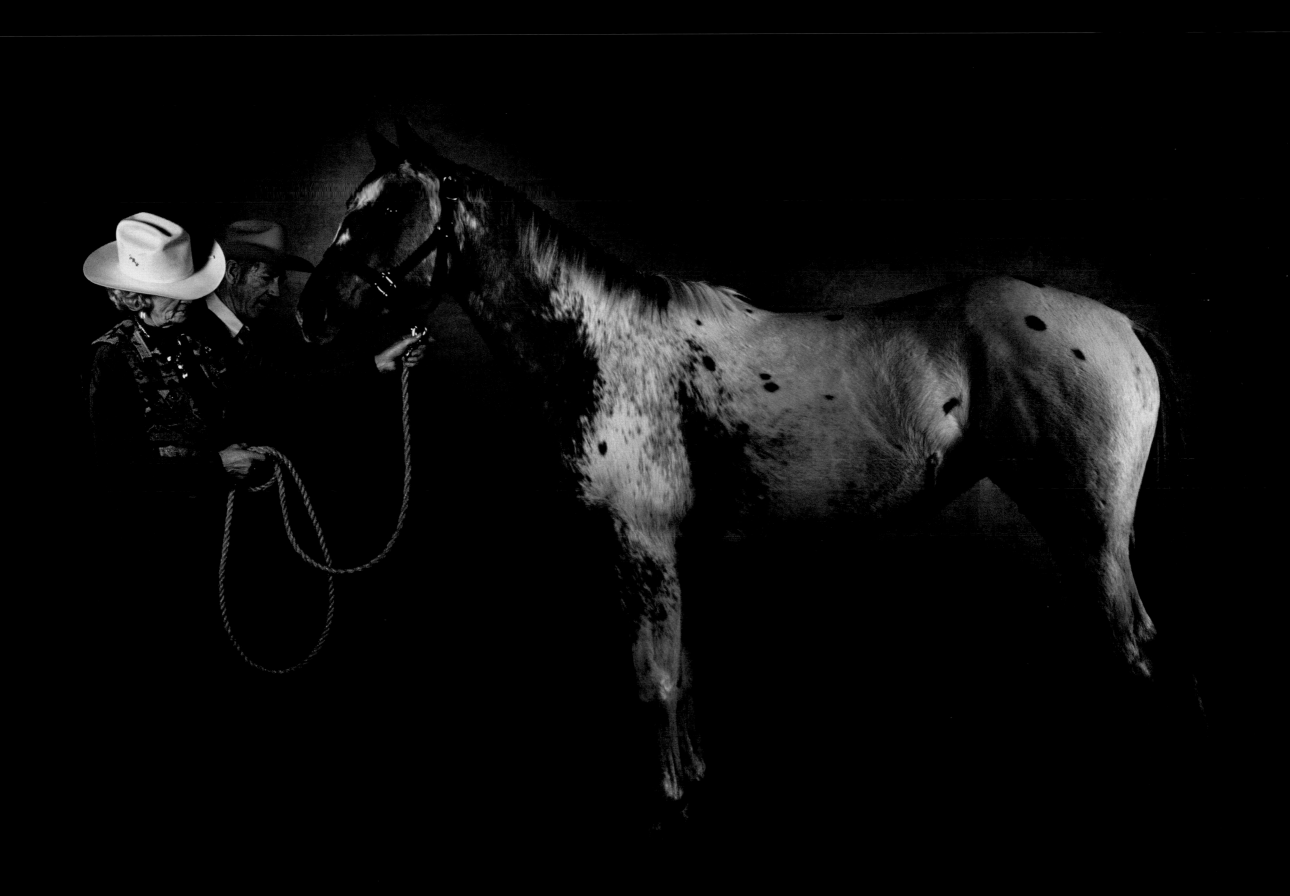

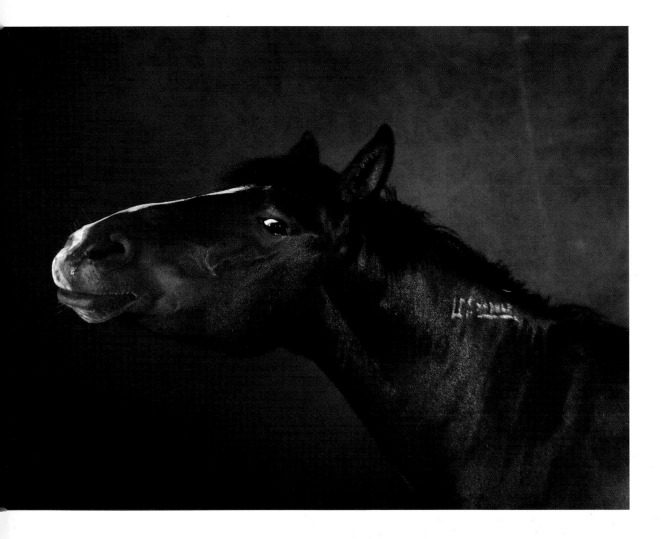

The horse is now an integral part of American legend and the history of the United States. When some of the most momentous events in American history are called to mind, they bring with them a rush of evocative images—a miner galloping into town to have a nugget of gold weighed, horses pulling a string of covered wagons as settlers make their way west, a line of Native American warriors atop a ridge surveying the distance while their horses fidget and shuffle beneath them. So many men of the American west—from General Custer (1839–76) and Chief Crazy Horse (c. 1842–77) to Buffalo Bill (1846–1917) and John Wayne (1907–79)—were intrepid horsemen. When John W. Russell created the Pony Express weekly mail service in April 1860, he made it possible to send a letter across the United States, from Washington, D.C., to San Francisco, a distance of 2,850 miles (3,000 km) in just ten days, thanks to a relay system that leaves you breathless just thinking about it. Horses were changed every 12 miles (20 km) and riders every 75–100 miles (120–160 km).

Many Americans have a great deal of affection for the horse, which has become a spirited symbol of freedom and wide, open country and a form of national mascot, second only to the bald eagle. It is also true to say that, of all the horses in America, people have a particular soft spot for the mustang. No ordinary horse, the mustang really is a "breed" apart—a distant descendant of the "large dogs" brought over from Spain by the Conquistadors in the late fifteenth century. The first Native Americans to see the horse believed it to be some form of supernatural being. Subsequently, having escaped from—or been abandoned by—their Spanish masters, these horses returned to the wild where they were subjected to the harsh process of natural selection. As a result, they developed an extremely strong constitution and an extraordinary vitality, spreading "like wildfire" throughout the American continents, especially in North America.

"Wild" is not quite the correct term; only animals that have never been tamed by man can be truly classified as "wild." Domestic animals that have returned to the wild are usually described as "feral," although "wild" is a stronger term with more exciting and even glamorous connotations. It is certainly more in line with the image that rodeo enthusiasts like to project of the proud and impetuous, "untameable" "bucking broncos." This only makes the deft skill and great speed with which the Native Americans were able to tame and ride these "wild" horses all the more remarkable. It also makes the methods used by the modern "horse whisperers"—popularized by Nicholas Evans in *The Horse Whisperer* (1996)—all the more admirable. The methods used to win the confidence and "break" or "start" these horses are described in detail by Monty Roberts in *The Man Who Listens to Horses* (1996).

Today, American mustangs are becoming increasingly less "wild." In the early twentieth century there were almost two million mustangs, so many that they were becoming a nuisance and were even regarded as "vermin," since they damaged crops and monopolized grazing. Like their Australian counterparts, the Brumbies, they were hunted relentlessly and almost totally wiped out. There are currently only a few thousand of these horses left, carefully contained and controlled on vast reservations.

Still, the mustang has managed to survive its fall from grace and has emerged from its long ordeal with increased stature and an air almost of martyrdom. Today, redefined as part of the national heritage, it is a protected species and the object of much care and attention on the part of the many enthusiasts belonging to numerous conservation associations. Some, like the Spanish Barb Breeders Association (SBBA), stress the mustang's Barb and Spanish origins. Others, who want to immortalize it as the horse of the Blackfeet, have formed the Blackfeet Buffalo Horse Coalition (BBHC).

86, 87. American Quarter Horses undergo rigorous training. Deep in the Rocky Mountains, on pastures grazed by his hornless Black Angus cows, William Kriegel breeds around fifty Quarter Horses per year. As well as his Montana ranch, Kriegel also owns the famous La Cense Stud Farm (near Rambouillet, in France). In the space of a few years, La Cense has become the mecca of what some people refer to as "natural horsemanship," where one of the best-known American "horse whisperers," Pat Parelli, teaches his famous "method."
88. *Digger*, a **mustang,** owned by Jessica Russell.
89. Robert Black Bull—founder of the Blackfeet Buffalo Horse Coalition, on the Blackfeet Indian Reservation, Browning (Montana)—presents one of his favorite **mustangs**. Robert Black Bull is fighting to have these horses reintroduced into the wild and, among other things, has devised a youth empowerment program to encourage young Native Americans to become involved in the protection of the breed.
90. *Dolly*, a **mustang,** presented by the Russell family. From left to right: Cody, Lisa, Bob, Jessica and their dog Grace.
91. *Strip*, a **Quarter Horse**, presented by the Griffith family. From left to right: Bob, Wyatt (age six), Bud, ranch foreman, his wife, Cheryl, and Hallie (age eight).

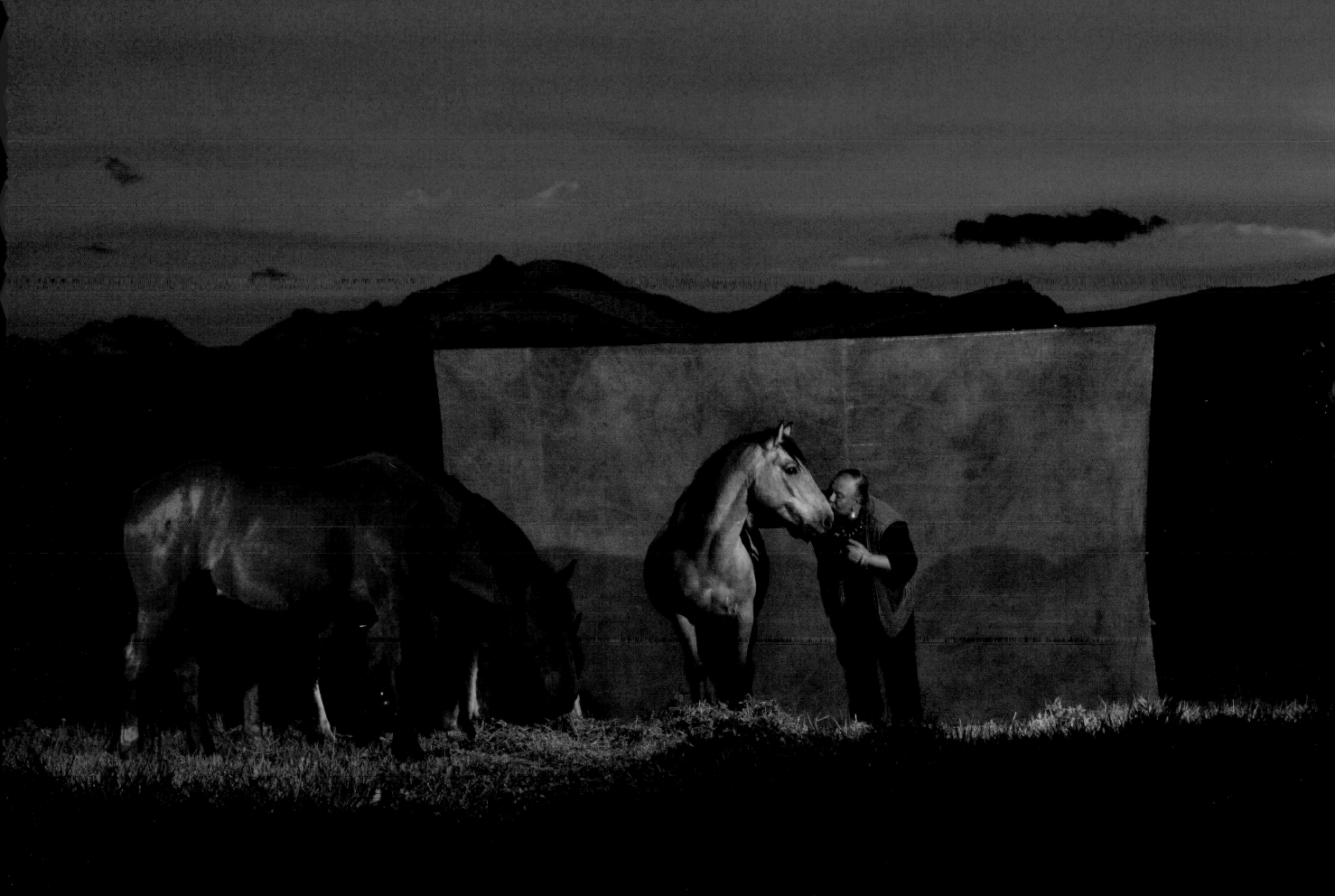

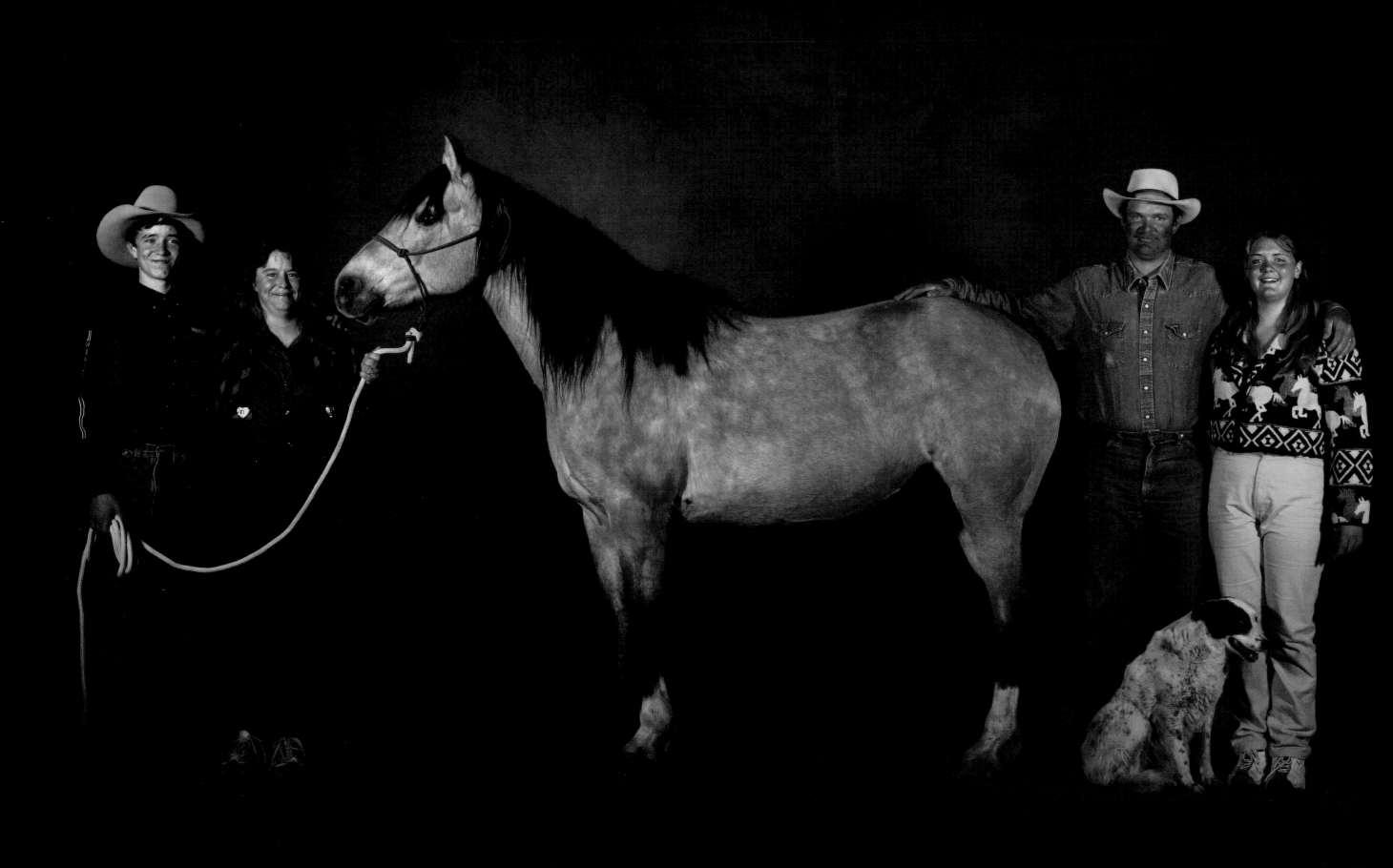

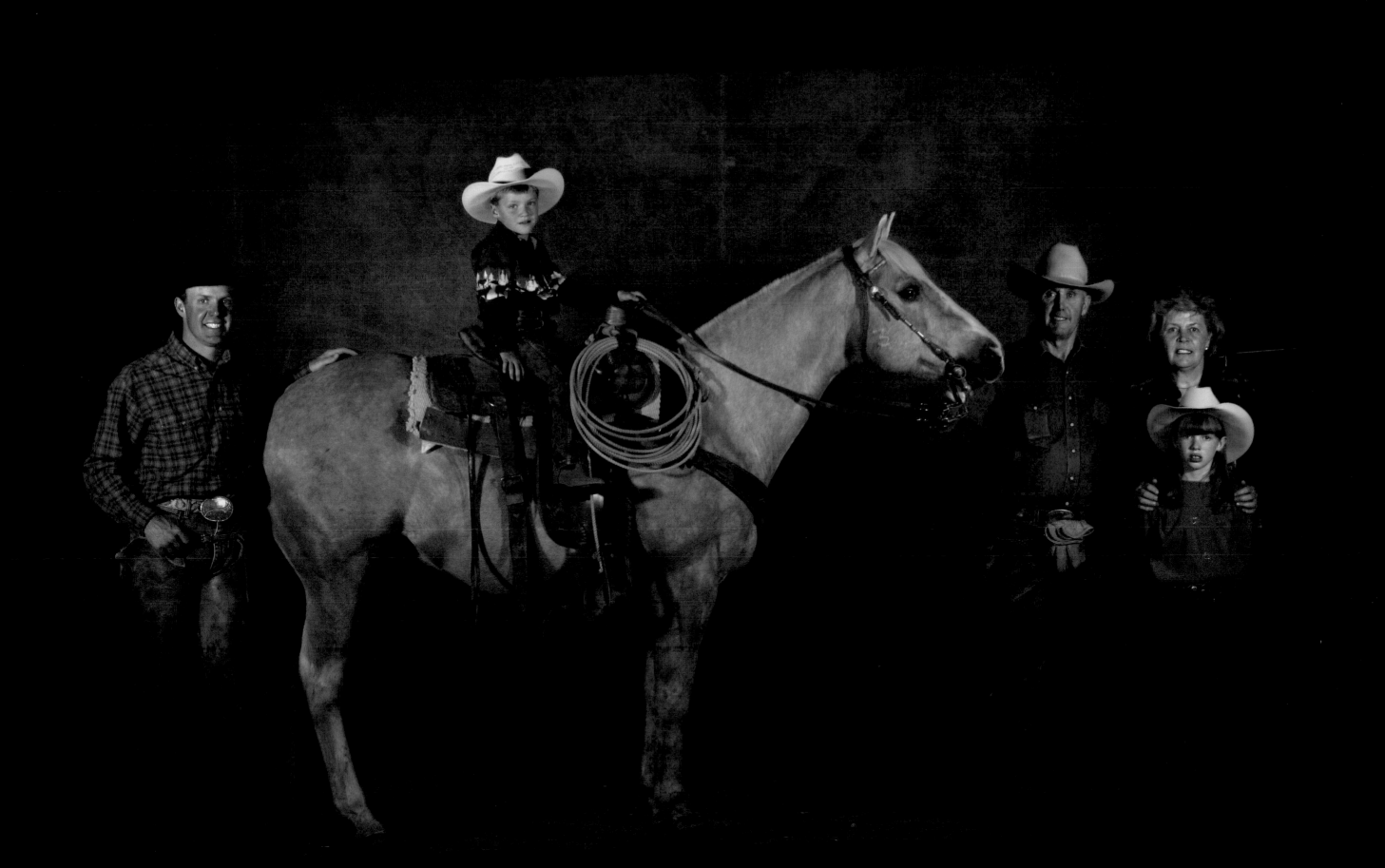

The Quarter Horse and Morgan: true success stories

As a horse-loving nation, the United States has produced some truly remarkable breeds. The oldest, best known and most widespread of these breeds is the American Quarter Horse, which numbers almost four million worldwide. Its unusual name derives from the fact that it was bred, in the early seventeenth century, by the English settlers of Virginia and Carolina (on the East Coast) to take part in races run over a quarter of a mile (about 400 m). This relatively short distance required horses that could make lightning starts and had great capacity for acceleration.

The Quarter Horse, probably a cross between horses of Spanish and English descent, gradually became the prototype of the cowboy horse, the ideal all-purpose horse that was both lively and intelligent. It is what its many supporters call a "complete horse," with a fine, muscular neck well set on powerful, sloping shoulders, a broad, deep chest, a short, muscular back, strong loins, massive, rounded hindquarters, clean, hard legs and a character that is obedient and eager to work, with good "cattle sense" (i.e., well suited to driving and "cutting" cattle). Robust, fast, courageous and reliable, this medium-sized horse (14.3 hh/59 in) is one of the great success stories of American breeding.

The other great success is the Morgan, which, although not as well known outside the United States, is just as interesting. The origins of the breed were purely fortuitous.

It began in the late eighteenth century, in a small town in Vermont. The town's singing master, a good man named Justin Morgan, had lent some money to a friend who, unable to repay him, settled his debt with a horse. The horse—a young stallion named *Figure*, born in the neighboring state of Massachusetts—was of doubtful origin, although its sire may have been a Barb and its dam a Welsh mare. It was small (14 hh/56 in) and compact, with a kind temperament. Not knowing what to do with it, Morgan rented it out as a stud horse. Amazingly, all its offspring proved to be stocky and courageous bays (with a black mane and tail)—just like their sire.

When the horse's owner died, it was on loan to Robert Evans, a local farmer, who put it to work in the fields, while at the same time continuing to use it at stud. The valiant little horse continued to produce identical foals, strong and generous, regardless of the mare. It finally came to the attention of the army and was bought and used as a "professional" stallion on one of the army stud farms. Renamed *Justin Morgan* in honor of the late choirmaster, this exceptional horse died in 1821 at the advanced age of thirty-two, leaving a line of robust and versatile horses that were in constant demand for the U.S. cavalry until the army became mechanized.

The many exploits performed by these versatile horses—which worked equally well under saddle, in harness or as draft and pack animals—feature prominently in the golden legends of the Wild West. One of these is the story of *Comanche*, the only horse to survive the famous Battle of Little Bighorn (January 25, 1876). Despite many wounds, it lived for many years and regularly took part, saddled and bridled but unmounted (a sign of mourning), in commemorative ceremonies.

Slightly smaller and stockier than the Quarter Horse, the Morgan founded several other typically American breeds: the Missouri Fox Trotter, the Tennessee Walking Horse and, more recently (nineteenth century), the American saddle horse. Today, these breeds are primarily selected for their exaggeratedly high action in paces such as the "fox trot," "running walk," "flat foot," "slow gait" and "rack," which are extremely popular in the United States. Although they present quite a spectacle, these gaits are not always natural and sometimes involve practices (the use of artificial aids, surgical intervention, etc.) that are not permitted in Europe.

92. *Montana's GC Tracer*, a **Missouri Fox Trotter,** owned by Neil O'Peterson and presented by Tymbre.
95. The cowboys of La Cense Montana: Bud Griffith, Bob Russell, Dan Hill, Dick Chaffin and Bob Griffith, and their **Quarter Horses.**

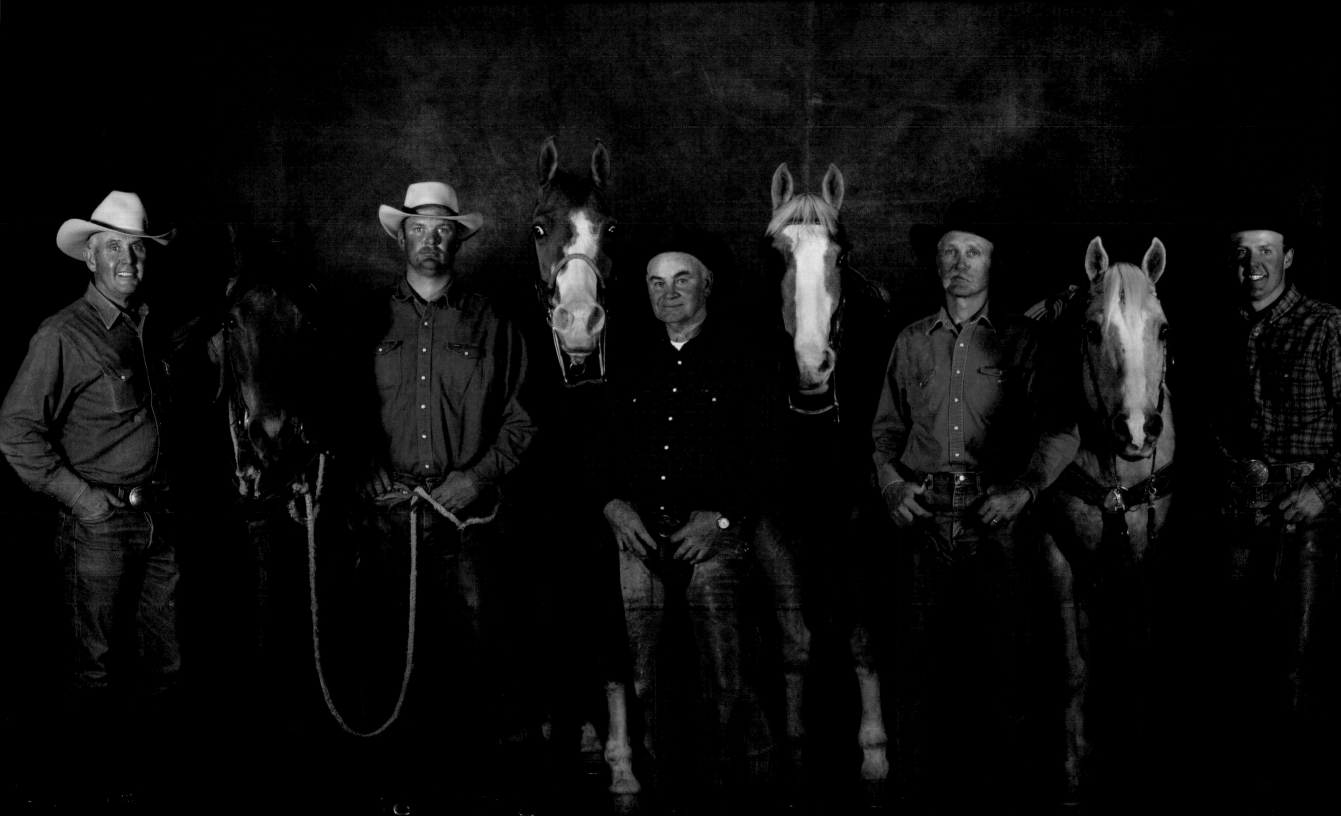

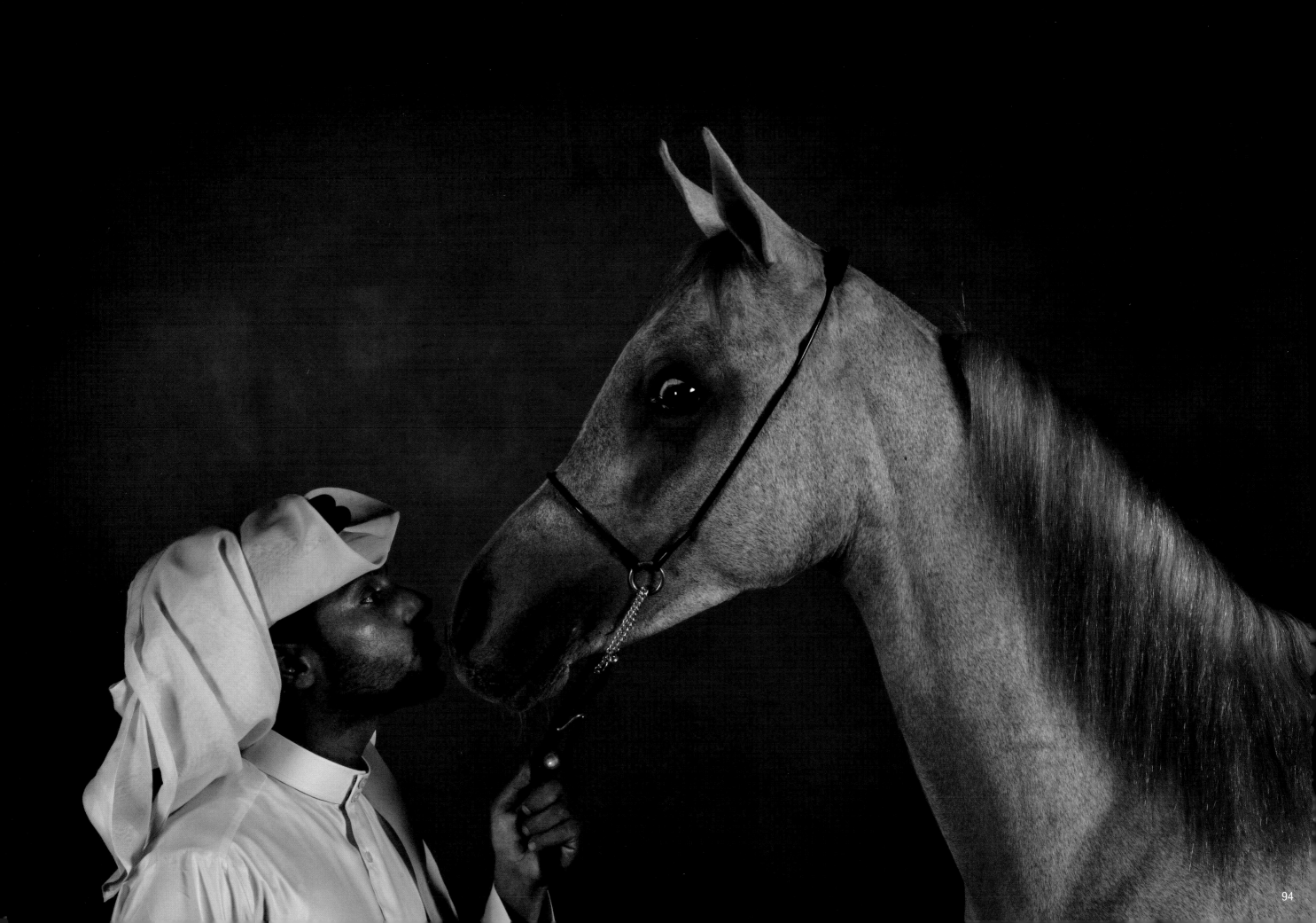

The Orient: improving Western breeds

The Arab truly is one of the most beautiful horses on earth, and many people are extremely passionate about this amazing creature. Even those who are not particularly interested in horses are struck by its grace, elegance and flamboyance. Spirited and noble, it has a fine head, with large, expressive eyes, dished face and flaring nostrils, and a good coat, high tail carriage and light, airy movements. Its fiery temperament adds a hint of danger.

Thousands of suras, verses, proverbs and legends sing its praises and acclaim its qualities. The Arab people in particular believed that this horse embodied the qualities of all other breeds. In *The Horses of the Sahara* (*Les Chevaux du Sahara*, published in 1853), General Eugène Daumas, French consul at Mascara and an expert on Barbs, Arabs and the traditions of North Africa, said that it has the courage of the wild boar, the grace of the gazelle, the lightheartedness of the antelope and the speed of the ostrich.

The fertile imagination and poetic genius of the Arabian storytellers really came into their own when they recounted the origins of the horse and how one of the most arid regions in the world (Arabia) could have become the birthplace of one of the most beautiful "breeds" of horses in the world. They say that it was all quite simple, although there are several versions of the same story. The best known is related in a Bedouin legend: "Then Allah took a handful of the South Wind and he breathed thereon, creating the horse and saying: 'Thy name shall be Arabian, and virtue bound into the hair of thy forelock. . . . I have preferred thee above all beasts of burden. . . .'"

However, some people prefer a more scientific explanation of the Arab's origins, choosing to stick to the theory that this horse adapted gradually from horses imported two or three centuries before the advent of Islam, from Mesopotamia, Turkey, Iran and even central Asia, by the Bedouin of the Nejd region. This is the only region on the Arabian Peninsula that provides grass for grazing, thanks to the streams of water running down from the high plateaus.

Ultimately, it does not really matter. Arguments between the experts concerning the real or supposed origins of the Arab horse have become irrelevant at a time when the breed is scattered all over the world and its finest examples no longer come from its land of origin. Today, the breed includes horses of very different types and sizes—between 13.3 and 15.3 hh (55–63 in)—depending on where they are bred, the preferences of their breeders and the uses for which they are intended. This is in spite of the best efforts of a centralized organization—the World Arabian Horse Organization (WAHO)—which, since it alone is qualified to decide whether a horse is a purebred Arab or not, has acquired an omnipotent status.

During the latter half of the twentieth century, it was the Americans who became the world's principal breeders of Arab horses. Today, over half of the 500,000 officially registered purebred Arabs are to be found in the United States, where they are all too often selected on purely aesthetic criteria and paraded solely in shows that are little more than glorified beauty contests—the equine equivalent of "Miss World." Some truly beautiful horses have been bred in order to compete in these contests, but they are often maladjusted temperamentally and quite useless as saddle horses. Indeed, the practice seems ill advised for an animal that owes much of its reputation to its riders' martial exploits.

In Russia, Arabs tend to be bred for their speed. One of the world's largest stud farms for purebred Arabs is the Tersk Stud near Pyatigorsk, in the foothills of the Caucasus Mountains. Meanwhile, the Arab countries are trying to reconcile the requirements for both physical beauty and nobleness of temperament. They continue to produce animals that are beautiful and loyal as well as spirited and robust.

Some fine examples of purebred Arabs from the stud farm of Sheikh Hamad bin Khalifa al-Thani, emir of Qatar. Situated about 9 miles (15 km) from the capital Ad Dawhah (Doha), the stud was established in the early 1990s, near Ar Rayyan, the scene of a historic Qatari victory over the Turks at the end of the Ottoman Empire.
94. *Roba Al Shaqab* (by *Safir* out of *Rabaab Al Shaqab*), a purebred **Arab** born in 2003, held by Jassim Al Kabi.
96, 97. *Adnan Al Shaqab* (by *Al Adeed Al Shaqab*), a purebred **Arab** born in 2001 and champion colt of Qatar in 2002.
98, 99. Three purebred **Arab** yearling fillies (by *Gazal*) from the Al Shaqab Stud Farm. Left: *Roba Al Shaqab* and *Al Noof*. Right: *Enshoda Al Shaqab*, *Roba Al Shaqab* and *Al Noof*.
100–101. *Al Adeed Al Shaqab* (center), an eight-year-old purebred **Arab** of Egyptian descent and world champion in Paris in 2002, presented by Ahmed Mousadaq at Umm Said, near Ad Dawhah (Doha). On the left, the mare *Imperial Jaliisah* is ridden by Ali Ismael Al Bakir.

If there is Garden of Eden for the horse, then it must be in the sumptuous lands of the **Orient**, lying somewhere between the Red Sea and the Bay of Bengal. It is a region that encompasses three worlds, civilizations and languages—Persian, Turkic and Arabic. This is the origin of the supreme horse breed, the star of the equine world and the stud horse that improved the horses of the West—the purebred Arab. Whether it is entirely pure or not, or even entirely Arab or not, its blood flows in the veins of most European breeds—racehorses and sporting horses, saddle and draft horses, leisure and warhorses, all have shared this common ancestry.

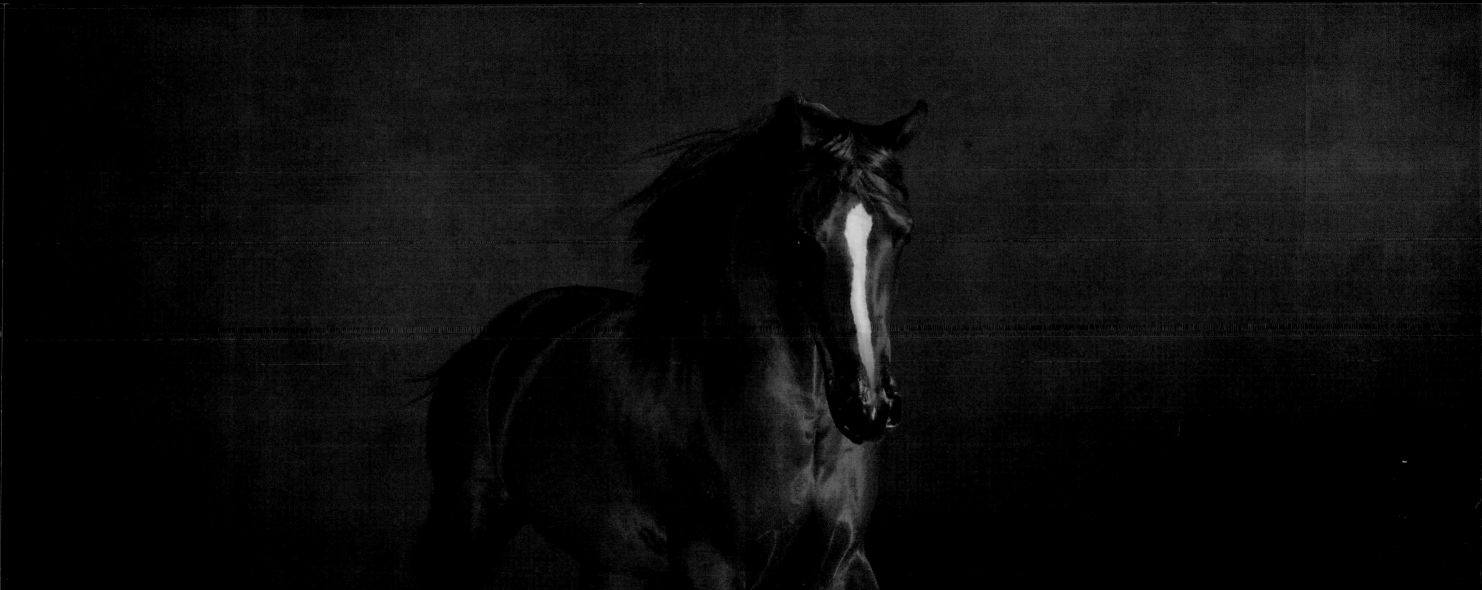

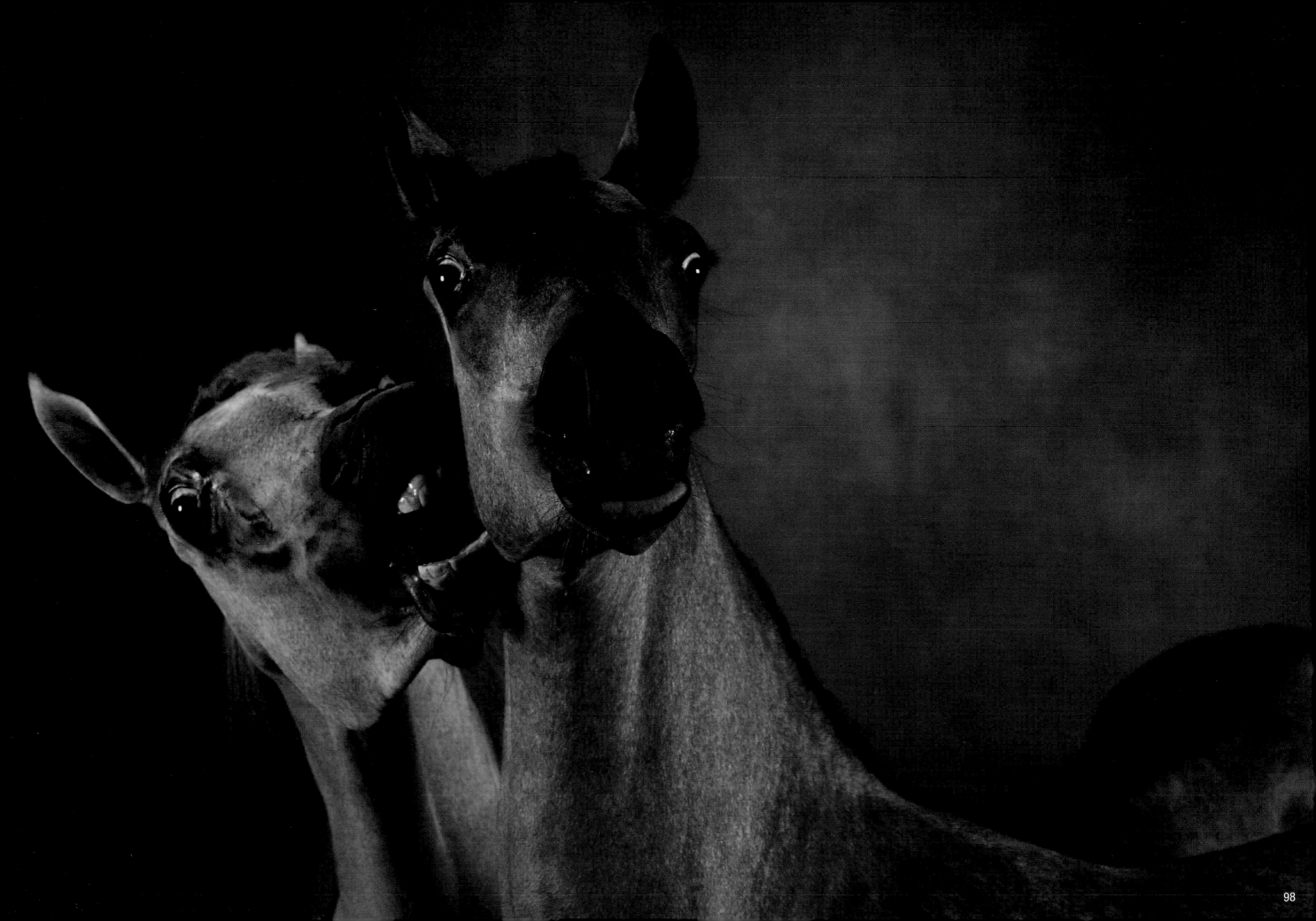

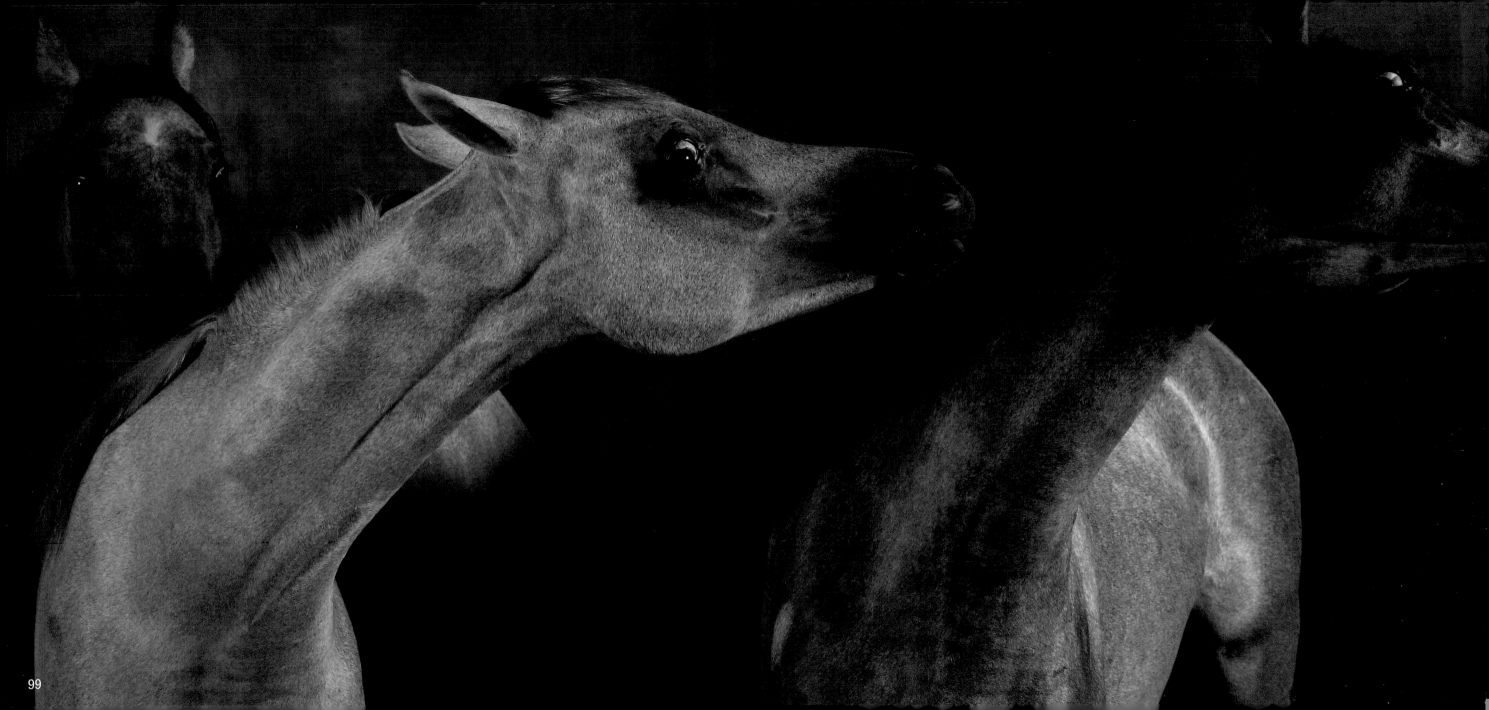

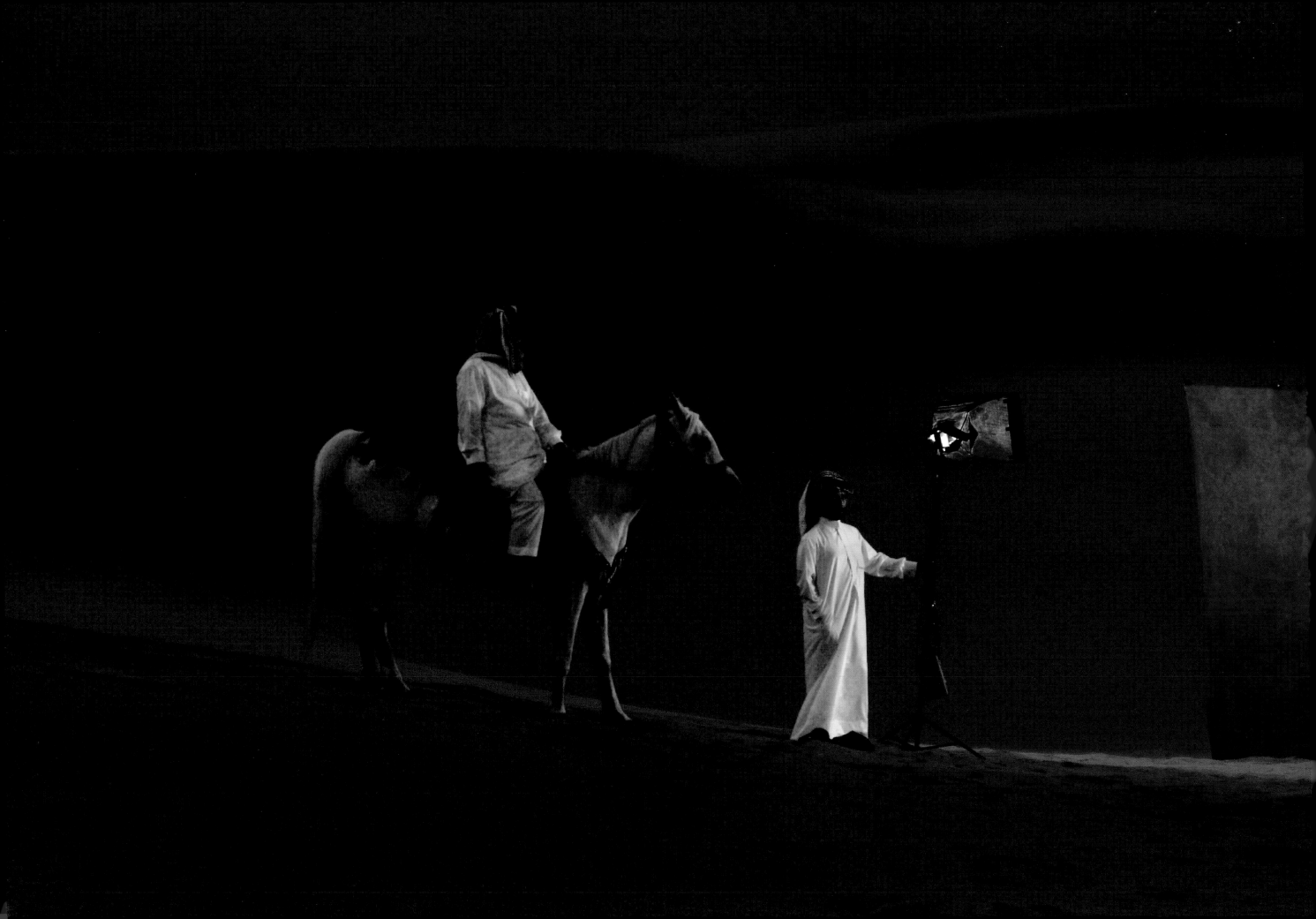

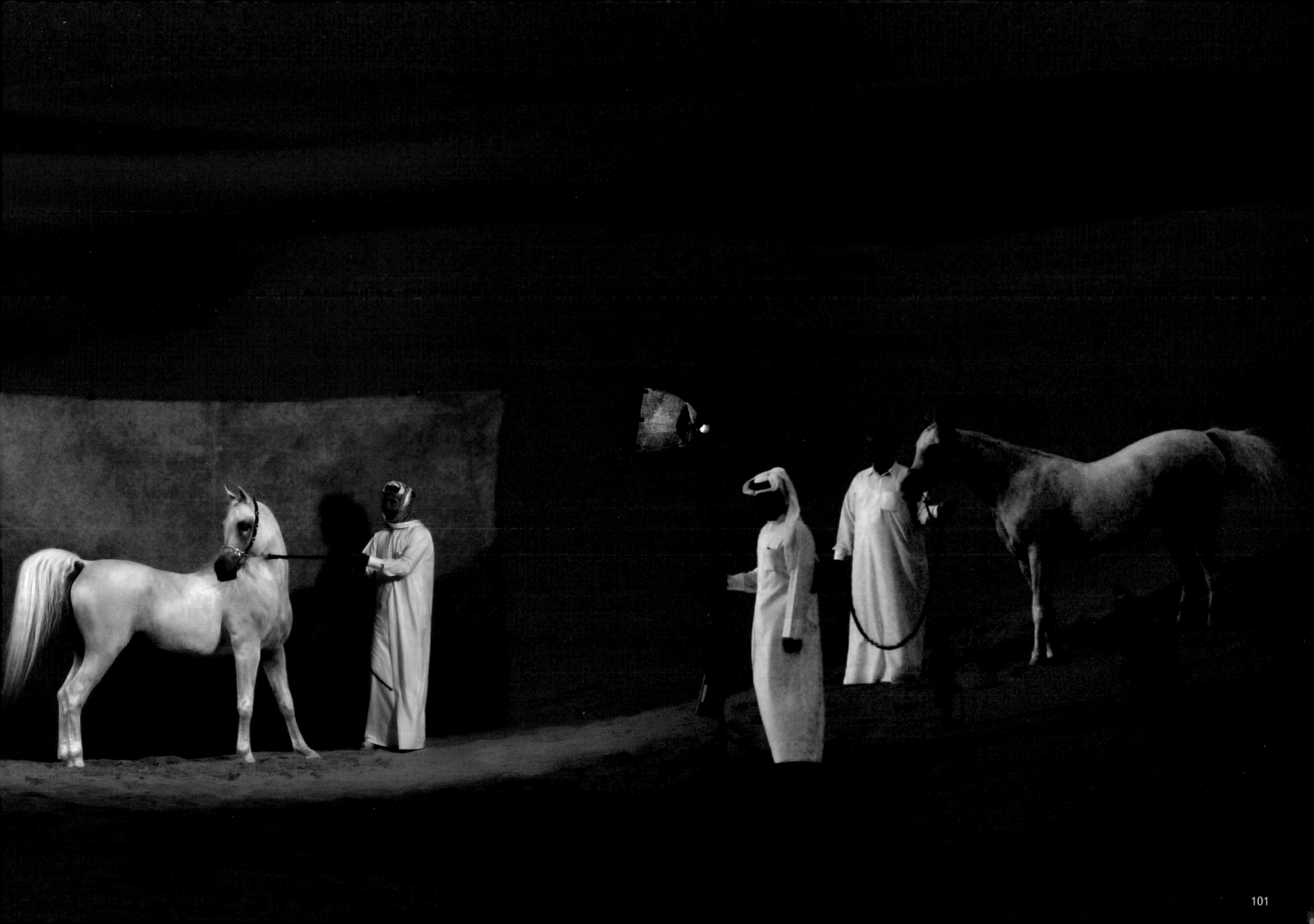

The purebred Arab: really pure, really Arab?

One more bone of contention between the English and French is the matter of who was the first to introduce the Oriental horse to the West. Apparently oblivious to the fact that both nations could have discovered it during the Crusades, each continues to claim the merit for this discovery.

The British maintain that it was King James I (1566–1625), son of Mary Queen of Scots and a keen horse-racing enthusiast, who first had the idea of importing Oriental stallions to cover English mares, with a view to increasing the strength and stamina of local horses and improving their performance.

The French assert that it was Napoleon Bonaparte (1769–1821), who was extremely impressed by the small horses ridden by the Mamelukes (a warrior caste) during his famous Egypt expedition (1798–99). It has been said that, while he may not have succeeded in overwhelming Egypt entirely, he was certainly inspired by the quality of the horses he found there and lost no time in adopting them for his own use.

Some of these horses have earned a place in history. *Ali* (or *Aly*), a 14.2 hh (58 in) gray stallion (the Arabs never geld their horses), was brought back to Europe and ridden by Napoleon (as first consul) at the Battle of Marengo (1800) and (as emperor) at the battles of Essling and Wagram (1809). Another was *Marengo* (who is often confused with *Ali*), a smaller (13.3 hh or 55 in) iron-gray stallion captured at Abu Qir (1799). He accompanied Napoleon throughout his career until the Battle of Waterloo (1815),

where he was wounded, captured and taken back to England. He died in England in 1832, at the age of thirty-eight, and his skeleton can still be seen in the National Army Museum in London.

However, the comprehensive inventory of the emperor's horses, drawn up by Philippe Osché in *Les Chevaux de Napoléon* (2002), reveals a disturbing fact: most of the horses referred to as "Arabs" probably did not belong to the Arab breed as it is known today. At the time, there was little regard for the niceties of modern ethnology. "Arab" was a generic term and was used indiscriminately to refer to all Oriental horses. Arabs, Barbs, Terskys and Turkomans (Turkmens), as well as Ottoman, Kurdish, Persian and even Ethiopian horses, were all grouped together under the name "Arab."

The same principle was applied to ethnic groups: the famous Mamelukes encountered by Napoleon in Egypt did not have much in the way of Arab blood in their veins. This warrior caste was composed exclusively of former slaves from central Asia, the Caucasus and even the Balkans.

Some fifty years later, the situation had changed very little. In 1862, General Daumas was still able to write: "Call him Arabian, Barb, Turk, Persian, Nedji, it matters little for all these terms are but baptismal names. The name of the family is the Horse of the Orient" (*Les Chevaux du Sahara*). It also fuels the arguments of those who are now challenging the Arab origins of the "Arab" horse and assert that Europeans did more than discover it—they created it!

This opinion is obviously not shared by the Arab nations. Since the 1970s, they have made every effort to reestablish links with their glorious equestrian past by creating specialist stud farms in Morocco, Jordan, Saudi Arabia and the Gulf States—today regarded as among the best in the world—and by reviving practices traditionally associated with the horse, such as falconry.

The horses in the photographs on pages 102, 103, 104, 105, 106 and 107 are all purebred Arabs.

102. *Safi Al Shaqab* (by *Safir* out of *Poema*), born in 1997 and champion stallion of Qatar in 2001, ridden by Ahmed Mousadaq, at Al Hamla.

103. A Qatari falconer. Hunting is one of the favorite pastimes of the Arabs of the Gulf states.

104. *Al Adeed Al Shaqab* with the Al Qadi family.

105. *Wazmeia* (by *Al Adeed* out of *Dalilat Albadeia*), held by Mahmoud Abdelfatah Badair.

106. *Al Adeed Al Shaqab*.

107. *Aliah Al Shaqab* and her filly foal.

Fortunately, there are a great many people who want to prevent the purebred Arab from being cast in the role of simply improving other breeds and/or being used purely as a show animal. To this end, they continue to promote its qualities of endurance and speed in an increasing number of specialist events. For example, one of the most recent "World Endurance Championships" was held in Dubai, in 1998—when Sheikh Muhammed bin Rashid al-Maktoum himself took part—and races reserved for "small" horses are regularly run in France (Cagnes-sur-Mer), Russia (Pyatigorsk) and Lebanon (Beirut). The following two photographs were taken at the Hippodrome du Parc, in Beirut.

108. The six-year-old purebred **Arab** *Rayan* ("radiant"), owned by Henri Chalhoub and presented by jockey Joseph.

109. The four-year-old purebred **Arab** mare *Faten* ("beautiful"), owned by Nabil de Freige and Moufid Dabaghi and ridden by jockey Farouk.

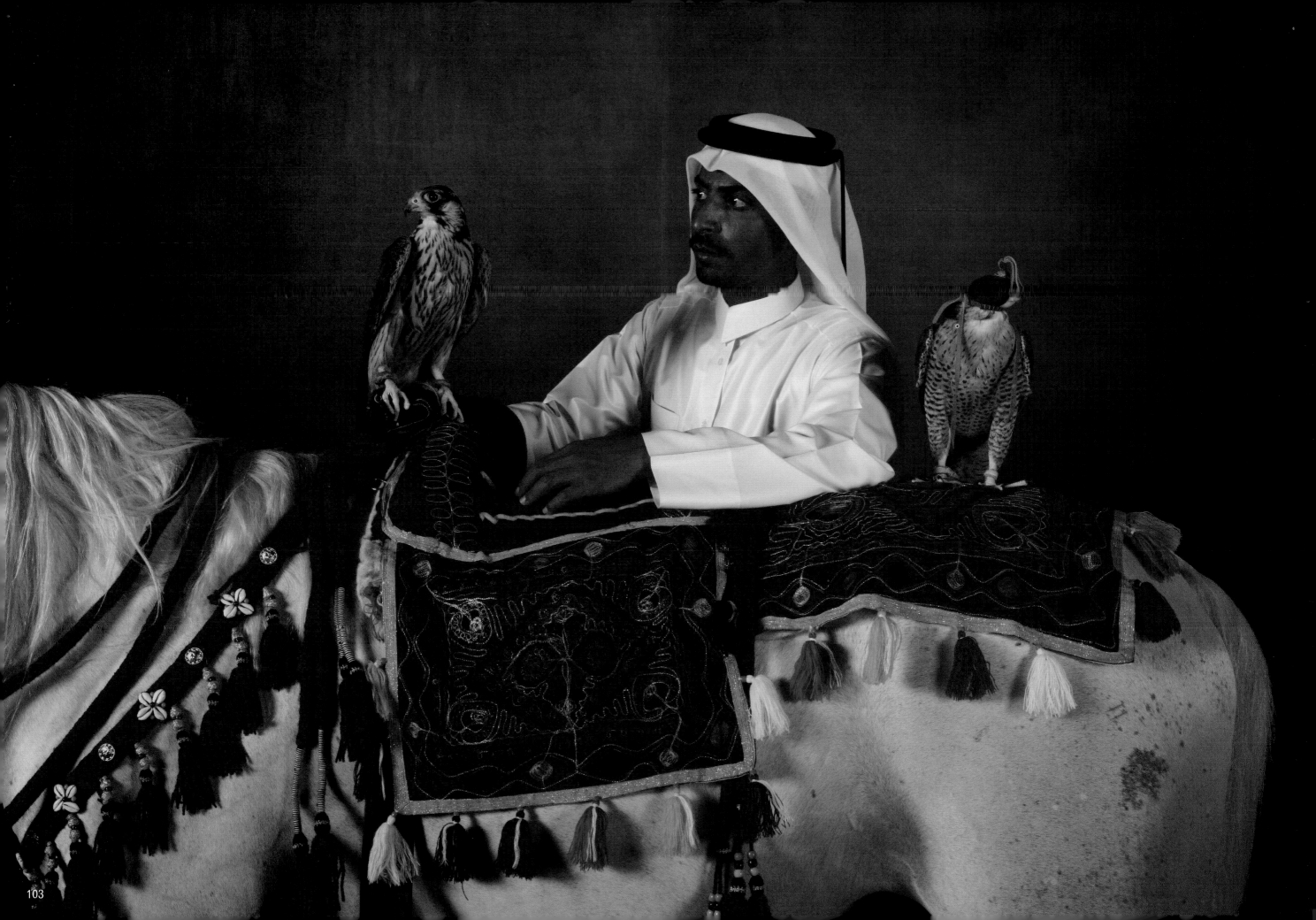

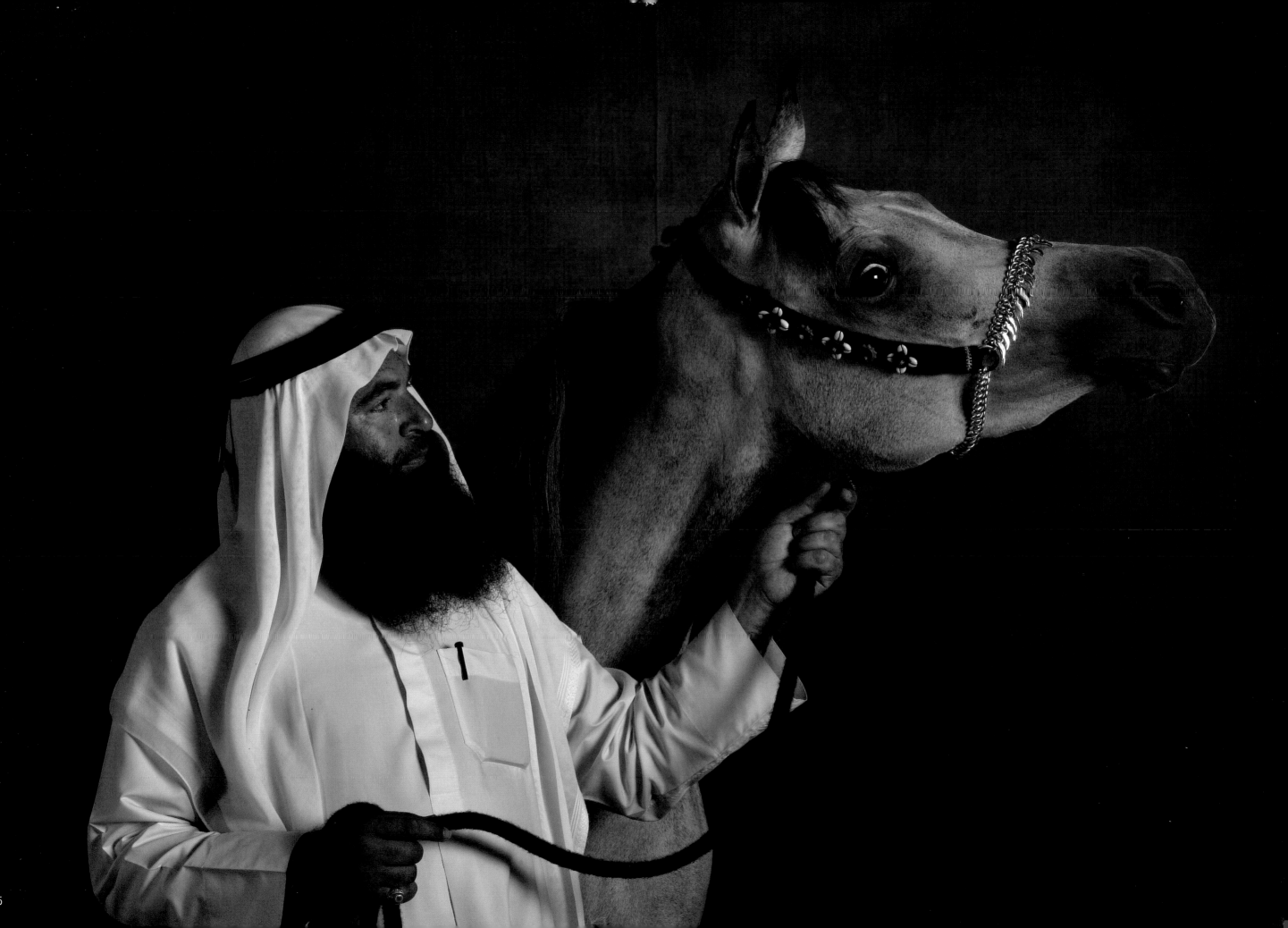

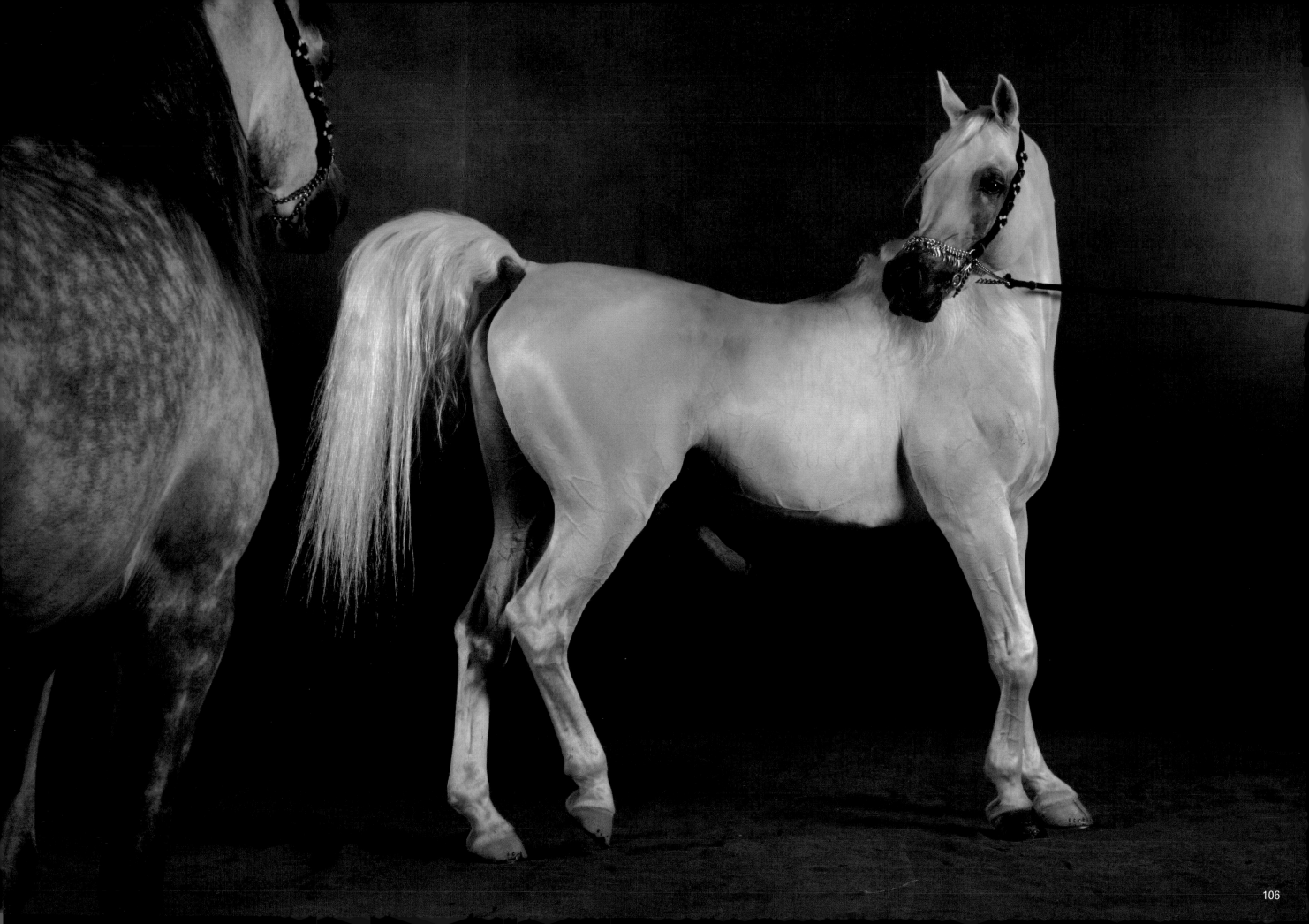

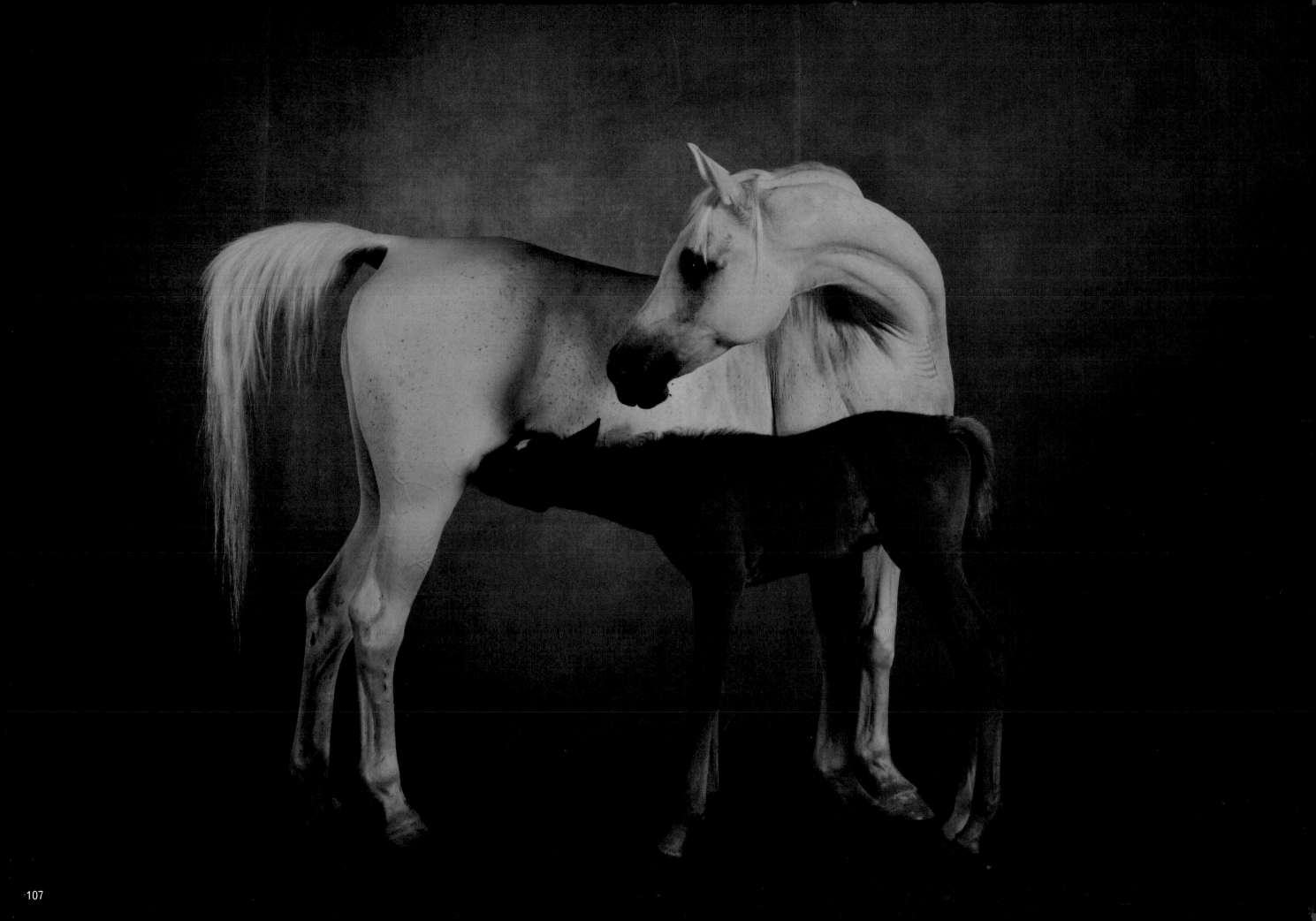

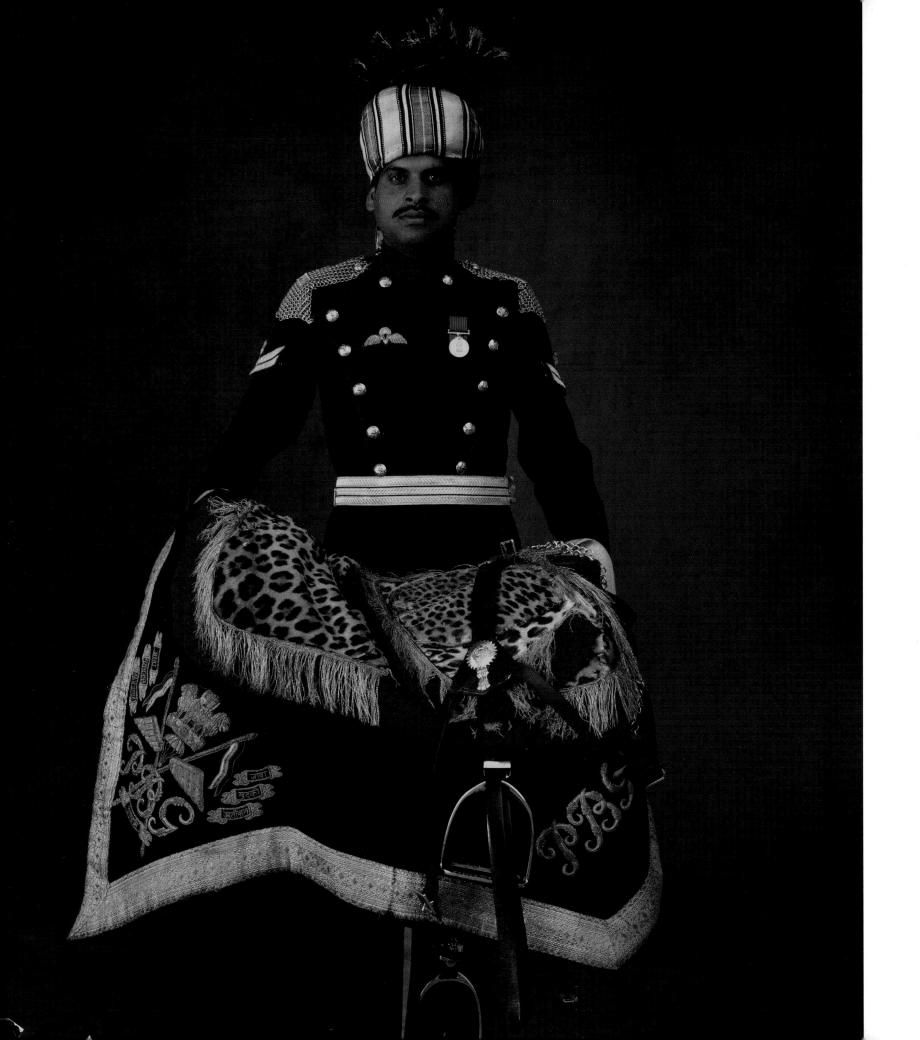

Horses from the Indian subcontinent: a deserving position of power

It is impossible to imagine a worse—or possibly better—line of ancestry than that of Zahir-ud-Din Muhammad (1483–1530), better known as Baber or Babur (the Arabic for "Tiger"). On his mother's side, he was directly descended (thirteenth generation) from Genghis Khan (c. 1162–1227), the Mongol conqueror, horseman of the steppes and founder of one of the greatest empires of all time. On his father's side, he was also directly descended (fifth generation) from Tamerlane (or Timur, 1336–1405), who was a noble Turk, fine scholar and lover of good horses but instilled terror by destroying towns and cities, wiping out dynasties and cutting off an impressive number of heads.

It was an ancestry that weighed heavily on his shoulders, but one that brought little in the way of inheritance. When Baber was born in 1483, his family controlled the region of Fergana, but this was a mere fraction of his ancestors' former empires. When his father died, in 1494, Baber was only eleven but already had to confront his paternal and maternal uncles—the sultan of Samarkand and the khan of Tashkent—who coveted his tiny kingdom. Ten years later, after some terrible battles fought on horseback, Baber had lost everything and departed for Kabul. He captured it in 1504 and from there went on to conquer northern India. In 1526, he rode into Delhi and founded the Mogul dynasty, which was to last for more than two hundred years. It gave rise to an extremely sophisticated civilization.

Unlike their ancestors, who had razed the cities they conquered, the Great Moguls—the rulers of this new empire—were builders who constructed impressive fortresses, sumptuous palaces and magnificent mosques.

It was under Mogul rule that the art of painting miniatures also flourished. Regardless of the subject—war, hunting, religion and even love—the artists always contrived to include horses somewhere in the painting, richly caparisoned, their legs and tails reddened with henna, their forelocks surmounted by plumes.

In spite of the comfort of their palaces, the luxury of their furnishings, the succulence of their sweet and spicy dishes and the languid beauty of their concubines, the descendants of Genghis Khan and Tamerlane did not forget the animal that had brought them fortune and glory. The accounts of François Bernier, a great traveler and contemporary of Louis XIV of France (1638–1715), reinforce this. Bernier lived in India for ten years (1659–69). He entered the service of a Persian scholar who occupied a prominent position at the Mogul court, where one of his duties was to ensure the welfare of the emperor's five thousand horses. In this capacity, the Frenchman gained access to the inner sanctum of the royal palace and witnessed, for example, the audience that the emperor granted his subjects every day at noon. According to Bernier, during the hour and a half that this audience lasted, the emperor would distract himself by having some of the most beautiful horses in his stables brought before him, so that he could see whether they were being well treated and well looked after.

The Moguls' passion for their horses was not only due to their ancestry; it was also a matter of necessity. Their empire was founded, maintained and expanded in the face of opposition from numerous Hindu kingdoms, all with formidable cavalries—the horse certainly had not made its first appearance in India with the Turkish-Mongol invaders alone. At the time of the great Aryan invasions about 1500 B.C., the horse was already playing an important part in the desire for conquest and expansion. It was also held to be a quasi-sacred animal and as such was sometimes sacrificed. The invaders, who it is thought may have come from the Caspian Sea region, penetrated the Indus Valley. Their religious beliefs combined with those of the indigenous population to form the basis of Hinduism. Unlike the Bible, which rarely mentions horses, the holy Hindu scriptures give them pride of place. For example, in the *Bhagavad Gita* (I, 14), Krishna—one of the avatars of the god Vishnu—appears as a youth, characteristically depicted with blue-black skin, driving a cart pulled by two white horses.

One of the horse's problems with India is its hot and humid climate; the monsoon regions simply do not suit it. New blood therefore needs to be imported on a permanent basis, something that India has done for centuries, continually bringing horses in overland from central Asia and by sea from Arabia. Many of these horses—which usually came from Oman, at the southern tip of the Arabian Peninsula—were brought into the state of Gujerat, near the border of Pakistan, where the crossing of local and imported horses ultimately created a new breed: the Kathiawari. Although similar to the Arab, the tips of the ears point inwards so sharply that, when pricked, they almost touch, forming what could be described as a heart shape, or, more appropriately, an ogive, a pointed arch found widely in Mogul architecture. The Marwari, an elegant little horse from Rajasthan, to the north of Gujerat, is very similar to the Kathiawari and is also three-quarters Arab.

Horses are still imported into India, but nowadays they are mostly racehorses. During British rule, the Indians realized the English passion for racing; in return, the English discovered polo. Today, Indian horses are still used for parades, just as they were in the time of the Great Moguls. One cavalry regiment has been retained solely for the purpose of parading through the streets of Delhi once a year, on January 26, the day of the Indian national festival.

110, 111. A prestige regiment, the Indian Presidential Body Guard mounts dark bay, almost black, horses. Only the trumpet major has a gray horse. On the ceremonial saddle, covered with leopard skin, the initials PBG (Presidential Body Guard) are embroidered in gold.

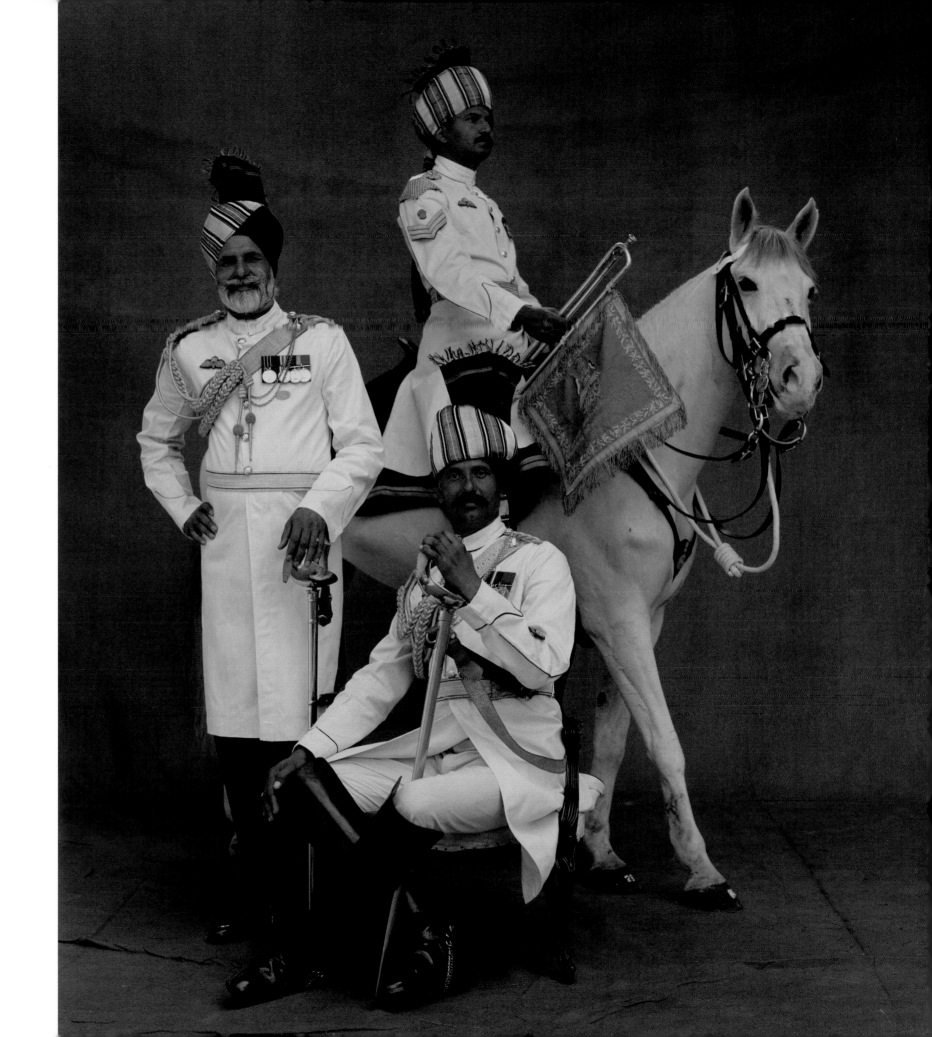

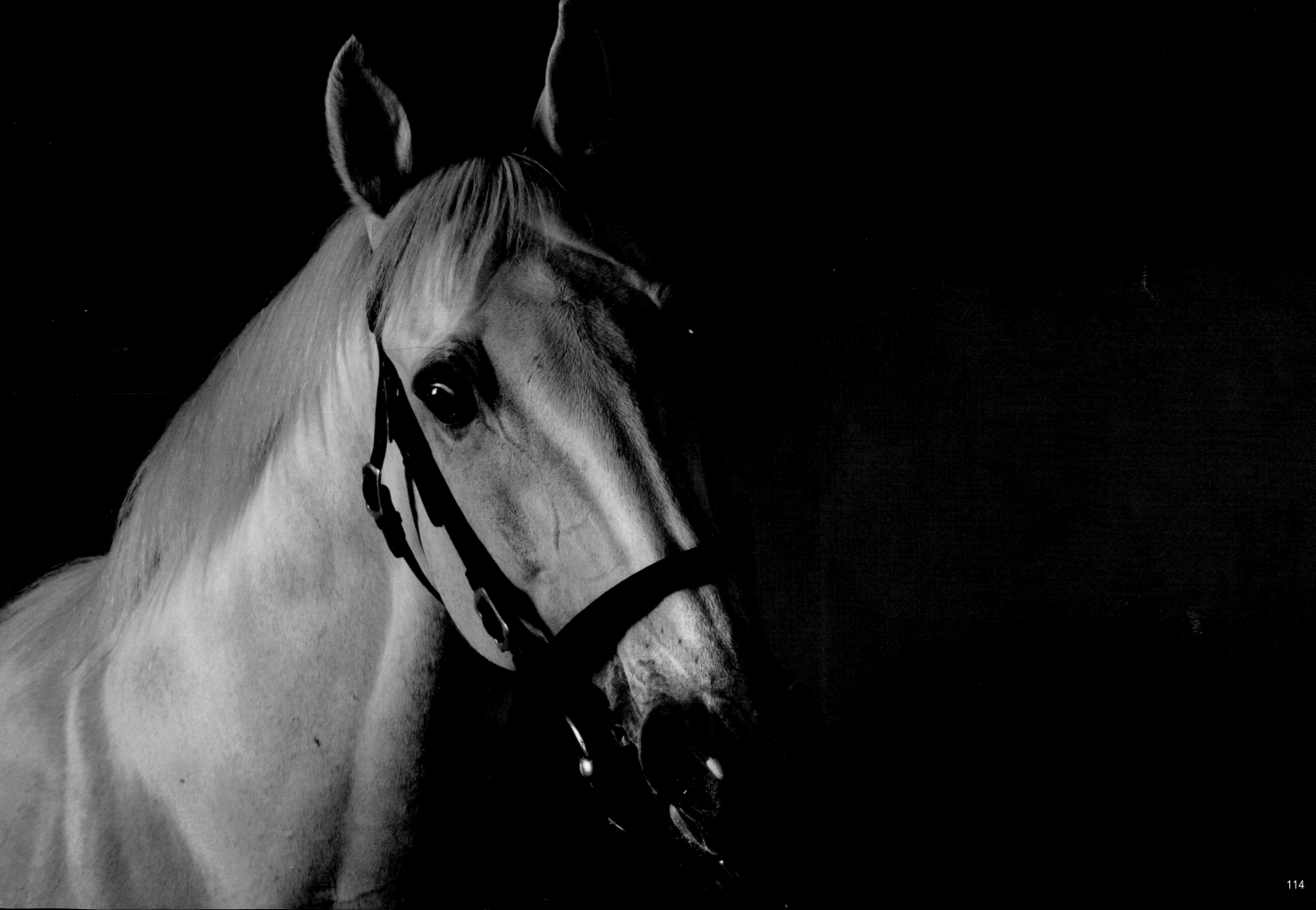

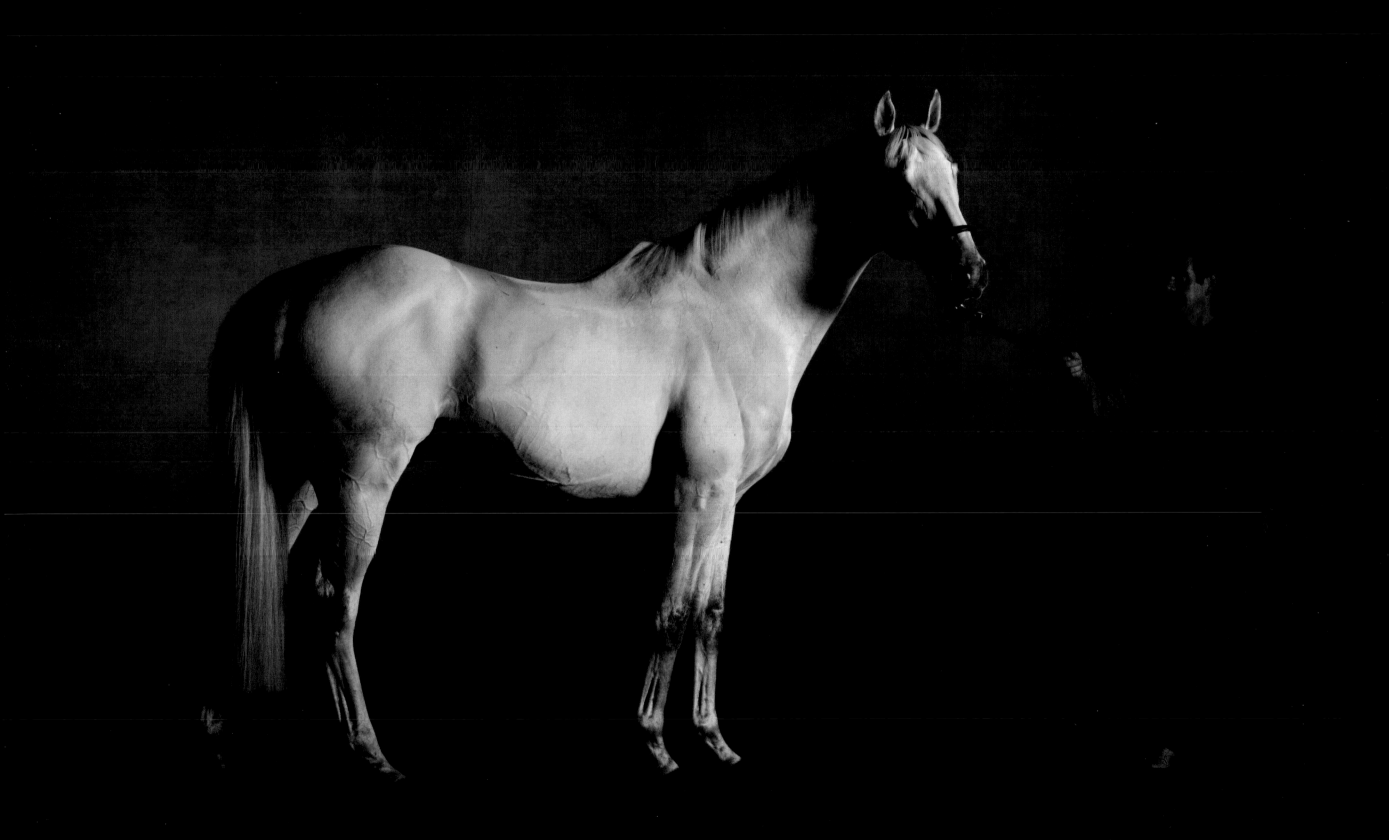

The English Thoroughbred: the fastest horse in the world

"The horse is not one of man's *conquests*—even the most beautiful—but rather one of his *products* (possibly the most beautiful) . . . the result of human genius, the pure product of culture." This is how artist Christian Renonciat describes the horse. As a sculptor, he gives pride of place to horses in his work. The English Thoroughbred is a pure creation—a "pure product," to use Renonciat's term—one of man's finest "inventions" and one of the great success stories in the history of man's domestication of the horse. The result of the work of several talented breeders, it is quite simply a work of art, a masterpiece.

There is no real standard against which to measure the Thoroughbred, and it can stand between 15.1 and 17.3 hh (61–71 in). English anatomist, painter and engraver George Stubbs (1724–1806) skillfully depicts it in his paintings. He excelled at painting these large and elegant but spirited creatures, at a time when the breed was becoming established and already beginning to dominate the racecourses.

What follows is not a detailed description of the breed's complicated ancestry, with its multiple lines of descent, but rather an outline of its origins. James I (originally James VI of Scotland until, in 1603, he was crowned James I, king of England, Ireland and Scotland) was the founder of the Newmarket and Epsom races. He is thought to have been the first person to have the idea of improving the progeny of English mares by putting them to Oriental stallions. His grandson Charles II (1630–85) wanted to perpetuate the tradition and complete what his grandfather had started, but on a much grander scale. He sent trusted envoys to the Levant and Maghrib to bring back a number of fine stallions. The royal envoys scrupulously fulfilled their mission and returned home with the stock—Turkoman, Barb and Arab mares and stallions—that formed one of the cornerstones of the breeding program, which would soon produce a new strain of racehorses. These animals were tried and tested on the racecourse, selected for their speed and improved with new injections of "Arab" or comparable blood.

According to the record books, three stallions used to improve this new breed came to be regarded as the foundation stallions of the Thoroughbred dynasty—the Byerley Turk, a bay brought to Yorkshire

c. 1690, the Darley Arabian, a dark bay imported from Aleppo (Syria) in 1704 and the Godolphin Barb or Arabian, another dark bay whose story deserves special mention.

Born in 1724, the Godolphin Barb was one of a number of horses given to Louis XV of France (1710–74) in 1731 by the bey of Tunis. The horse was not to the French king's taste and he ordered it to be removed from the royal stables. It was duly sold and ended up in harness on the streets of Paris. An Englishman traveling through the city bought it and took it to England, where he sold it to a publican who was a racing fanatic. Having raced the poor creature somewhat unsuccessfully, the publican sold it to Lord Godolphin, a former royal treasurer, member of Parliament and enthusiastic horse breeder whose successes were more a matter of luck than judgment. He did not immediately recognize the qualities of his Barb, which was relegated to the role of "teaser" until it managed an unplanned covering of a beautiful chestnut mare named *Roxane* and proved itself to be a good sire. The stallion had finally found its rightful "niche" and has been known as the Godolphin Barb ever since.

The Godolphin Barb's line of descent includes *Matchem* (b. 1748), a horse that was also descended, via its dam, from the Byerley Turk. The latter's line of descent includes *Herod* (b. 1758), also descended from the Darley Arabian via his dam. In the Darley Arabian's line of descent, *Eclipse* (b. 1764) was descended—via his dam—from the Godolphin Barb. *Matchem*, *Herod* and *Eclipse* were the first generation of the great Thoroughbred dynasties. The descendants of the best known, *Eclipse* (he was born during an eclipse of the sun), have included more than a hundred winners of the Epsom Derby, Britain's foremost flat race. About 1770, George Stubbs painted a portrait of this exceptional horse—an extremely rangy animal, with an arrowlike head, long neck, slender body and long, fine, powerful legs, that was evidently built for speed. It was the prototype for what from then on came to be known as the English Thoroughbred. It should be pointed out, however, that "English" describes the origin of the breeders rather than the horses, while the term "Thoroughbred" denotes an exceptional animal, but one that is the result of quite a mixture of breeds.

Today, the Thoroughbred has become an international breed and there is therefore a tendency to drop the adjective that alludes to the "Englishness" of its origins and simply refer to it as "the Thoroughbred," a much more appropriate term that reflects the purity of its breeding. This is how the Americans, who have become its principal breeders, tend to refer to it. While England continues to be a major center for the production of racehorses, it ranks only third in terms of the number of foals dropped each year—approximately ten thousand, compared with twenty thousand in Australia and almost fifty thousand in the United States. A number of other countries also produce Thoroughbreds: France, Germany, Italy and, above all, Ireland, which also has some of the finest stud farms for the breed, along with those of Kentucky in the United States.

This internationalization has come about because horse racing, which was born in England, has now spread throughout the world. The races offering the most prize money are run in Japan and Dubai, but Hong Kong, Moscow and New Delhi also have major racetracks, and the stakes are also high in the African capitals of Dakar, Cotonou and Ouagadougou.

With such big prize money now at stake, stud fees have soared. At the last estimate, a single service by the stallion *Stormcat*, owned by a famous stud farm in Kentucky, cost half a million dollars, while a yearling filly—which, to use racing jargon, could turn out to be a "champion" or a "dead loss" —was knocked down for two million Euros at a recent auction (August 2002) in Deauville (France), one of the centers of the international Thoroughbred trade.

This beautiful filly, named *Vimy Ridge*, was bought by Sheikh Maktoum Al Maktoum who, with his brothers, is currently one of the top racehorse owners in the world, with over six thousand horses scattered among a dozen magnificent stud farms in Europe, the United States and his own country, the United Arab Emirates.

The families that currently dominate the world of racing hail from Europe (the Wildensteins), America and Japan, but the most influential come from the East, such as the famous Ismaili dynasty of the Aga Khans. By investing their fortunes in the development and improvement of the

English Thoroughbred, the Orient has once again come to the aid of the West.

The horses in the photographs on pages 112–113, 114, 115, 116 and 118–119 are all English Thoroughbreds.

112–113. The Gilltown Stud in County Kildare, Ireland, has three first-class stallions—*Daylami*, *Sinndar* and *Kalanisi*—which, put to carefully chosen brood mares (e.g., the three-year-old mare *Banadiyka*, presented here under a sycamore by Joe Dempsey), produce the superstars of the future.

114, 115. *Daylami*, a gray stallion born in 1994 (by *Doyoun* out of *Daltawa*), the first champion in the world to win seven Group 1 races. On the right, *Daylami* is presented by his handler Liam Foley.

116. *Sinndar*, a bay stallion born in 1997 (by *Grand Lodge* out of *Sinntara*), the only horse to have won the Derby, the Irish Derby and the Prix de l'Arc de Triomphe in the same year.

118–119. At a flat-out gallop on the Curragh racetrack, south of Dublin, in Ireland. *Morning*, a four-year-old gray mare (by *Ali Royal*), owned by Stephen Hayden and ridden by Lesley MacCormack, and *High Living*, a three-year-old bay filly (by *Diesis*), owned by Lady O'Reilly, ridden by Nicola Shadwick and trained by John Hayden (Stephen's father).

As well as being great horse-racing enthusiasts, the English have another great passion—foxhunting—and have created a horse specially for that purpose, although it is also extremely well suited to other equestrian sports such as show jumping and eventing. The hunter is the result of crossing Thoroughbreds with hardy horses.

117. *Ivanhoe*, a seven-year-old hunter, owned by Mr. Adsetts (Badminton) and presented, in the style of a painting by George Stubbs, by Mathew Laurence (complete with top hat).

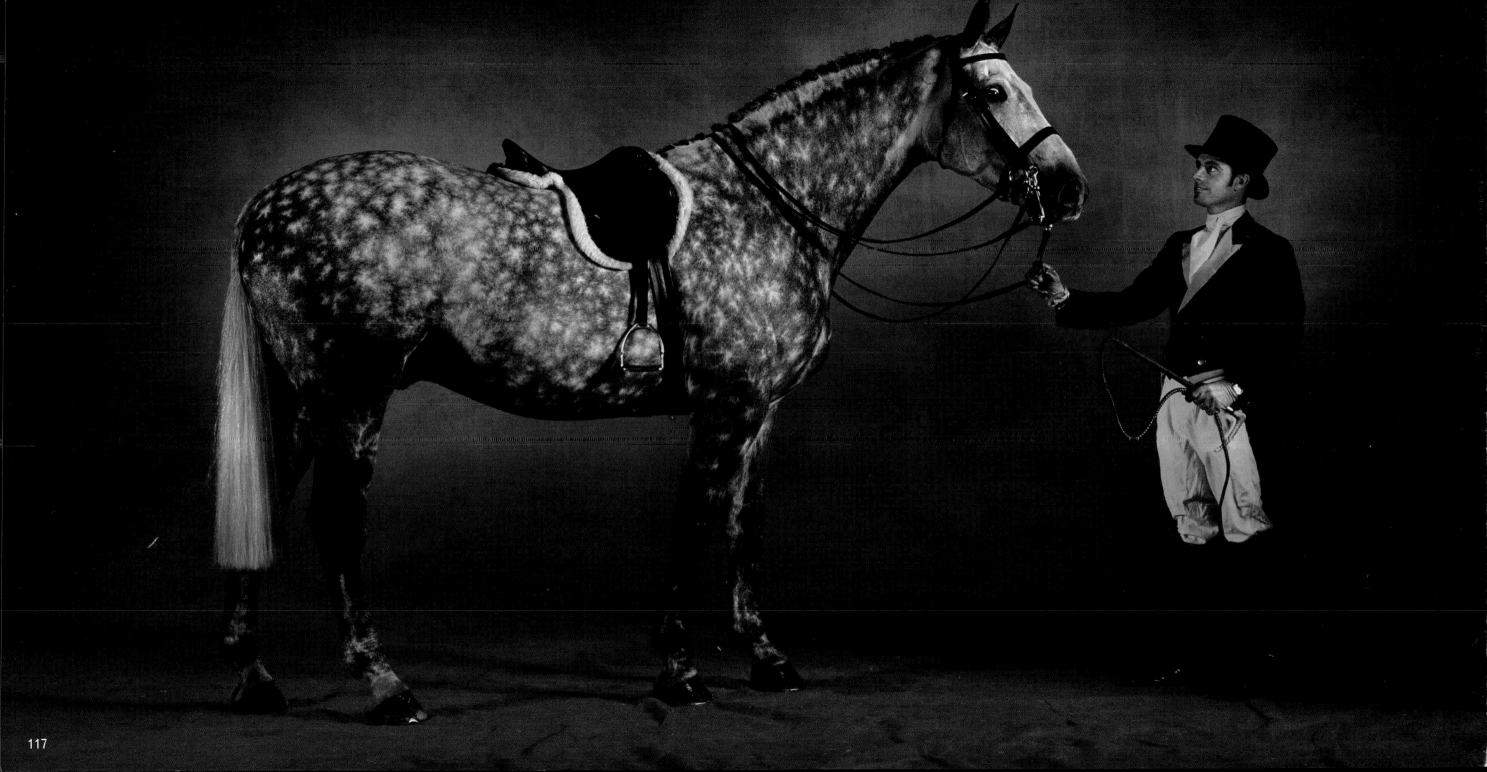

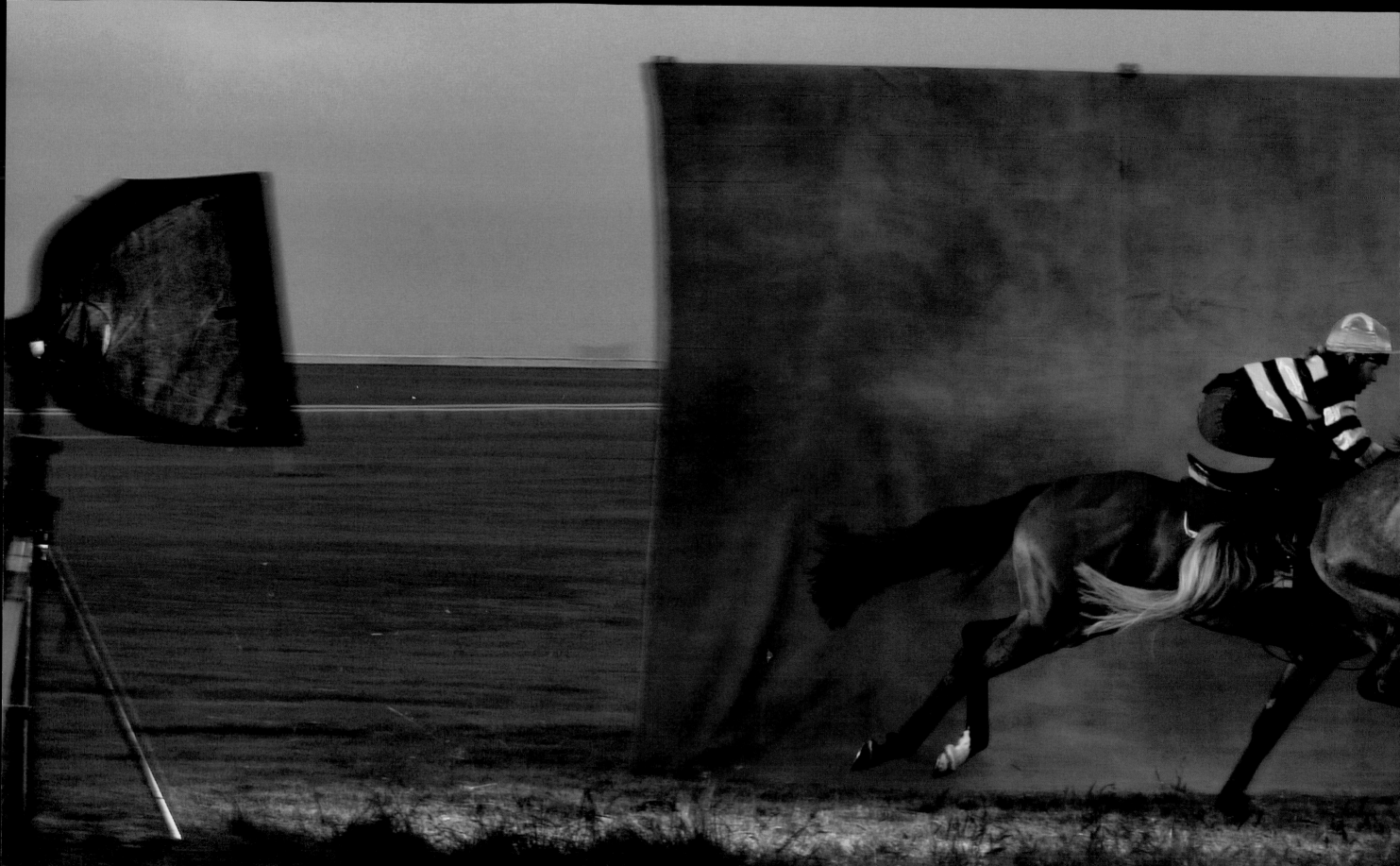

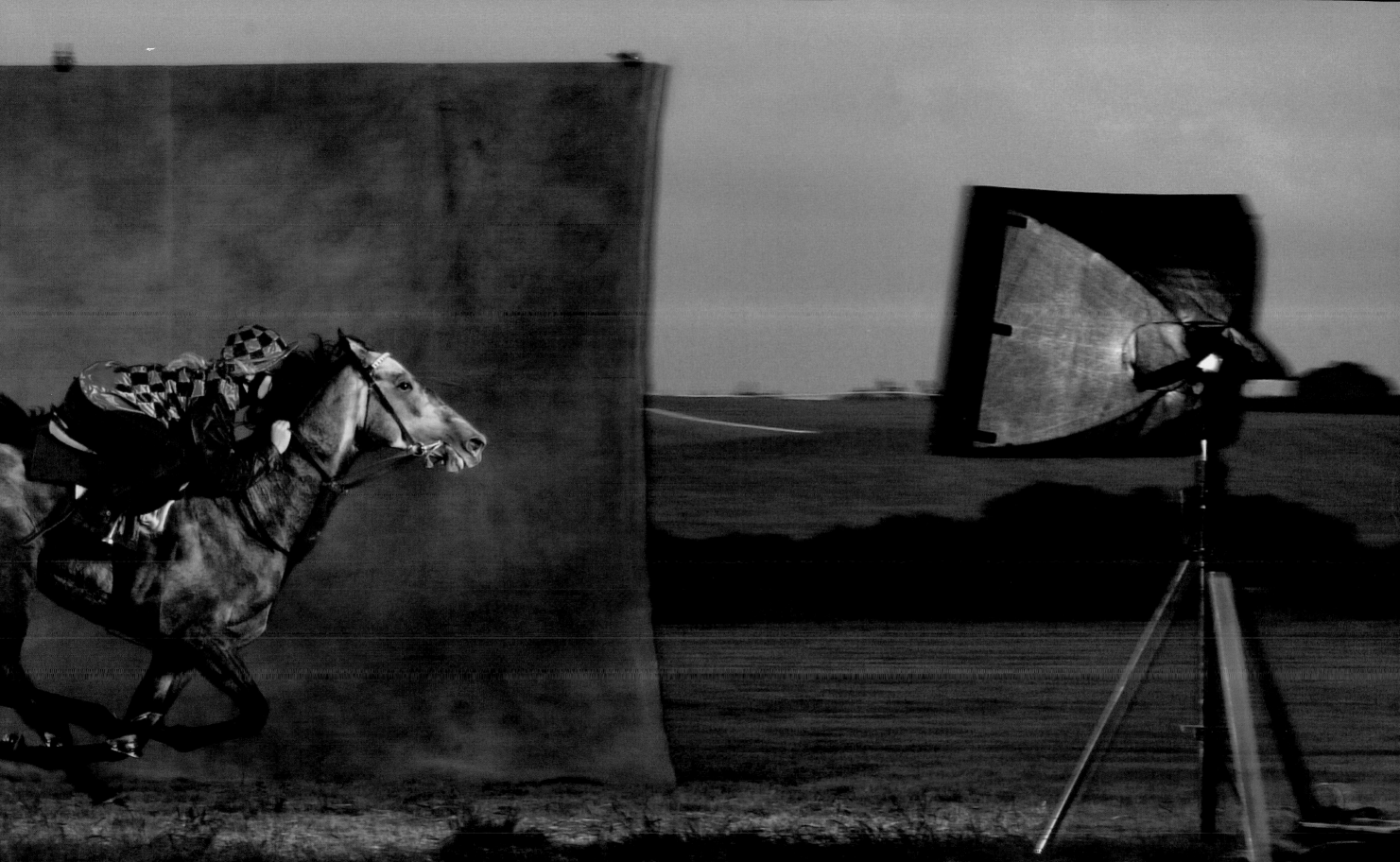

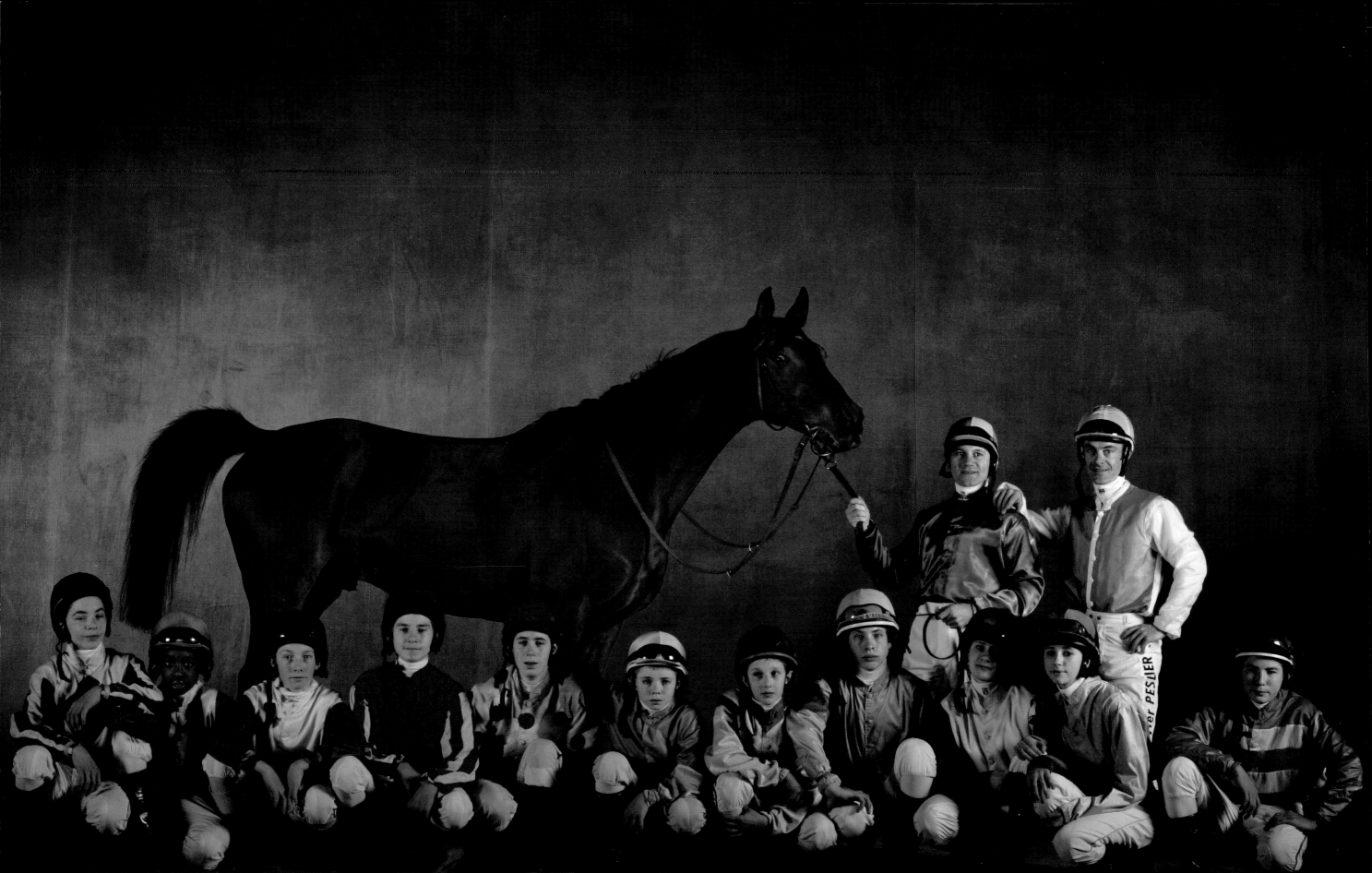

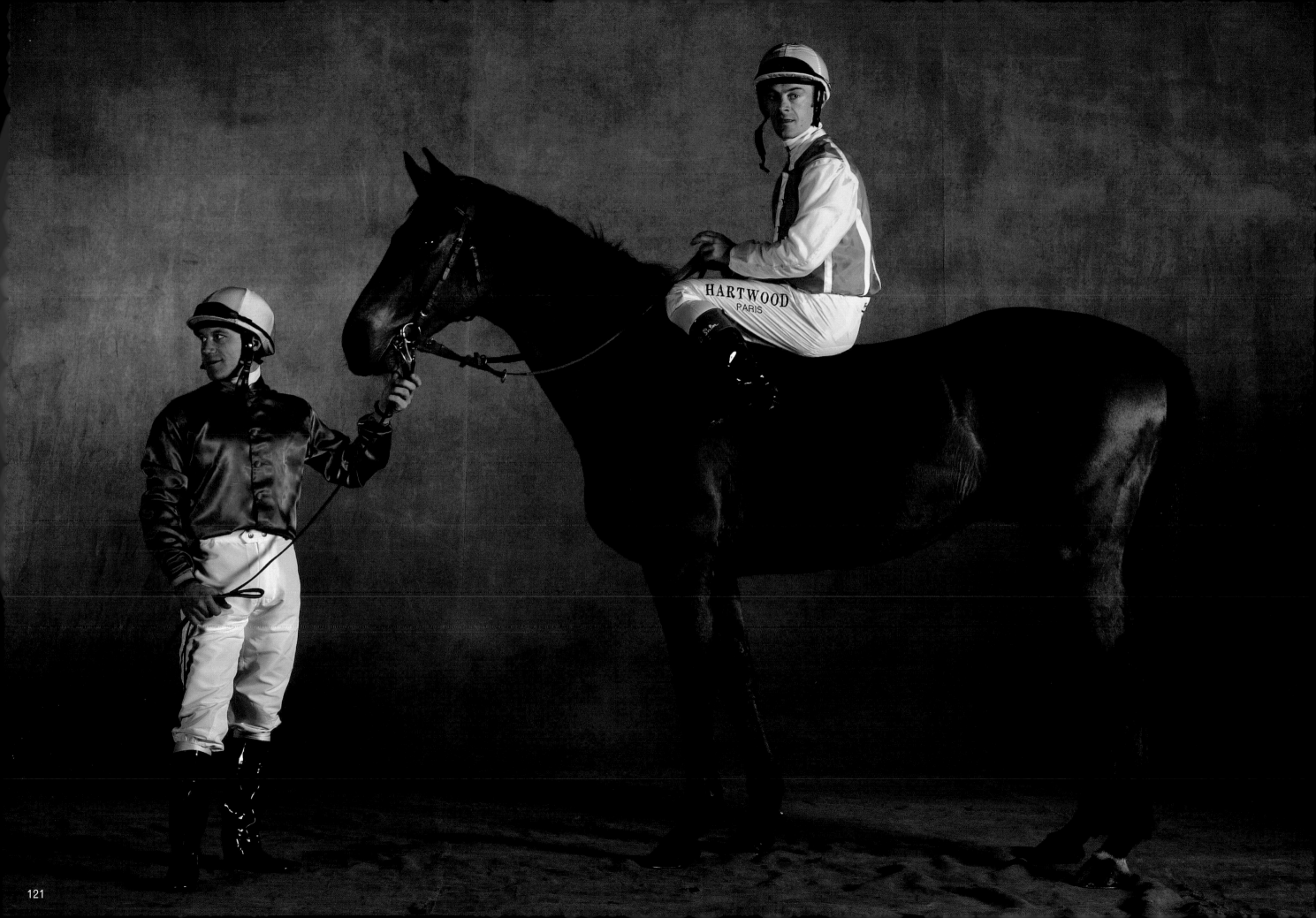

Before any major construction work can be undertaken in France, regulations stipulate that the soil and substratum of the site must be carefully examined. This typically French invention, known as preventive archaeology, is regarded as a pointless and persnickety precaution that has greatly irritated developers, public works contractors and highways engineers by curtailing their activities. However, just a few years ago, the policy proved to be completely vindicated.

In November 2001, before work could begin on the new bypass planned for the town of Clermont-Ferrand, capital of the Auvergne region, excavations were carried out on the site, in accordance with regulations. On this occasion the archaeologists made an amazing discovery. They uncovered a tomb containing eight men, lying one behind the other, the left arm of each resting on the shoulder of the man in front, and eight horses, carefully laid on their right sides, their heads pointing to the south. Although the exact causes of their death and the circumstances and meaning of this Gallic burial are unknown, it does reveal a great deal about the very special relationship that has always linked horse and man in this ancient land.

Before France was sanctified following the conversion of the Frankish king Clovis I (c. 466–511) in A.D. 500, it was known as Gaul. In mythological terms, it was the beloved daughter of Epona (meaning "Divine Horse"), the Gallic horse goddess whose cult was adopted by the Roman cavalry.

For centuries, Gaul had been a sort of vast experimental breeding ground that gave rise to many different types of horses. A rich land at the crossroads of Europe, it was also a place where many different cultures became intermingled. Continually subjected to a wide range of influences, it frequently fell victim to the avaricious nature of the peoples who came on horseback to occupy or just pass through from all four corners of the earth—Celts, Huns, Goths, Franks, Vandals and Moors. They came from the east and the north—from the steppes of Asia and the depths of the Germanic lands—and from the south—from the Iberian Peninsula and even from as far afield as North Africa. It was these invasions—whether their effect was civilizing or destructive, whether they were Berber or Barbarian—that helped to make France the land of four hundred horses. This

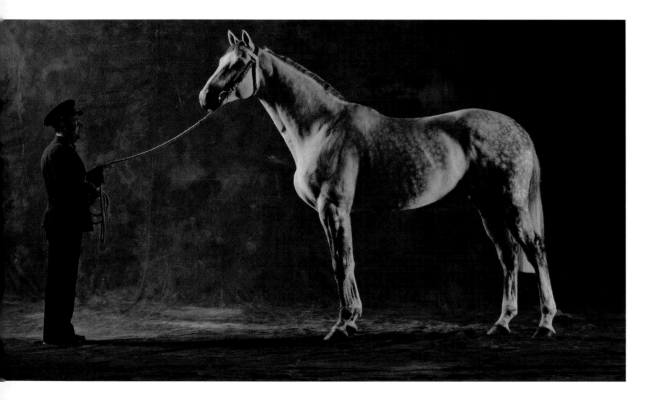

early chaos also gave rise to a culture of order and of the methodical turn of mind and love of logic that became the dominant characteristic of French civilization.

It would be impossible to explore all the twists and turns of the horse's amazingly rich history in France. Therefore, it seems appropriate to turn directly to the story behind the creation of the French saddle horse. After World War II, it was decided to rationalize the breeding of an animal that mechanization had rendered useless, or of much less use, by merging the many different types of saddle horses that had been so carefully and patiently adapted for various purposes in each region. In 1958, it was ruled therefore that there would be no more Norman or Anglo-Norman (also known as half-bred) horses, no more local breeds like the Vendéen, Charollais, Angevin or Bourguignon. Instead, there would be just a single "breed" known as the French saddle horse.

Thanks to its many different origins, fifty years after this enforced integration, there are still many different types of French saddle horse. One of these, defined somewhat negatively as the AQPS—Autre Que Pur Sang (which translates as "other than Thoroughbred")—is bred exclusively for racing. However, it is mainly in the field of events such as dressage, show jumping, cross country and eventing that the "breed" tends to excel today, with such examples as Galoubet (descended from a line founded by English Thoroughbreds) and Jappeloup (descended from a line of trotters) which, ridden by Pierre Durand, won a gold medal at the Seoul Olympics in 1988.

The other major "breed" of "French" saddle horse is the Anglo-Arab. It was created in the nineteenth century by Eugène Gayot (1808–1891), one of the most eminent French hippologists of his day and a veterinary surgeon (like his father, who was for a time inspector of the Neapolitan stud farms of Joachim Murat, one of Napoleon's most celebrated marshals and king of Naples). In 1840, Gayot became director of the Haras du Pin Stud Farm, where he promoted the introduction of English Thoroughbred blood into the local breeds, thereby producing the Anglo-Norman which was unfortunately lost a century later in the great melting pot of the French saddle horse. When he became director of the Haras de Pompadour, in 1843, he had the oppor-

tunity to realize a long-standing dream—to combine the speed of the English Thoroughbred with the endurance of the Arab.

The result was a big thoroughbred horse (over 16.1 hh/65 in) that was elegant but powerful, a very distinguished horse with outstanding paces and "bags of personality." While it can sometimes be difficult, the Anglo-Arab can also put its heart and soul into the task in hand. Used in AQPS races, dressage and show jumping, it is above all in cross-country events that its qualities shine through.

Four breeds said to be "thoroughbred" breeds are recognized in France and are promoted by the national stud farms: the purebred Arab, the English Thoroughbred, the Anglo-Arab and the French Saddle Horse.

120, 121. The sixteen-year-old **English Thoroughbred** and former champion racehorse *Al Capone*, by *Italic* (by *Carnaval* out of *Bagheira II*) out of *L'Oranaise* (by *S'Agaro* out of *Paris Jour*), accompanied on the left by the students of the École des Courses Hippiques (Gouvieux, France) and presented on the right by Dominique Bœuf and Olivier Peslie.

122. The **Anglo-Arab** stallion *Quain* (by *Emir IV* out of *Maïa du Vent*), bred at the Haras du Pin Stud Farm, in Normandy.

123. The **English Thoroughbred** stallion *Freedom Cry* (by *Soviet Star* out of *Falling Star*), placed second in the Grand Prix de Paris in 1995. One of the top stallions at the Haras du Pin Stud Farm.

124, 125. The **French saddle horse**.
Left: The four-year-old *Lou du Veret*, presented by his owner Agnès Juhel-Anfray. Right: Two brood mares "with foal at foot," presented by their owner Arsène Aubry.

126, 127. The nine-year-old **French saddle horse** stallion *Hors la Loi II* (by *Papillon Rouge* out of *Ariane du Plessis II* by *Joyau d'Or*), ridden by the famous Brazilian champion Rodrigo Pessoa at the Haras de Ligny stud farm (Belgium).

128–129. French saddle horse *Estival de Quints*, born in 1992 (by *Le Tot de Senrilly* out of *Reine de Landeves*), ridden by Rodolphe Lacourte.

130–131. The nine-year-old **French saddle horse** *Hortus de Pierre* (by *Papilllon Rouge* out of *Sika du Rouet* by *Nantoung*), owned by the Haras du Pin stud farm (Normandy).

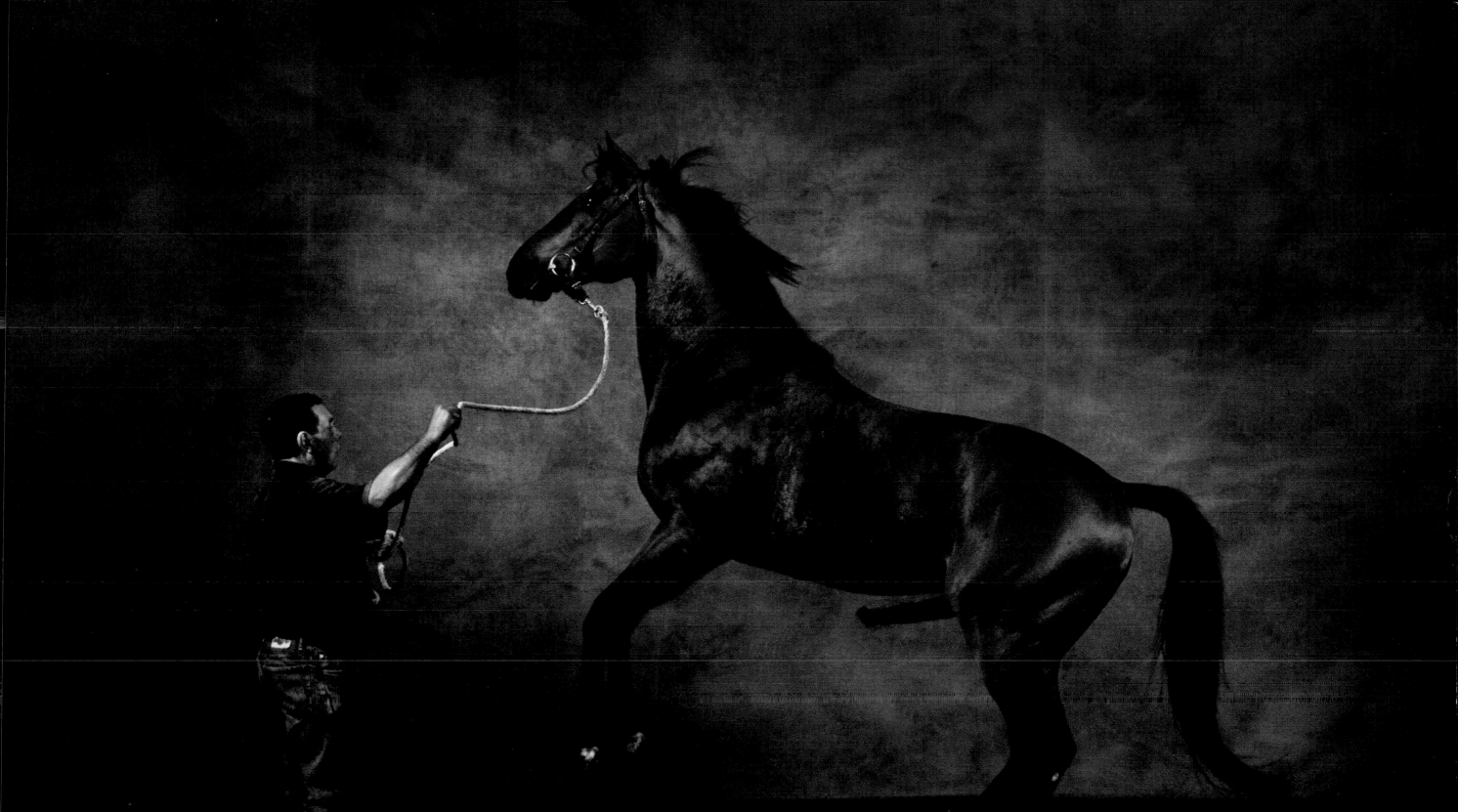

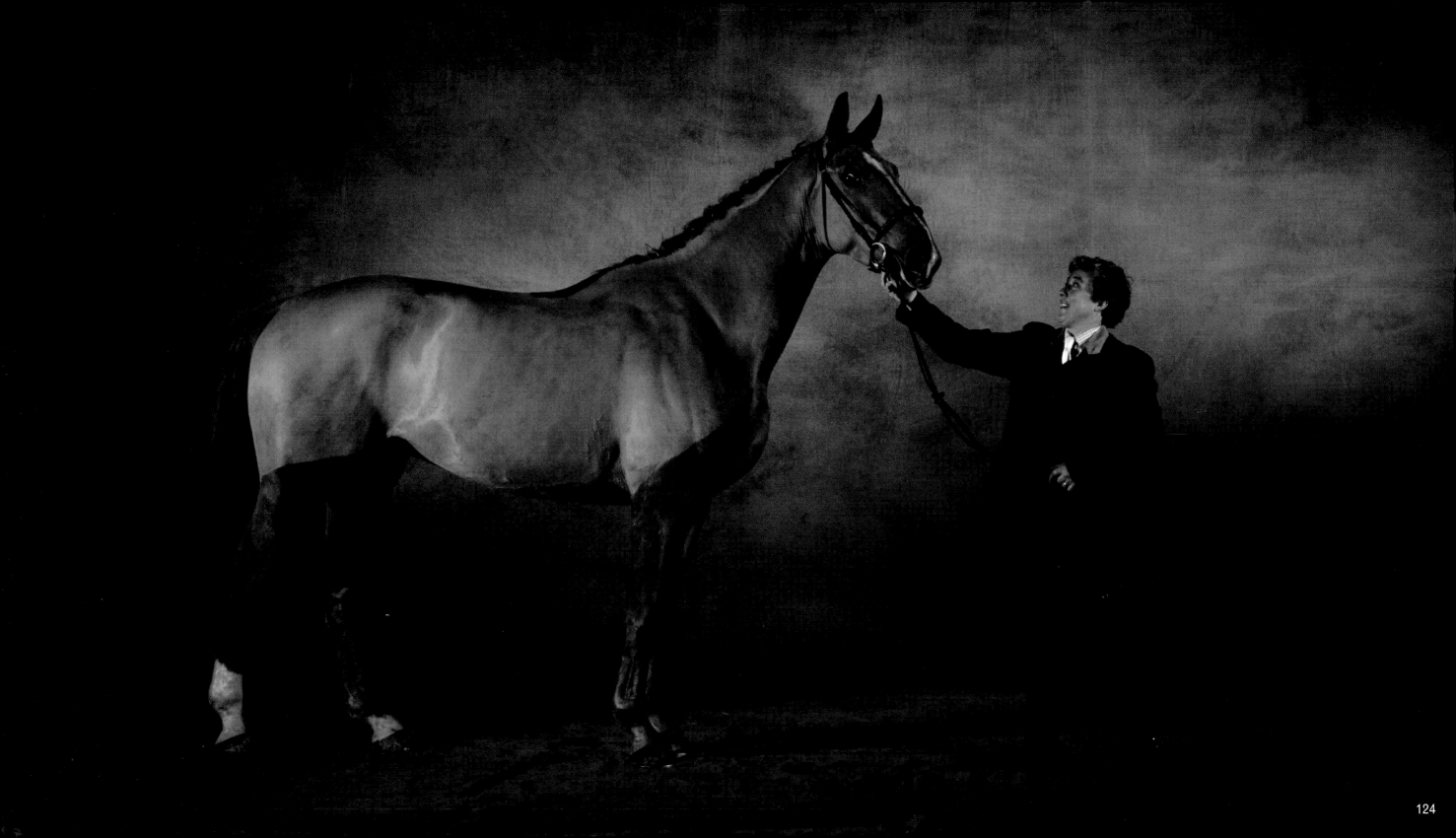

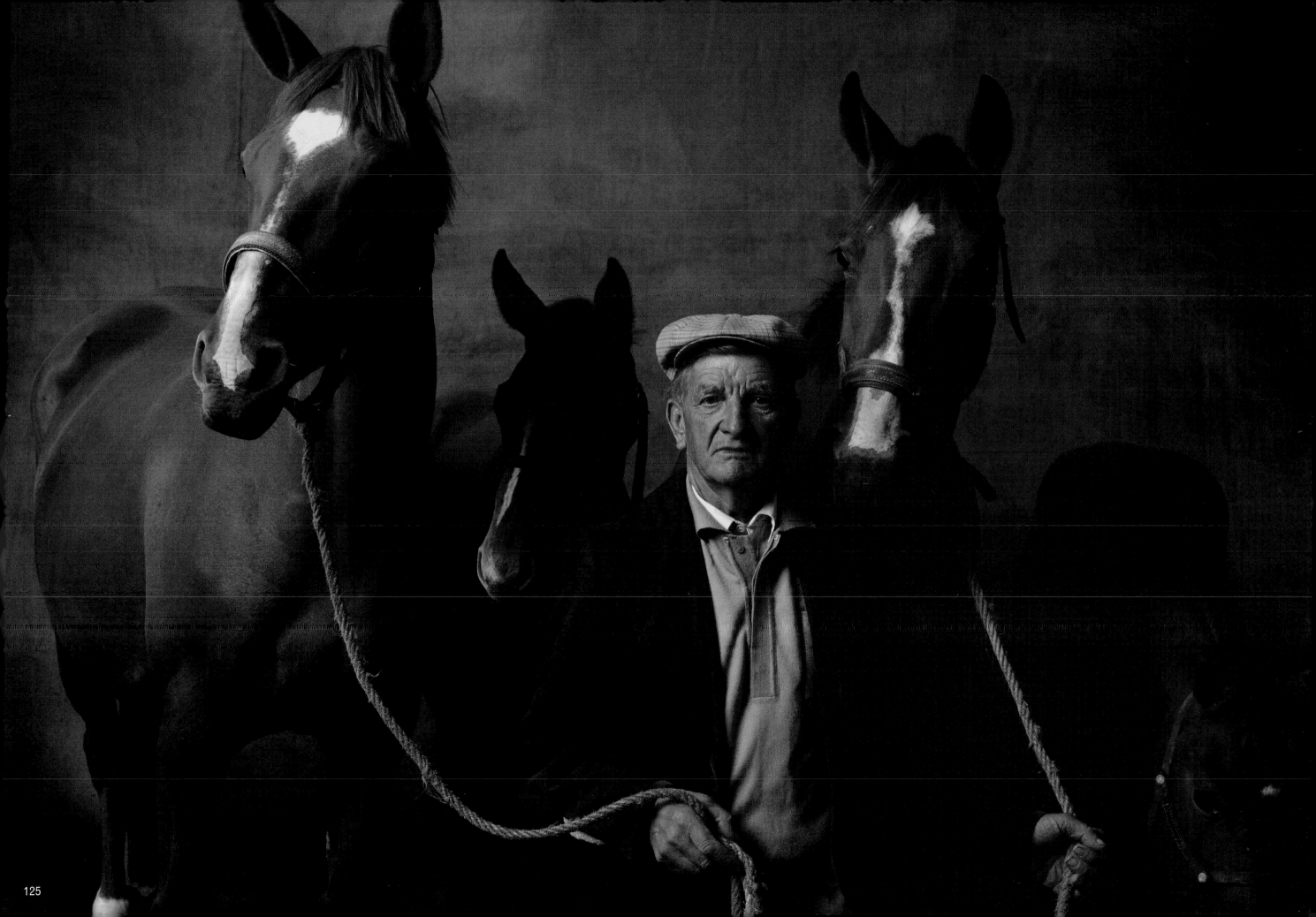

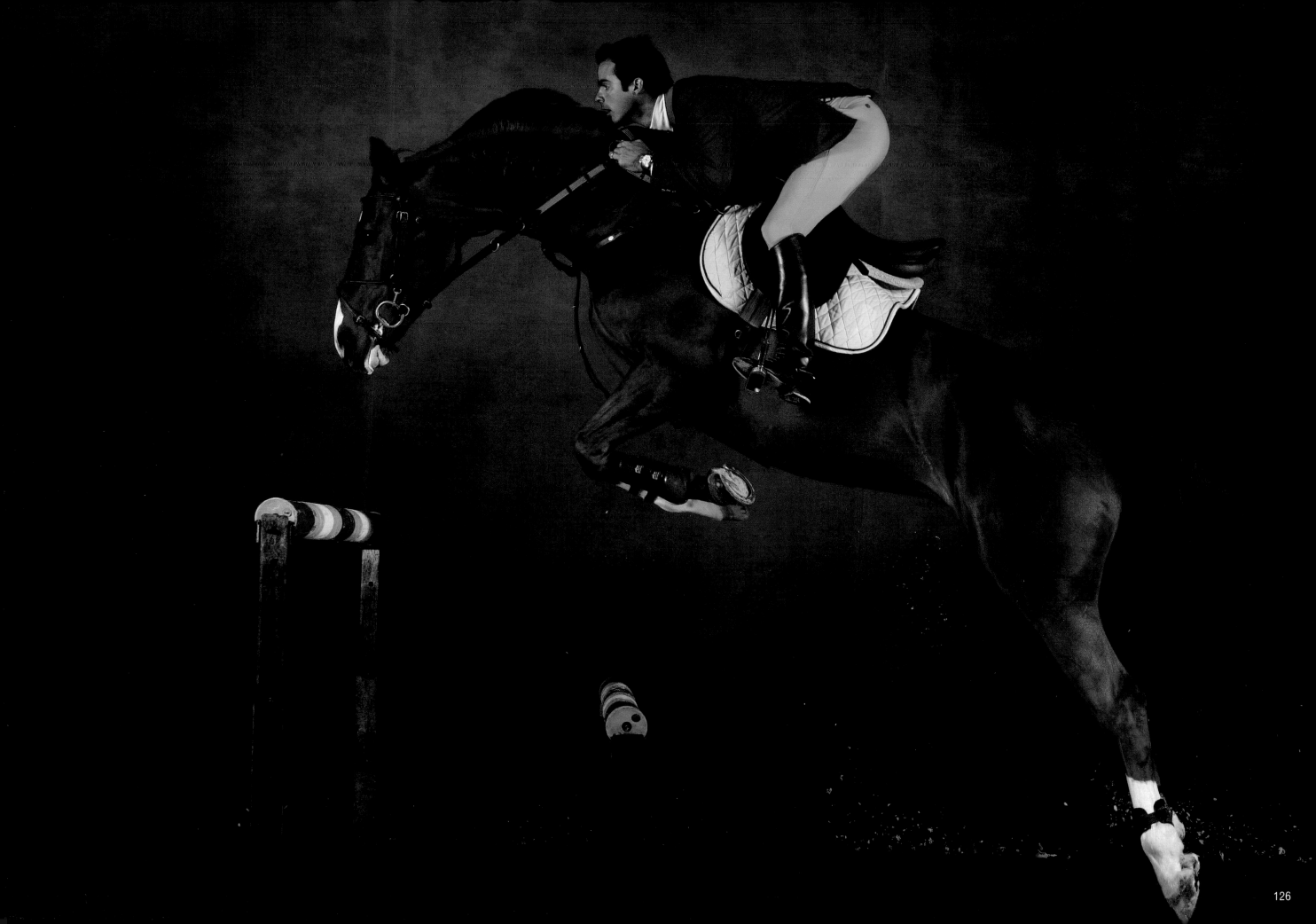

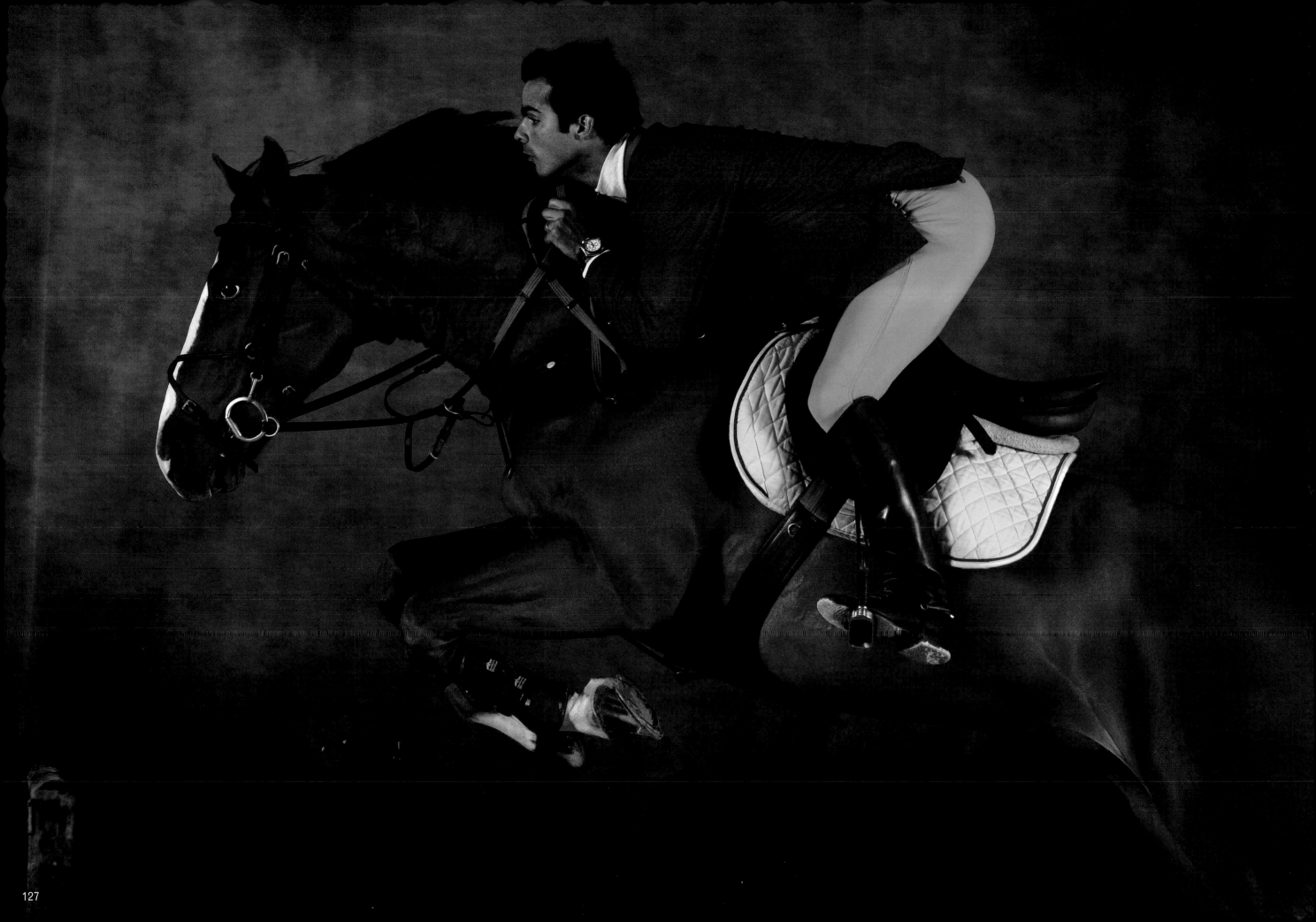

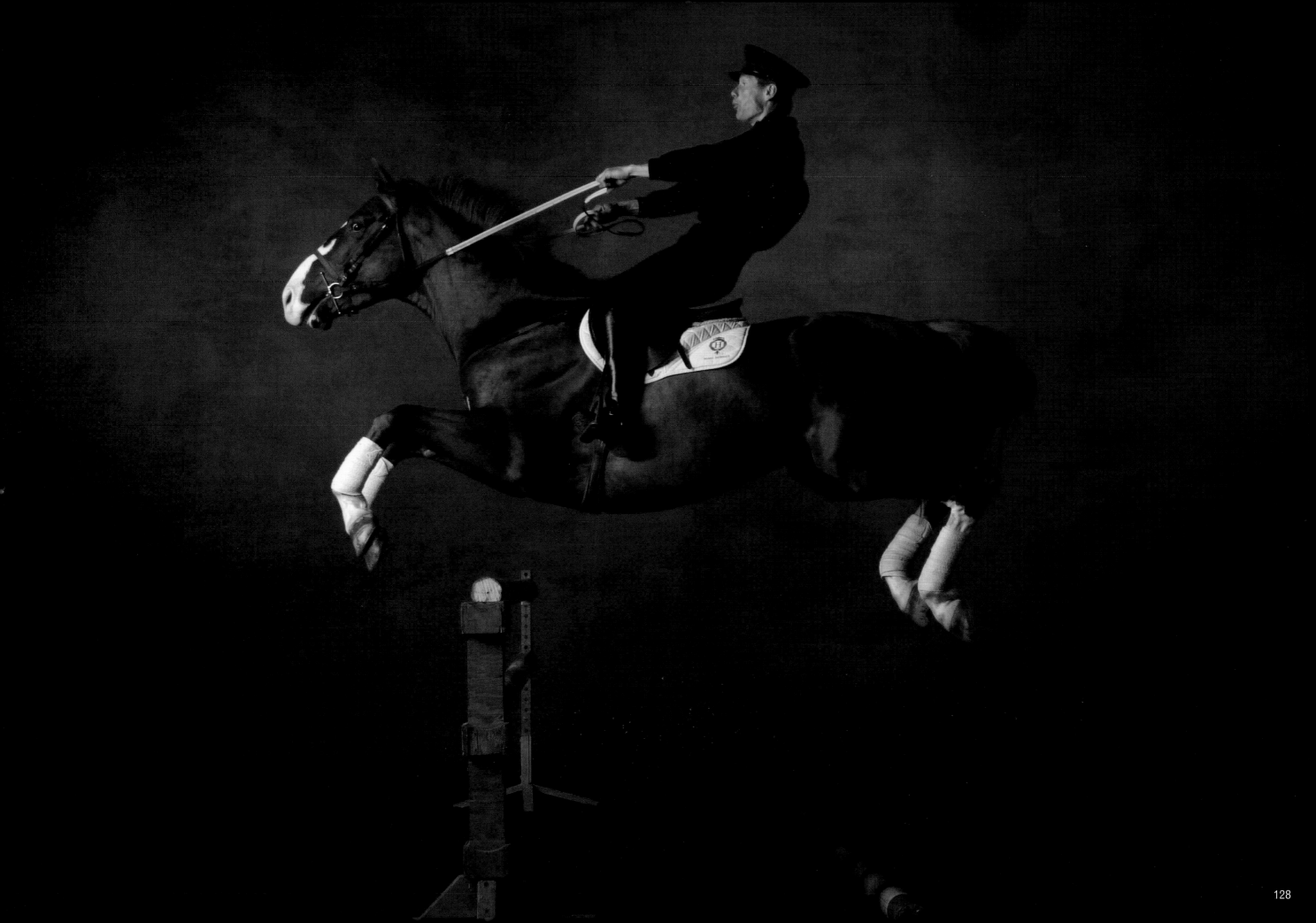

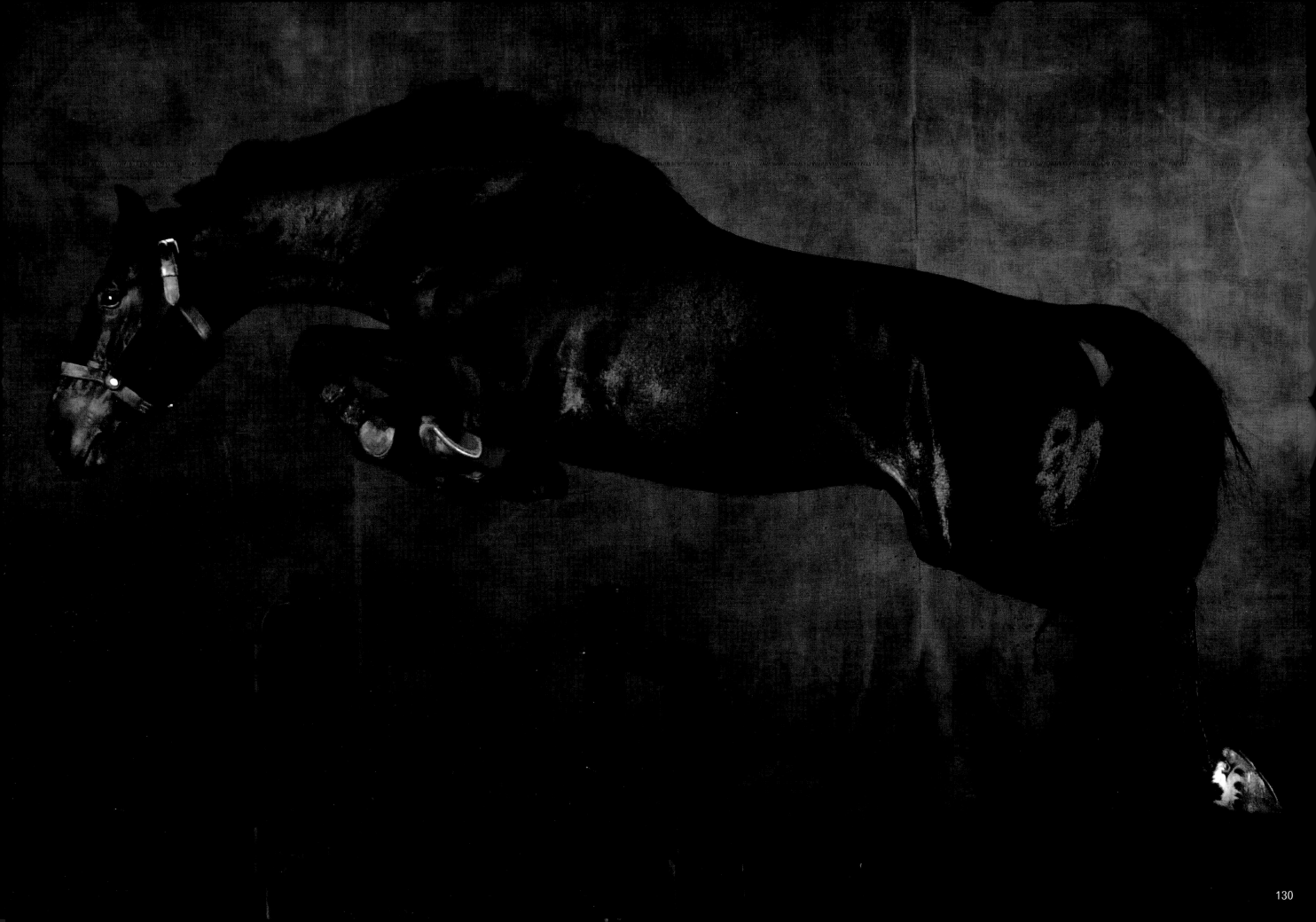

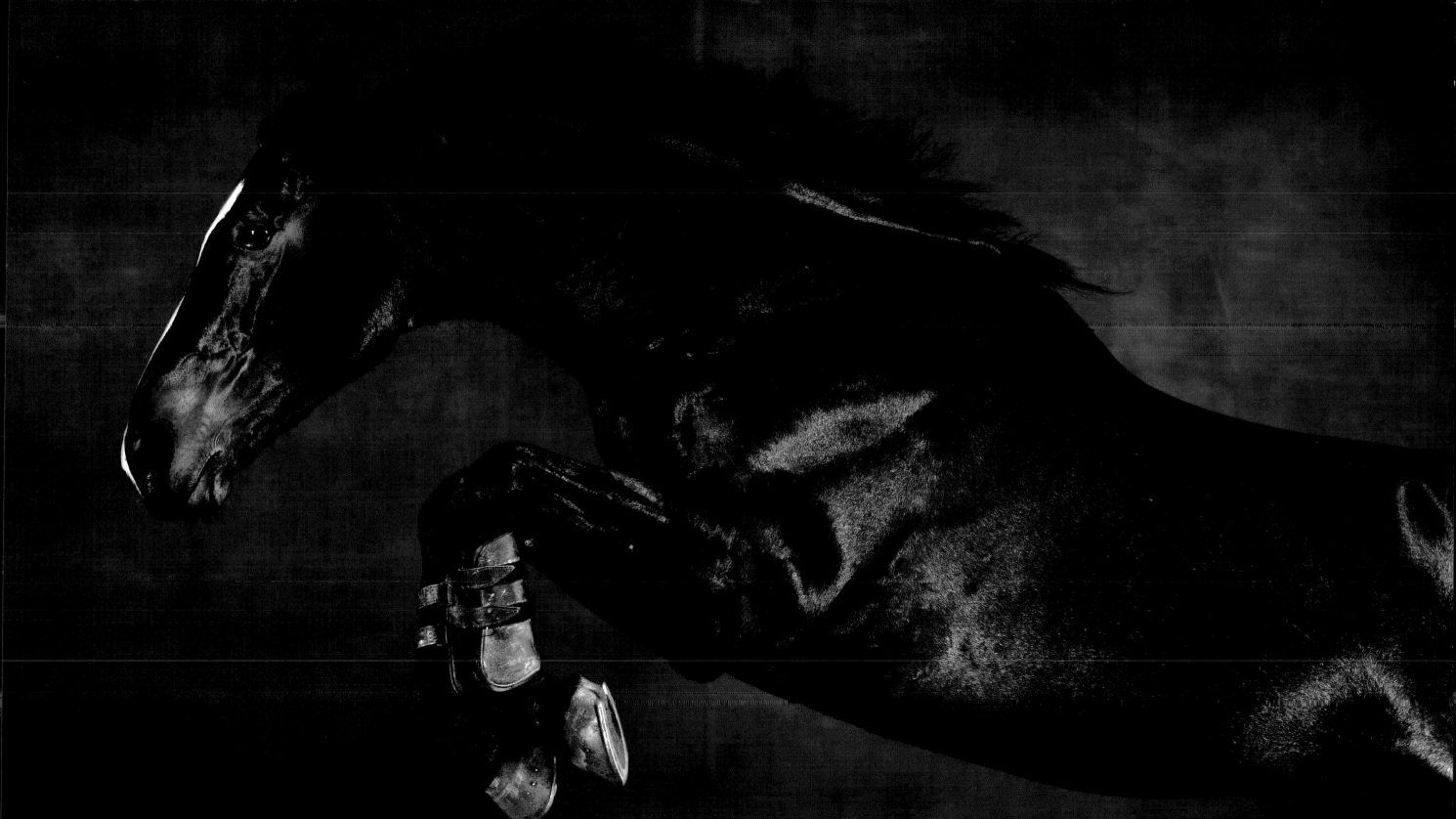

Trotters: France and farther afield

Trot racing is a true passion in France. While breeding gallopers tends to be more of an aristocratic pursuit and remains the preserve of a relatively small number of wealthy horse lovers, trotters are often bred by country dwellers and farmers who own two or three brood mares and who breed, break in, train and race their horses themselves. "There are about 7,000 people who dream of producing a champion, although they are reluctant ever to admit it," wrote an expert in the field, journalist Jean-Pierre Reynaldo in his book *Trotteur, quand tu nous tiens*, (roughly translated as *The Passion Inspired by Trotters*).

Very much a spectator sport, like soccer or cycling, French trotting attracts vast crowds and receives considerable media coverage. Trotting stars sometimes become national heroes, their fame reaching far beyond their already wide circle of fans. You do not have to be a cycling buff to have heard of Lance Armstrong and Bernard Hinault, or a soccer fan to recognize Beckham and Zidane. Similarly, if you live in France, you do not have to read the French racing newspaper *Paris-Turf* every day to be familiar with such evocative names as *Gelinotte, Roquépine, Bellino, Idéal du Gazeau, Lutin d'Isigny* and *Potin d'Amour*, or to have followed *Ourasi*'s glittering career. This French champion won the prestigious Prix

d'Amérique trotting race three years in a row (1986, 1987 and 1988), before he was forced to surrender first place to a mare called *Queila Gédé* in 1989. He streaked to victory again in 1990, winning the race for a record fourth time—a first in the history of this world-famous event.

Ourasi's extraordinary career ended with this record and included fifty-eight wins, earning his owners over three million Euros, a world record for winnings by a trotter. It is no wonder that this kind of money inspires the dreams of ordinary people, particularly because, as Jean-Pierre Reynaldo rightly pointed out, "There's no mystery to breeding trotters: good breeding stock produces good horses, but champions are often produced by sires that are not in quite such demand." In other words, anyone could strike it lucky. As a result, around ten thousand foals are dropped every year in France.

Most of these horses will never see a racecourse in their life because they are allowed to race only after competing in speed trials. In order to qualify for a race they need to perform well in preliminary rounds and prove, for example, that they can trot just over half a mile (1 km) in less than a minute and a half. As a comparison, *Ourasi*'s personal best was 1 minute, 11.5 seconds over a distance of 1 mile (1.6 km)—equivalent to an average speed of 31.24 mph (50.27 km/h).

What becomes of the thousands of horses that fail to make the grade? This is a taboo subject in the trotting world, where those who are generally open and upfront can be rather guarded with or suspicious of outsiders, not unusual for some rural areas.

Although no one is eager to admit it, the truth is that horses that perform below par end up being sent to the slaughterhouse.

Fortunately, a lucky few do escape this fate—they are sold off cheaply and then retrained for equestrian tourism, hunting, riding, even endurance competitions (in which they perform remarkably well). As a result of their rural origins, these fine horses can still travel long distances, although they are not always capable of racing at high speeds.

Usually good-natured, generous and energetic, sturdily built and fairly tall (between 14.3 and 16.3 hh/59–67 in), French trotters can be used both under saddle and in harness although, strangely enough, this twofold ability is rarely exploited in racing.

Other countries, apart from France, organize harness races: the United States, which succeeded in developing an extremely swift trotter, the American Standardbred; Russia, the birthplace of the Orlov trotter, regarded as the progenitor or, at any rate, the benchmark for trotters throughout the world; and lastly Sweden and Italy, where this speciality breed is also well loved. However, France is virtually the only country where horses can compete in trotting races with jockeys. This form of racing is sometimes criticized for being somewhat

farcical. Admittedly, it does lack the stylishness of harness racing, but a visit to the Vincennes racecourse, the world arena for trot racing, soon sets the record straight. Evening race meetings are particularly thrilling. You cannot fail to be gripped by the excitement of the event and the spectacle of such magnificent animals thundering down the course, pulling the light two-wheeled sulky and its gaudily dressed driver behind them, wheels screeching on the black cinder track. For the trotting enthusiast, there are few finer sights.

Established in the mid-nineteenth century, the French trotter is a skillful mix of bloodlines: Anglo-Norman, English Coach Horse (Norfolk trotter), Russian trotter and English Thoroughbred. This breed is now challenging the American trotter for world supremacy.
133. *Insert Gédé*, a six-year-old **French trotter**, owned by Joël Séché, trained by Jean-Luc Bigeon and presented by his stableboy Cyril Buhigné.
134–135. *Kahela de Luc*, a five-year-old **French trotter** mare (by *Boss du Buisson* out of *Saldone*), winner at Vincennes and Enghien at the age of two, driven by Sylvain Devulder on the racetrack of the Grosbois Training Center (Paris region).

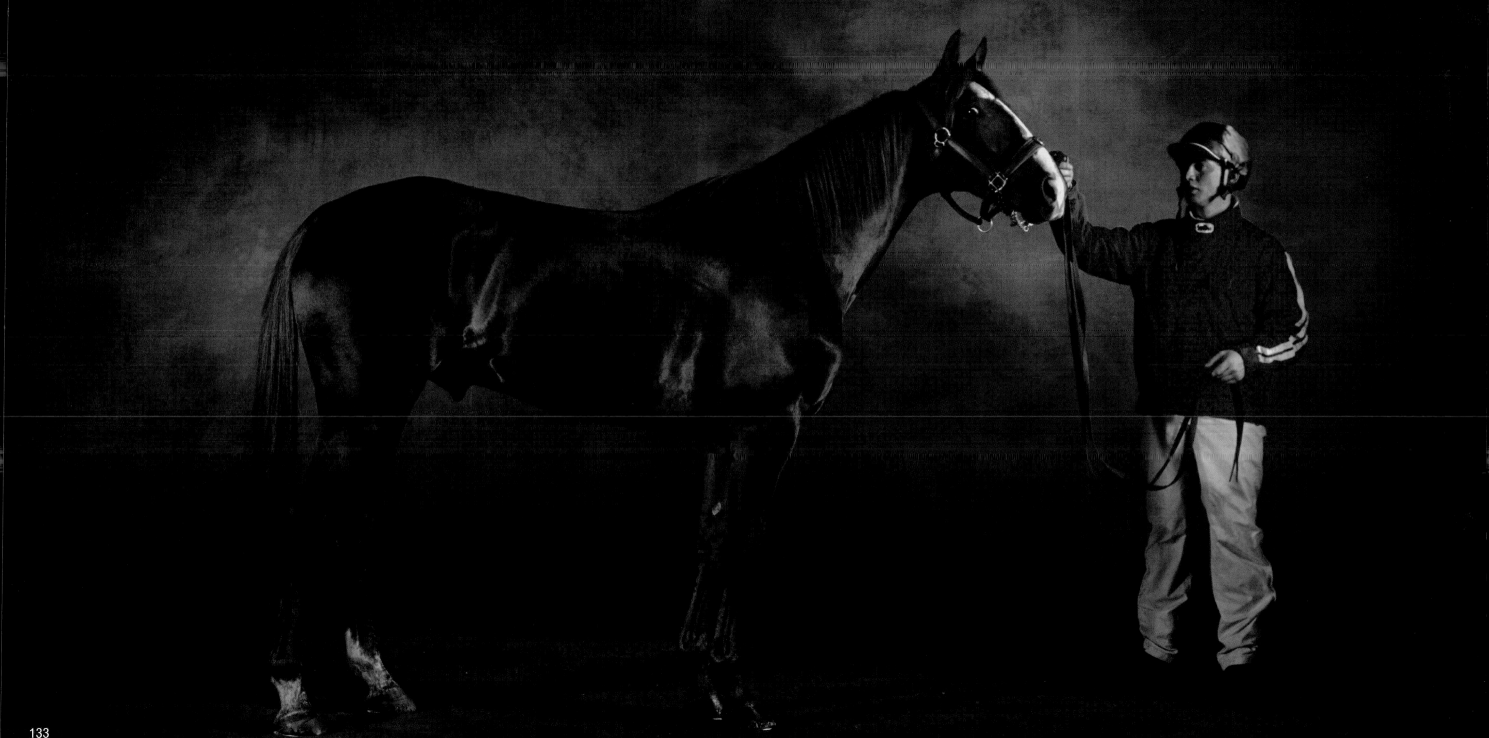

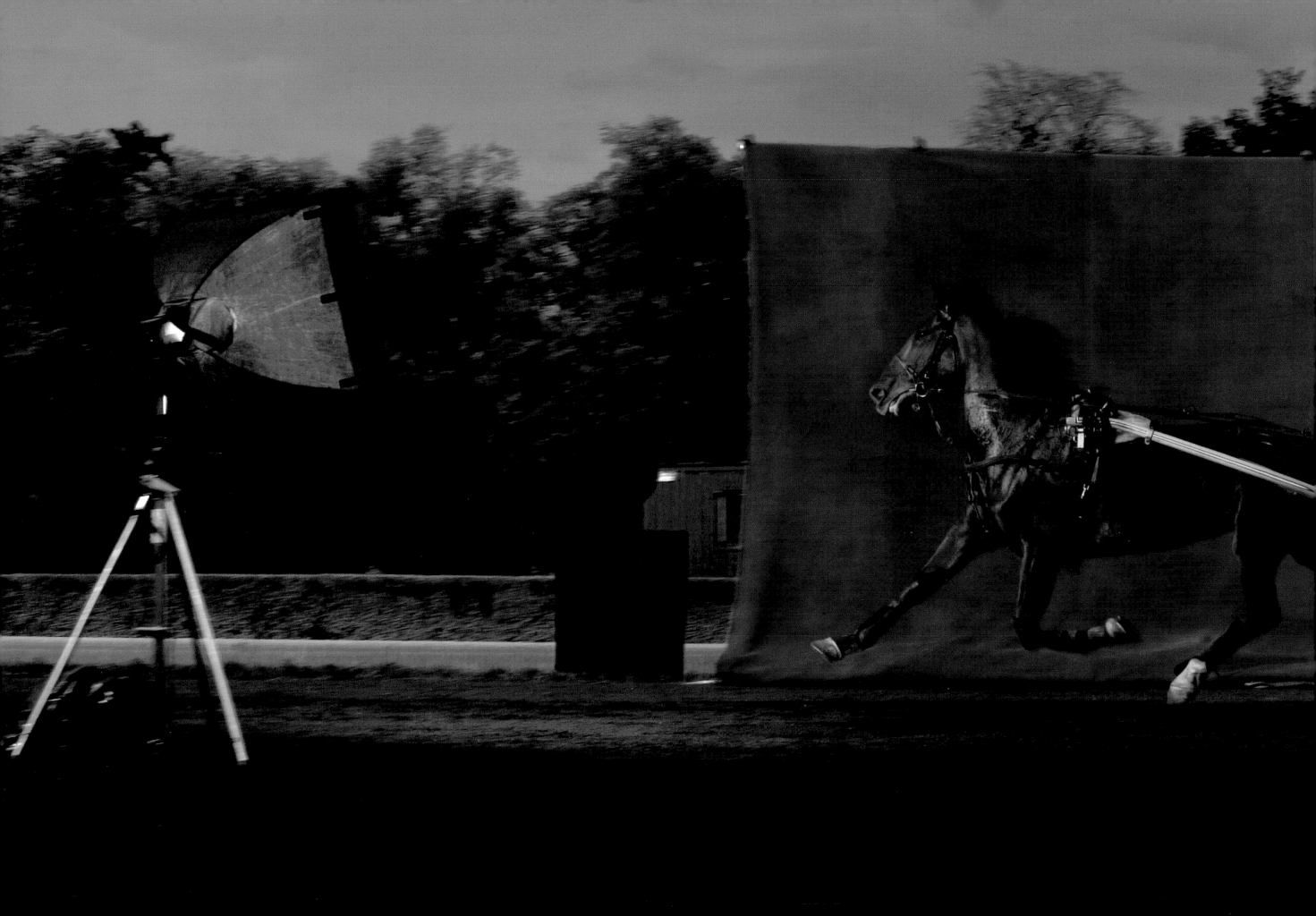

Cob and Friesian: dual-purpose horses

Although the phrase has passed out of current usage to a certain extent, these horses used to be described as "dual-purpose" because they could be either ridden or driven in harness. Not fast enough to be included in the saddle horse category and not heavy enough to be regarded as proper draft horses, they were more likely to be harnessed to light four-wheeled conveyances, or together in teams of two, four or six to pull a stagecoach or carriage. The larger of these horses came to be known as coach horses. This general category of horses was once very widespread, but only a couple of breeds exist today.

Norman Cobs are still bred, albeit in small numbers, in the Saint-Lô region of France. They stand 15.3–16.3 hh (63–67 in), but often weigh a hefty 1,550–1,750 lb (700–800 kg). Breeders use the evocative phrase "close to the ground" to describe this horse, which has a somewhat angular conformation. Although stocky, it differs from "heavy" horses because of its fine musculature, hard legs and elegant gait. This breed has both heart and stamina, which makes it a joy to ride and recalls its Anglo-Norman origins.

The origins of the Friesian breed are more difficult to determine. This horse is now extensively bred far from its birthplace of Friesland (in the Netherlands). As is often the case with horses, it is the successful product of a crossbreeding program that seems to owe more to luck than to judgment. Not surprisingly, the Dutch are keen to trace its origins back to distant indigenous ancestors. However, this horse has clearly been crossed with Oriental stallions in the past and, although it is impossible to say with any real accuracy by how much the breed was improved, it is certain that it contains Barb, Andalusian and Arab blood.

This magnificent horse has great class, with an all-black coat, proud carriage, a thick, flowing mane and feathers partly covering its hooves. It can obviously be ridden, but its beauty, grace and nobility are best observed when it is in harness, which is when it shows the true extent of its generous spirit, energy and enthusiasm.

It is easy to see how this breed has become such a firm favorite, even with people who have little or nothing to do with riding or driving horses. If French children want to adorn their bedroom walls with a poster of a horse, many will choose that of *Zingaro*, the wonderful Friesian horse owned and ridden by the renowned trainer Bartabas, who named his famous equestrian theater after him.

Many people mourned when this magnificent animal died in 1998 on a tour of the United States. Obituaries were published in all the main newspapers and even poets joined the ranks of the mourners: "You, emblem of arrogance/you, roguish colossus who play/the mythological beast/and relish making time stand still/as the world fetes you like an idol," wrote André Velter (in his book *Zingaro suite équestre*, 1998). "You, whose galloping hooves pound the stones/you know that your might impresses/with its silver glints/but you have a tender gaze beneath your forelock/and faith, almost, in the mornings of the world."

137. *Loukoum de Vallière*, a four-year-old **Norman Cob**, presented by his breeder Norbert Coulon, with friends Aurélien Decaen, Jean Quiédeville, Pierre Bihel, Maurice Agnes and Christophe Colard, all breeders themselves.
138. *Koert*, an eleven-year-old **Friesian,** owned by Philippe Harcourt and presented by Ann Zagradsky.
139. Trainer Fritz Deutschenbaut presents his **Friesians**, *Oege*, *Jakob*, *Douwe* and *Marcel*.

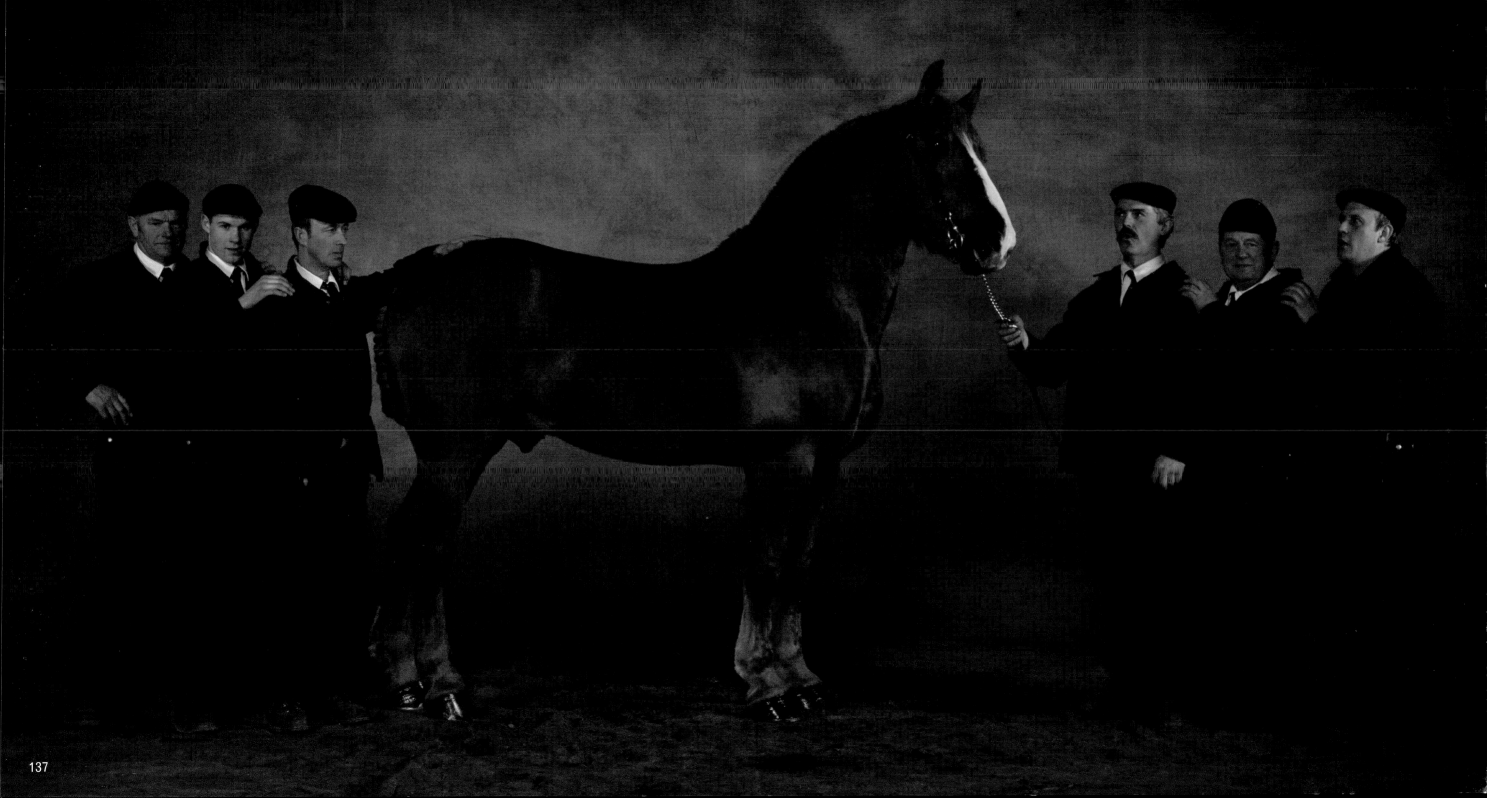

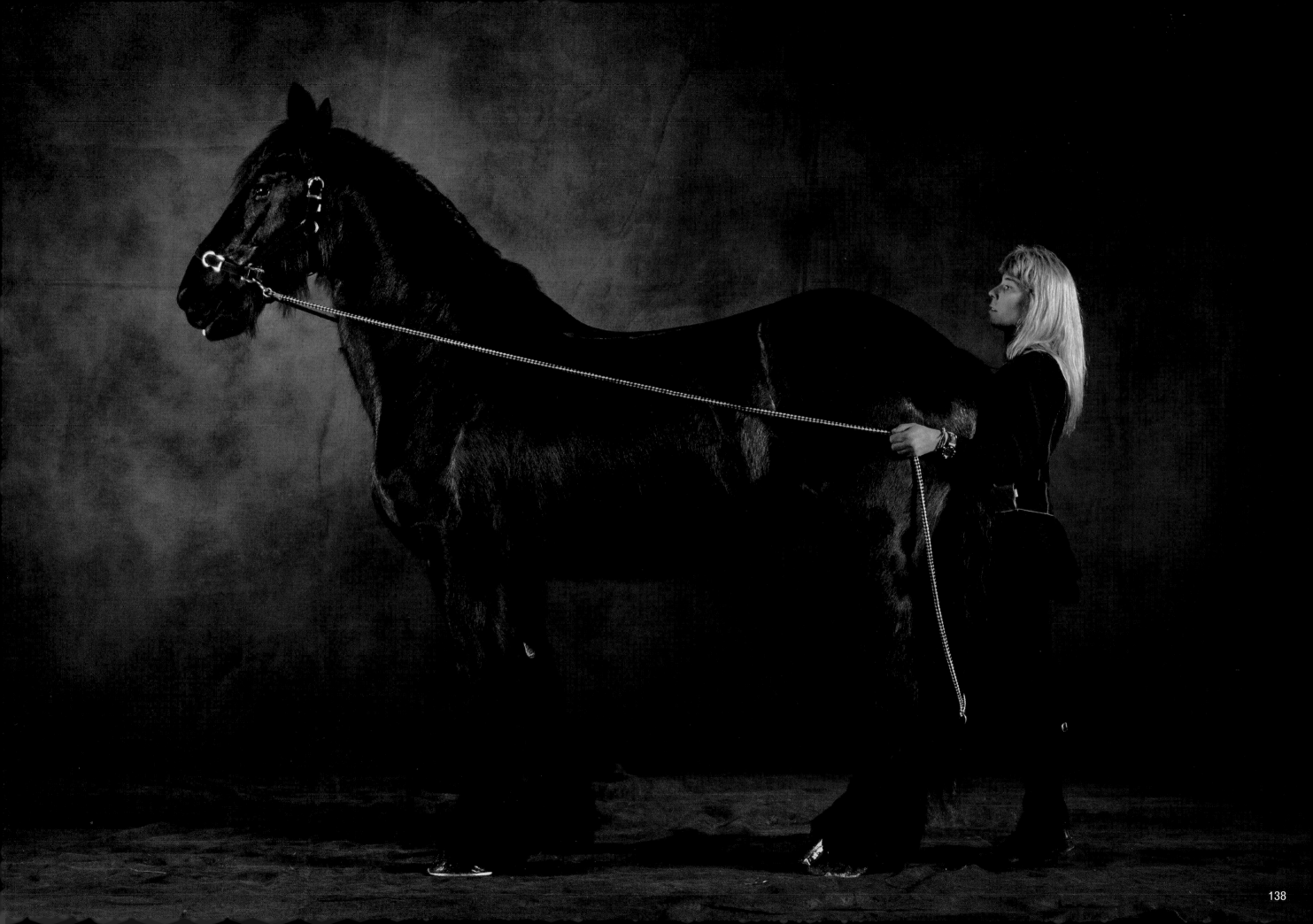

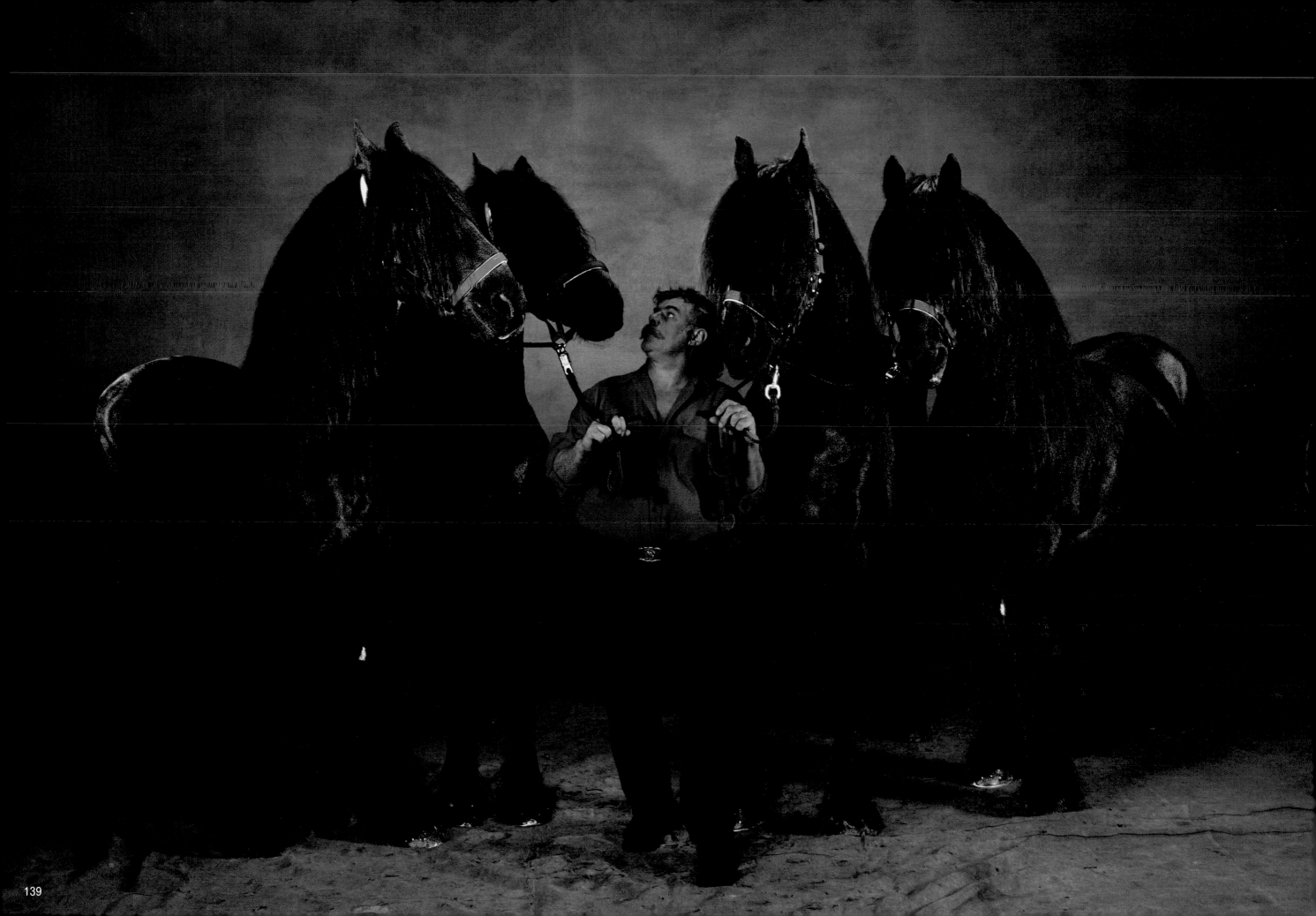

German horses: great sporting breeds

In his most famous novel *The Ogre* (*Le Roi des aulnes*), which won the 1970 Prix Goncourt (the top French literary award), Michel Tournier (b. 1924), a philosopher and scholar, describes "an enormous black gelding, rippling with muscles and with rump and hair as ample as a woman's," on which the hero of the story, Abel Tiffauges, takes riding lessons. One day, his teacher, an old riding master called Pressmar, decides to tell him *the truth* about the horse: "Compare the dynamics of the horse with that of the deer, for example. All the deer's strength is in his shoulders and neck. But all the horse's strength is in his crupper. A horse's shoulders are fine and flat, just as a deer's crupper is thin and tapering. A horse's weapon is his kick, which comes from the crupper; a deer's is his antlers, the force of which comes from the neck. A deer moves by a sort of front-wheel drive; a horse impels himself forward by the motion of his hindquarters. In fact, a horse is a crupper with organs attached in front."

This particular description of the horse, which has become an anthology piece in French literary collections, is a good description of Tiffauges's mount, a Trakehner. In the novel set in 1940 in East Prussia, the horse came from Trakehnen, a stud farm founded two centuries earlier by King Friedrich Wilhelm I (1688–1740) and enlarged by his son Friedrich II (1712–86), better known as Frederick the Great.

Five years after the episode related in Tournier's novel, the Soviets seized control of East Prussia. Fleeing the advance of the Red Army, officials in charge of the royal stud farm managed to take away with them a large number of brood mares during the harsh 1944–45 winter. However, the Russians did not lose all the Trakehners. They managed to salvage some mares and stallions and continued breeding for themselves, developing the breed in various stud farms scattered about their vast territory. In fact, in 1970 when Elena Petushkova became the world dressage champion and Olympic gold medalist, Petushkova was riding *Pepel*, a Trakehner as black as the coal mined in the Urals.

The original stud farm no longer exists and the Trakehner is now bred in many places. This, coupled with the fact that over the past century it has occasionally been necessary to rebuild the breed by injecting large doses of new blood (particularly English and Arab), has led the Germans to regard the Trakehner as an international breed—like the English Thoroughbred, the purebred Arab and the trotter (mainly of American origin), breeds that are all widely bred in Germany.

However, the German breeders owe their sterling reputation less to these "federal" breeds and more to the diversity and quality of their "regional" breeds. Unlike the well-intentioned French, who, just after World War II, combined local types of horse in a single major breed (French saddle horse), the Germans promoted the development of breeds peculiar to each of the *Länder* in the federal republic. This breeding policy has produced some remarkable results. In half a century, Germany has become one of the foremost producers of top sporting horses in the world and the leading producer in Europe.

A brief overview of the breeds, moving from north to south, includes Holstein, Mecklenburg, Oldenburg, Hanoverian, Westphalian, Rhineland Heavy Draft, Hessian, Württemberg and Bavarian Warmblood. The Hanoverian, for example, is the result of judicious crossbreeding (Holstein + English Thoroughbred + Trakehner, in particular) and a rigorous, persistent process of selection. Standing at 16.1–17.1 hh (65–69 in), the Hanoverian is a powerful jumper (cf. *Deister* who, ridden by Paul Schockemöhle, was voted "Horse of the Century") as well as a first-class dressage horse. Not too highly strung, the breed is elegant rather than dazzling, reflecting contemporary requirements.

The Holstein, on the other hand, is a sturdy breed from northwest Germany and was an acclaimed "dual-purpose" horse for many years before becoming the excellent sporting horse it is today. The breed was then lightened by the addition of foreign blood (once again English Thoroughbred) to meet new market demands. *Corlandus*, which was ridden in dressage by the French-German rider Margit Otto-Crépin, is one of the more famous examples of this breed.

141. The **Russian Trakehner,** *Khan Baty*, a seven-year-old stallion, bred in the Tver Region and presented by his owner Anatoly Inozemtsev.

142. The **Hanoverian** *Wolke VII*, a four-year-old mare, owned by Diedrich Meyer and presented by Anett Kumpe.

143. Although the **Rhineland Heavy Draft** *Valido's Boy* is fourteen years old, he still has plenty of life.

144. The **Holstein** *Loutano*, a fifteen-year-old stallion, presented by Gilles Marnay at the Haras du Pin Stud Farm in France, but owned by the Holstein breeders' association in the Netherlands.

145. The **Mecklenburg** *Greif*, a four-year-old stallion, presented by Christian Heineking, an employee at the state stud of Redefin (Germany).

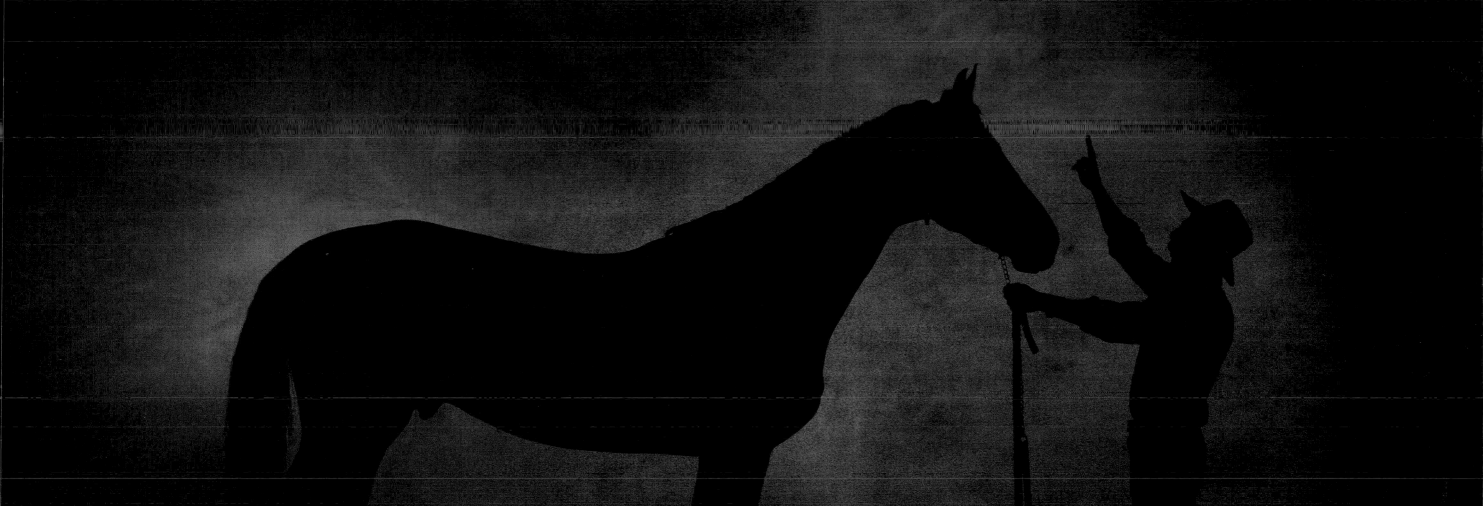

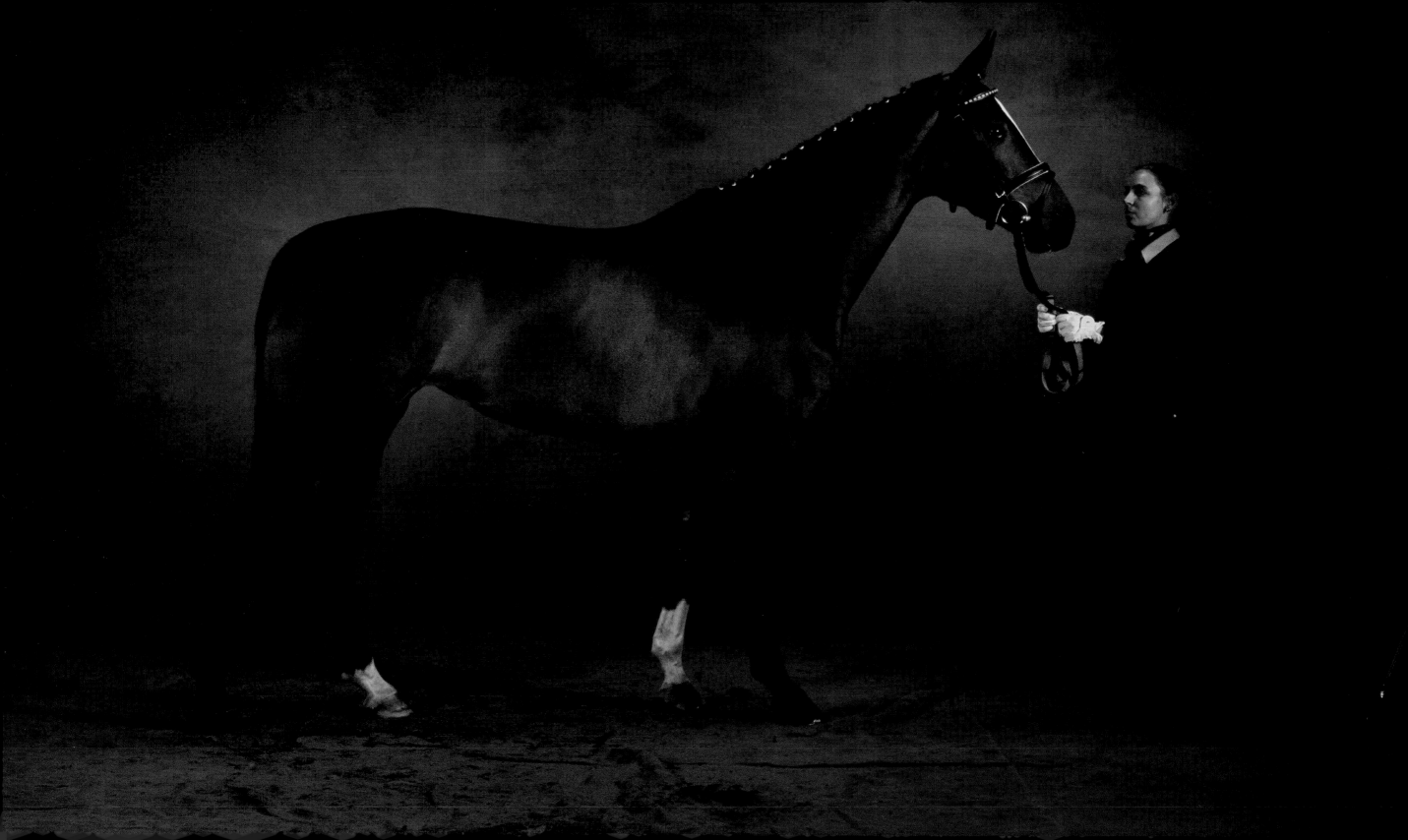

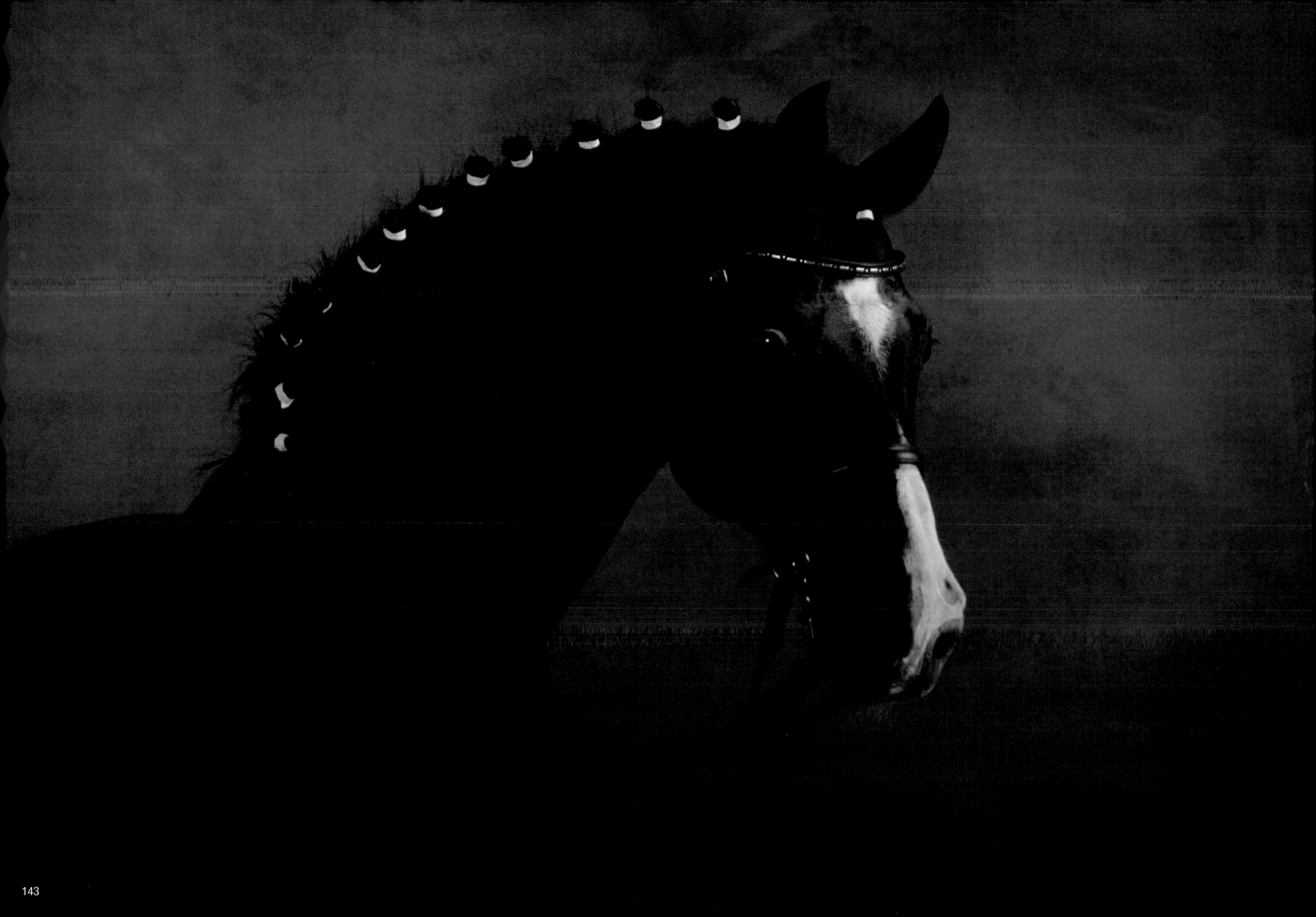

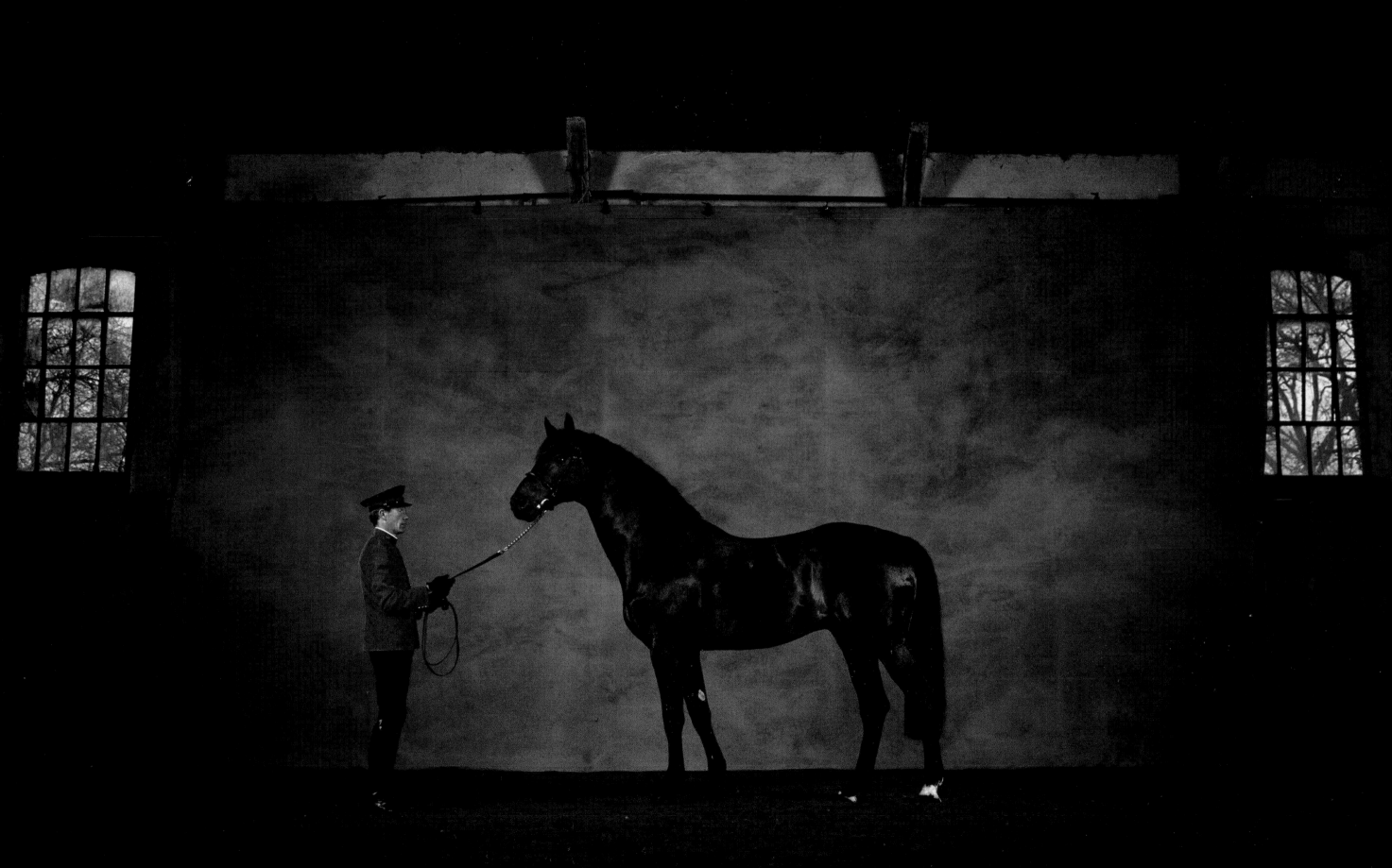

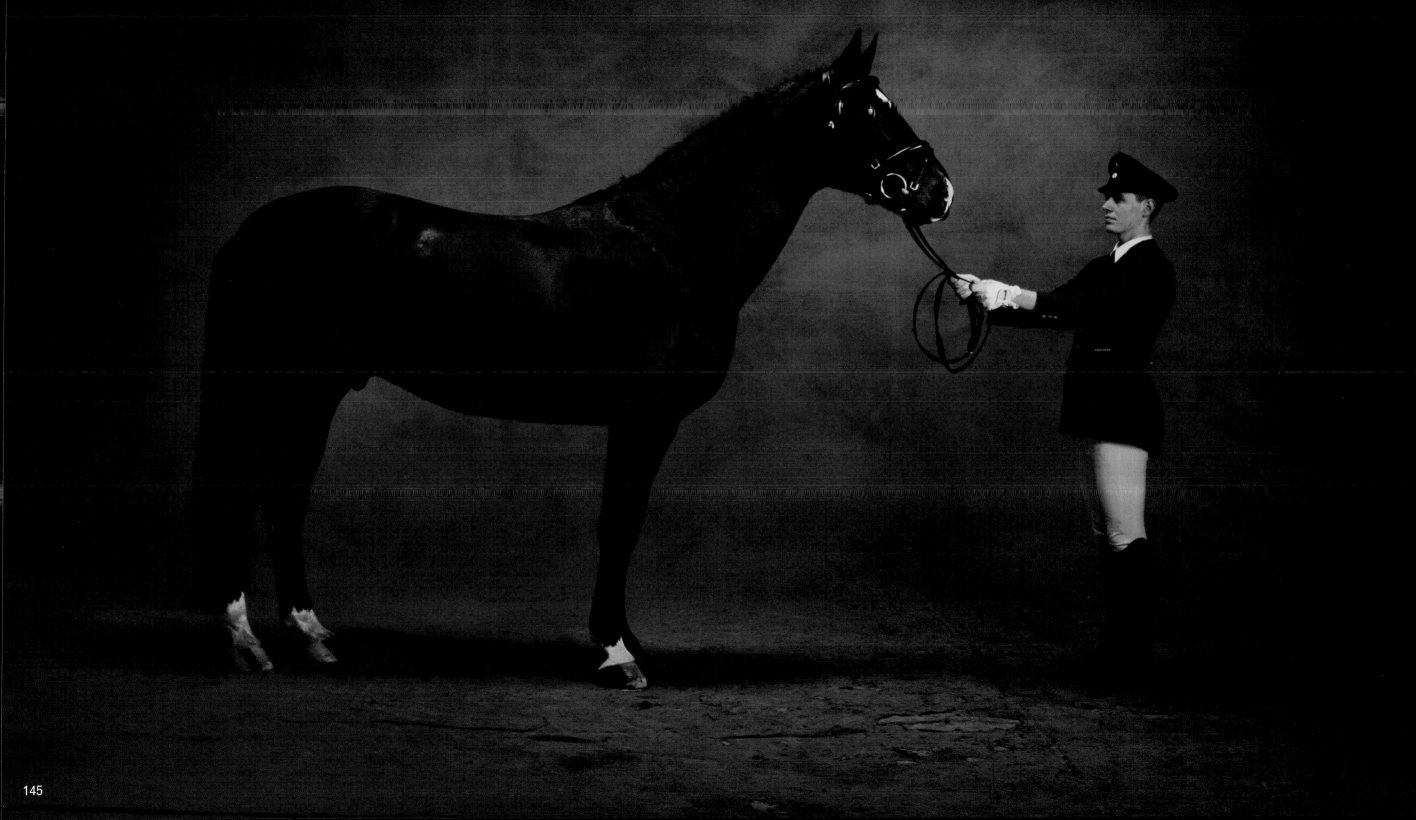

Italy: the art of horse riding

Horse lovers owe a deep debt of gratitude to Italy. However, it is too often forgotten that this country has given Europe several magnificent breeds of horses, as well as the first riding manual.

The first book on horsemanship to appear in a European language was written in 1245 by Giordano Ruffo, the Calabrian stable master at the court of Frederick II (1194–1250), Holy Roman emperor, king of Germany and king of Sicily. Although this was not a proper manual of horsemanship (it was nearly two centuries before the Portuguese king, Dom Duarte, published a work worthy of this name, in 1434), it was an authentic veterinary treatise, which—according to French scholar Mennessier de la Lance—tackled "breeding, foaling, schooling, bitting, shoeing, outward appearance and ailments with remedies for each one" (in his *Essai de bibliographie hippique*, 1915–21).

It was in the sixteenth century that Italy laid down the foundations of horse riding, later known as "French equitation" because it flourished in France under the reign of Louis XIV. Nevertheless, the origins of horse riding can be traced back to Naples, Rome and Ferrara, where academies dedicated to the study of the equestrian arts proliferated during the Renaissance. One of the most famous of these institutions was Federico Grisone's academy, which taught dressage movements such as *piaffe*, *passage* and most of the "airs above the ground" that form what is now known as *haute école: courbette, croupade, ballotade, pesade* and *capriole*.

Grisone's treatise *Gli Ordini di cavalcare*, published in 1550, was translated into French in 1559. It also appears to have been translated into English, or at least adapted and abridged, by riding master Thomas Blundeville in 1560 as *The Arte of Ryding and Breakinge Great Horses*. In Blundeville's book, he set out some excellent principles that still apply to riders today. For example, he said that it was vital to maintain gentle but firm pressure on the mouth to ensure that the horse was well-behaved and light on its feet. However, he also suggested some retaliatory measures to deal with stubborn horses that would now result in the intervention of the animal protection agencies. Some punishments were quite ordinary (shouting insults and hitting the animal with a stick) while others were much more inventive, entailing the use of burning straw, a cat tied by its back to a long pole and shaken under the horse's belly, or sharp spikes (sometimes a hedgehog) placed under the tail. Although such drastic measures may be shocking today, they were fairly standard practice at the time.

Cesare Fiaschi, founder of a rival academy in Ferrara, held views slightly different from those advanced by the Neapolitan master. He thought unresponsive horses should be treated "harshly and roughly," but overenthusiastic horses should be ridden "in a friendly, gentle manner." This was definitely a step in the right direction.

Things improved even further with Giambattista Pignatelli. A student of Fiaschi's who was to become a famous riding master himself, he commented that riders should be "sparing with their blows and lavish with their caresses," according to the French riding instructor Antoine de Pluvinel (1555–1620). After becoming the riding master of the (future) King Louis XIII (1601–43), Pluvinel wrote a treatise called *L'Instruction du roy en l'exercice de monter à cheval*, which is regarded as one of the seminal books of the renowned French school of equitation and which, particularly after François de La Guérinière (1688–1751), acquired international acclaim.

Three centuries after giving rise to the *haute école* style of riding, the Italians continued their pioneering work, revolutionizing the equestrian world. It is probably not an exaggeration to say that one Italian, Federico Caprilli (1868–1907), invented competitive riding as it is practiced today. He was the first to come up with the idea of jumping an obstacle not with the shoulders inclined backwards, one hand on the pommel and the other in the air, but, on the contrary, with shortened stirrups, leaning forwards over the neck. This is such a natural position that it is hard to see why it was not adopted until the early twentieth century.

Italy has also produced some exceptional horses. The Neapolitan tops the list and merits a short description, even though the breed became extinct long ago. Giuseppe Maresca, a dedicated breeder, is hoping to be able to rebuild it. This remarkable horse traces its origins back to the famous episode in Hannibal's Italian campaign that has become known as the "Delights of Capua" (216–215 B.C.). The Carthaginian leader was eager to make a stop in this picturesque town in Campania (just north of Naples), as his army needed to rest before attacking Rome, and he wanted to enjoy the many pleasures on offer; he also sought fresh horses for his cavalry. Even then, Capua was famous for its horses, which were of Etruscan origin. These horses were probably crossed with the Punic horses (in other words, Barbs) that had been imported by the Carthaginians. Whatever the case, when Charles of Anjou (1285–1325) seized Naples almost fifteen centuries later at the instigation of the pope and became King Charles I, he was staggered by the great Oriental beauty of the horses he found there.

The Angevin kings were replaced by the Aragon rulers, who succeeded to the throne of Naples in the fifteenth century. The Iberian horses they brought with them were crossed with local horses to produce the Neapolitan breed. Salomon de la Broue, who, like Pluvinel, came to Naples to learn the "new" art of equitation, wrote that the city produced horses that were "perfect in beauty and gentleness."

This superb breed has not become completely extinct; it continues to live on through the Lipizzaner, the star of the famous Spanish Riding School in Vienna. With a special talent for performing pirouettes and other acrobatic movements required by the Austrian riding masters, the Lipizzaner are all descended from six stallions, two of which—*Neapolitano* and *Conversano*—were Neapolitans.

Twentieth-century Italy has remained a great equestrian nation with many breeds of racing, sporting and draft horses. Breeds of leisure horse include the Salerno, the Maremmana, a hardy saddle horse native to Tuscany with a great deal of stamina, and the Murgese, a vigorous, sturdy and good-tempered saddle horse native to Puglia.

147. *Nottingham*, an eight-year-old **Murgese** stallion, owned by the forest rangers and presented by his rider Giuseppe d'Onghia.

148. *U Rondinella*, a fourteen-year-old **Maremmana** mare, presented by her owner Stefano Meattini.

149. *Zorro*, a thirteen-year-old **Maremmana** stallion, presented by his owner Miriano Manciati.

150, 151. The nineteen-year-old **Lippizan** stallion *Siglavy Alba 56* (by *Siglavy III* out of *Alba 31*), owned by Maryse Flauder, from Gazeran.

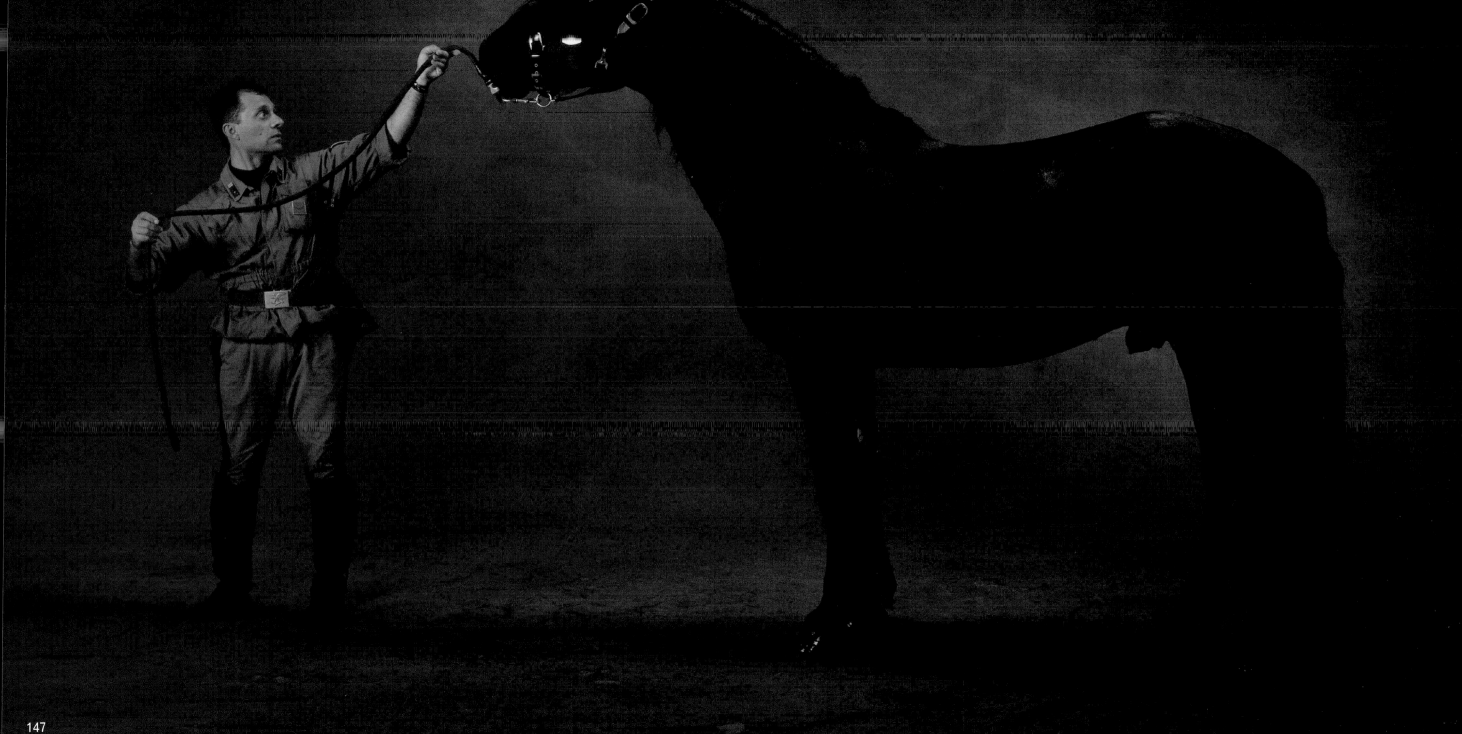

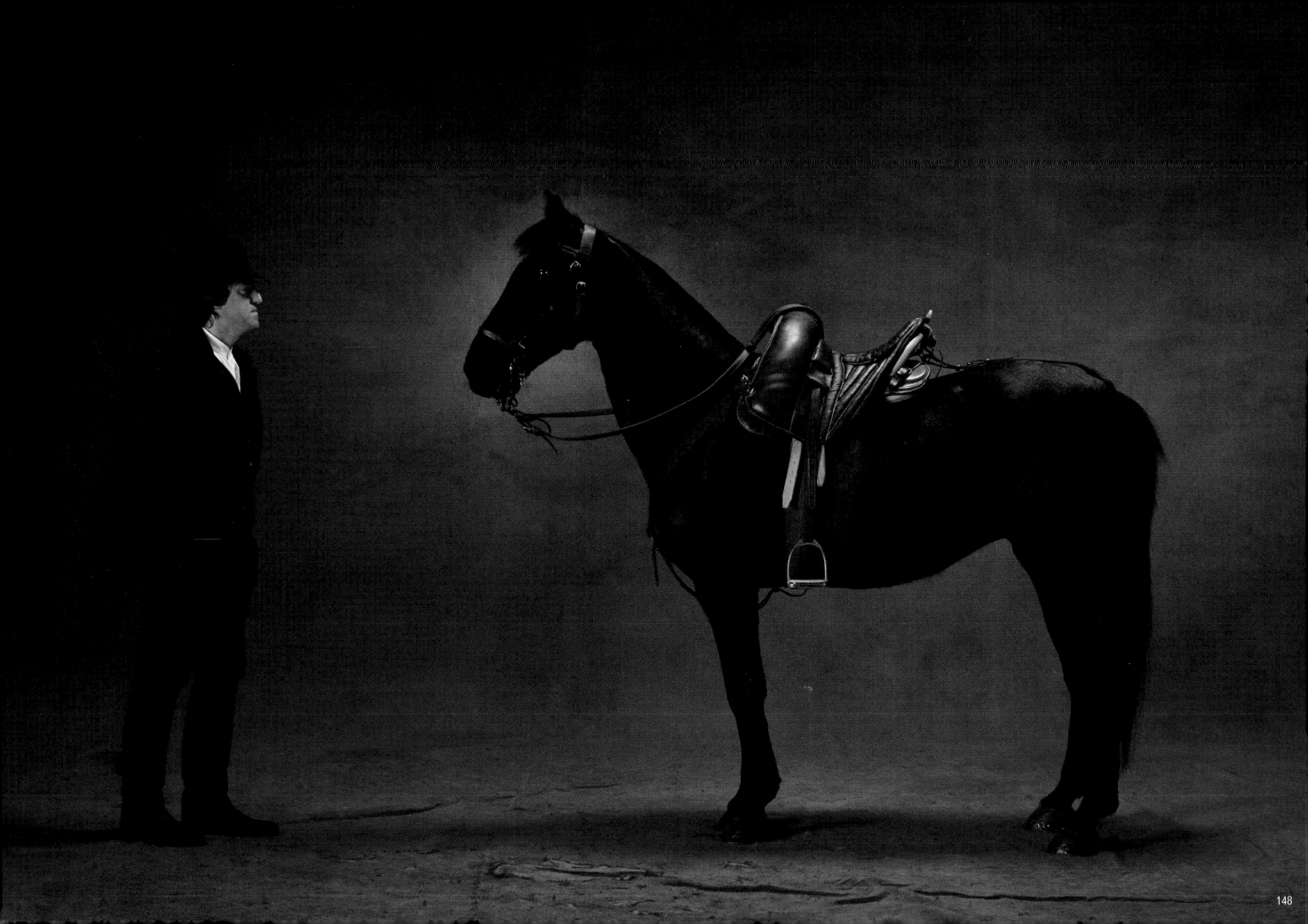

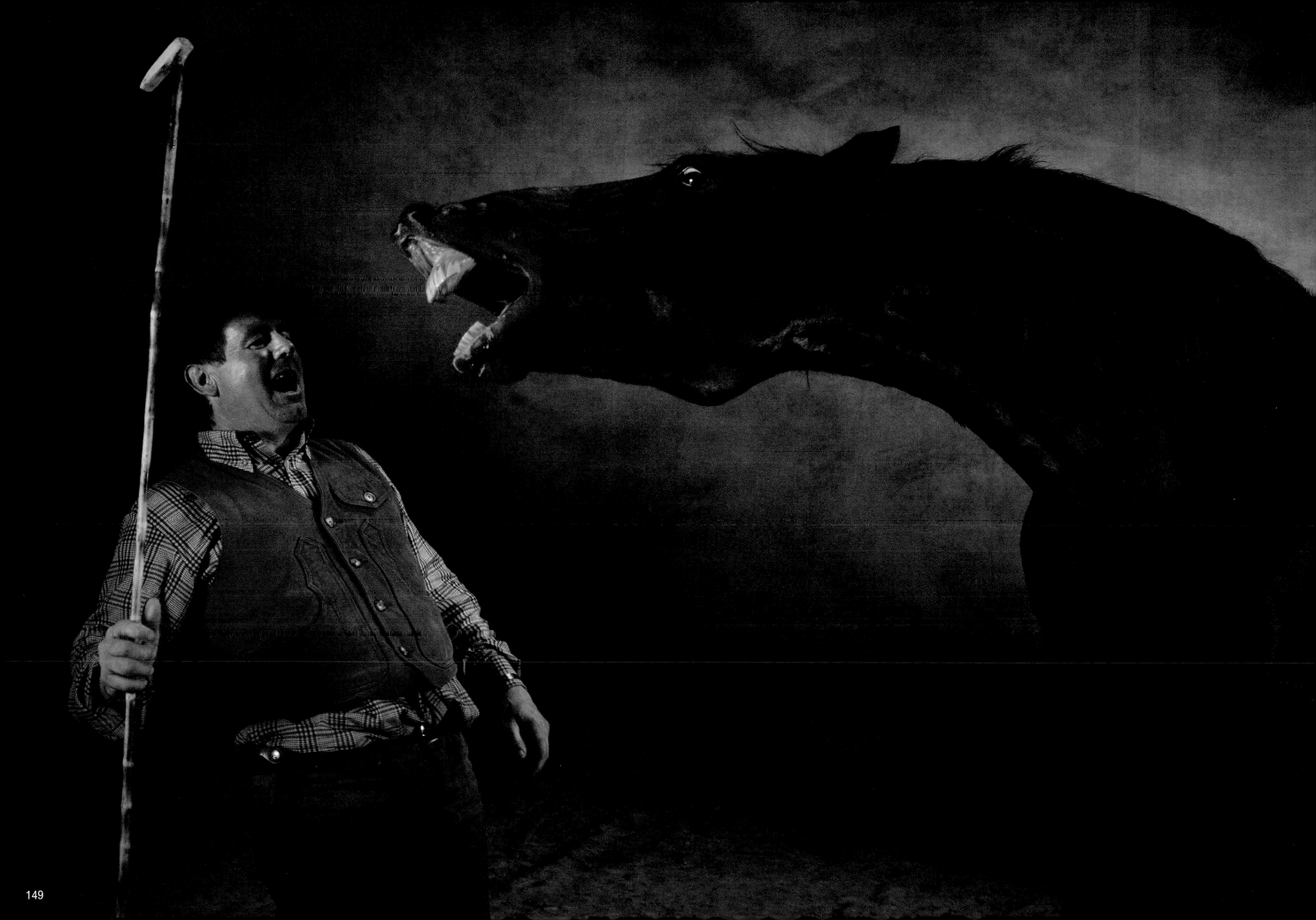

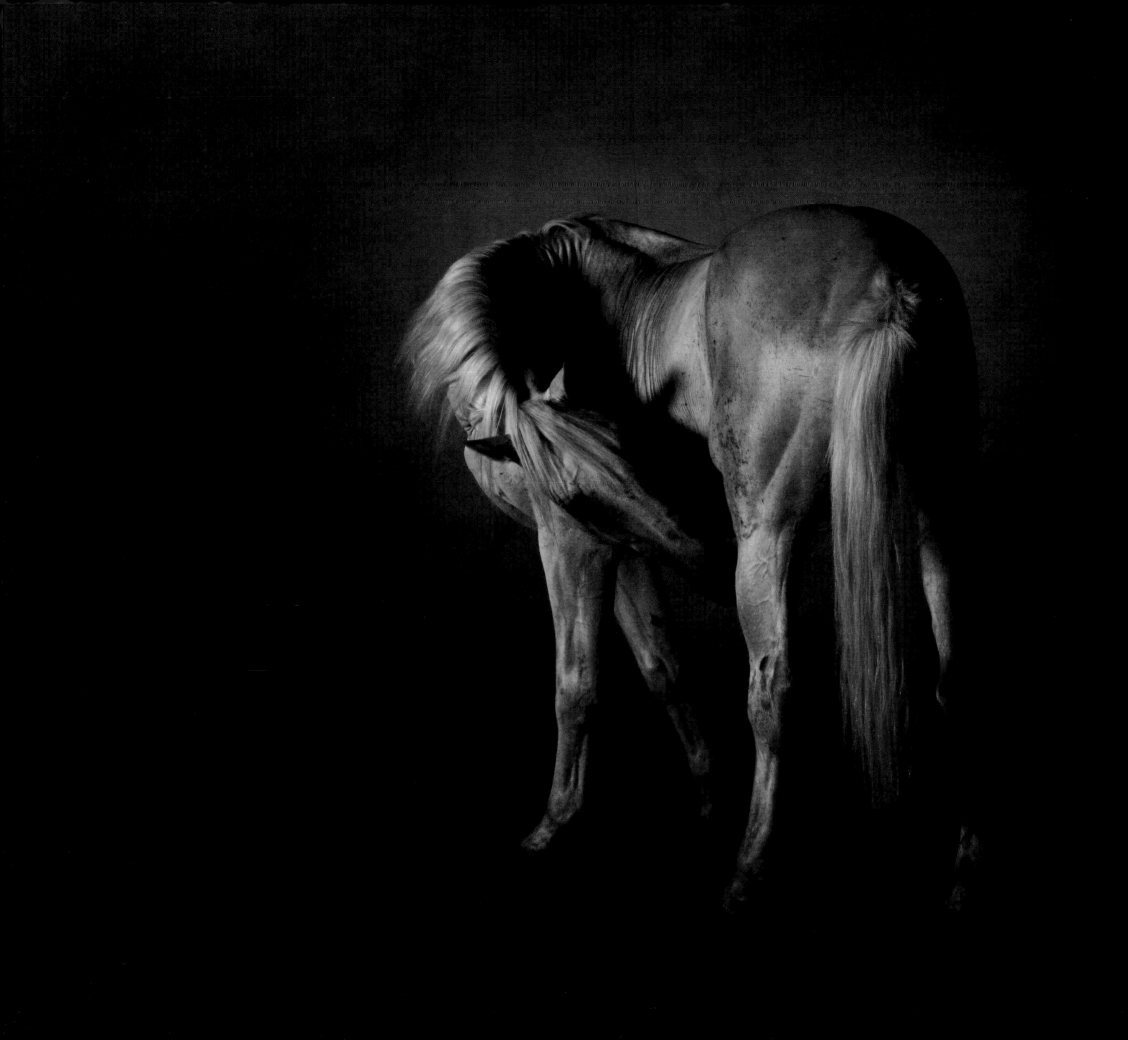

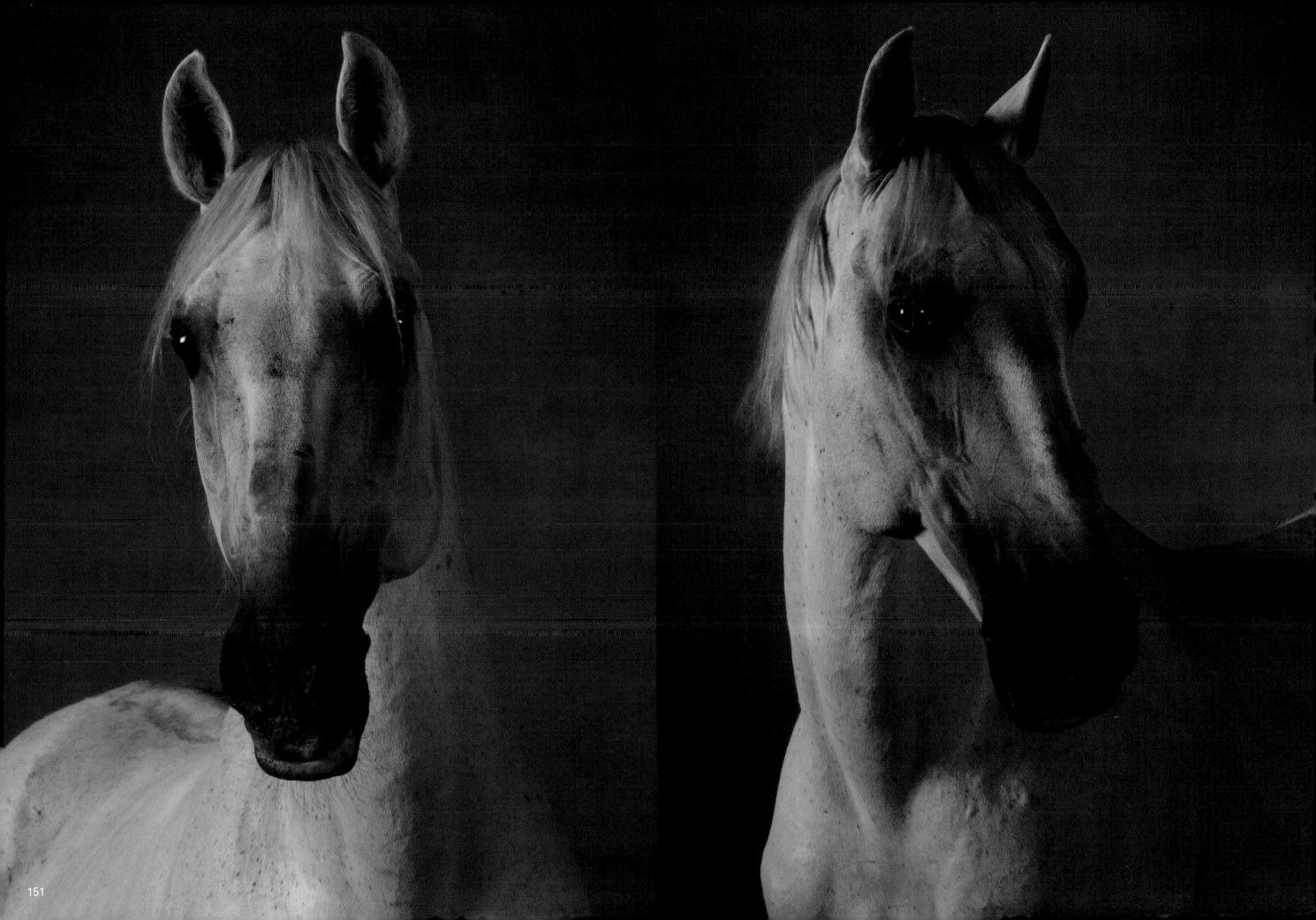

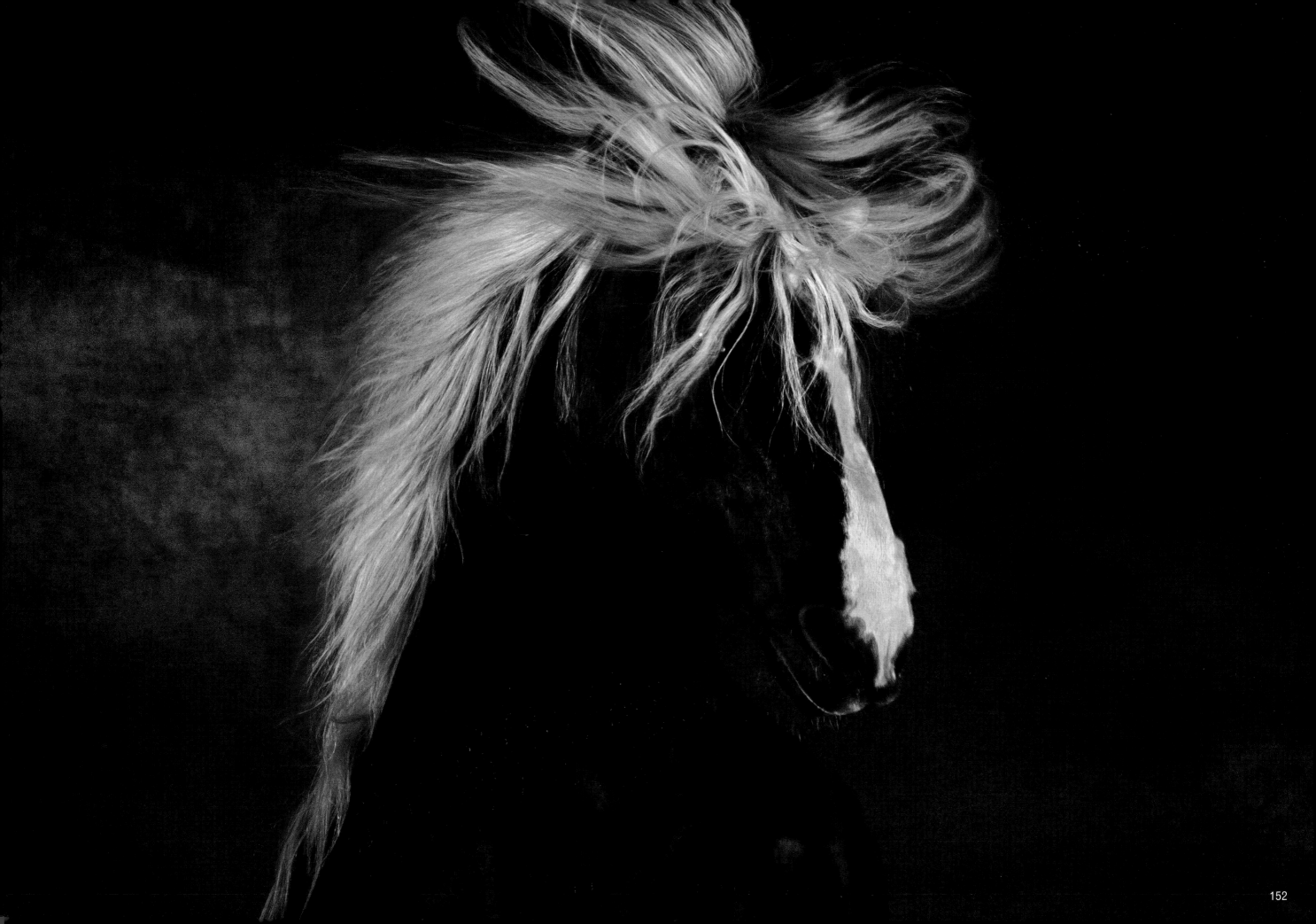

Great horses: treasures of the past

to get on your high horse is an expression commonly used to refer to someone behaving in an arrogant or superior manner, but in fact its origins are military. In the Middle Ages, no one could go to war without a "great horse." Those massive horses were capable of carrying the enormous weight of the caparisons as well as the rider, who was also heavily armor-clad—a combined load in excess of 220 lb (100 kg). In order to avoid exhausting the horses before they were taken into battle, their heavy breastplates were fitted only at the last moment and they were not mounted until it was time to fight. These chargers were called destriers because they were led to the battlefield unsaddled and unmounted, their reins held on the right (or dexter) side of the knight or squire. The noblemen who rode horses were called chevaliers or cavaliers after the French word for "horse" (*cheval*), while the young men of gentle birth who attended on the knights and carried their shields (which were often decorated with their coats of arms or escutcheons) were called esquires.

For centuries, man has fashioned the horse according to his needs, enhancing qualities and developing breeds for specific purposes. The commonly held belief is that, after thousands of years spent regarding the horse simply as a source of food, man finally decided to domesticate it in order to take advantage of its speed as a mount. However, archaeological research reveals that domestication may have resulted from man's realization of the horse's strength. The

earliest known evidence of man's use of the horse indicates that these magnificent animals were used in harness before they were ever ridden: "The earliest cart with four wheels known to have existed was in Ur, in 3500 B.C.," writes French anthropologist Jean-Pierre Digard (in *Le Cheval, force de l'homme*, 1994 and 2002), "and although it was probably devised for oxen, it may then have been adapted for dziggetais (Mongolian wild asses) and donkeys by the Sumerians." And subsequently for horses, enabling them to begin a successful career as draft animals, employment that began to founder only with the fairly recent advent of mechanization.

Although the first known horse-drawn vehicles originated in the Orient (the Hittites, Egyptians, Aryans and "Sea Peoples"), it was in the West that the most effort was made to transform and "improve" horses. The general idea was to make them broader and bigger, increasing their body weight without sapping their strength so that they could pull increasingly heavy loads. This tentative research, which involved continual cross-breeding and zoological experimentation, bore fruit during the mid-nineteenth century, at a time when agricultural, industrial and transport revolutions were radically changing the face of Europe.

The term "heavy breeds" is indicative of this change in approach. There was once such a wide variety of great horses that they could be classified by speciality. Horses small enough to be ridden were called army horses. Horses bred to be equipped with a packsaddle were called packhorses, while those destined to pull light carriages were called coach, carriage or shaft horses (because they were

harnessed between two shafts). A distinction was made between heavy and light draft horses. As one type of horsepower took over from the other with the appearance of motorized vehicles, these terms became less precise. People began to refer loosely to "work" horses, "utilitarian" horses, "farm" horses, "rustic" horses and, finally, "heavy" horses.

Immediately after the invention of the internal combustion engine, men turned their backs ungratefully on their former constant companions, and horses were considered fit only for slaughter. Fortunately, many horse lovers are now trying to find alternative methods of employing them that will ensure their protection. Organizations such as Traits de Génie, a French association dedicated to the promotion and protection of draft horses, are to be congratulated for their fine work. The ILPH (International League for the Protection of Horses) is the welfare branch of the FEI (International Equestrian Federation) and also does much to further the cause.

152. This horse of rustic origins (probably **Comtois**) is now a stylish entertainer. Nine-year-old *Felous* has been taught *haute-école* airs by his owner Arnaud Gilette, proving that a "heavy" horse can be nimble on his feet.

If the great "heavy horses" were man-made monuments of bricks and mortar, they would be towering cathedrals or impregnable fortresses. Over the centuries they have been bred and crossbred to meet our various needs—war, farming, transport, industry—but have now ceased to be as useful as they once were. Does this mean that they should be condemned to disappear? Are they now in danger of fading into neglect like the monuments of the past? If so, we should do everything in our power to save them as they are as much a part of our heritage as our great buildings.

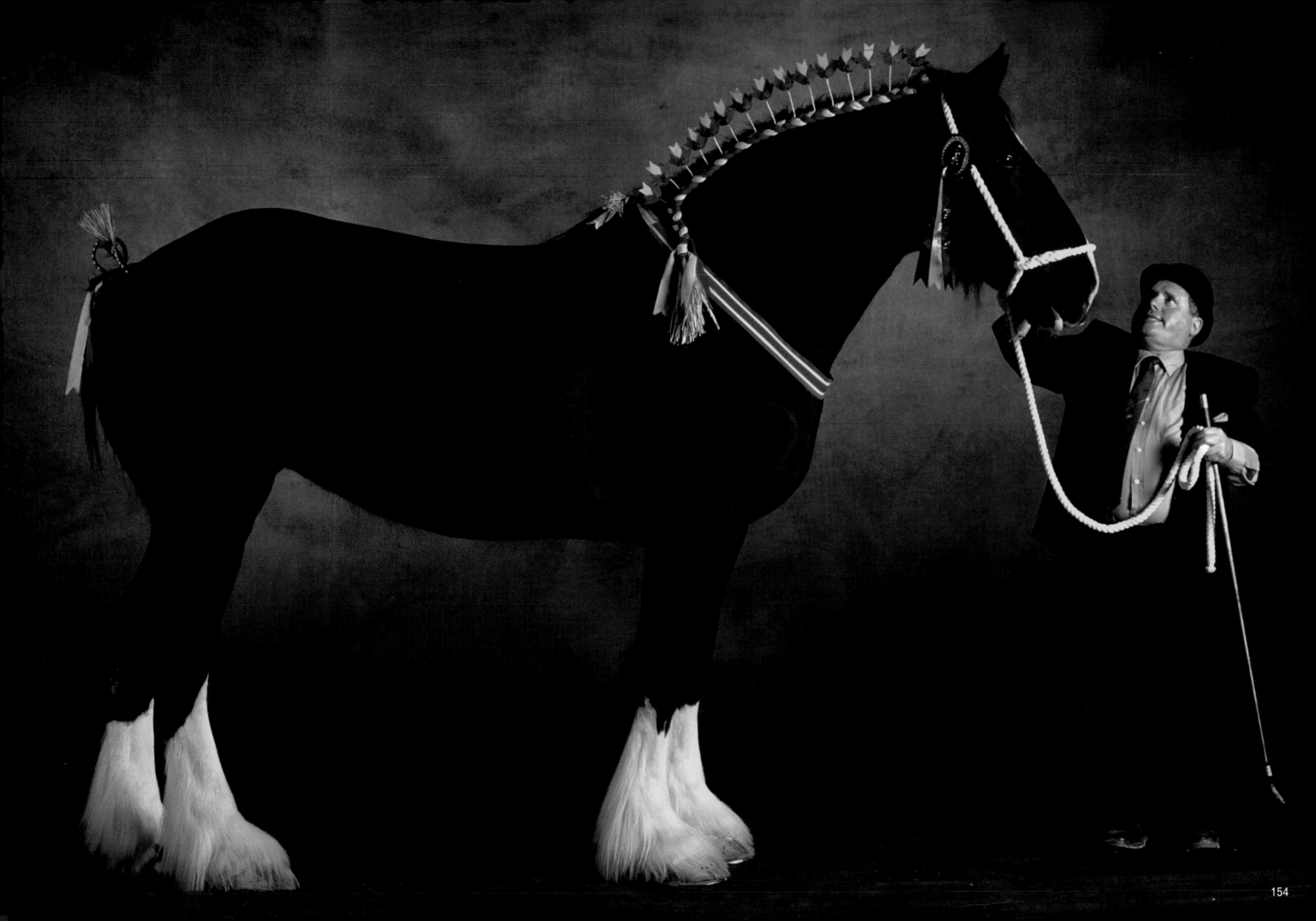

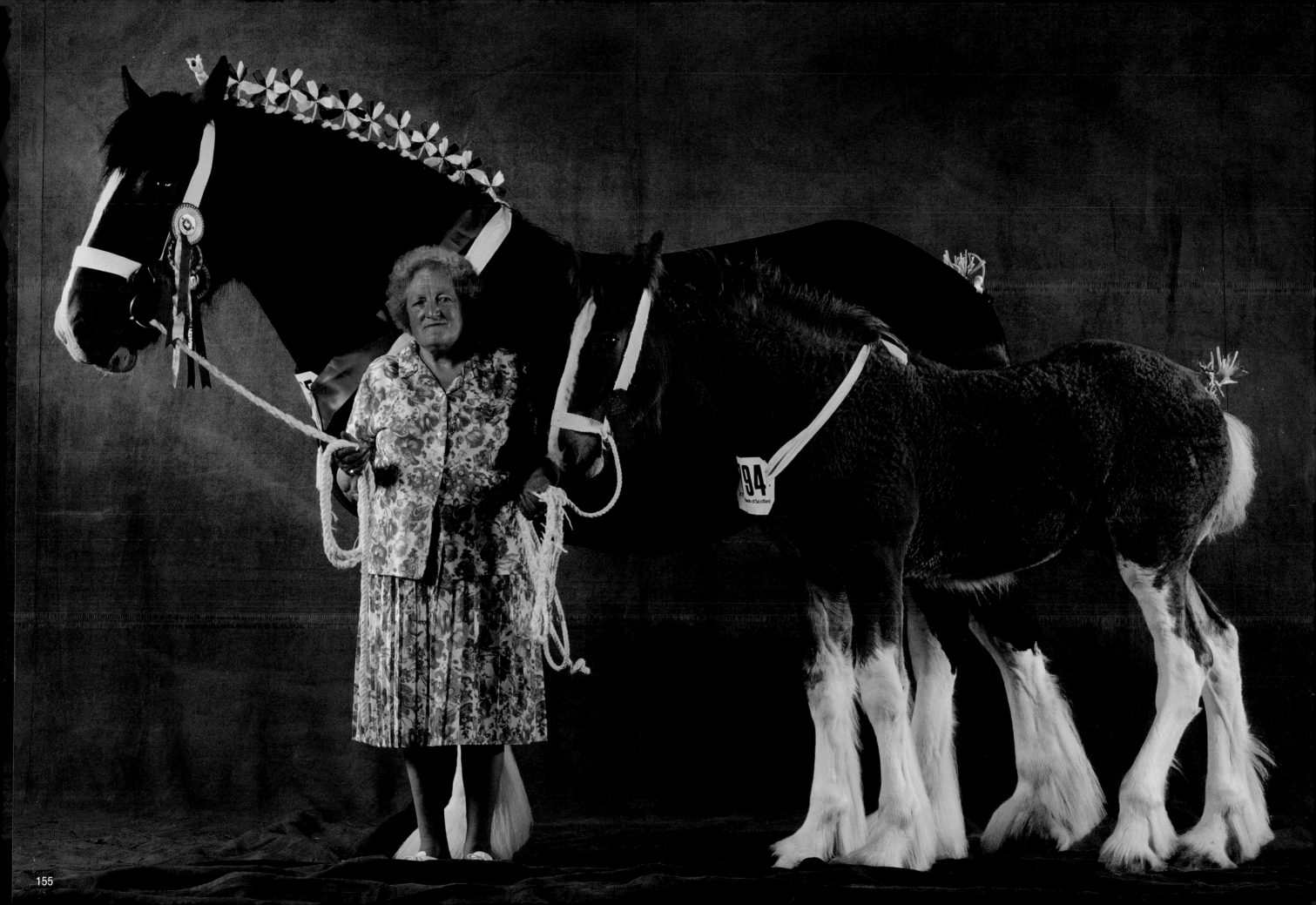

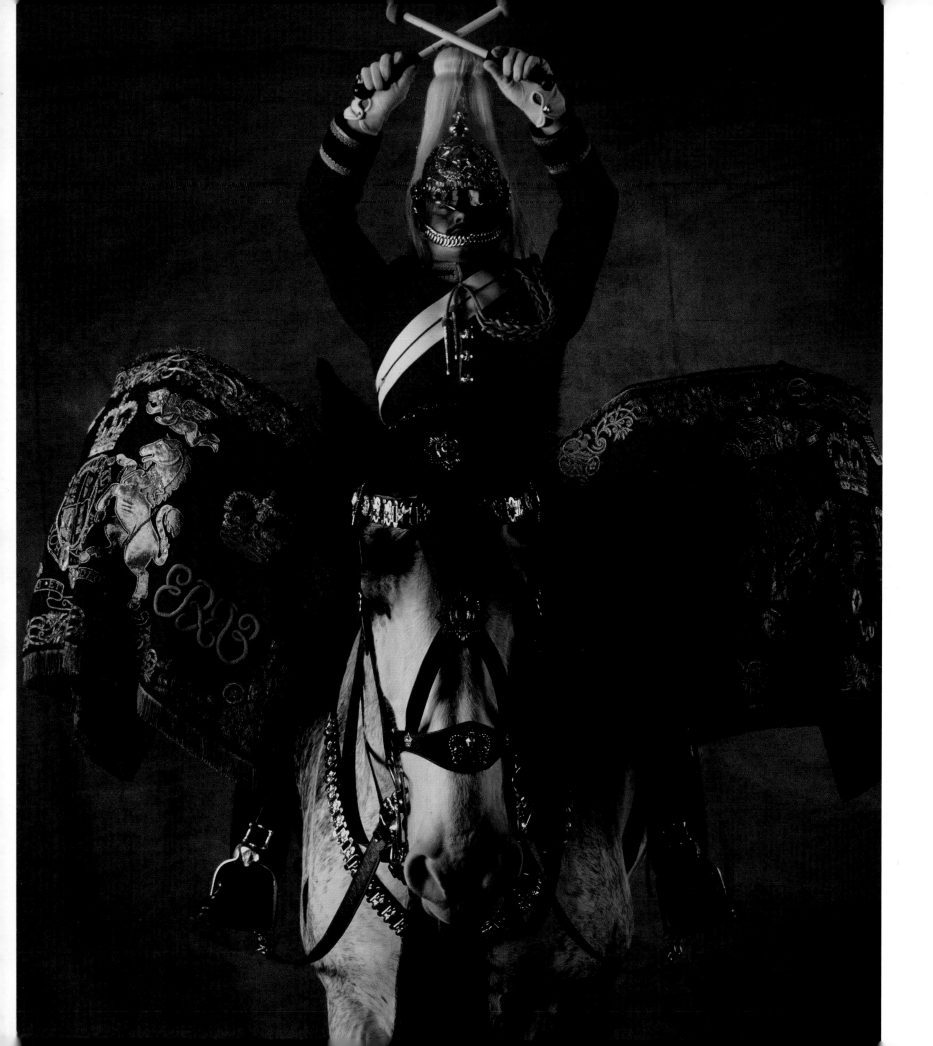

The Clydesdale: the pride of Scotland

The Clyde flows through the city of Glasgow and is famed for its wide estuary, home to the Royal Navy's nuclear submarines. However, as many horse lovers know, the Clyde was also the region that, in the last century, gave rise to a magnificent workhorse, the Clydesdale, which, though less sturdily built, is heavier than the Shire.

Its defining characteristic is its impressive, albeit paradoxical, appearance—although the Clydesdale is large and strong, it remains extremely elegant. This "heavy" horse has very fine features and, although thought to be sluggish by some, it has a spirited and energetic carriage.

It was not until 1826 that the first Clydesdales were introduced in Glasgow. However, the mares from this Scottish region had, like other breeds from the British Isles, benefited from the importation of Flemish stallions during the seventeenth century. Towards the end of the nineteenth century, the addition of Shire blood strengthened the relationship between the Clydesdale and the Shire, often regarded ever since as two varieties of the same breed.

At a time when heavy horses were at the height of their popularity, Clydesdales served Britain well. Like their English relative, they were frequently used to pull brewers' drays, but they also specialized in transporting coal, the heaviest load of the time, hauling it from the coal-producing areas to the towns and villages that were still not served by the railway.

In its native region, the Clydesdale breed played a key role in the birth and expansion of Clydeside, a vast industrial conurbation incorporating the city of Glasgow, which saw its population increase tenfold within a century: between 1801 and 1901 the number of inhabitants soared from around 150,000 to 1,500,000. Both heavy horses and laborers found more than enough work to go around in the iron and coal mines and the refineries, ironworks and shipbuilding yards that grew up around them.

This was also the period when "young" countries such as the United States, Canada and Australia were developing quickly and were in great need of a reliable source of energy. The Clydesdales were best suited to providing this horsepower. In Australia, these horses played a decisive role in the construction of the country, vindicating the opinion expressed by William Aiton, a late eighteenth-century English author, who wrote that the Clydesdale was the best British draft breed not only for farm work, but for any task that required strength, agility and docility.

The pioneers and colonists working in these far-off lands in what were often extremely tough and arduous conditions valued the Clydesdales' ease of maintenance as well as their great adaptability to hot climates and harsh weather—although it should be pointed out that these are qualities shared by most heavy horses.

Today, the Clydesdale maintains a relatively high profile in Great Britain. In Scotland, it is used in the maintenance of wooded areas, parks and gardens. Causing quite a stir wherever it appears, whether in harness races or show classes, it also plays a key role in British military parades as the horse upon which the great bass kettle drums are carried.

158, 159. A Lance Corporal drummer, mounted on a **Clydesdale** named *Belisarius*.

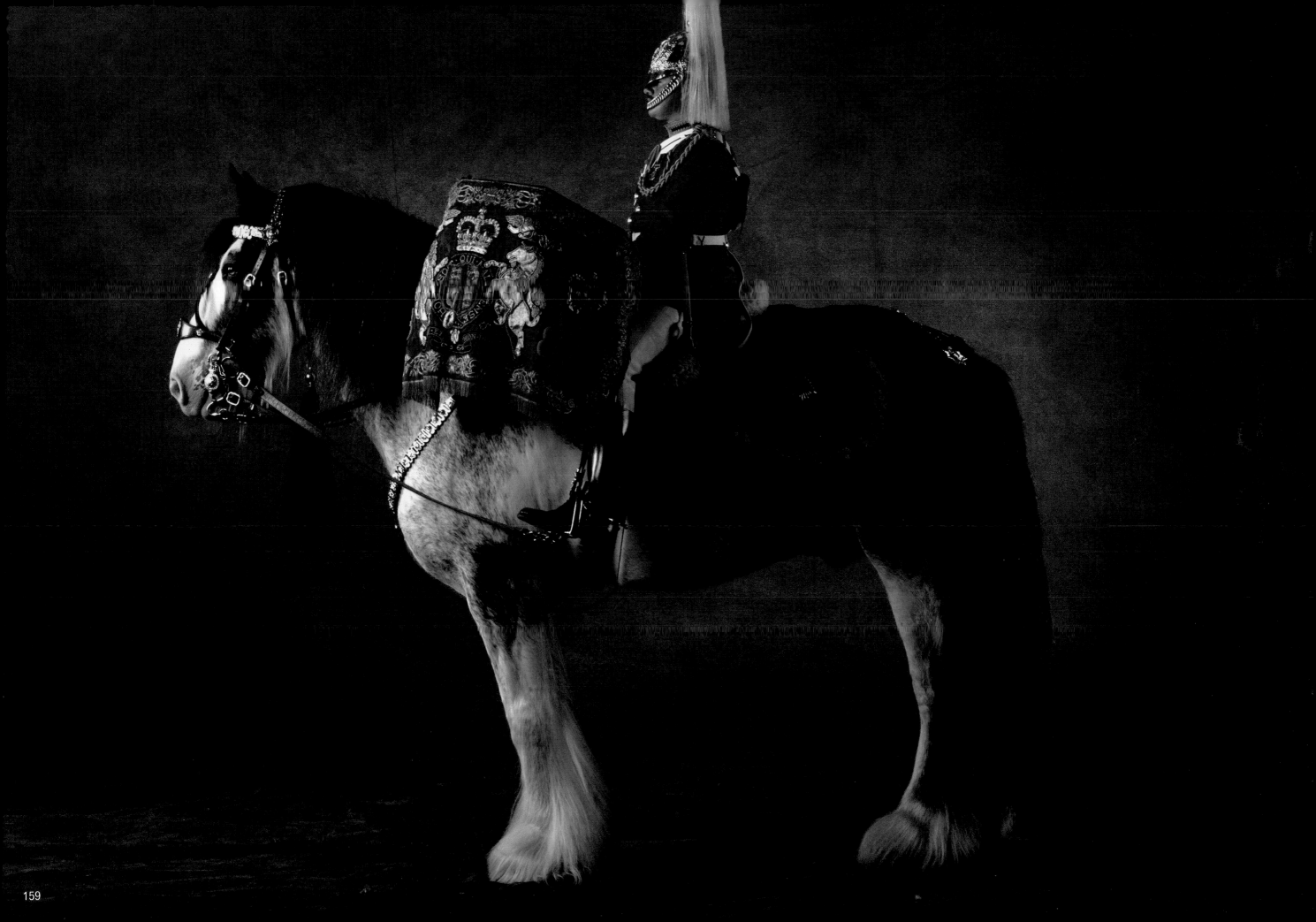

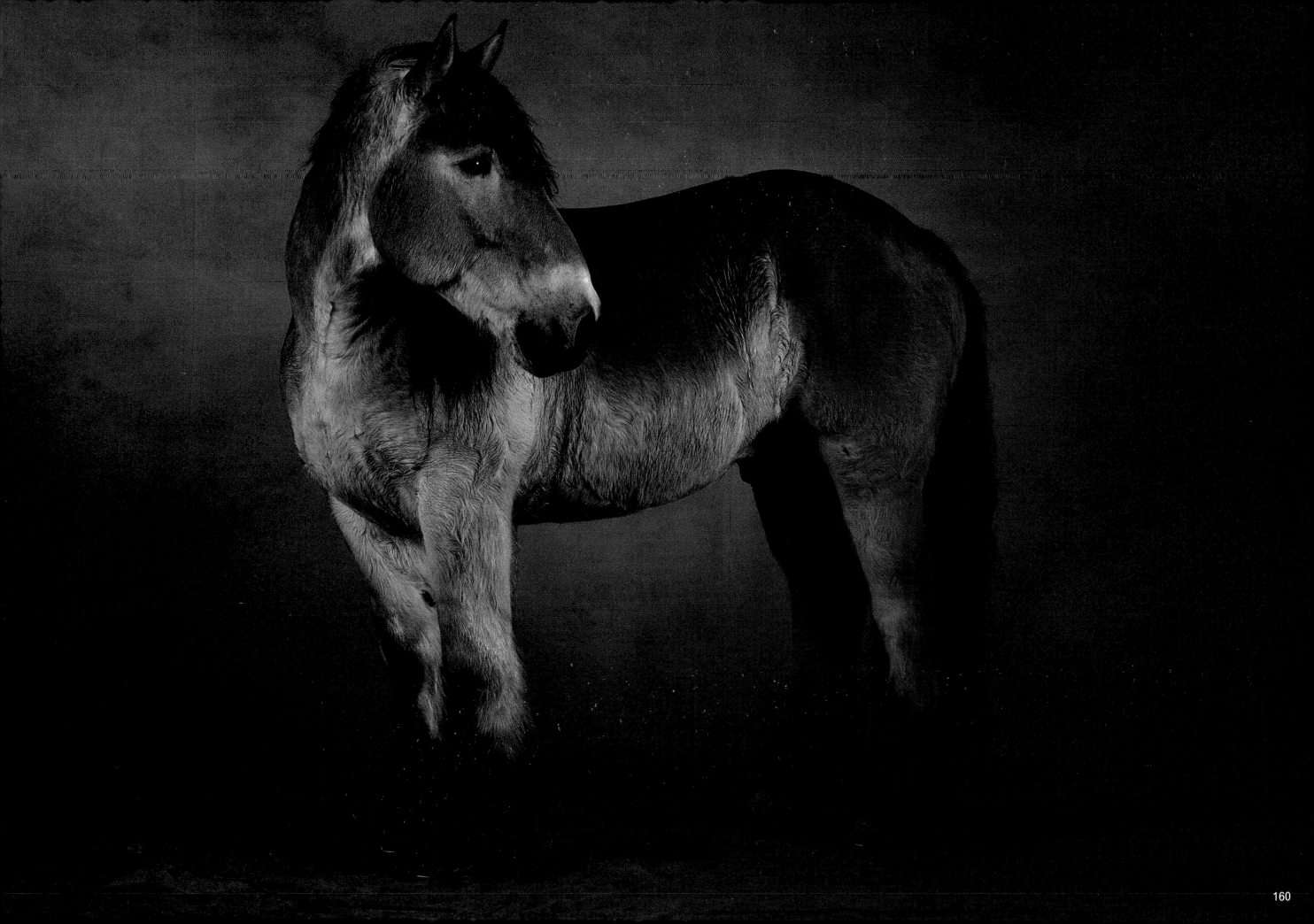

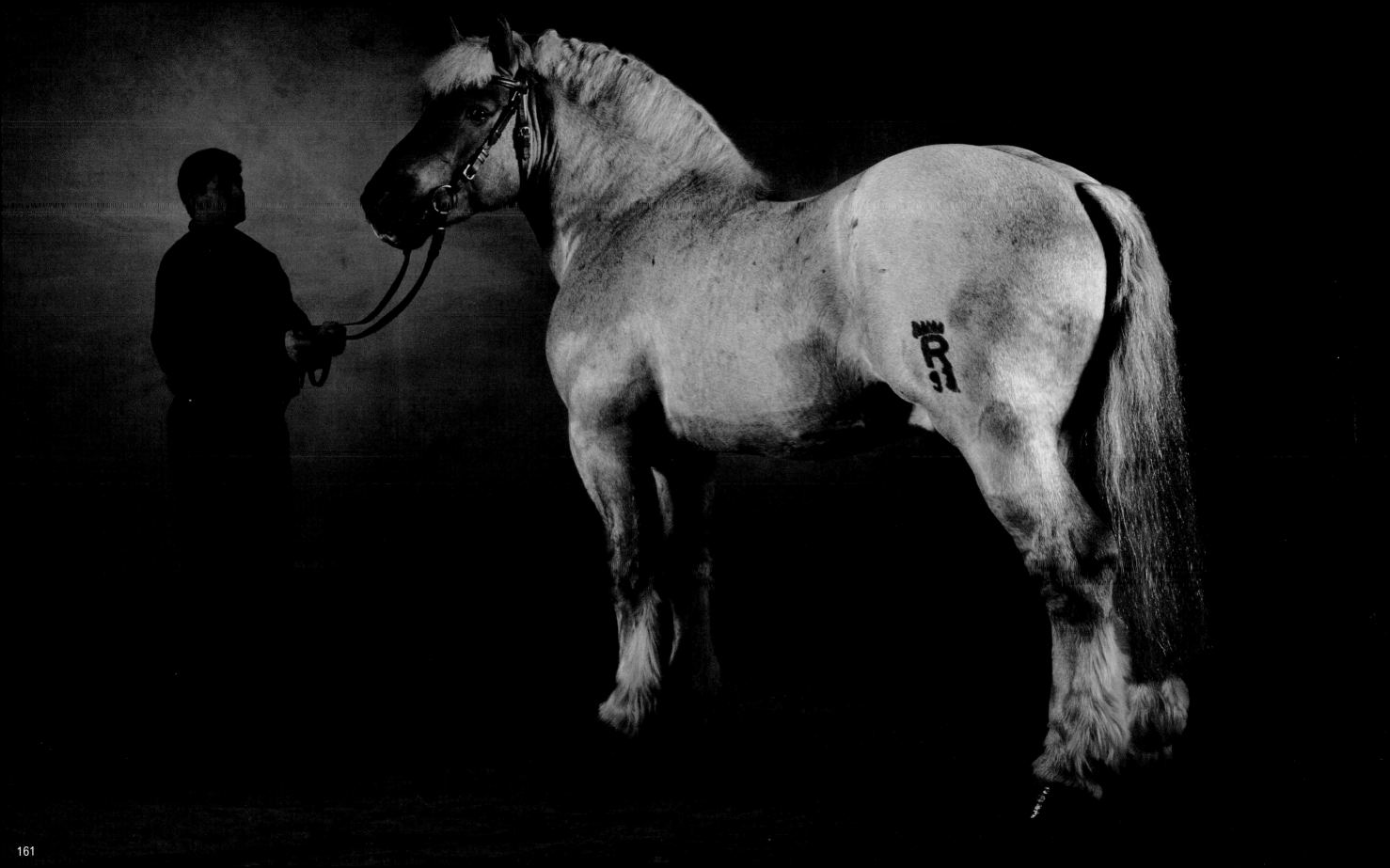

The commonest heavy horse in Germany comes from the Rhineland region. The result of crossbreeding not only between Rhineland breeds but also with those of Westphalia and Saxony, the line was strengthened in the nineteenth century by the introduction of the French Ardennais and Norman Cob (developed from half-bred horses) and most notably the Belgian Brabant (or Belgian Heavy Draft). It was not until the beginning of the twentieth century that the breed was considered fixed and was finally granted its own breed status, the *Rheinisches Deutsches Kaltblut* or Rhenish Westphalian Draft horse.

This is an extremely hardy horse, a dependable worker, quiet and manageable, with a compact and dense conformation, standing 15.3–16.1 hh (63–65 in), with a thick neck, broad chest and short, muscular limbs. Since the Rheinish Westphalian Draft horse reaches maturity relatively quickly and only begins to show its age quite late in life, it is likely to give its fortunate owner long and faithful service. It comes as no surprise to learn that it has become Germany's principal draft horse, except perhaps in the southern region of Bavaria where it now has competition from a medium-weight draft horse—the Pinzgauer Noriker—that has adapted perfectly to the mountainous terrain. This horse is descended from one of the five bloodlines of the draft horse known as the Noric or Noriker (or South German Coldblood), which is believed to be the oldest in Europe.

Two thousand years ago the Romans introduced the ancestors of this medium-sized horse (15–16.1 hh or 60–65 in) into the Roman province of Noricum, which covered roughly the same area as present-day Austria. They developed the strong, gentle, even-tempered and, more importantly, surefooted horse, which they needed for agricultural and forestry work, as well as for transport in mountainous regions.

In the sixteenth century the introduction of Andalusian and Neapolitan blood into the stock gave the Noriker character and agility. Perhaps the most popular of the five bloodlines descended from the Noriker was the Pinzgauer Noriker (now bred in Bavaria) mentioned above, improved by its breeders in the nineteenth century with Norman, Holstein, Hungarian, Oldenburg and Clydesdale blood.

160, 161. Two fine examples of their breed, the **Rhenish Westphalian Draft** horse. Left: Eleven-year-old *Big Ben*, owned by Hans Biesenbach. Right: *Hurrican*, a six-year-old stallion from the regional stud farm in North-Rhine-Westphalia, presented by the head groom Klaus Tönsfeuerborn

162. The *Tyrol Pesante Rapido* (**Italian** or **Rapid Heavy Draft**) the Italian cousin of the Noriker (from the Austrian side of the Tyrol) is worthy of its name ("heavy and fast"). It is fittingly represented here by *Nida*, a six-year-old mare shown by her owner Bortuzzo Natale.

163. Magnificent in harness, the eight-year-old Austrian **Noriker** *Hercules*, presented by his owner Fritz Ehrensperger.

164, 165. The northern horses. Left: *Marquis de Boehle*, a twelve-year-old **Belgian Heavy Draft** gelding, owned by Patrick Becker and presented by Céline Thelen. Right: *Inouïe d'Espérance*, a six-year-old **Trait du Nord** mare, owned by Lionel Corbier and presented by Michel Moreau.

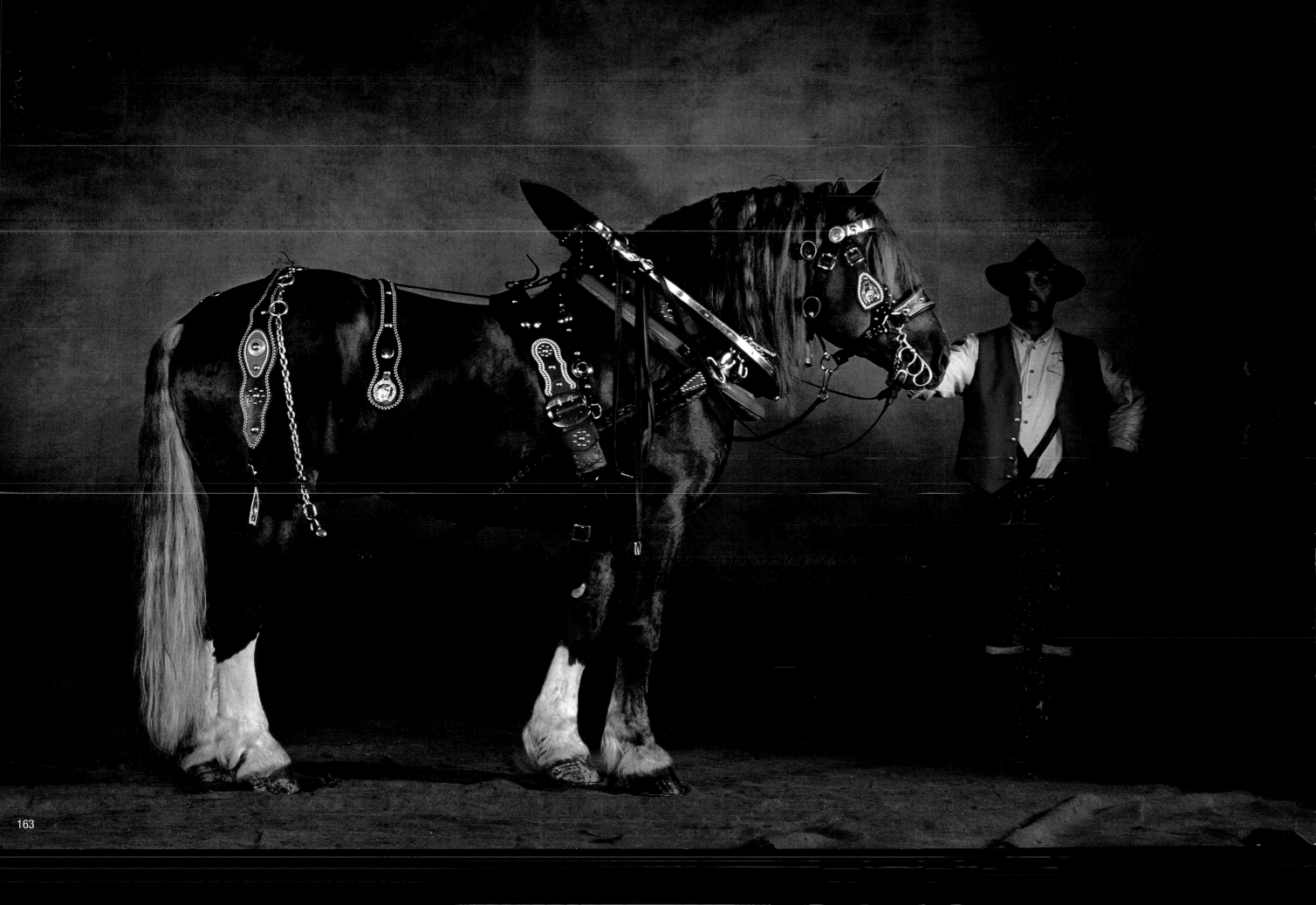

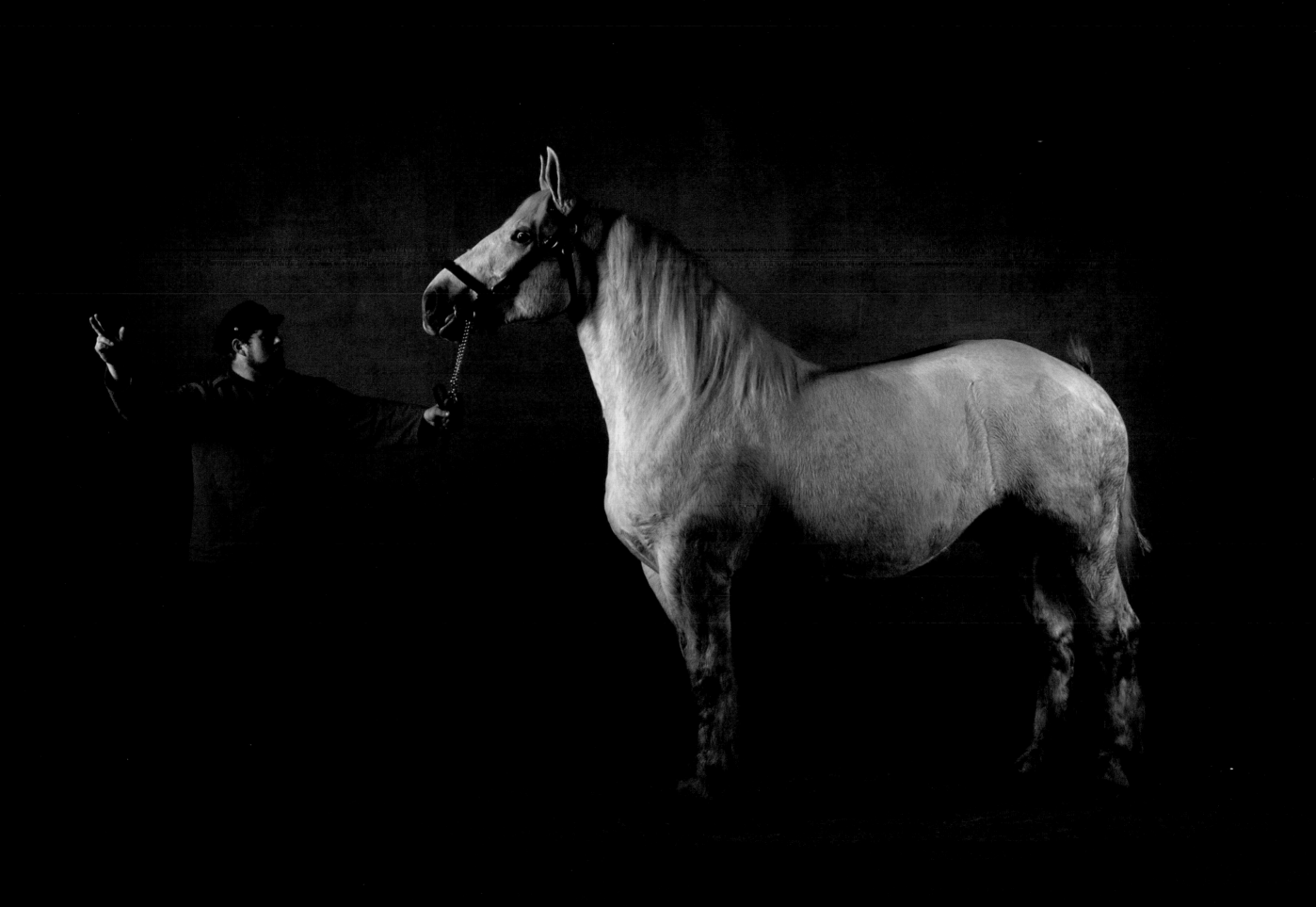

The Boulonnais: tough and enduring

The origins of the Boulonnais present something of a conundrum. Do its roots lie in a British breed, as some maintain? Did it ever come into contact with the horses of the Roman cavalry? What about the old English black horse and/or the great horses of Northern Europe or the horses abandoned by Attila the Hun's army in the fifth century—have any of these contributed to the Boulonnais bloodline? How much do we really know about what happened to the Arab stallions and Barbs brought back from the Crusades in the eleventh century by French knights? There is even a certain amount of vagueness surrounding the first attempts at crossing the Boulonnais with stallions from Flanders. It was not until the beginning of the nineteenth century and the input of blood from Percheron stock that something about its lineage was finally recorded.

During the first half of the nineteenth century the condition of the roads in the vast stretch of land between the Belgian frontier and the Seine Estuary at Le Havre was improved considerably, and the development of commerce and industry led to an increased need for road haulage. As a consequence, between 1830 and 1846 the amount of horse-drawn traffic on the roads doubled. The breeding of light coach/draft horses naturally followed the same upward trend.

The breeders set to work in all the areas of northern France that were active economically—specifically those around Boulogne, the wider Pas-de-Calais region that borders on Flanders, Picardy and Normandy and the area surrounding Paris. The nature of the land was in their favor: fertile soil generally rich in phosphates, beneficial for the development of strong bones, and plateaus of light, easily maintained soil that supports the abundant cultivation of crops. They could also draw upon the local people's long experience of working with horses at a time when oxen were used to plow the fields in other regions. In the north of France it was the Boulonnais mare that pulled the plow.

After a great deal of trial and error, including several attempts with Belgian stallions, the breed was finally improved, notably with input from Percheron stock. The final result was the Boulonnais. The horse we know today may not be exactly the same as the one first produced in the nineteenth century, but it is not too far removed. A graceful and balanced breed, the Boulonnais is considered a model of elegance. An average Boulonnais stands at around 15.3 hh (63 in) and has a coat that is generally any shade of gray, from light to dark. Valued for its strength, in the past the Boulonnais proved its staying power by transporting fresh fish from Boulogne to the Parisian wholesale markets at a steady 10 mph (16 km/h) in the days long before motorized transport and railways. Since 1991, a biannual endurance race called La Route du Poisson ("the Fish Route") has been held, which retraces the original route and commemorates the sterling service that the Boulonnais gave to the French fish industry well over a hundred years ago.

176. *Kilda III*, a three-year-old **Boulonnais** mare, presented by her owner Martial Marie.
177. *Joyeuse Gibarlet*, a four-year-old **Boulonnais** mare, presented by her owner Franck Matte.
178, 179. *Idéal II*, a seven-year-old **Boulonnais** stallion, weighing 1,760 lbs (800 kg). This champion stallion of 2002 is presented by his owner Bernard Hochart (accompanied on the left by his wife, Francine, and his son Kevin).

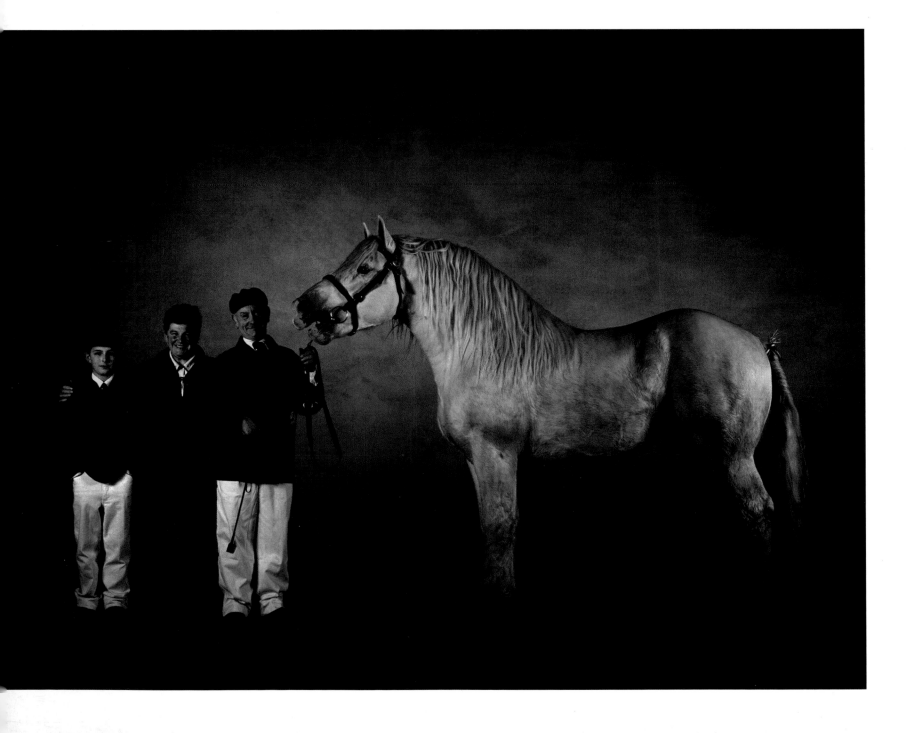

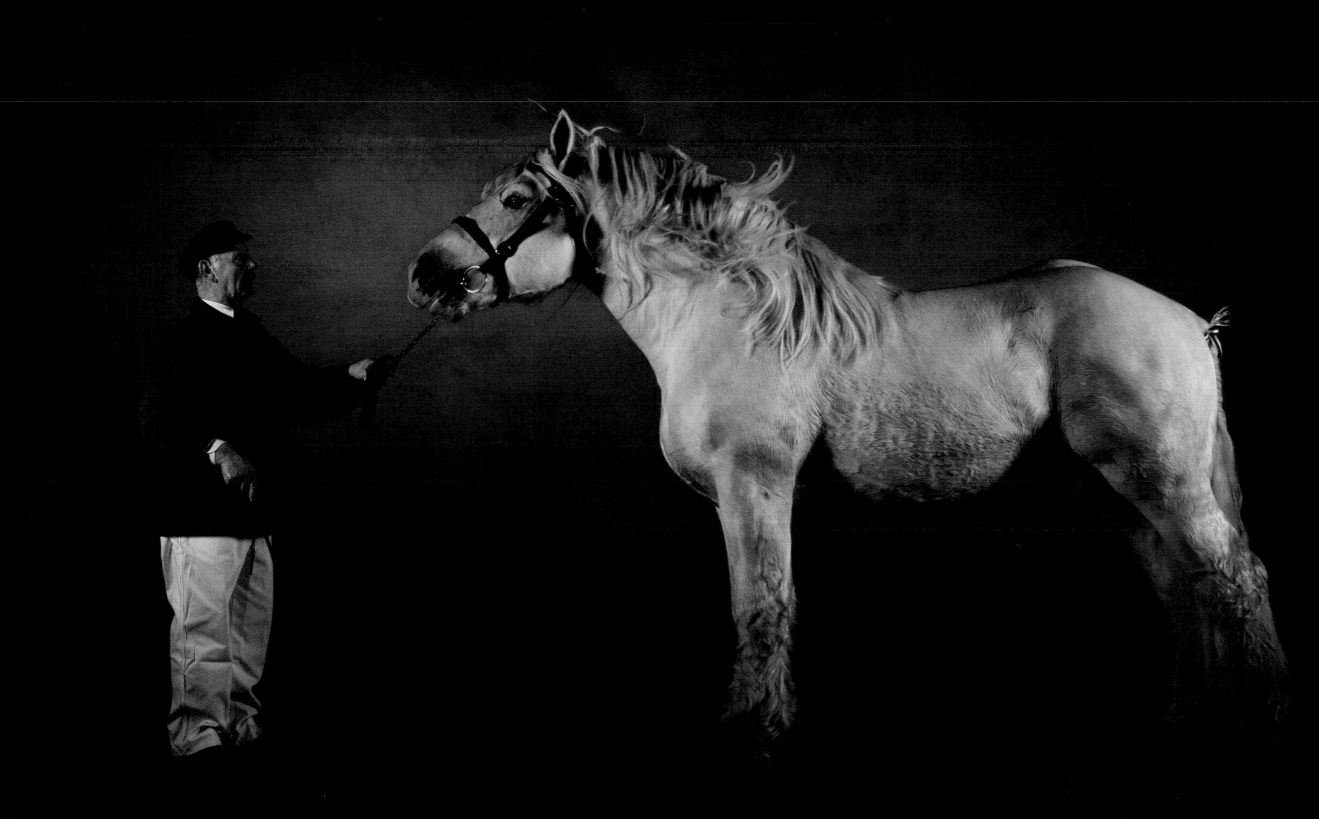

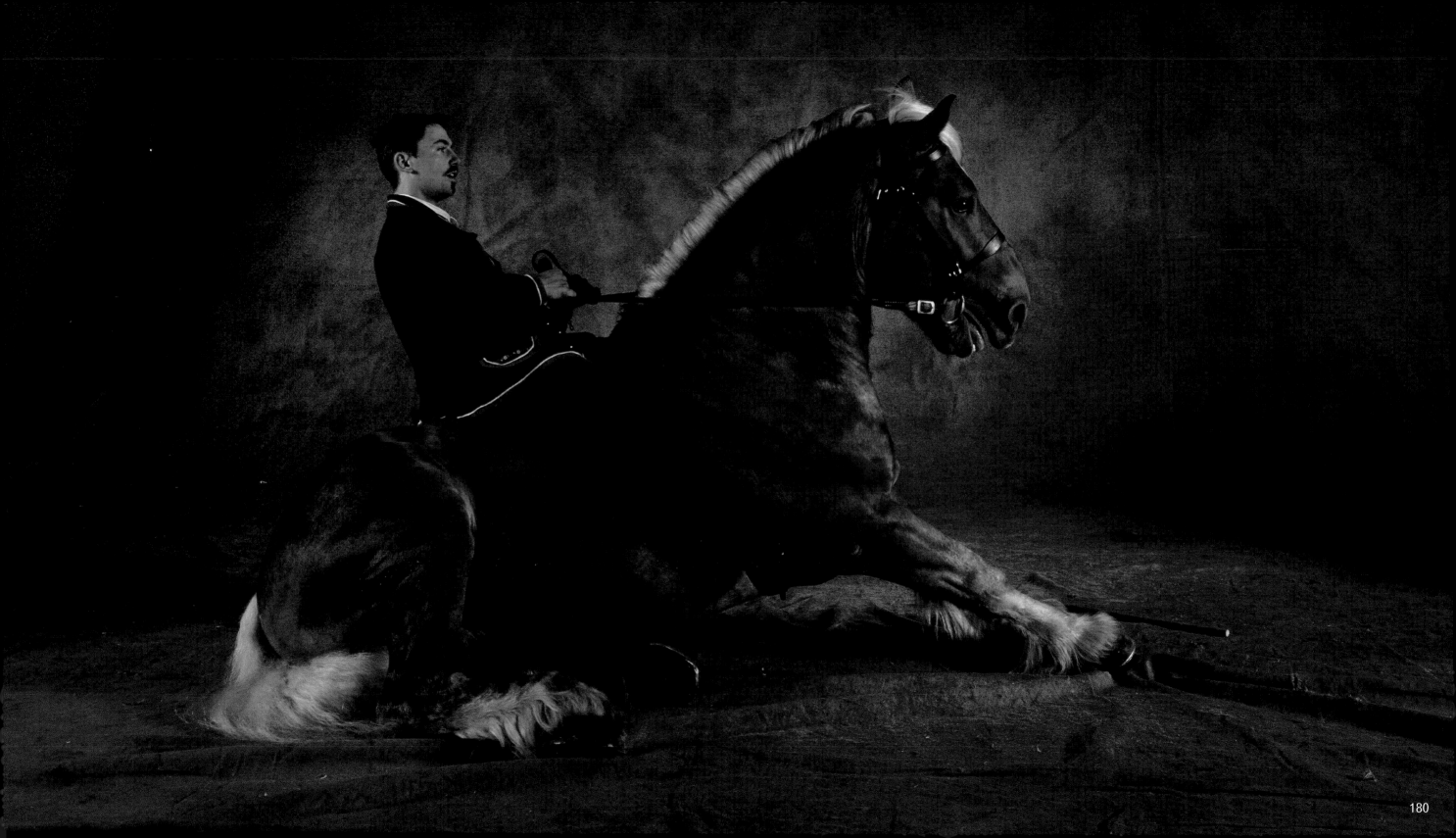

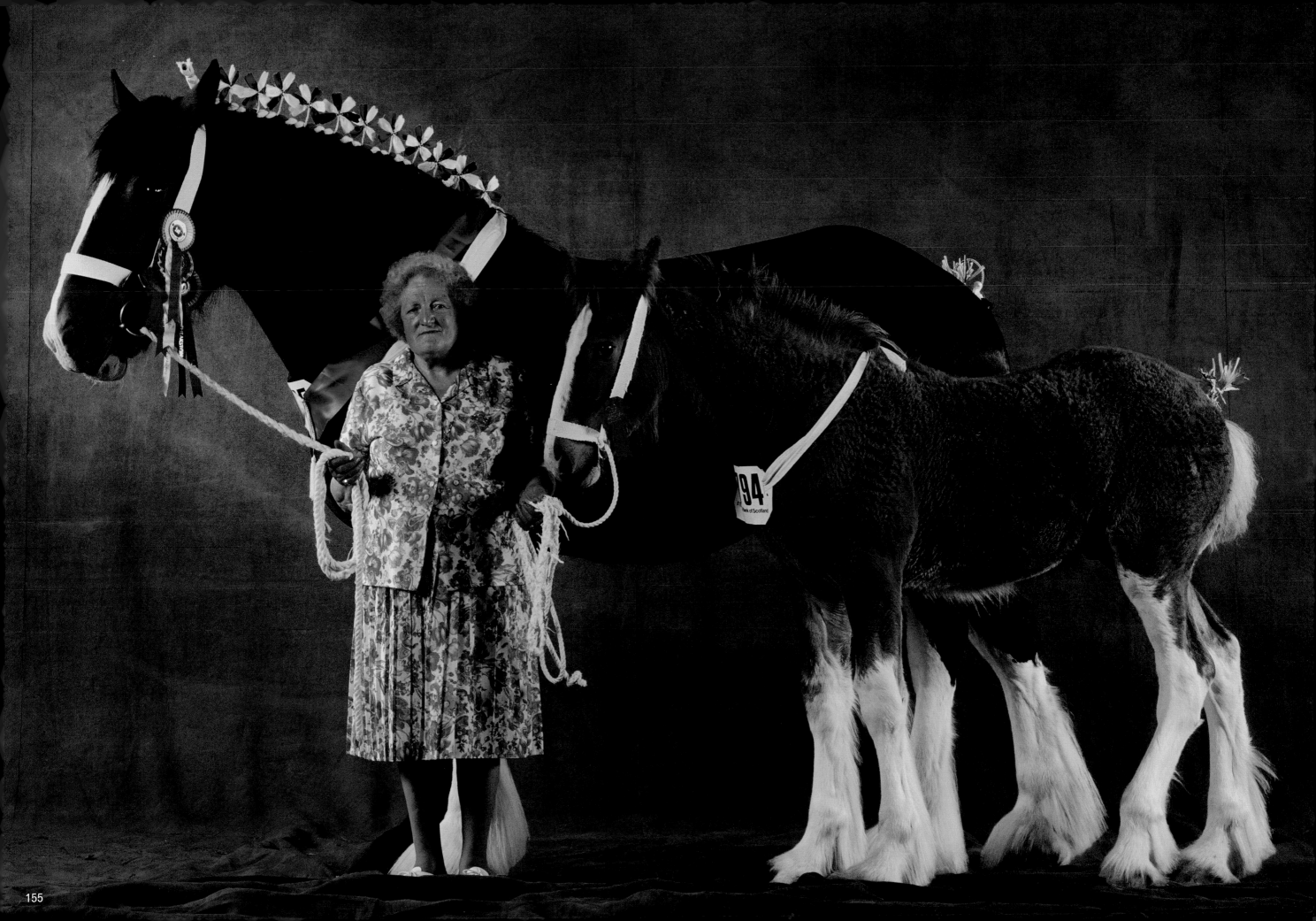

The Shire and Suffolk Punch: English gentle giants

The tallest horse in the world can stand 19.3 hh (79 in) high and weigh over a ton. The record is held by a nineteenth-century Shire stallion, *Samson*, which stood at an astonishing 21.2 hh (86 in). The English Shire horse is not only the tallest, broadest and strongest heavy horse in the world, but it is also one of the oldest. Julius Caesar referred to a great black horse (*equus magnus*) found in the north of England, which was probably a distant ancestor of the Shire. Between the two breeds are centuries of hard work, breeding and crossbreeding with horses from northern Europe, particularly Flanders.

If the Shire's distant ancestor was as ugly, lazy and bad-tempered as has been documented, this is simply one more reason to praise the skill of the breeders who succeeded in producing an elegant horse (apparently by adding some Arab blood) that is so placid that it can be safely ridden by a child.

When people picture these gentle giants, many see them harnessed to huge brewers' drays, transporting heavy barrels from the breweries to the inns, a job they are rarely given now, except for publicity campaigns. After virtual extinction during the 1950s owing to the effect of widespread rural mechanization, over the past few years the Shire has regained numerous admirers and has even acquired new employers—it is estimated that there are now around three thousand Shire horses in existence. In 1981, *Farmer's Weekly* reported that a single breeder in the north of England had sold two hundred Shires in the past year to work in the agricultural or industrial sectors. The article was called "Shires Help to Cut the Costs."

England can still also boast the magnificent Suffolk Punch, another possible descendant of the famous *equus magnus* mentioned by Caesar. One look at this animal is enough to tell you that it certainly does not lack muscle. Native to the southeast of England, this compact breed (the nickname "Punch" means short and thickset) has a massive head, thick neck, muscular shoulders and short, powerful legs. It has clearly been bred for hard work. As with so many other horse breeds, there is a certain amount of debate surrounding its origins: the foundation stallion may have been *Blake's Farmer*, born in 1760, or a trotter eight years its junior, belonging to a Suffolk breeder, one Thomas Crisp from Ufford. However, it must have taken a great deal of crossbreeding to produce the present-day conformation and qualities of this breed. The first imported crosses probably date back to the thirteenth century and may even include descendants of Norman mares from the time of William the Conqueror (*c.* 1028–87).

The Suffolk Punch is a powerful, energetic and courageous horse. Put to work from the age of two, it is able to provide good and loyal service for at least twenty years on only a moderate amount of food. Capable of pulling heavy loads or plowing for several hours without food or drink, it is the most frugal of the heavy horses. Nothing seems to shake its courage, spirit or gentleness. Its relatively small size—usually 15.3–16.3 hh (63–67 in)—also makes it very maneuverable when working in urban areas. Farmers, on the other hand, value the lack of feathering on its legs, which makes this horse well suited to the clay soil of eastern England. In contrast, the legs of its English and Scottish relatives—the Shire and Clydesdale breeds respectively—are almost entirely covered in feathers.

154, 155. Two fine **Shire** specimens. Left: *Regius Victorious* (by *Black Den Mascot* out of *Regius Jet*), presented by Stuart Harrison. Right: *Stanley House Duchess* and her foal *Stanley House John Bukk*, presented by Mrs. Anne Hull.
157. *Richard*, a **Suffolk Punch**, in full harness, presented by his owner Mrs. C. J. Clark.

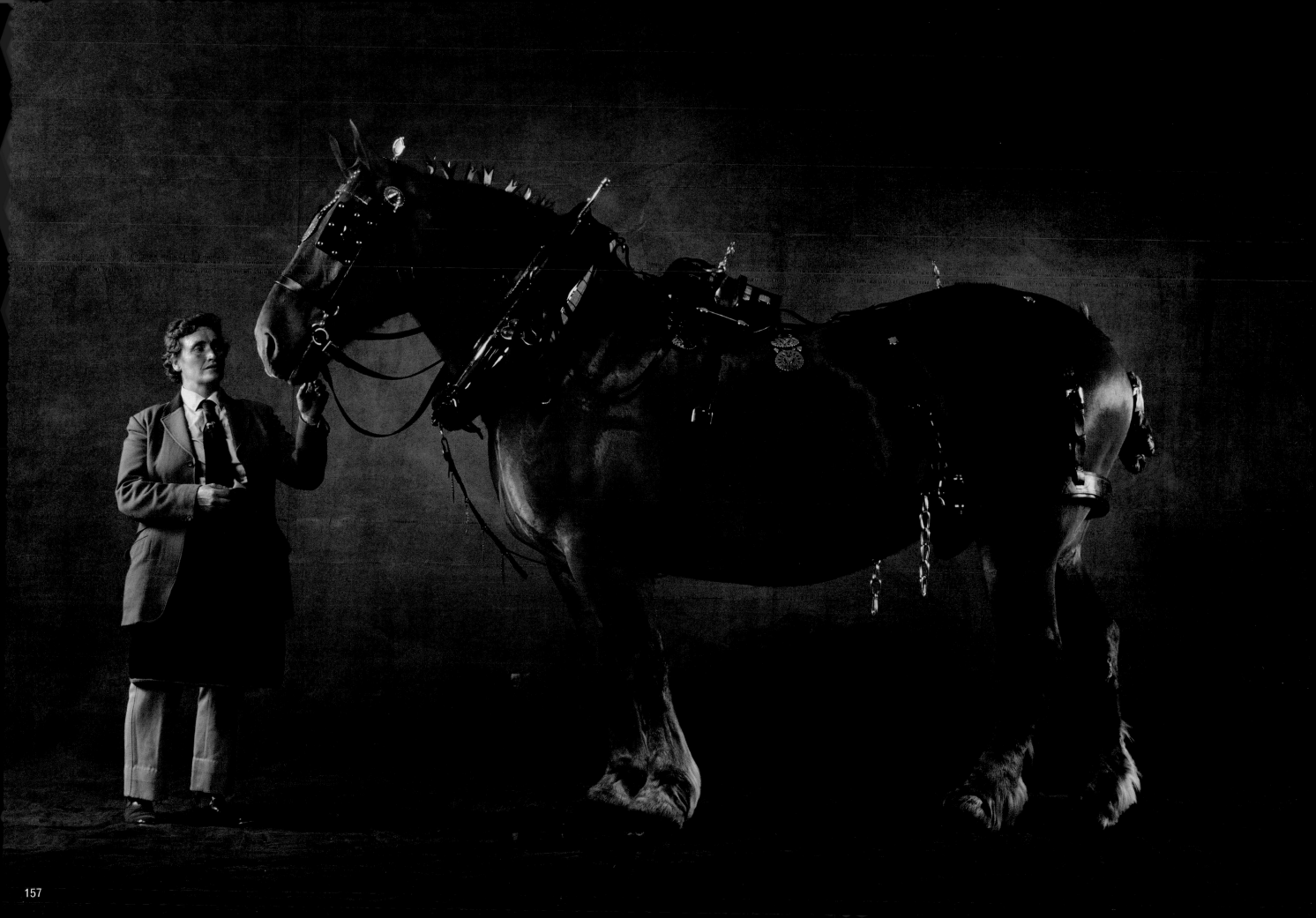

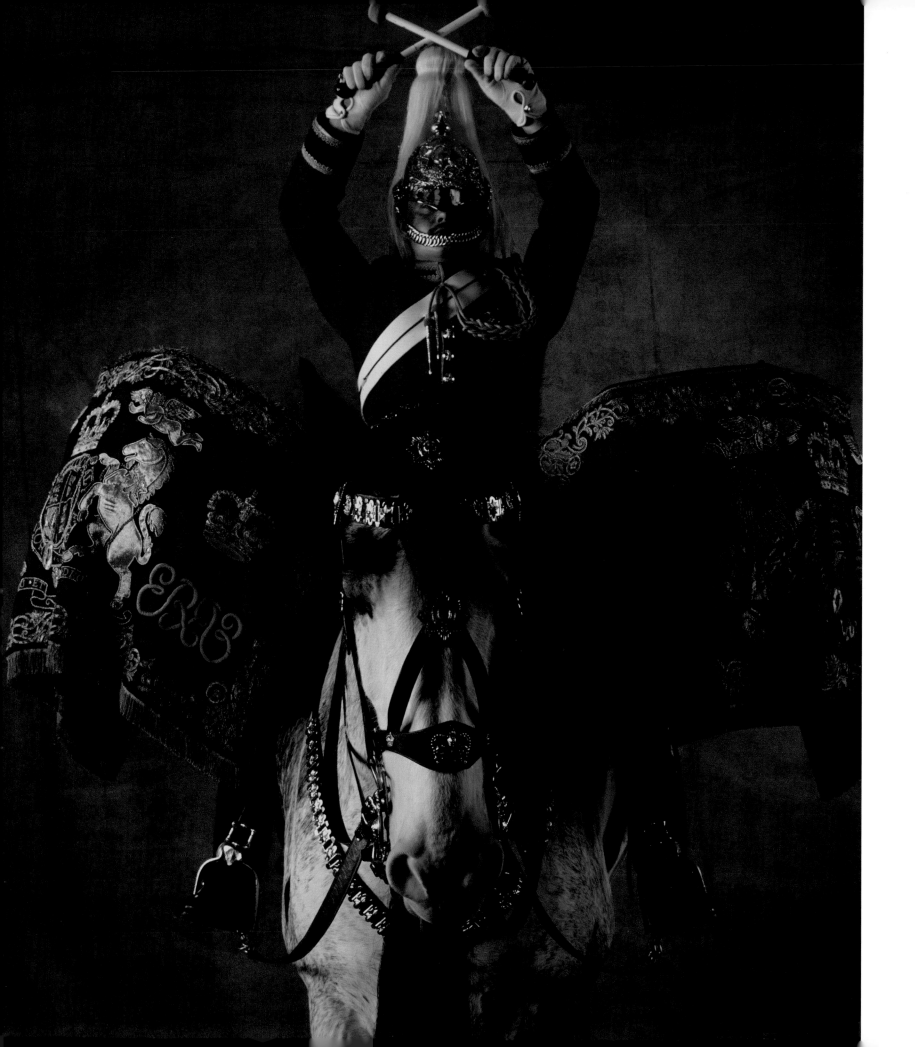

The Clydesdale: the pride of Scotland

The Clyde flows through the city of Glasgow and is famed for its wide estuary, home to the Royal Navy's nuclear submarines. However, as many horse lovers know, the Clyde was also the region that, in the last century, gave rise to a magnificent workhorse, the Clydesdale, which, though less sturdily built, is heavier than the Shire.

Its defining characteristic is its impressive, albeit paradoxical, appearance—although the Clydesdale is large and strong, it remains extremely elegant. This "heavy" horse has very fine features and, although thought to be sluggish by some, it has a spirited and energetic carriage.

It was not until 1826 that the first Clydesdales were introduced in Glasgow. However, the mares from this Scottish region had, like other breeds from the British Isles, benefited from the importation of Flemish stallions during the seventeenth century. Towards the end of the nineteenth century, the addition of Shire blood strengthened the relationship between the Clydesdale and the Shire, often regarded ever since as two varieties of the same breed.

At a time when heavy horses were at the height of their popularity, Clydesdales served Britain well. Like their English relative, they were frequently used to pull brewers' drays, but they also specialized in transporting coal, the heaviest load of the time, hauling it from the coal-producing areas to the towns and villages that were still not served by the railway.

In its native region, the Clydesdale breed played a key role in the birth and expansion of Clydeside, a vast industrial conurbation incorporating the city of Glasgow, which saw its population increase tenfold within a century: between 1801 and 1901 the number of inhabitants soared from around 150,000 to 1,500,000. Both heavy horses and laborers found more than enough work to go around in the iron and coal mines and the refineries, ironworks and shipbuilding yards that grew up around them.

This was also the period when "young" countries such as the United States, Canada and Australia were developing quickly and were in great need of a reliable source of energy. The Clydesdales were best suited to providing this horsepower. In Australia, these horses played a decisive role in the construction of the country, vindicating the opinion expressed by William Aiton, a late eighteenth-century English author, who wrote that the Clydesdale was the best British draft breed not only for farm work, but for any task that required strength, agility and docility.

The pioneers and colonists working in these far-off lands in what were often extremely tough and arduous conditions valued the Clydesdales' ease of maintenance as well as their great adaptability to hot climates and harsh weather—although it should be pointed out that these are qualities shared by most heavy horses.

Today, the Clydesdale maintains a relatively high profile in Great Britain. In Scotland, it is used in the maintenance of wooded areas, parks and gardens. Causing quite a stir wherever it appears, whether in harness races or show classes, it also plays a key role in British military parades as the horse upon which the great bass kettle drums are carried.

158, 159. A Lance Corporal drummer, mounted on a **Clydesdale** named *Belisarius*.

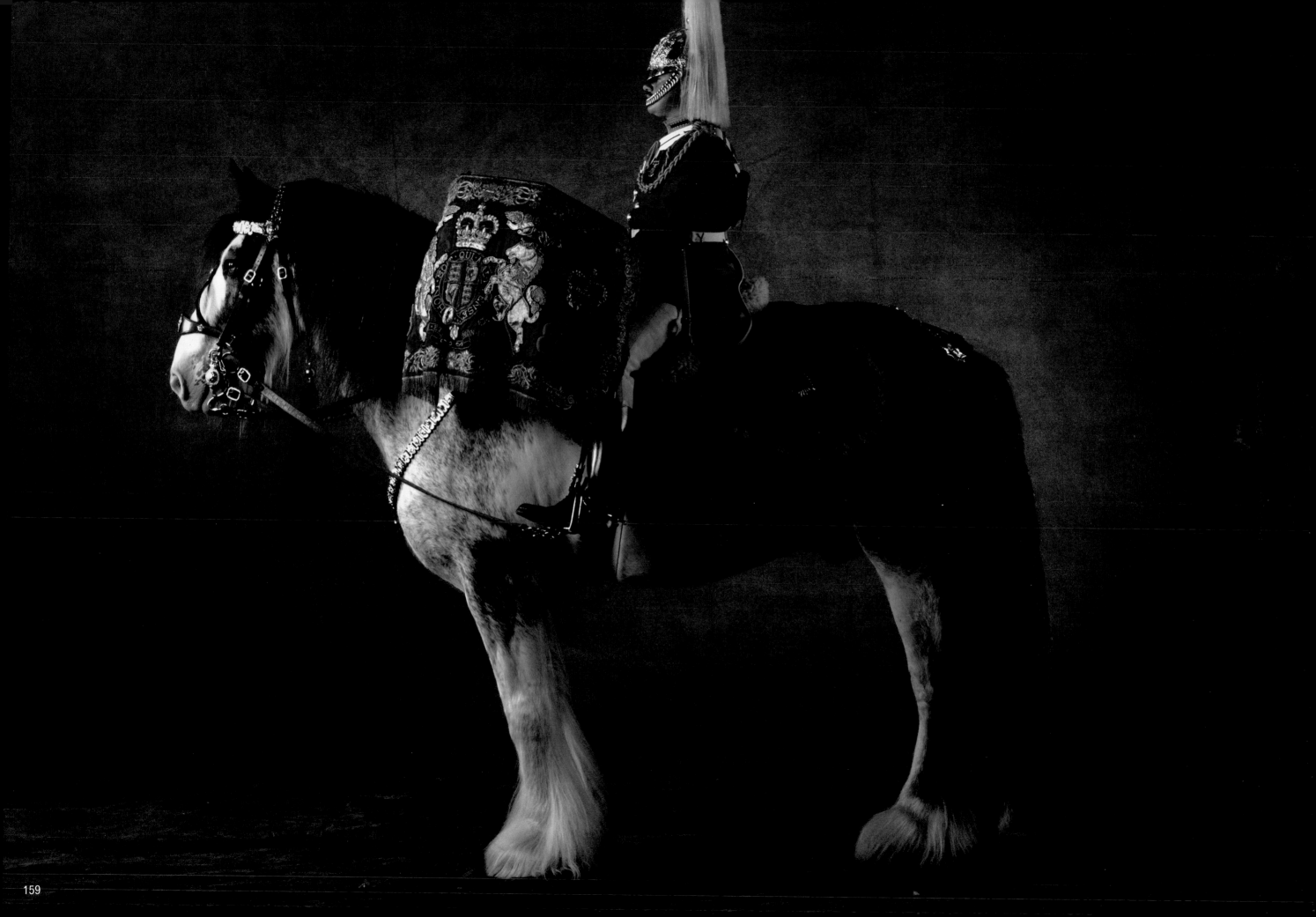

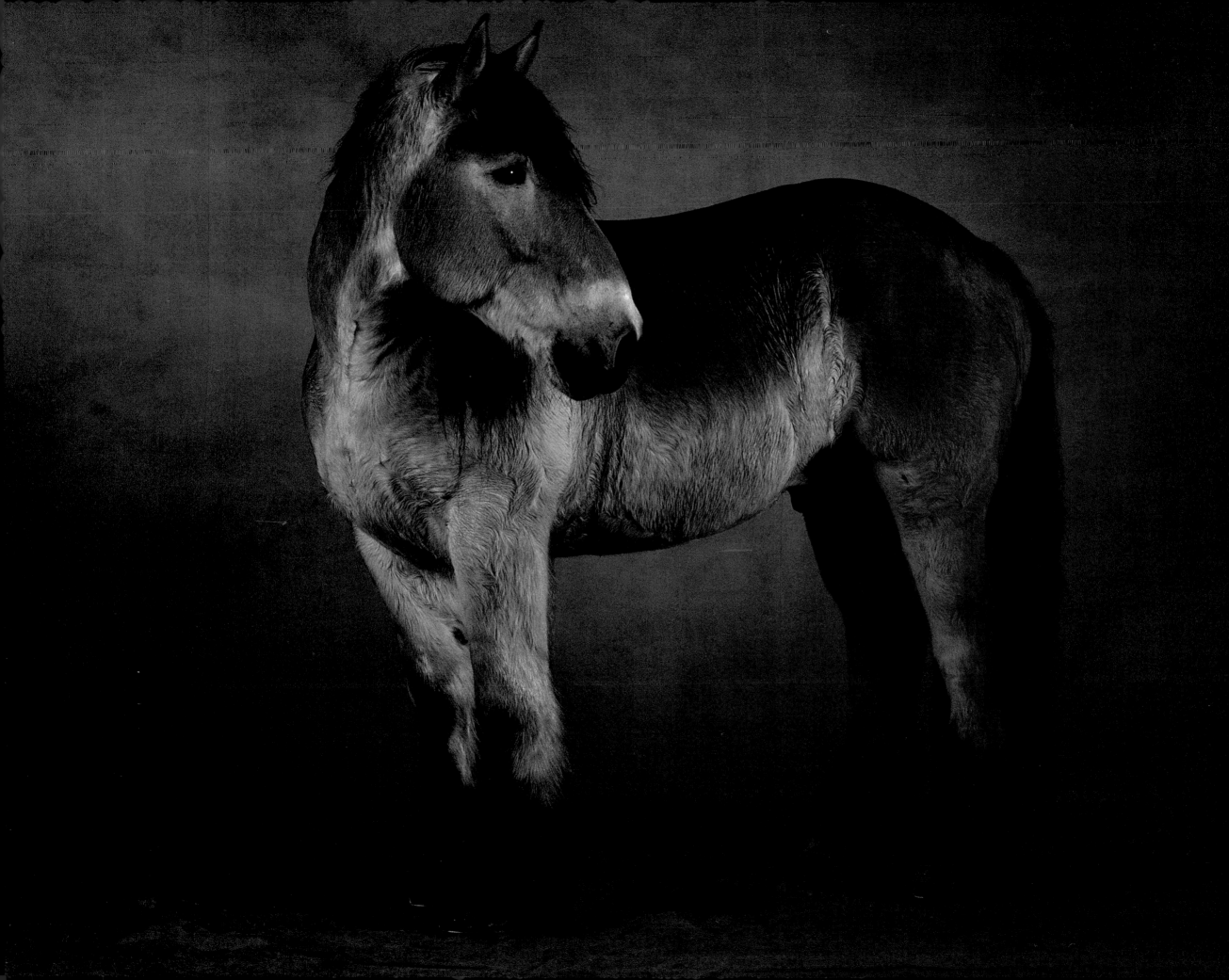

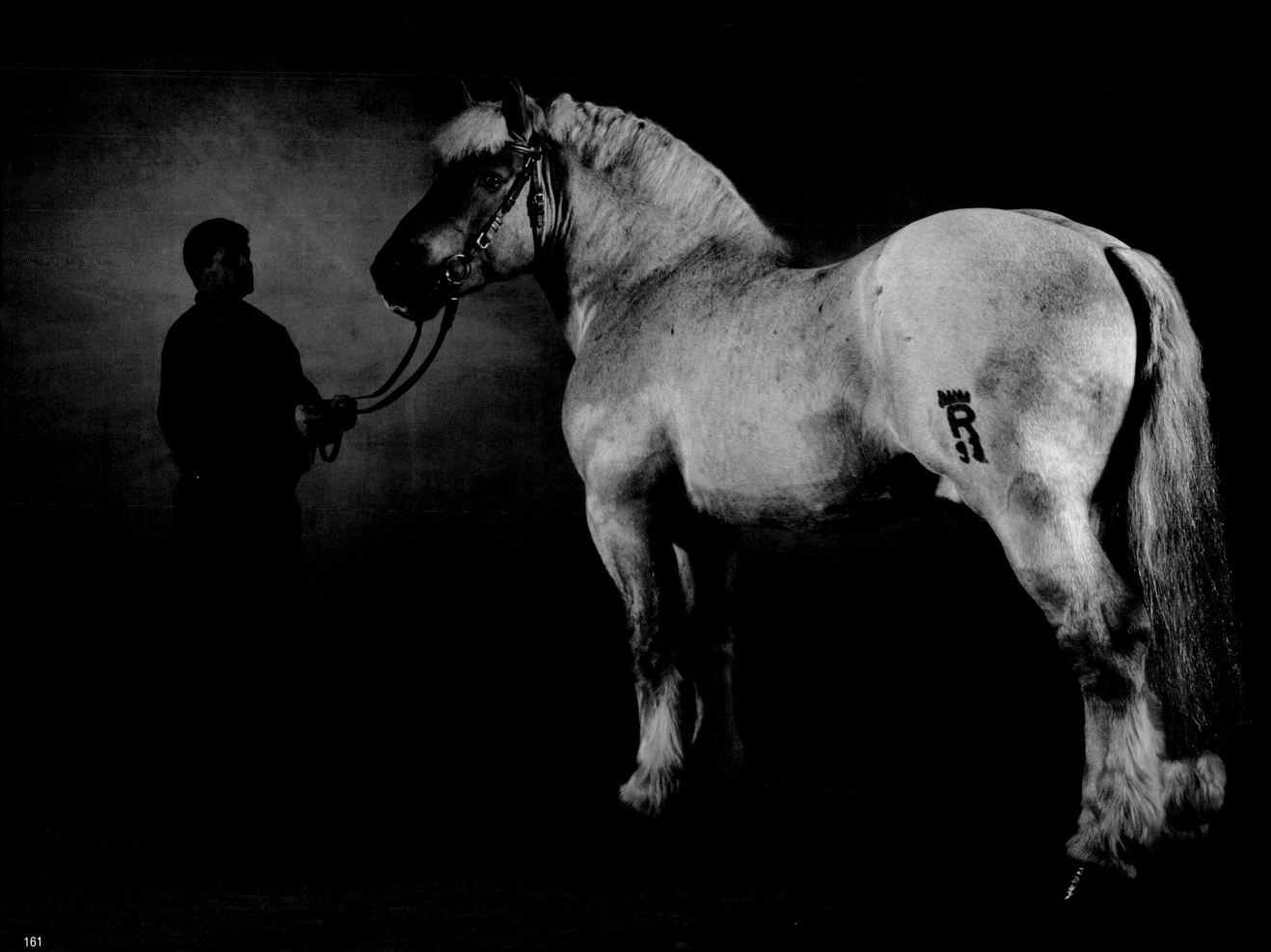

German heavy horses: dependable characters

The commonest heavy horse in Germany comes from the Rhineland region. The result of crossbreeding not only between Rhineland breeds but also with those of Westphalia and Saxony, the line was strengthened in the nineteenth century by the introduction of the French Ardennais and Norman Cob (developed from half-bred horses) and most notably the Belgian Brabant (or Belgian Heavy Draft). It was not until the beginning of the twentieth century that the breed was considered fixed and was finally granted its own breed status, the *Rheinisches Deutsches Kaltblut* or Rhenish Westphalian Draft horse.

This is an extremely hardy horse, a dependable worker, quiet and manageable, with a compact and dense conformation, standing 15.3–16.1 hh (63–65 in), with a thick neck, broad chest and short, muscular limbs. Since the Rheinish Westphalian Draft horse reaches maturity relatively quickly and only begins to show its age quite late in life, it is likely to give its fortunate owner long and faithful service. It comes as no surprise to learn that it has become Germany's principal draft horse, except perhaps in the southern region of Bavaria where it now has competition from a medium-weight draft horse—the Pinzgauer Noriker—that has adapted perfectly to the mountainous terrain. This horse is descended from one of the five bloodlines of the draft horse known as the Noric or Noriker (or South German Coldblood), which is believed to be the oldest in Europe.

Two thousand years ago the Romans introduced the ancestors of this medium-sized horse (15–16.1 hh or 60–65 in) into the Roman province of Noricum, which covered roughly the same area as present-day Austria. They developed the strong, gentle, even-tempered and, more importantly, surefooted horse, which they needed for agricultural and forestry work, as well as for transport in mountainous regions.

In the sixteenth century the introduction of Andalusian and Neapolitan blood into the stock gave the Noriker character and agility. Perhaps the most popular of the five bloodlines descended from the Noriker was the Pinzgauer Noriker (now bred in Bavaria) mentioned above, improved by its breeders in the nineteenth century with Norman, Holstein, Hungarian, Oldenburg and Clydesdale blood.

160, 161. Two fine examples of their breed, the **Rhenish Westphalian Draft** horse.
Left: Eleven-year-old *Big Ben*, owned by Hans Biesenbach.
Right: *Hurrican*, a six-year-old stallion from the regional stud farm in North-Rhine-Westphalia, presented by the head groom Klaus Tönsfeuerborn
162. The *Tyrol Pesante Rapido* (**Italian** or **Rapid Heavy Draft**) the Italian cousin of the Noriker (from the Austrian side of the Tyrol) is worthy of its name ("heavy and fast"). It is fittingly represented here by *Nida*, a six-year-old mare shown by her owner Bortuzzo Natale.
163. Magnificent in harness, the eight-year-old Austrian **Noriker** *Hercules*, presented by his owner Fritz Ehrensperger.
164, 165. The northern horses.
Left: *Marquis de Boehle*, a twelve-year-old **Belgian Heavy Draft** gelding, owned by Patrick Becker and presented by Céline Thelen.
Right: *Inouïe d'Espérance*, a six-year-old **Trait du Nord** mare, owned by Lionel Corbier and presented by Michel Moreau.

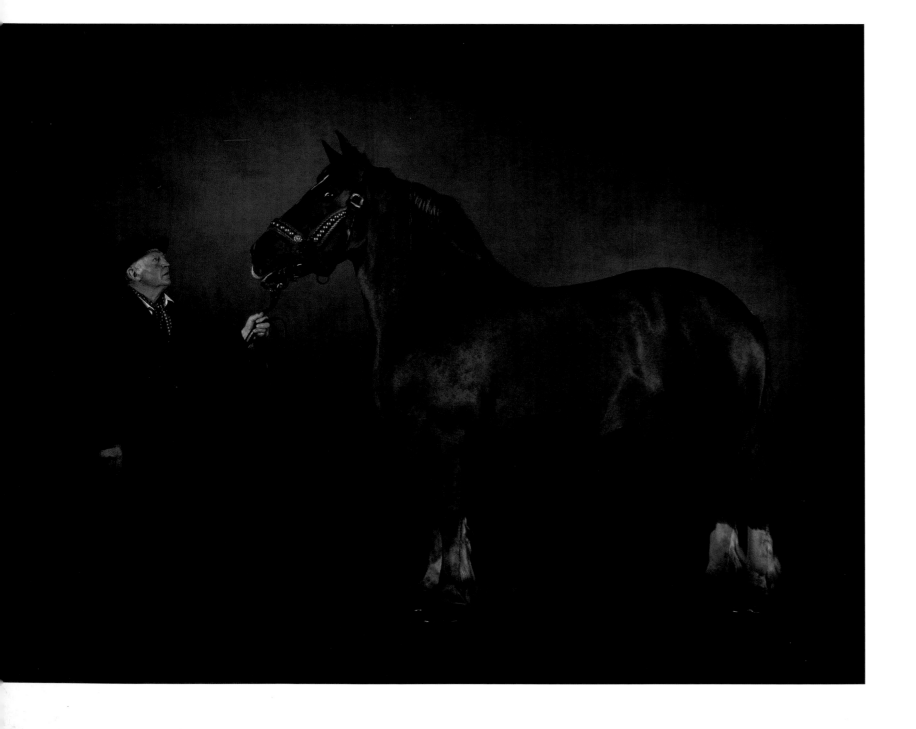

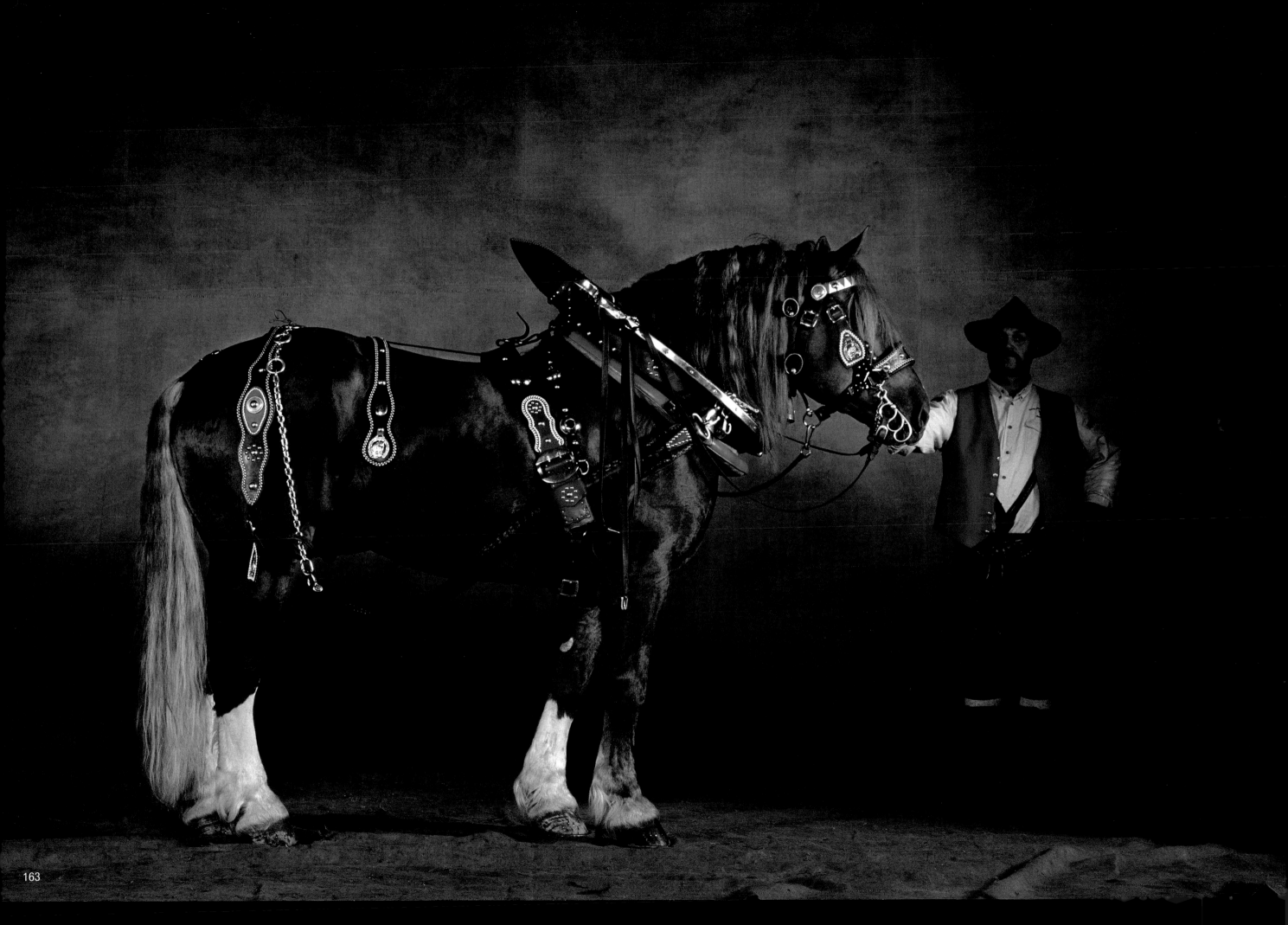

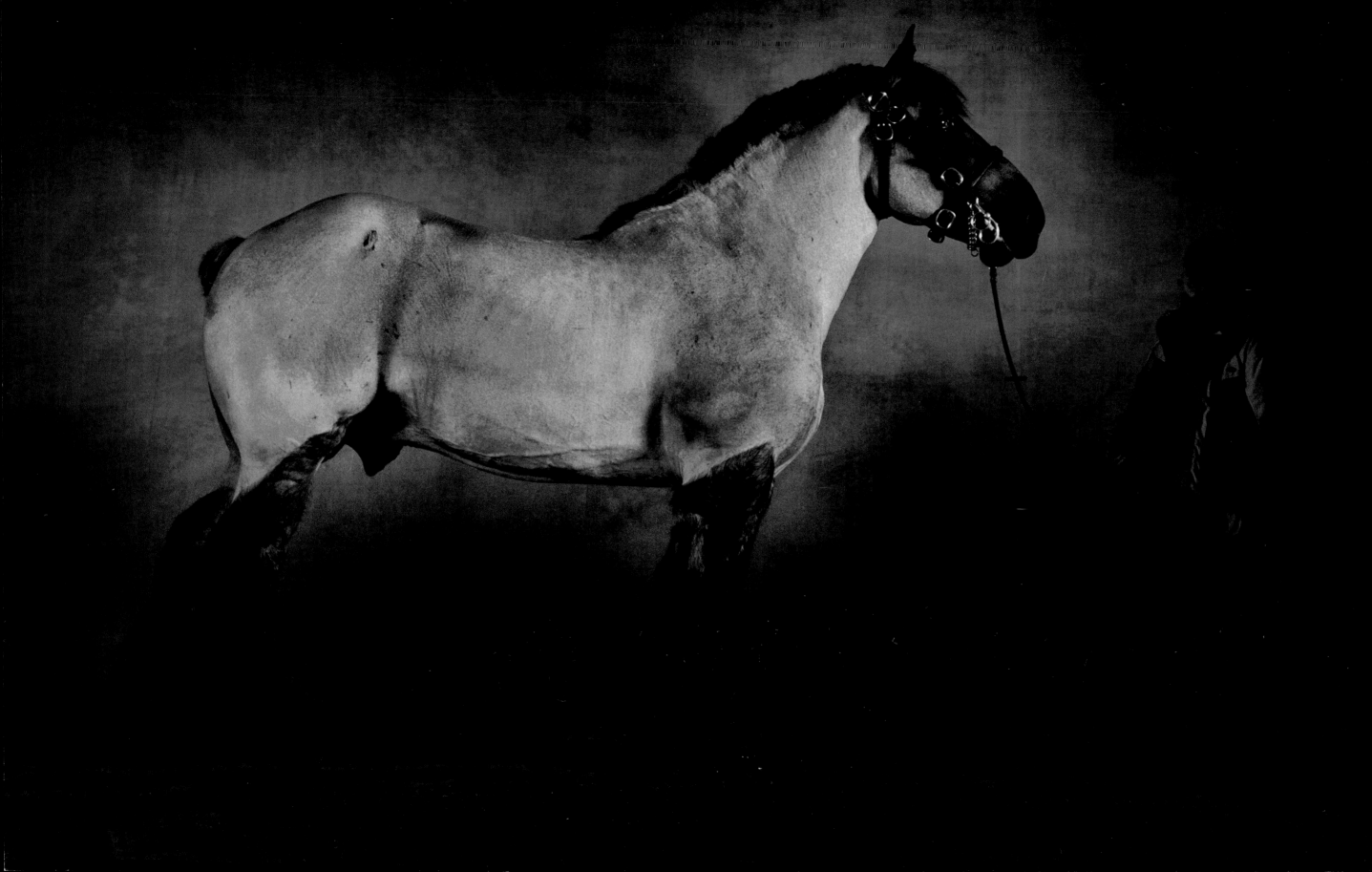

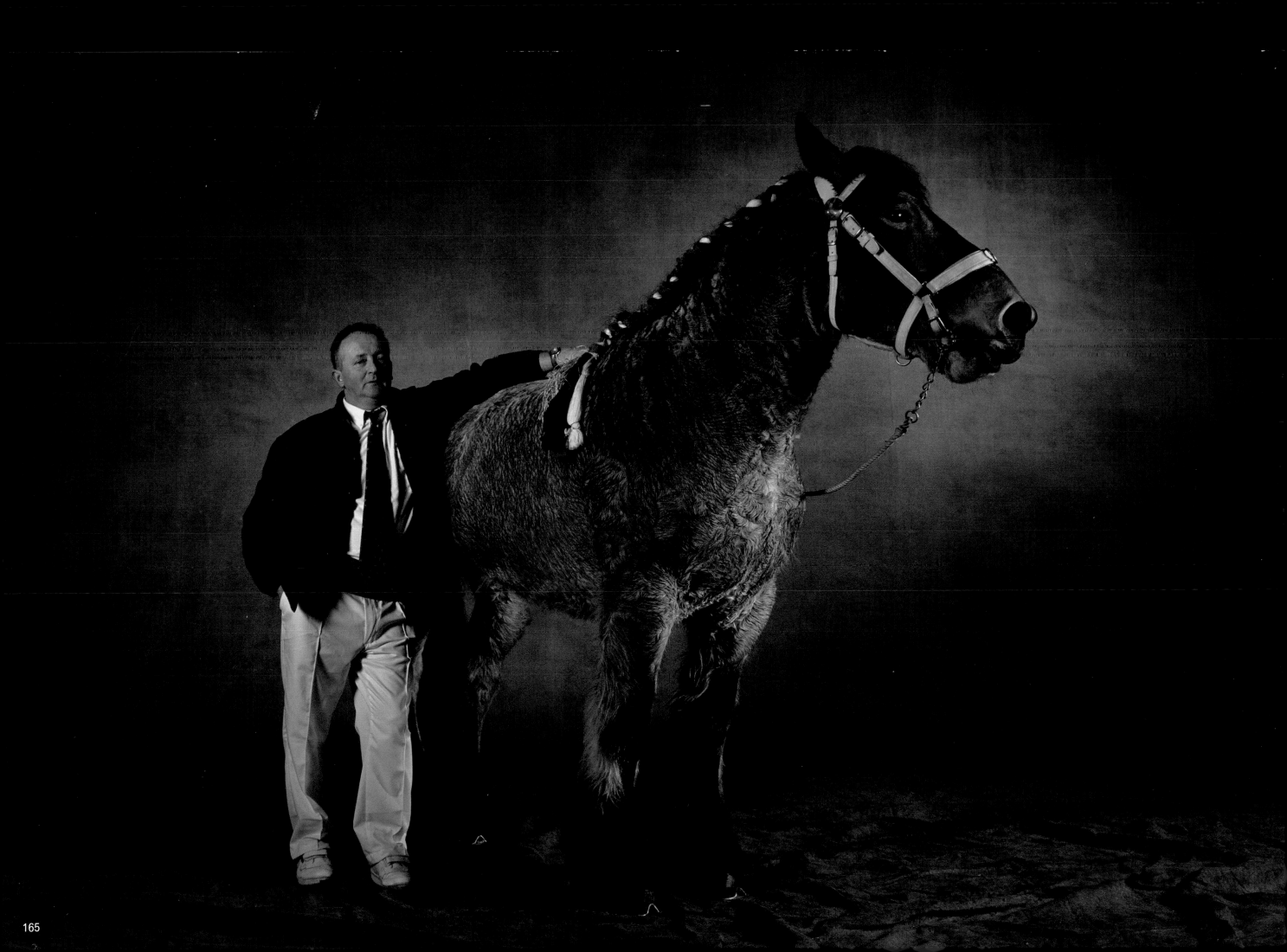

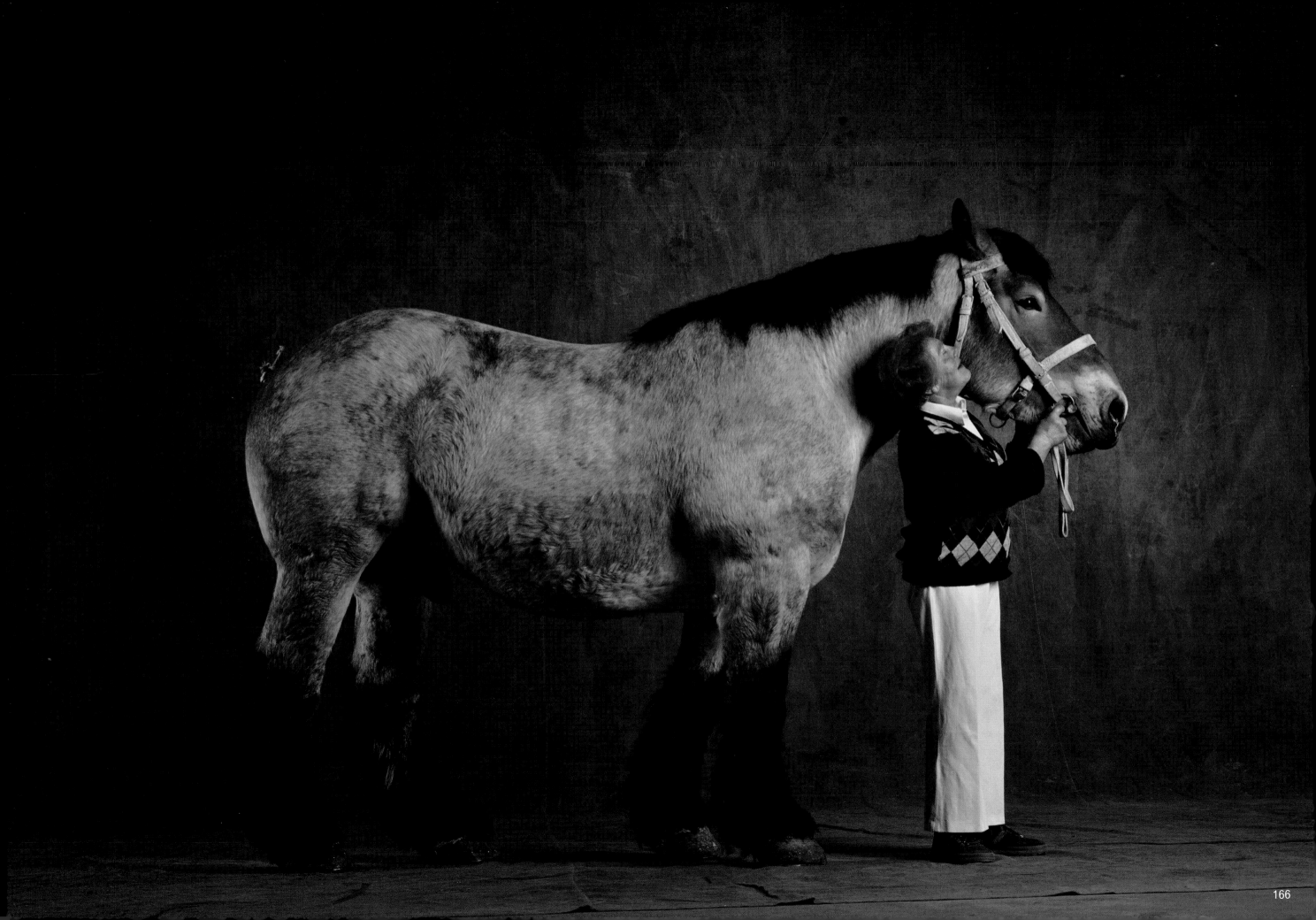

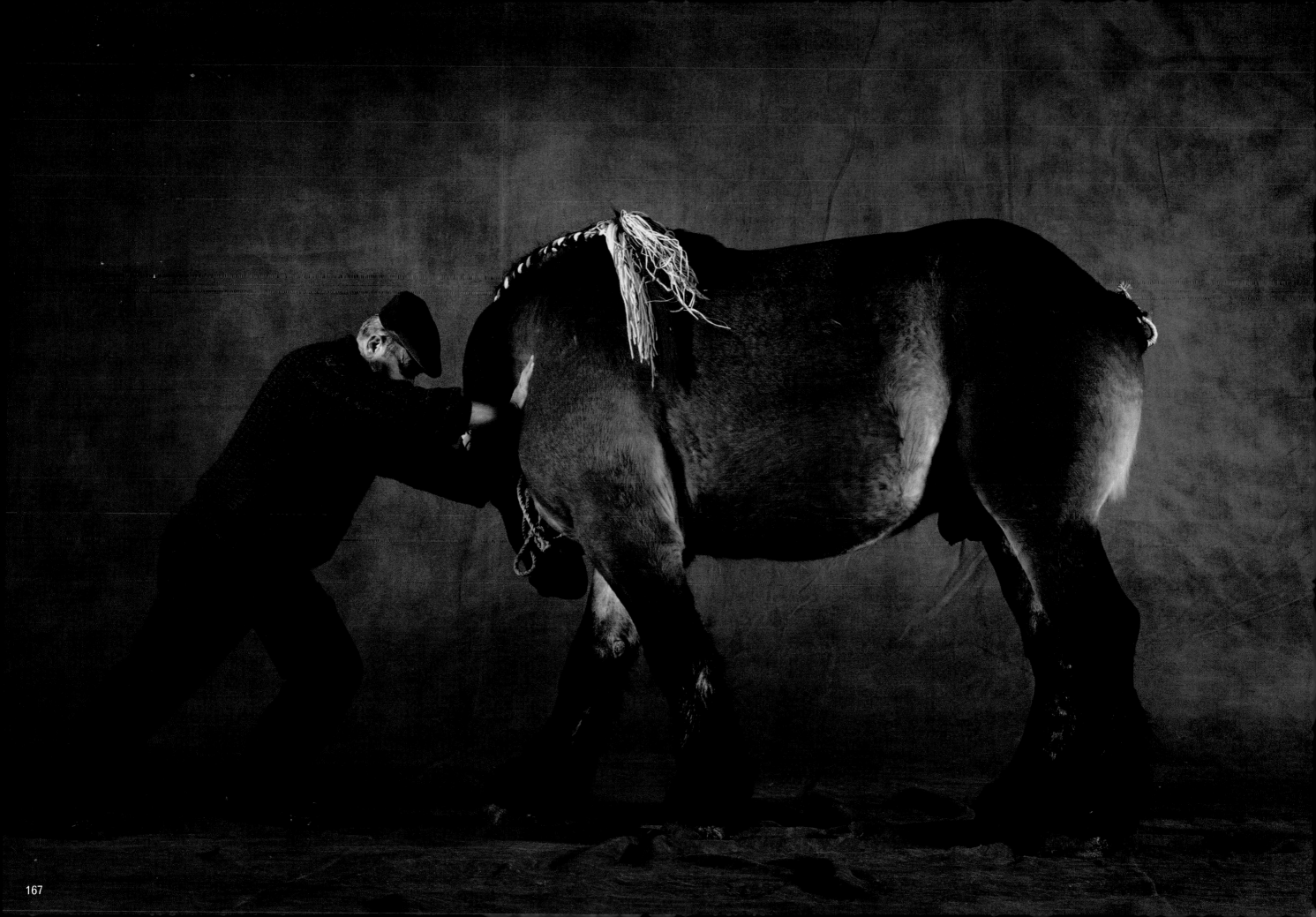

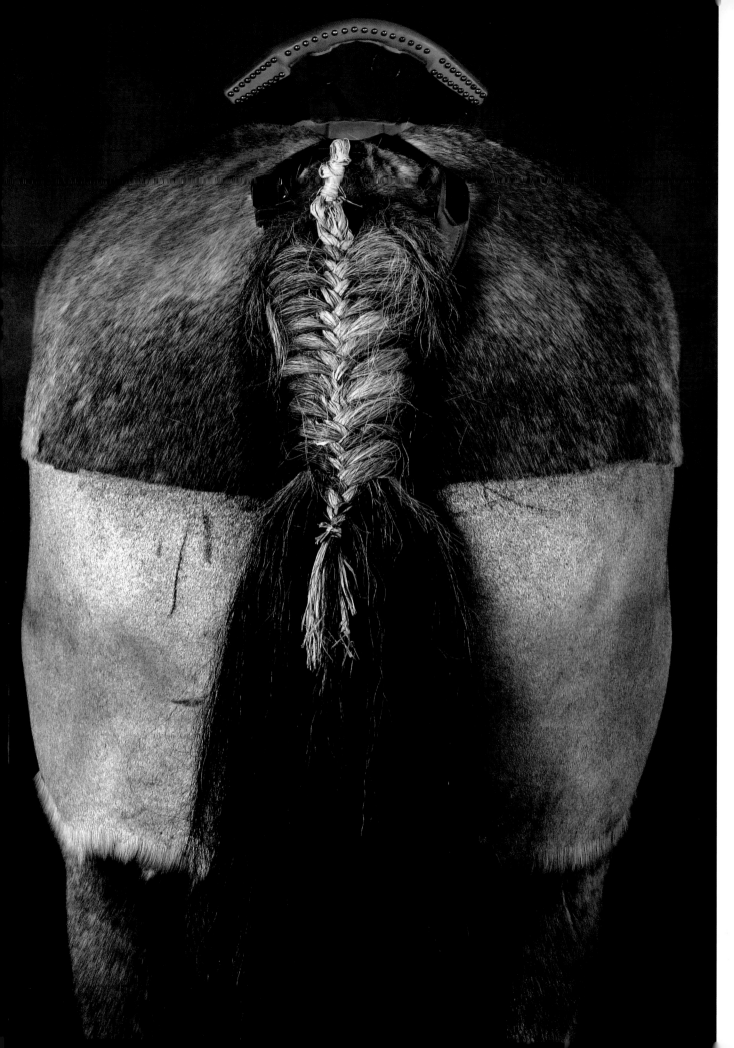

Belgium: home of the draft horse

The saying "no one is a prophet in his own land" could be applied to the Brabant (or Brabançon). Thanks to its particular characteristics and potent genes, this ancient breed, originally from the heart of Belgium, has contributed to the stock of most other European heavy breeds at some time or other, although it has now almost disappeared from its own country.

The Brabant has been sought after for centuries by breeders from all parts of the world, and it has been crossed with mares throughout Europe and as far afield as Russia. The Shire, Clydesdale, Irish Draft, Trait du Nord, Suffolk Punch, Rhenish Heavy Draft and Ardennais are just some of the breeds that owe the Brabant a great deal.

The success of this powerful breed is owed to the early establishment of its characteristics in the Middle Ages. Bred in Flanders and the Brabant, it was known at that time as the "Flanders Horse." Thanks to the heavy soil of these regions, it developed great flexibility in the knees, enabling it to pull its legs with ease out of the muddy morass into which the broad clay plains of the region descend when it rains. It was a trait that was carefully encouraged by the local breeders. At the end of the nineteenth century the classification of the breed was officially drawn up and subdivided, with few variations, into three Brabant types: the large Gros de la Dendre, with its light bay coat, the Gris de Hainaut or Gris de Nivelles, with a gray, roan or strawberry-roan coat, and the dark bay Colosses de Méhaigne type.

These three breeds generally shared the same characteristics, which made them suitable for heavy agricultural or forestry work and all kinds of transport needs. They remain hardy and docile, stolid, tough, uncomplaining and undemanding. Their hauling power is immense and rivals that of the Shire. Today, the cross of these three Brabant breeds is known as the Belgian Heavy Draft.

Certainly the Brabant—or Belgian Heavy Draft—is less lively than some of its rivals, to the extent that it could be described as phlegmatic, if not downright lethargic. Nevertheless, the Brabant and the many breeds to which it has contributed are much loved. Among them, the Trait du Nord deserves mention, crossbred originally from two heavy-horse champions, the Ardennais and the Boulonnais.

In a report to the Equestrian Congress of 1912, Monsarrat, one of the founders of the breed's stud book, defined the Trait du Nord as "an enlarged Ardennais, made fuller, taller and finer by the infusion of various bloodlines. While it is undoubtedly true that in many aspects it resembles the Belgian horse…it is particularly distinguished by its refinement and energy."

The extensive development of sugar-beet cultivation in the north of France, on the border with Belgium, played a considerable part in the birth of this new breed. The proximity of these two regions and their reliance on the heavy horse led to the frequent exchanging of mares and stallions between the breeders of the two neighboring countries.

On the French side it was clear that powerful horses were needed, not only for the deep-plowing of wet, heavy soil, but for pulling heavy loads of beets, stacked in wagons grossing five to seven metric tons in weight, to the sugar refineries at harvest time. Since the local French horses lacked the size and weight for this task, Belgian breed-

ers were called in to help, and with great success—and so it was that the Trait du Nord continued the Brabant bloodline but on French soil.

A fine example of the Trait du Nord stands 15.3–16.1 hh (63–65 in), and by five years of age a stallion or gelding weighs around 2,000 lbs (900 kg). The mares are hardy and solid and, even when in foal, can carry on working right up to the moment of giving birth without mother or foal coming to harm.

Of course, like all breeds, the Trait du Nord does have its detractors. It has been called lethargic, a criticism that has been applied equally to the Brabant. However, it seems that although this was the case when the breed was first introduced, when the search for strength was paramount, from 1903 onwards the tendency towards lethargy began to be corrected.

Unfortunately, the two World Wars that ravaged the north of Europe and curbed cross-border relations were very damaging to both the Trait du Nord and its breeders— all the more so since a regular input of Belgian blood proved to be necessary to keep intact the breed's qualities, which tended to be weakened by the effects of the locality.

166. *Bonar du Moulin*, a three-year-old **Ardennais** stallion, lovingly presented by his owner Céline Blaise.

167. The three-year-old **Ardennais** stallion *Espoir des Joncs*, presented (with some difficulty) by his owner Pol Gonnet.

168, 169. *Ludivine du Roseau*, a five-year-old **Trait du Nord** mare (by *Espoir de Bouvines* out of *Divine du Roseau*), owned by Claude Lemaire and presented by Bernard Bazelis.

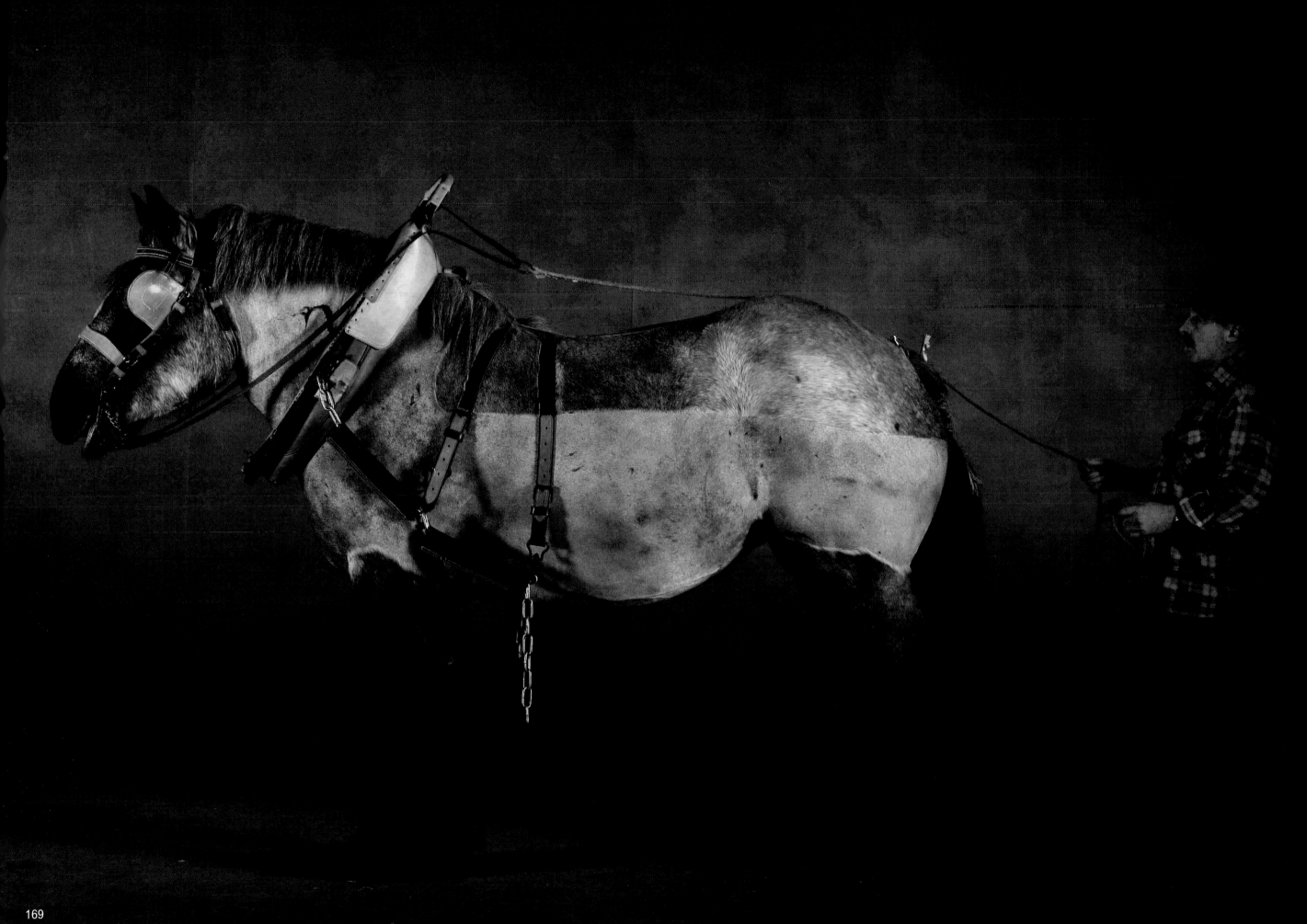

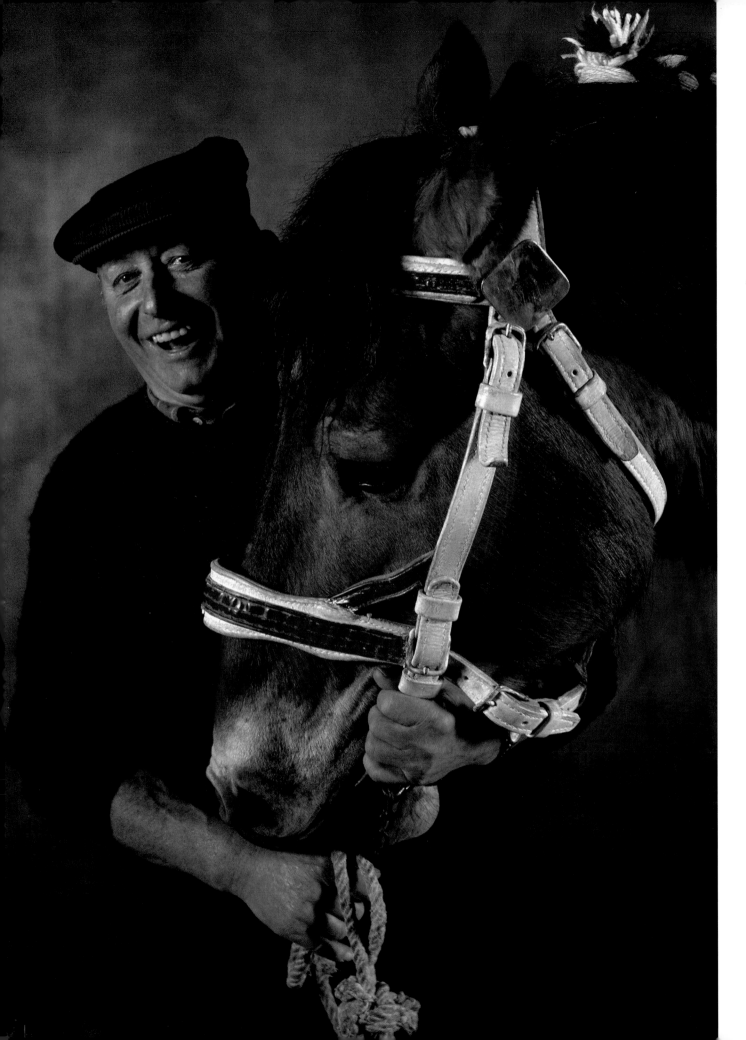

The Ardennais: the perfect workhorse

If the Brabant appears as a kind of common grandfather to a number of European heavy-horse breeds, the Ardennais seems to be the Brabant's ancestor. After all, it can trace its ancestry (just as the Camargue, the Pottok and others besides them) to the Solutré horse, whose remains have been found in quantity at the base of the Solutré cliff in Mâcon. The Ardennais takes its name from the Ardennes, the region adjoining the Franco-Belgian frontier that is considered to be its true birthplace. The origins of its line stretch back to the Quaternary period and the creatures that lived in the Rhone, the Saone and the Meuse basins. It was one of the first horse breeds to be domesticated, with its size and weight developing gradually over the ages. Archive documents reveal that by Roman times the Ardennais had made such a name for itself as a hard worker that Caesar's armies employed it too.

Much later, in the nineteenth century, breeders established its characteristics by gradually phasing out all crossing with animals from outside the region and only breeding from animals born and raised on home ground. Hailing from this large forested region in the southeast of Belgium that stretches into northern France and Luxembourg, the Ardennais has evolved into the splendid breed of heavy horse that we know today.

Its characteristics were originally determined by the climate—the long, cold, rainy and snowy winters of the Ardennes and the short but hot summers. As months of fine weather were relatively few and far between, the Ardennais was obliged to work very hard for most of the year, necessitating good health and a high level of fitness.

The rugged terrain that covered much of its territory, with its steep-sided hills and deep valleys, also played a part in the development of the breed, demanding great strength and energy. With an obedient and calm nature, the Ardennais became the perfect workhorse, ready to take on whatever tasks were demanded of it with skill and dexterity.

Physically, the Ardennais has a compact and muscular body with an energetic and rather long gait and a strong head with an alert and friendly expression. The horse stands 15.1–16.1 hh (61–65 in) and weighs about 2,000 lbs (900 kg).

It is easy to understand why the military also made use of the Ardennais. It appears that in 1812, during Napoleon's retreat from Russia, the Ardennais were the only horses able—albeit with great difficulty—to haul back to France some of the artillery and other heavy equipment. At the beginning of the nineteenth century, crossed with the Arab as well as the Boulonnais and the Percheron, the Ardennais gave rise to the three bloodlines for which it is known today: the old type

raised in the Vosges and Lorraine, and now very much reduced in numbers; the blood-line from the north known as the Trait du Nord, a strain made heavier by the addition of Brabant blood; and lastly the Auxois, a very heavy draft horse.

170. *Espoir des Joncs*, a three-year-old **Ardennais** stallion (1,587 lb/720kg), and his owner Pol Gonnet.
171. *Hercule*, a two-year-old **Ardennais** stallion presented by his owner Émile Peupion.

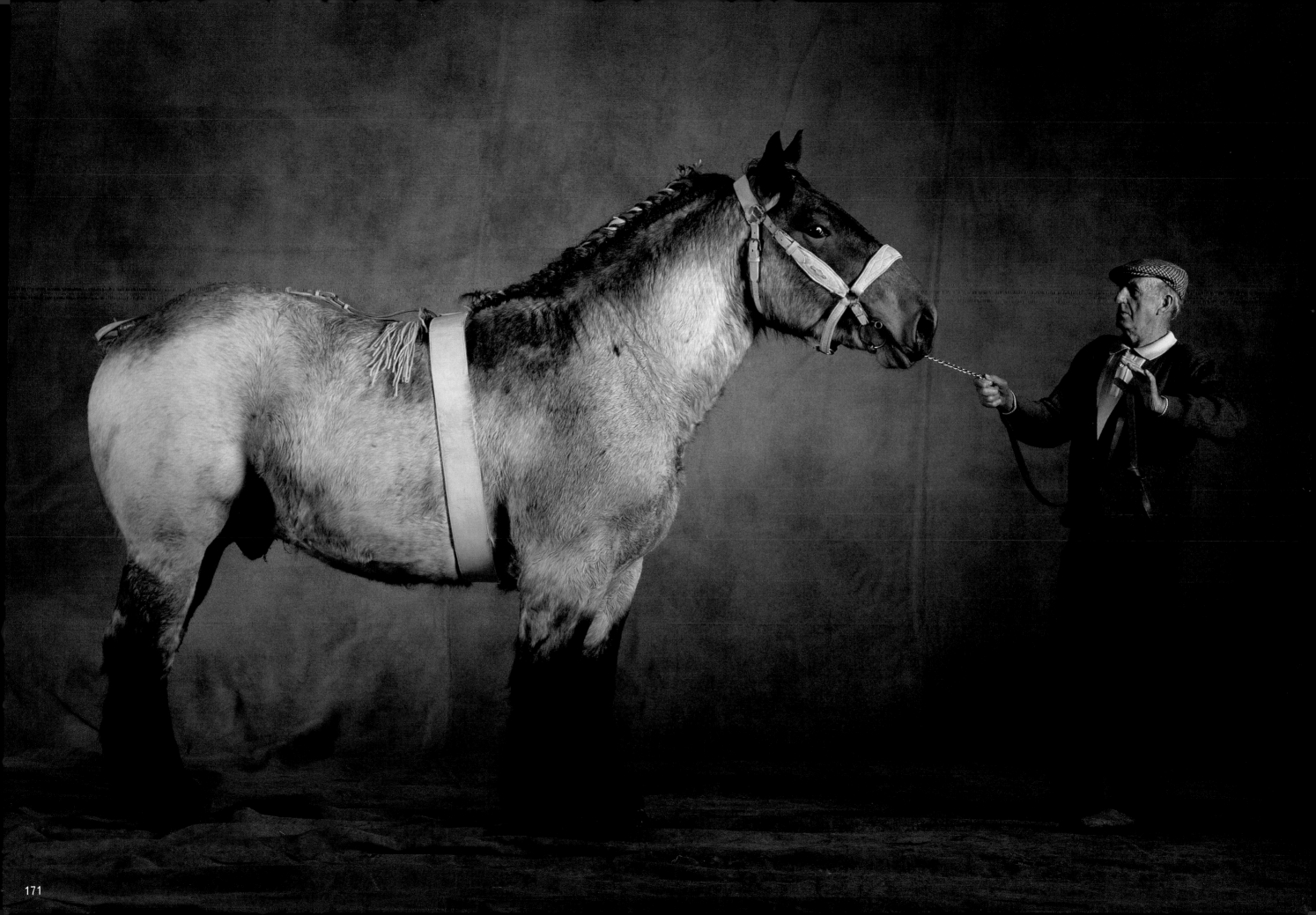

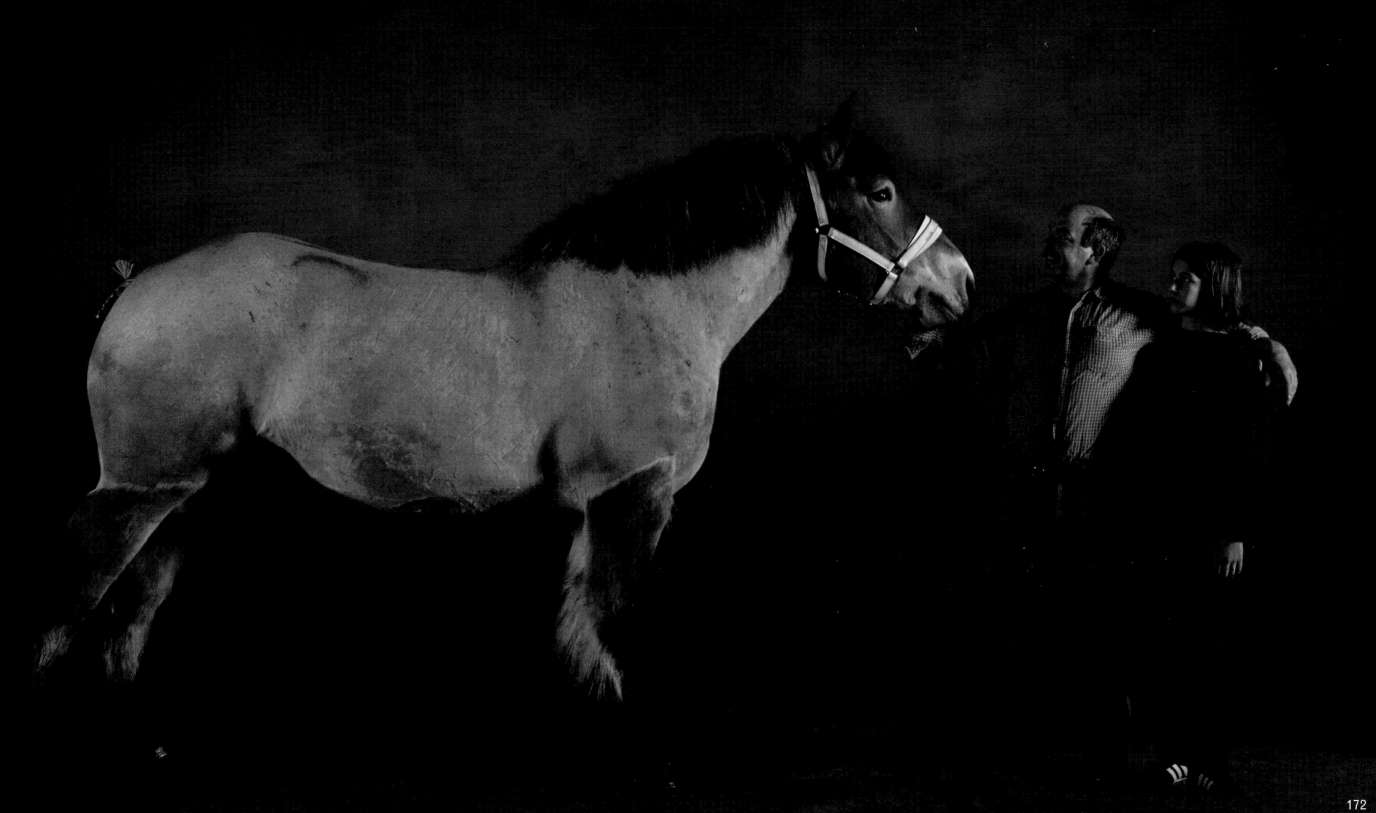

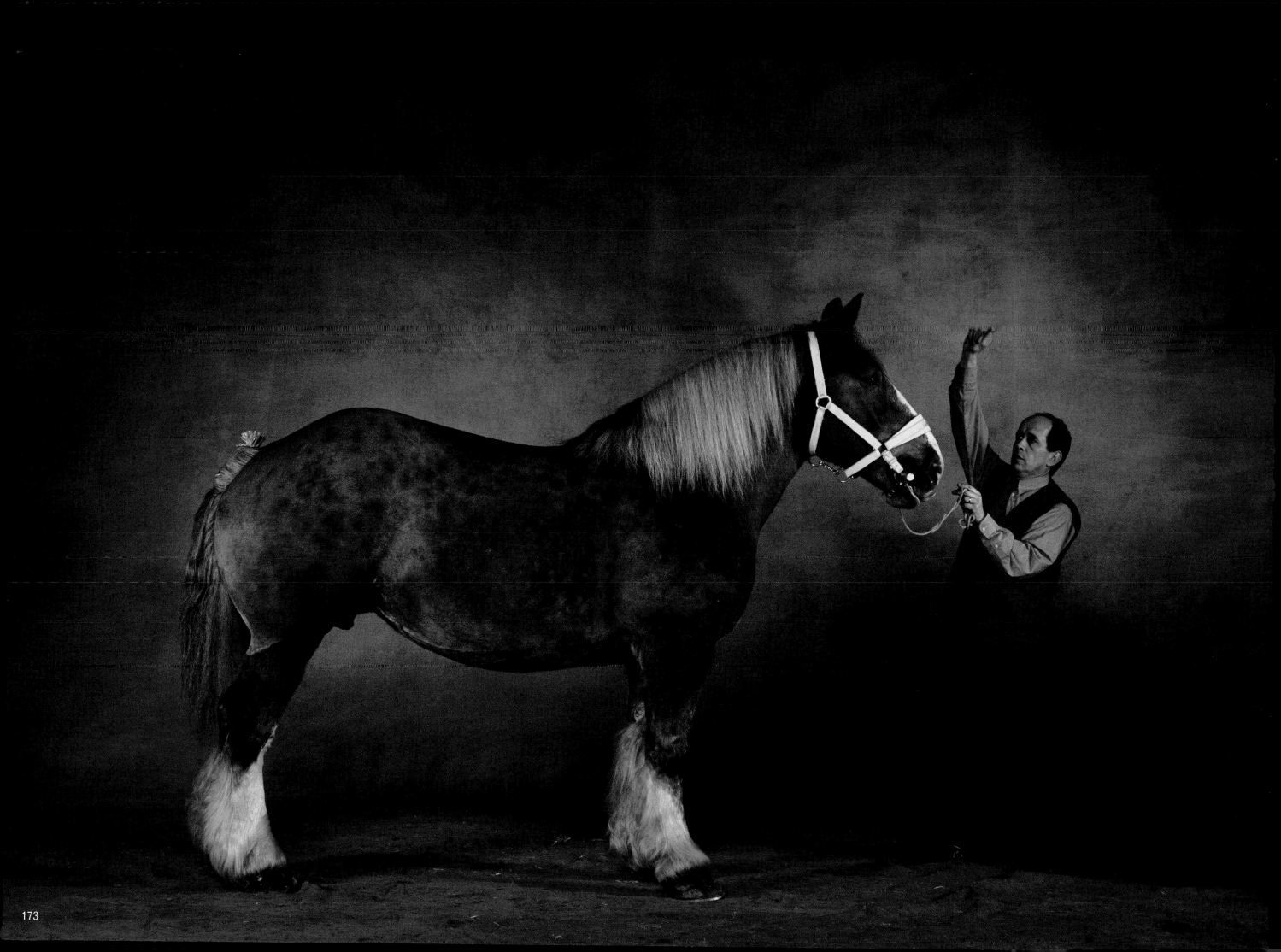

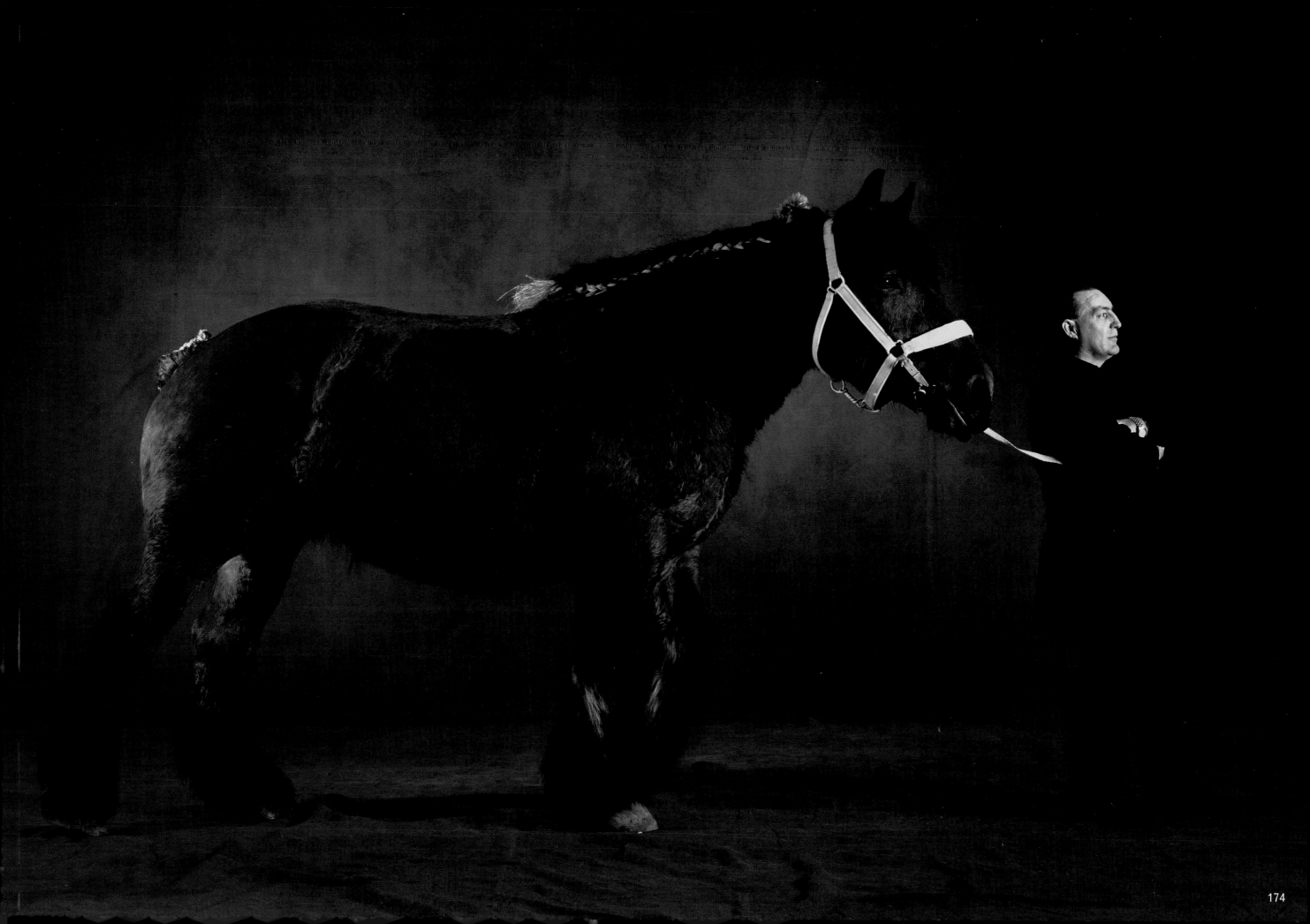

The Auxois: an unlikely racehorse?

You might think that, as with other breeds of heavy horse such as the Augeron, the Nivernais and the Trait du Maine, the Auxois line would have petered out slowly and quietly in the depths of its native territory in Burgundy, but in this instance you would be quite wrong.

Documents relating to the oldest racecourse in France are held in the municipal archives in Semur-en-Auxois on the Côte d'Or, the hillside region in Burgundy where many of France's finest wines are grown. According to local history, for years the townsfolk held an annual foot race at a large fair that took place in the town on the day after Pentecost. The winner received a pair of knitted hose, "supplied by the shopkeepers and paid for by the guilds."

On June 16, 1639, faced with the problem of attracting more custom for the fair, the town magistrates decided to organize a horse race in addition to the traditional foot race. By 1652 the winner's prize was "a ring of gold to the value of fifteen pounds," the runner-up received a sash of white taffeta and the third a pair of gloves. And so the Course de la Bague (or "Race of the Ring") was born.

Since then, with the exception of a short period between 1794 and 1804, when horses were requisitioned by the army, the race has been a yearly event, eventually moving to its present date of May 31. In 2002, the Course de la Bague took place as usual, but this year there was a difference. The race had previously been run with saddle horses only, but in 2002 local heavy horses were included for the first time.

Burgundy, the native region of the Auxois, is considered one of the most beautiful and fertile in France, its rich soil providing abundant grazing for both Charolais beef cattle, a speciality of the region, and for the raising of sturdy foals.

The Auxois breed was the result of a cross between the Ardennais and a local horse, the old Bourguignon breed. Very little is known about the latter except that it was smaller and lighter than the line it helped to found and was used in harness as well as for work in the fields and woods.

As elsewhere, the industrial revolution that took place in the nineteenth century and the accompanying modernization of cultivation methods created the need for a heavier and more powerful horse. Today, the Auxois stands at 15.3–16.2 hh (63–66 in) and has a coat that is normally bay or roan.

In 1913, the Auxois Horse Breeding Society (founded in 1900) succeeded in establishing a breed stud book, which it continues to promote today. And, in 1993, milk from Auxois mares was sold commercially for the first time. Apparently it is an excellent remedy for certain digestive ailments. Thankfully, rather than face the butcher's block, the Auxois continues to thrive today in its homeland.

172. *Koniz du Val*, a four-year-old **Auxois** brood mare, owned by Michel Petit and presented by one of the principal organizers and backers of the Course de la Bague, Michel Cortot (and his daughter Delphine).

173. *Helena*, a seven-year-old **Auxois** brood mare, presented by her owner Pierre Pasdermadjian.

174. The seven-year-old **Auxois** brood mare *Duchesse*, breed champion in 1997, proudly presented by her owner Abel Bizouard.

175. *Igloo*, a spirited six-year-old **Auxois** stallion, owned by the Cluny National Stud and presented by Thierry Gallet.

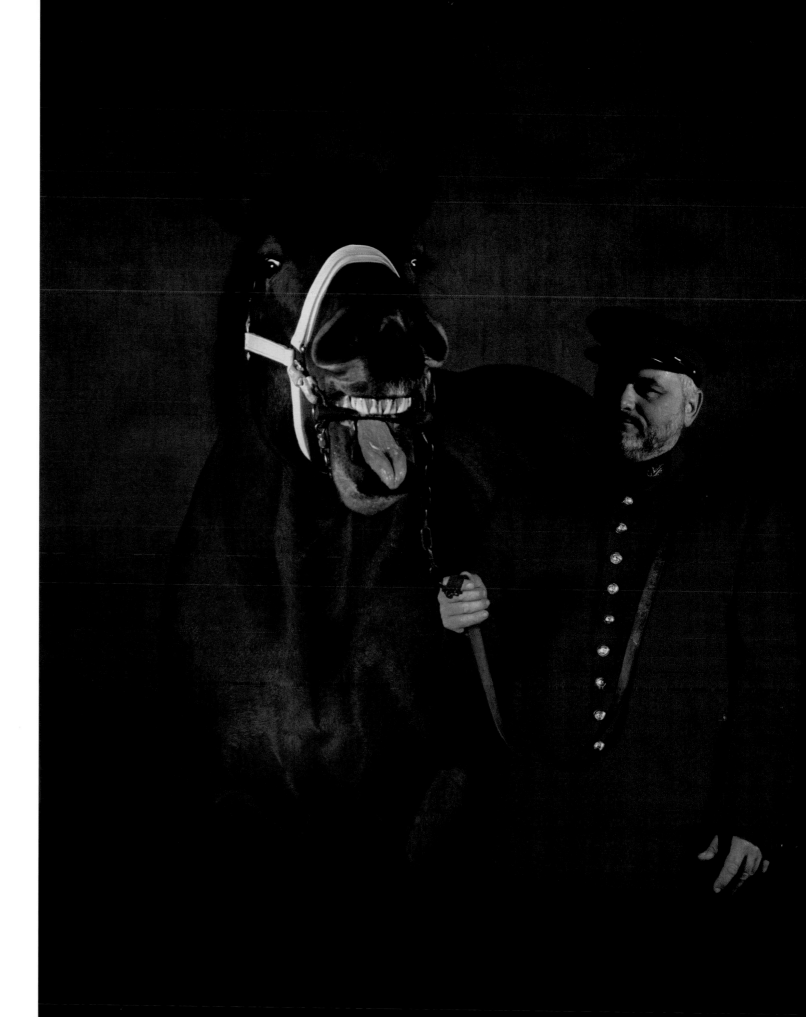

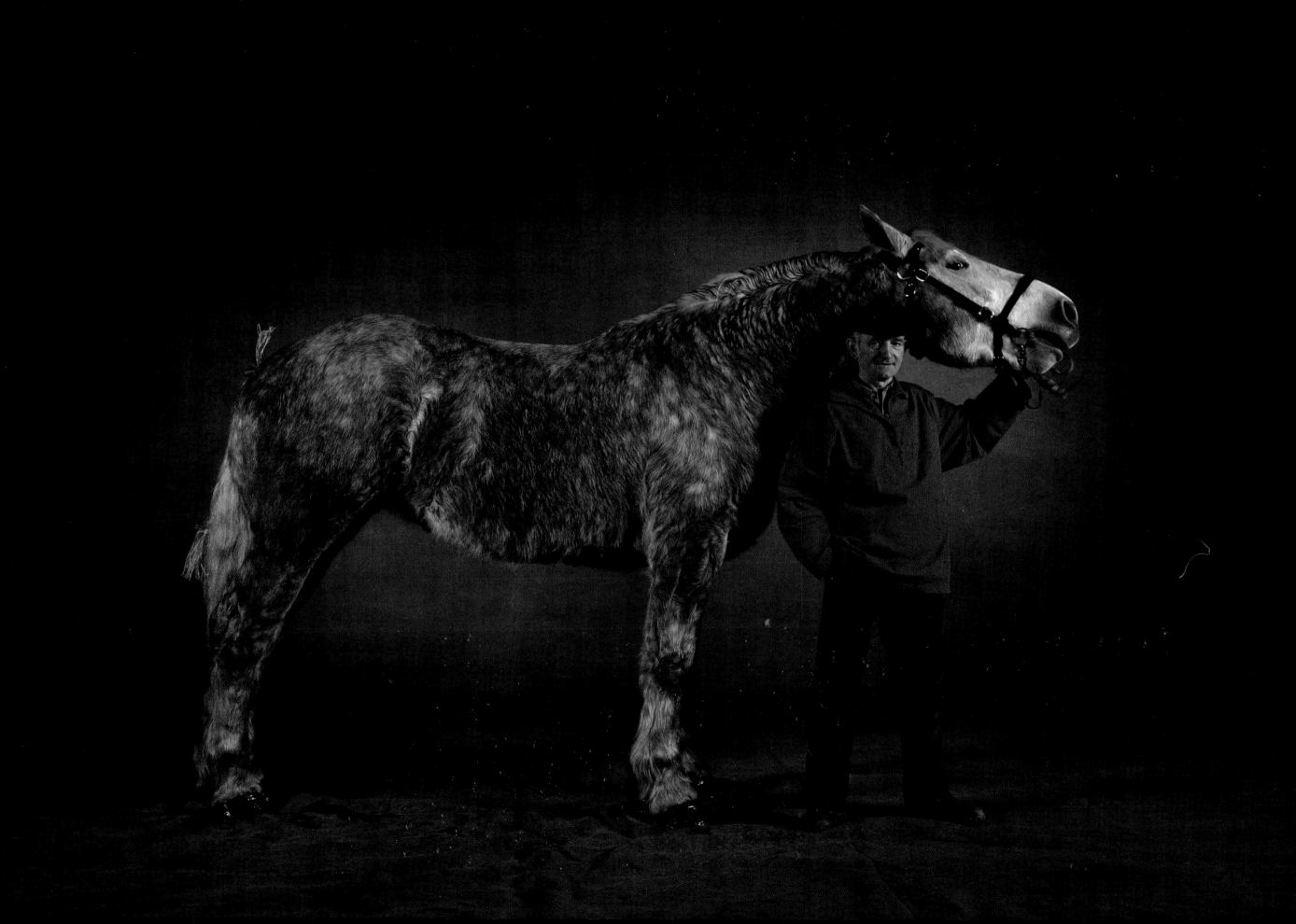

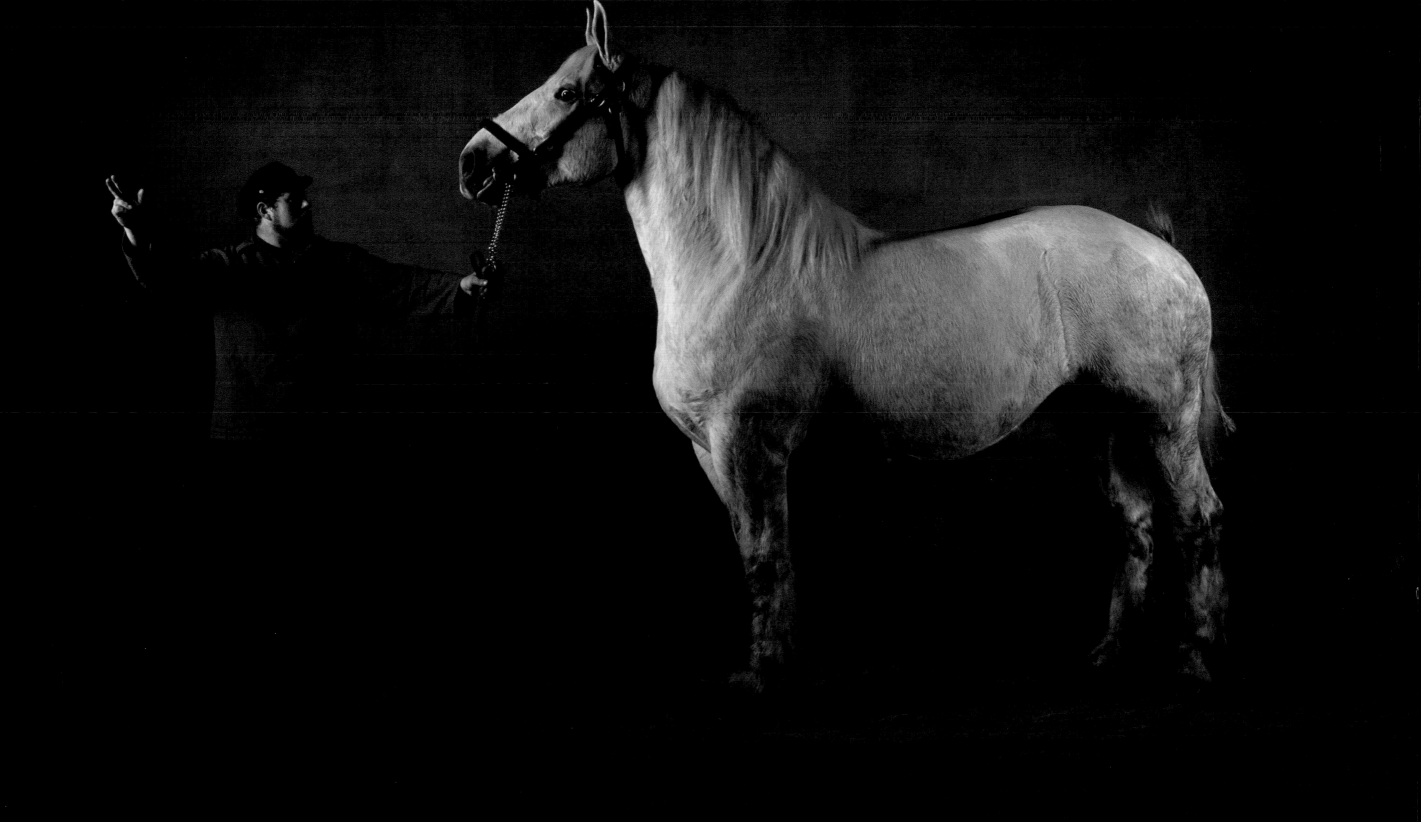

The Boulonnais: tough and enduring

The origins of the Boulonnais present something of a conundrum. Do its roots lie in a British breed, as some maintain? Did it ever come into contact with the horses of the Roman cavalry? What about the old English black horse and/or the great horses of Northern Europe or the horses abandoned by Attila the Hun's army in the fifth century—have any of these contributed to the Boulonnais bloodline? How much do we really know about what happened to the Arab stallions and Barbs brought back from the Crusades in the eleventh century by French knights? There is even a certain amount of vagueness surrounding the first attempts at crossing the Boulonnais with stallions from Flanders. It was not until the beginning of the nineteenth century and the input of blood from Percheron stock that something about its lineage was finally recorded.

During the first half of the nineteenth century the condition of the roads in the vast stretch of land between the Belgian frontier and the Seine Estuary at Le Havre was improved considerably, and the development of commerce and industry led to an increased need for road haulage. As a consequence, between 1830 and 1846 the amount of horse-drawn traffic on the roads doubled. The breeding of light coach/draft horses naturally followed the same upward trend.

The breeders set to work in all the areas of northern France that were active economically—specifically those around Boulogne, the wider Pas-de-Calais region that borders on Flanders, Picardy and Normandy and the area surrounding Paris. The nature of the land was in their favor: fertile soil generally rich in phosphates, beneficial for the development of strong bones, and plateaus of light, easily maintained soil that supports the abundant cultivation of crops. They could also draw upon the local people's long experience of working with horses at a time when oxen were used to plow the fields in other regions. In the north of France it was the Boulonnais mare that pulled the plow.

After a great deal of trial and error, including several attempts with Belgian stallions, the breed was finally improved, notably with input from Percheron stock. The final result was the Boulonnais. The horse we know today may not be exactly the same as the one first produced in the nineteenth century, but it is not too far removed. A graceful and balanced breed, the Boulonnais is considered a model of elegance. An average Boulonnais stands at around 15.3 hh (63 in) and has a coat that is generally any shade of gray, from light to dark. Valued for its strength, in the past the Boulonnais proved its staying power by transporting fresh fish from Boulogne to the Parisian wholesale markets at a steady 10 mph (16 km/h) in the days long before motorized transport and railways. Since 1991, a biannual endurance race called La Route du Poisson ("the Fish Route") has been held, which retraces the original route and commemorates the sterling service that the Boulonnais gave to the French fish industry well over a hundred years ago.

176. *Kilda III*, a three-year-old **Boulonnais** mare, presented by her owner Martial Marie.
177. *Joyeuse Gibarlet*, a four-year-old **Boulonnais** mare, presented by her owner Franck Matte.
178, 179. *Idéal II*, a seven-year-old **Boulonnais** stallion, weighing 1,760 lbs (800 kg). This champion stallion of 2002 is presented by his owner Bernard Hochart (accompanied on the left by his wife, Francine, and his son Kevin).

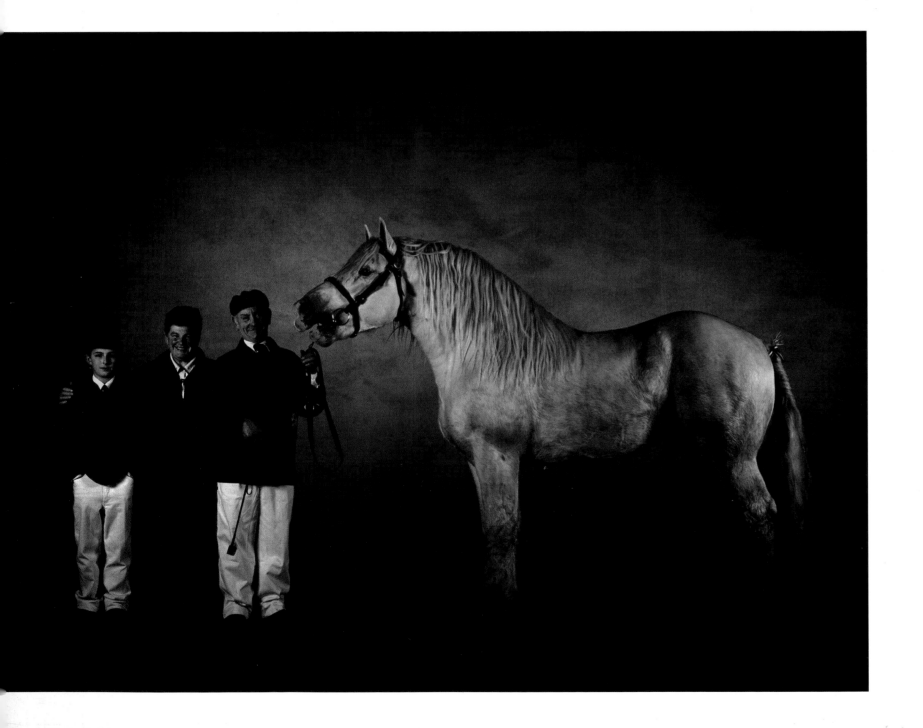

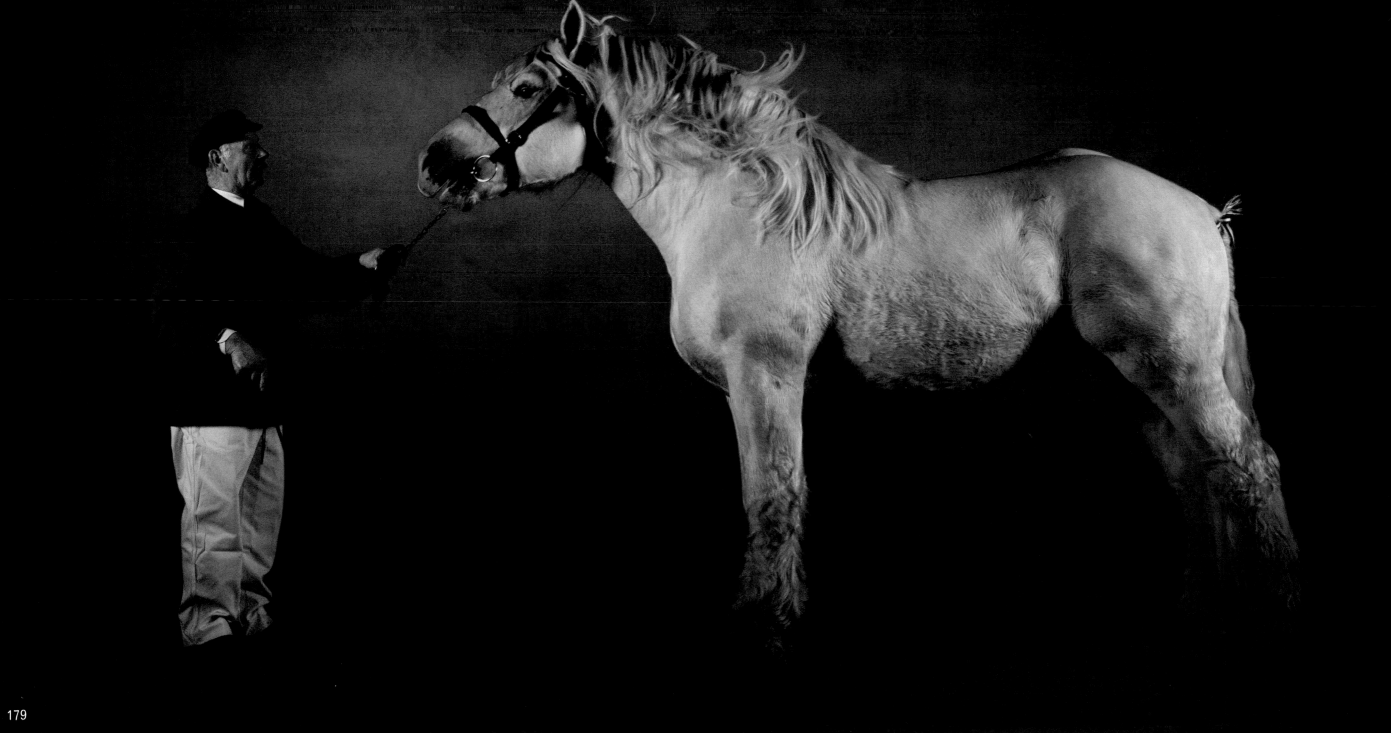

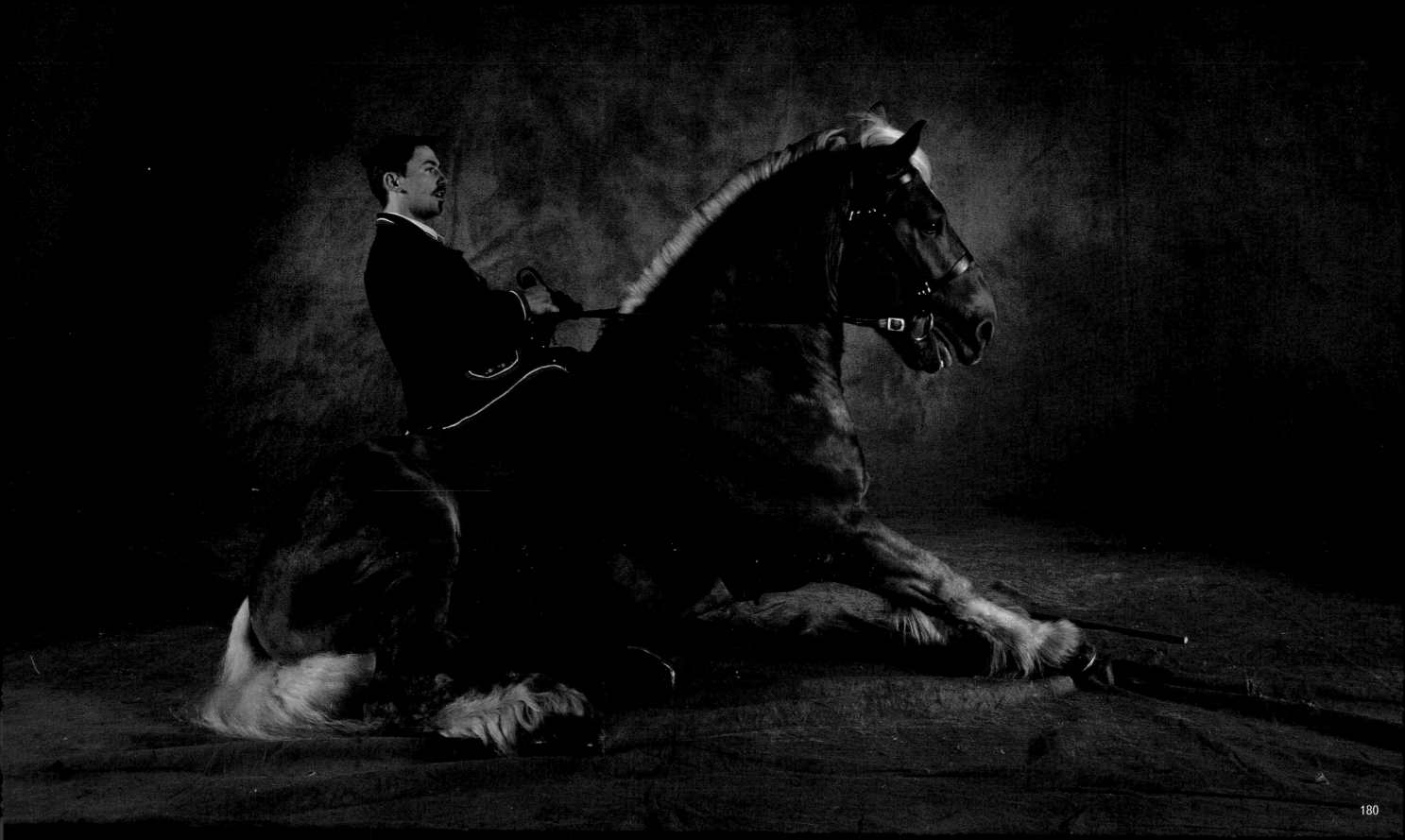

The Comtois: a French favorite

Franche-Comté, in the east of France, a mountainous region with a harsh climate, is home to the Comtois, a tough but active and surefooted breed with plenty of energy and character. Much loved by its owners, its well-made legs with solid bones mark it as a good workhorse.

Around 1905 a small Ardennais from Lorraine was selected as the best stallion with which to improve the local breed and raise its status to that of a true draft breed. The crossbreeding was a success and the Comtois stud book, opened in 1921, defined the breed in the following terms: "Average size from 14.3 to 15.3 hh (59–63 in), weight varying between 1,100 and 1,300 lbs (500–600 kg), coat generally bay."

Today, the breeding of the Comtois has been widely extended from its region of origin in the high Doubs to other mountainous regions, such as the Massif Central, the Pyrenees and the Alps. While the Breton remains the most widely found heavy horse in France, the Comtois comes a close second.
180. *Houblon*, an eight-year-old **Comtois** (by *Duc* out of *Duchesse*), presented by Jean-Louis Cannelle.

Brittany: "the mother of horses"

The day after the terrible storm of October 15, 1987, which ravaged Brittany and a large part of northern Europe, bulldozers were busy clearing the broken branches and trees brought down by the ferocious wind. However, due to the rocky nature of the terrain, the bulldozers were not able to penetrate off-road to clear away uprooted trees and vegetation. The obvious solution was to resort to traditional methods, so teams of Breton Heavy Drafts were made up and the debris was soon cleared.

The love affair between Brittany and its native horse is long-standing. Thanks to tradition and a natural predilection for the animal, the Breton people are great horse lovers. There is many a tale that alludes to what could be viewed as a rather excessive attachment by some owners to their horses—those at Saint-Pol de Léon apparently kept them in their homes, fed them hot food and entrusted them to the protection of their local saint, Saint Eloy (Eligius).

There is also the story of a prisoner who was working on a farm in Germany during World War II. One day he was kicked by a horse and cursed loudly in the Breton language. The horse, although known for its bad temper, pricked up its ears and calmed down at once. From that day onwards, the horse was a reformed character, at least as far as the Breton was concerned—it refused to obey any commands unless given by its compatriot in exile.

For centuries the undulating and sometimes wild landscape of Brittany meant that the horse was the only possible means of transport. In the Middle Ages the Breton peasants developed a breed of small but robust and compact horses that could be used both for riding and for carrying loads. The hard work in the fields was left to sturdy pairs of oxen, work to which they were better suited than the horses.

At the time there were numerous local types of the breed, but unfortunately the majority have disappeared over the years, as have, for example, the Trait du Cap, the Carrossier de Lannilis, the Criquet and the tiny Cheval d'Ouessant.

However, the Bidet, a particularly sturdy and resilient strain of Breton, managed to survive. Centuries later, Napoleon—who called it "the little Breton Cossack"—made great use of the Bidet in his cavalry.

Recently, breeders have developed two types of a Breton breed: the Postier Breton and the slightly heavier Breton Draft. Many attempts were made involving a number of different breeds before success was achieved—including crossing with Arab, Barb, Navarin and Limousin stallions, in an effort to inject some verve and distinction into the bloodline of the local mares. Danish and Norman coach horses were also tried, followed by the Norfolk Roadster. A cross with the Hackney gave the breed its fine, high action and later crosses with the Percheron, Boulonnais and Ardennais were also made. However, by the 1930s the breeders had given up on their attempts to introduce foreign blood into the stock and the Breton, like many others, was finally bred only from native stock.

Throughout the nineteenth century and during the first half of the twentieth, the breeders were in a frenzy of activity. The story goes that, when the vets responsible for the horses working in the mines in various regions of France pointed out to the mine supervisors that they were tiring their animals excessively, they always received the same response: "The mother of the horses is not dead: Brittany will provide more of them. . . ." They were right, and Brittany is still producing them today.

181. *Vivaldy*, a three-year-old **Postier Breton**, 2,090 lbs (950 kg), presented by his breeder Pierre Hameury.
182. *Kerenez de Kleg*, a three-year-old **Breton Draft**, presented by Jean-Luc Rauld.
183. *Manvers*, a three-year-old **Postier Breton**, 1,870 lbs (850 kg), breed champion at the Cordenas regional show in 2002.

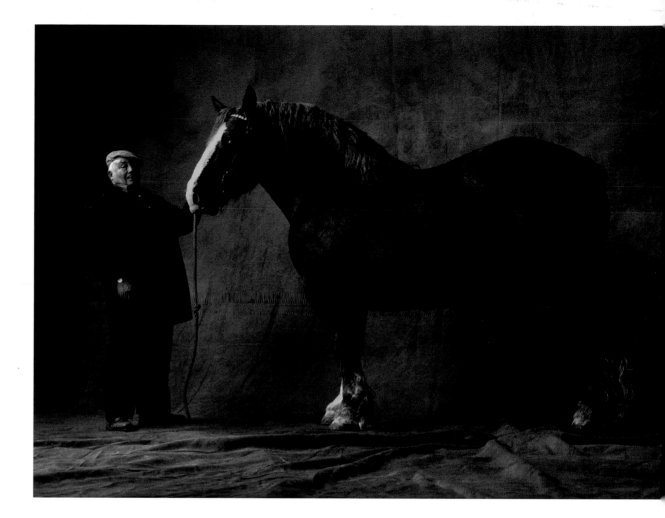

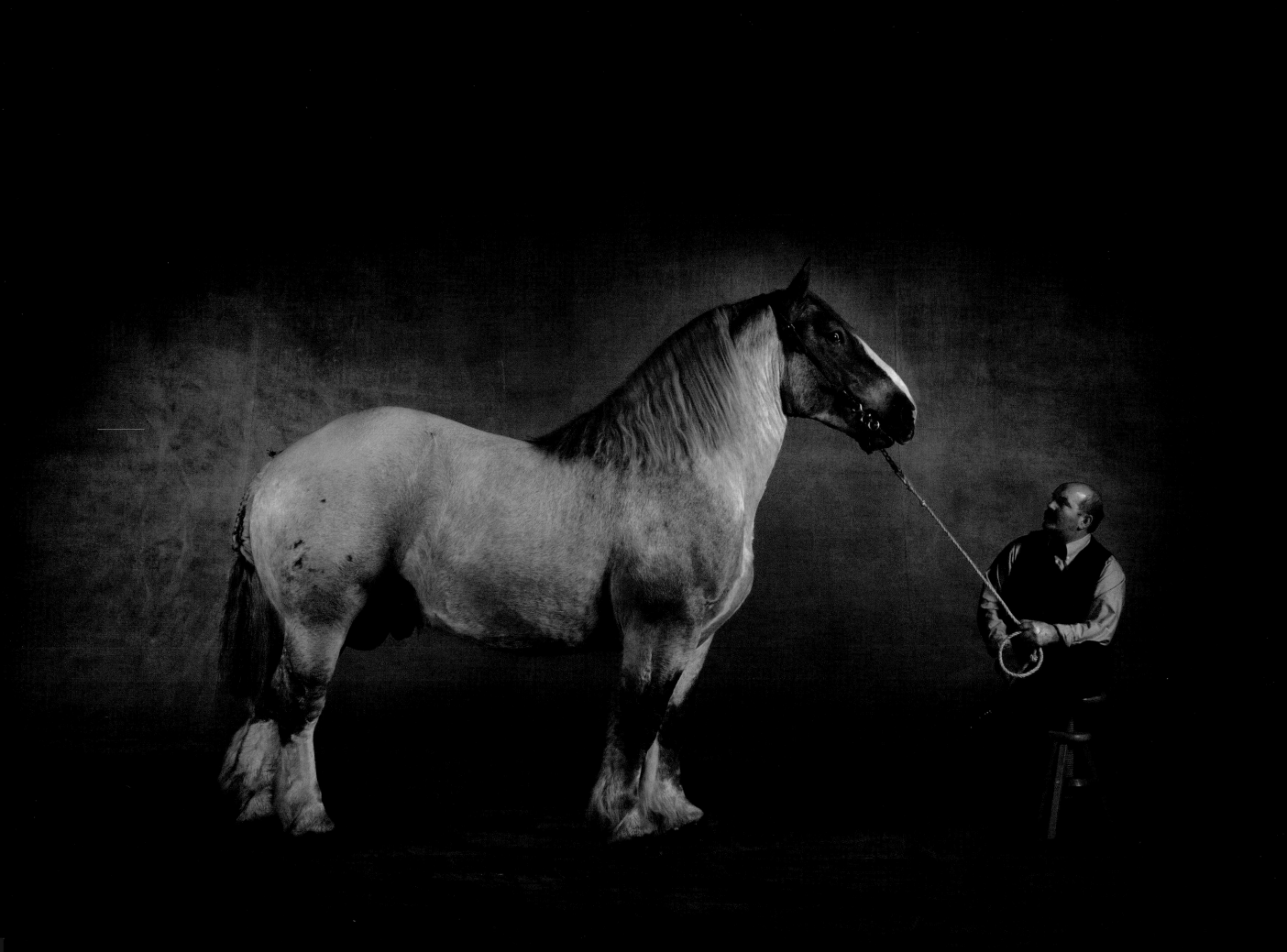

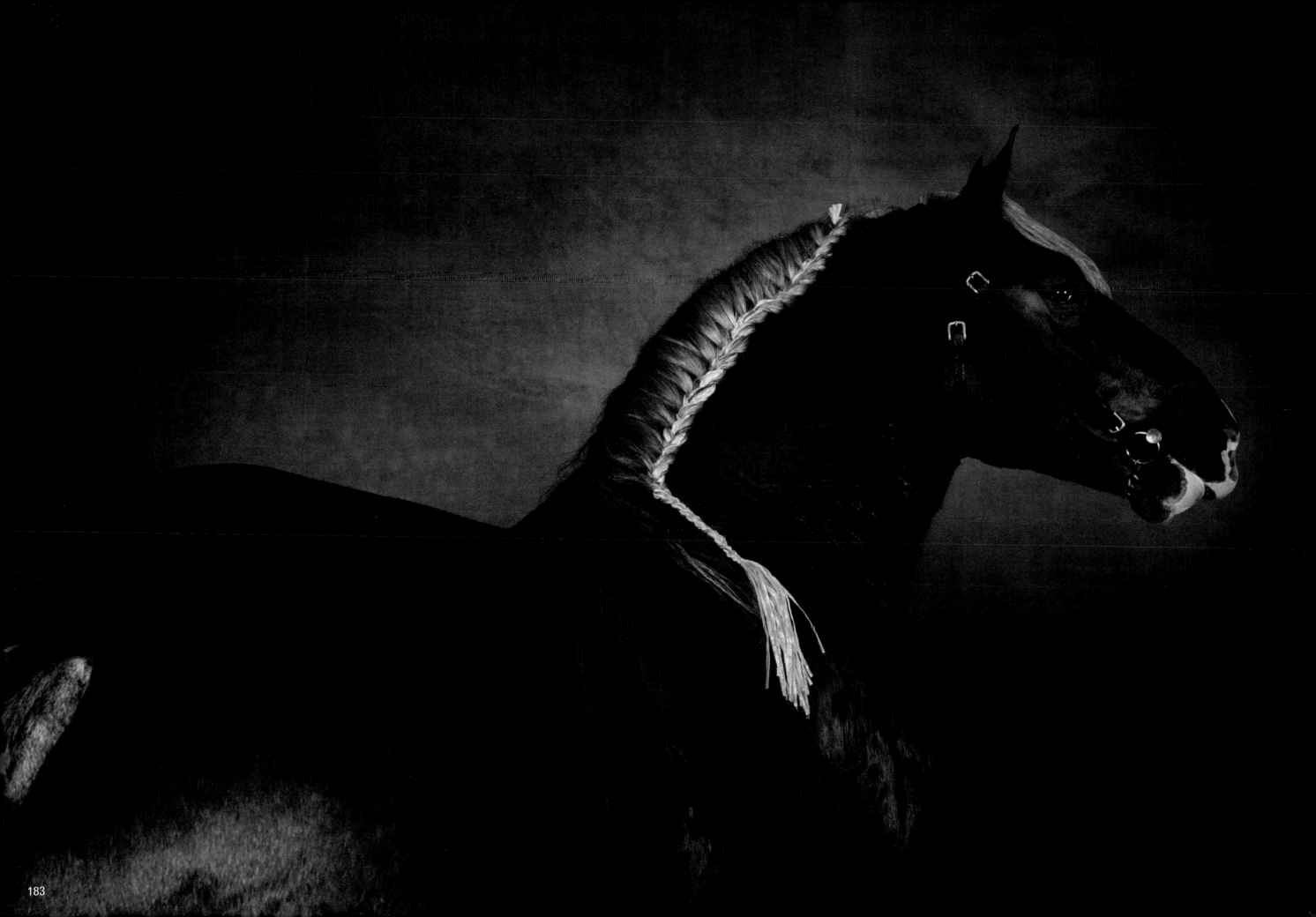

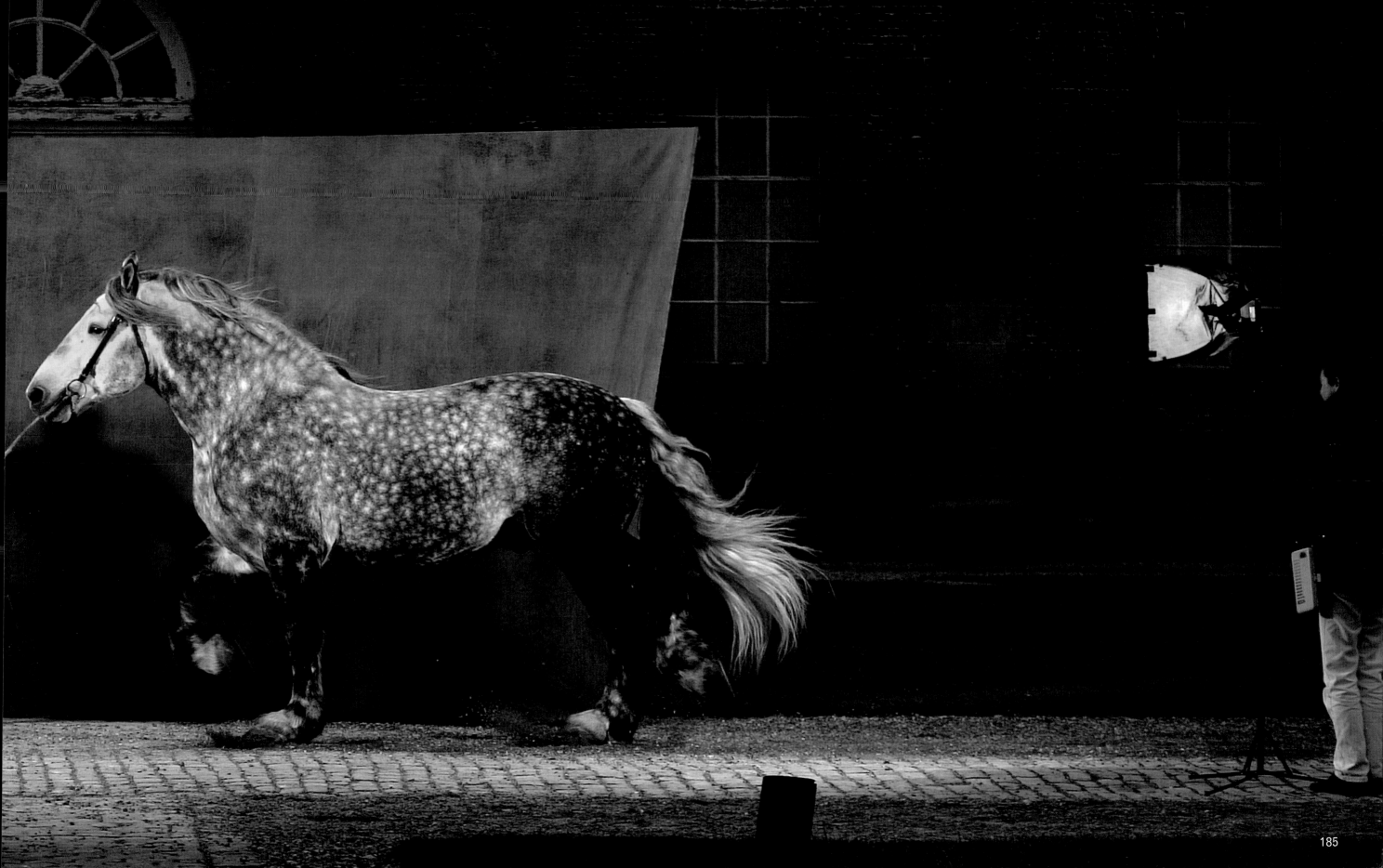

The Percheron: king of the heavy breeds

Which horse is deemed the archetype of all breeds, the epitome of the equine race and a point of reference for all breeders? It has to be the Percheron. Known throughout the world, its name has become synonymous with the heavy draft.

French in origin, its line has been enriched and improved by Eastern blood, to the extent that it has even been called "an Arab breed." There is a grain of truth in this, even if it did not happen exactly according to the legend. The story harks back to the battle of Poitiers, to the return from the Crusades of the counts of Le Perche, and to incursions by the Norman counts of Bellême into Spain. One thing at least is certain: it was during the eighteenth century and at the start of the nineteenth century that some new Arab strains were introduced to establish the characteristics of the Percheron, notably its famous dapple-gray coat.

In spite of the tales surrounding the origins of the Percheron, the fact remains that the local breeders knew perfectly well what they were doing. The quality of the local breeds, the expertise of the breeders and the effects of the terrain and the climate, which were manipulated skillfully, all played a large part in the success of this breed.

The relationship between horse and land has been mutually beneficial. The fertile and rich earth of the Orne, Sarthe, Loir-et-Cher and Eure-et-Loir regions has bred strong and powerful animals, while the land itself has profited from the hard work and legendary power of the Percheron.

It is generally agreed that the breed began with *Jean-le-Blanc*, born around 1824 and sired by an Arab stallion belonging to the French national stud of Royal du Pin. *Jean-le-Blanc* lived to the advanced age of thirty-two and died with an unblemished record. An official from the stud farm said of him at the time: "Although heavy and powerful, a true draft horse, there is something quite unique about his bearing. He possesses the characteristics of the breed so completely that people are inclined to take him for a large Arab." This would seem to be an accurate judgment of this magnificent animal. It confirms that its working role has not impaired its development in any way— neither curbing its formidable energy, nor erasing the distinctiveness that is the result of its distinguished bloodline.

Its success was predictable, and today the Percheron is the most popular heavy horse in the world. It has been exported across the continents, acclimatizing with ease to its surroundings and impressing everyone with its sense of contained power and its attractive and noble bearing. It was back in 1839 that the first Percheron was exported to the United States, where it remains very popular.

Percherons are as prolific as they are strong and healthy and have given rise to other Percheron types. The Auge, Berry, Loire Nivernais, Bourbonnais and Maine are all descended from it. With its robust good health and generosity of character, the Percheron has come to represent the fertility and richness of the land from which it is bred. The hedges surrounding the pasture help to shelter it from cold winter winds, while it owes the solidity of its bones to the chalky soil of its homeland. It is thanks to the skill of the breeders that the Percheron can make such light work of heavy loads.

Percherons, with their gray or black coats, are patient and honest, docile and tireless workers, at times precocious but always gentle with children. They become part of the family, working willingly in partnership with their owners, many of whom come to regard their horses as inseparable companions and confidants that share their responsibilities, joys and sorrows, rather than beasts of burden. In the past, two distinct types were recognized: the Petit Taille or Postier, standing 15.1–15.3 hh (61–63 in) with an average weight of 1,200 lbs (550 kg), and the Grand (or Gros) Taille, weighing between 1,550 and 2,200 lbs (700–1,000 kg) and standing

15.3–16.3 hh (63–67 in). The former was generally used to pull mail coaches or vehicles delivering the post, while the latter was generally used as a draft horse.

Today, these types have been redefined. The Trait is a large horse, admired by the Japanese in particular. It weighs an average 2,000 lbs (900 kg) and is suitable for agricultural work and haulage, while the Diligencier is more slender, lighter and highly valued for harness racing, as a rapid draft and as a saddle horse. The Americans are great fans of the breed, particularly of Diligenciers with black coats. Originally, as the name suggests, teams of four to eight Diligenciers pulled stagecoaches (*diligence* in French), which were the heaviest of all horse-drawn vehicles (they weighed up to nine tons when fully loaded), but were pulled along at a fast pace.

The French have a particular soft spot for the Percheron due to its long and illustrious career with the Paris Omnibus Company, which lasted from the mid-nineteenth century until 1913. At its peak, there were around fifteen thousand horses pulling heavily laden carriages—3,750 lbs (1,700 kg) when empty, much heavier when loaded with around thirty passengers— stopping and starting frequently along the (often slippery) cobblestoned routes.

The Omnibus Company preferred to use gray Percherons with coats of as light a shade as possible to increase their visibility and limit the risk of collision—particularly in the evening when the light began to fail. Horses were therefore just as prevalent on the cobblestones of the city as they were in

the fields of the countryside. After many years of grueling work trudging the streets, the time came to retire; for the Percheron, it was generally a return to the land. There, with a friendly farmer and his family, the horse could grow old in peace, with the satisfaction of a job well done.

184–185. The ten-year-old **Percheron** stallion *Gallien*, by *Silver Shadows Sheik* (U.S.) (by *Lo Lynd Joc Lac*) out of *Toscane* (by *Neubourg*), owned by Sylvie Biget and presented by David Jollivet. *Gallien* has been at the Haras du Pin Stud Farm since 1997.

187. An "English" **Percheron**, *Three Holes Grenadier*, presented by his owner Richard Johnson.

188. *Momino*, a three-year-old **Percheron** stallion (by *Éditeur* out of *Craminette*), presented by Michel Lepoivre.

189. *Terrible*, a ten-year-old **Percheron** stallion (by *Iran* out of *Lorraine*), with his owner Michel Lepoivre (Saint-Aubin-de-Courteraie).

190. The nine-year-old **Percheron** *Galopin Delanoe*, French national stallion (by *Quarte* out of *Voltige*), presented by Joseph Dudouit.

191. The **Percheron** *Maître d'Atout*, held by Joseph Dudouit, and *Julie Sheik du Sap*, a six-year-old **Percheron** mare, held by Daniel Bourges.

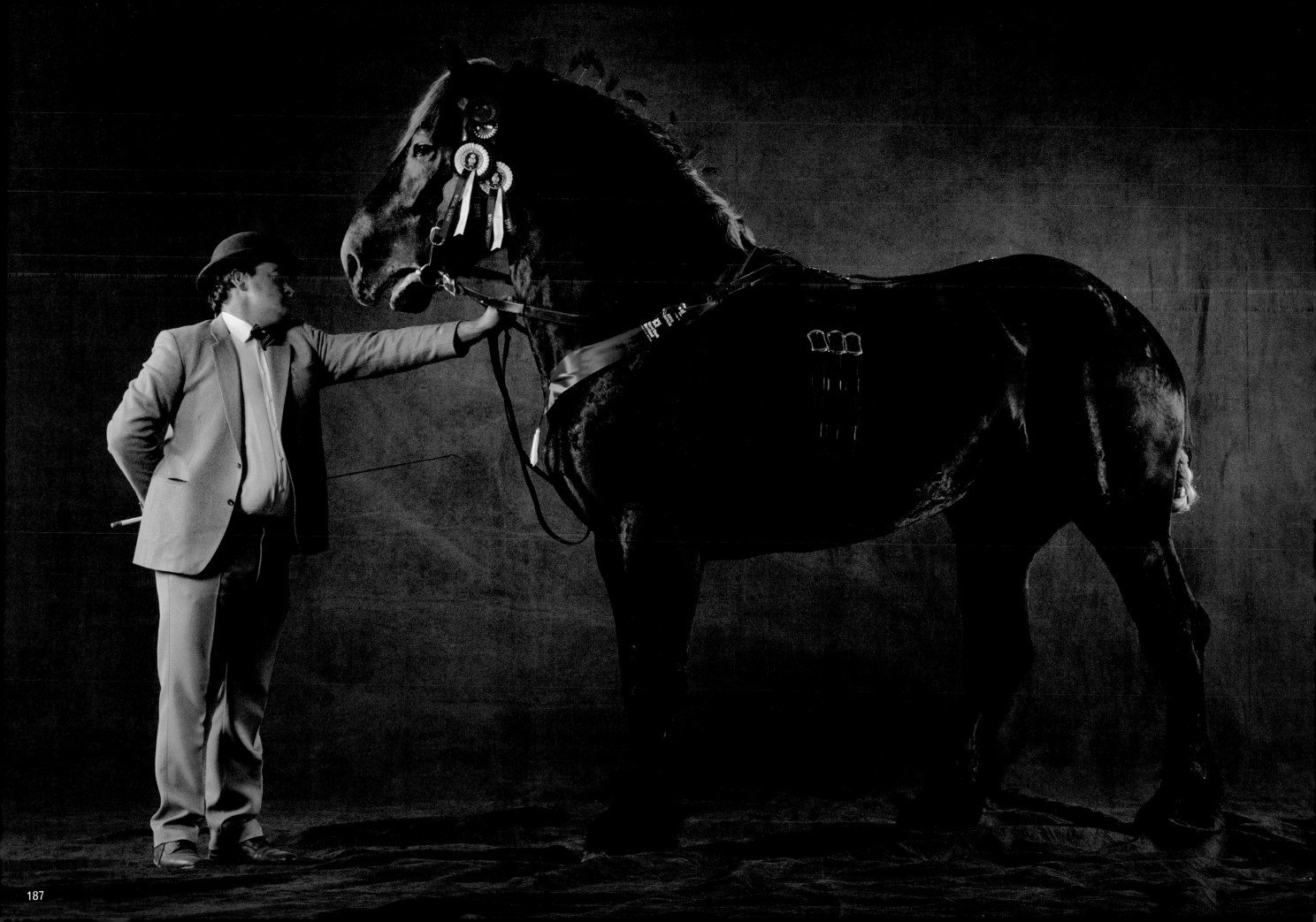

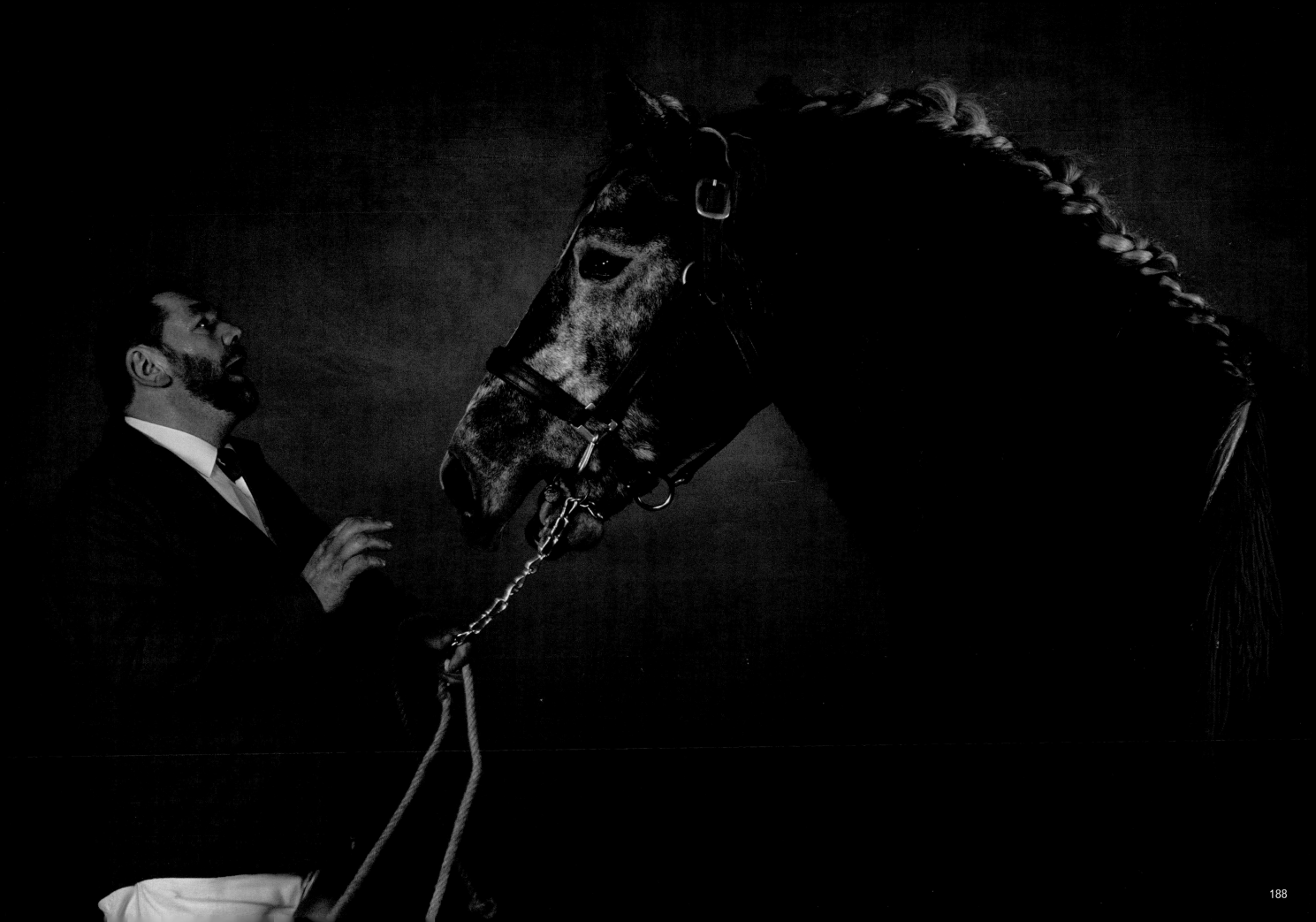

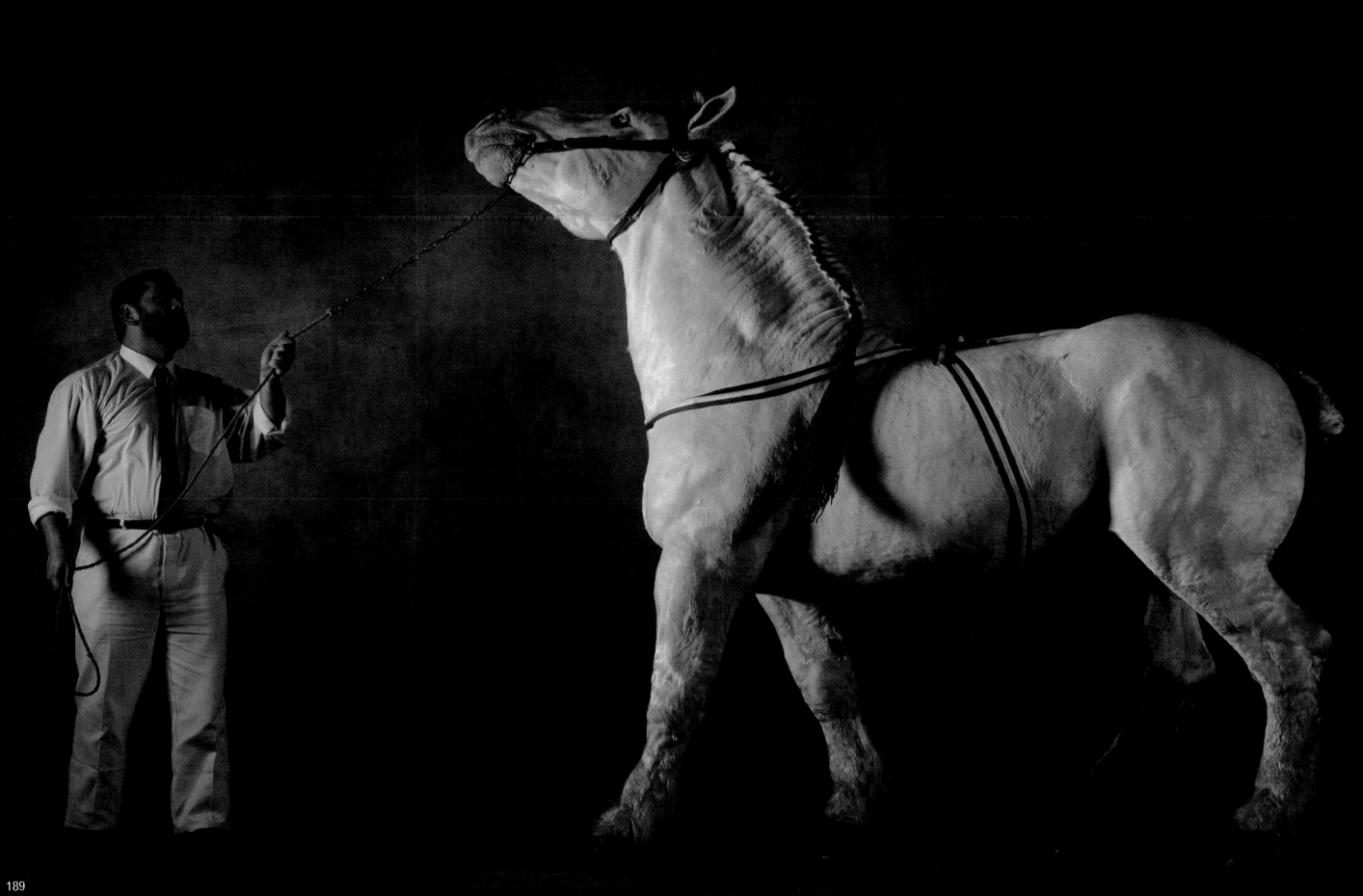

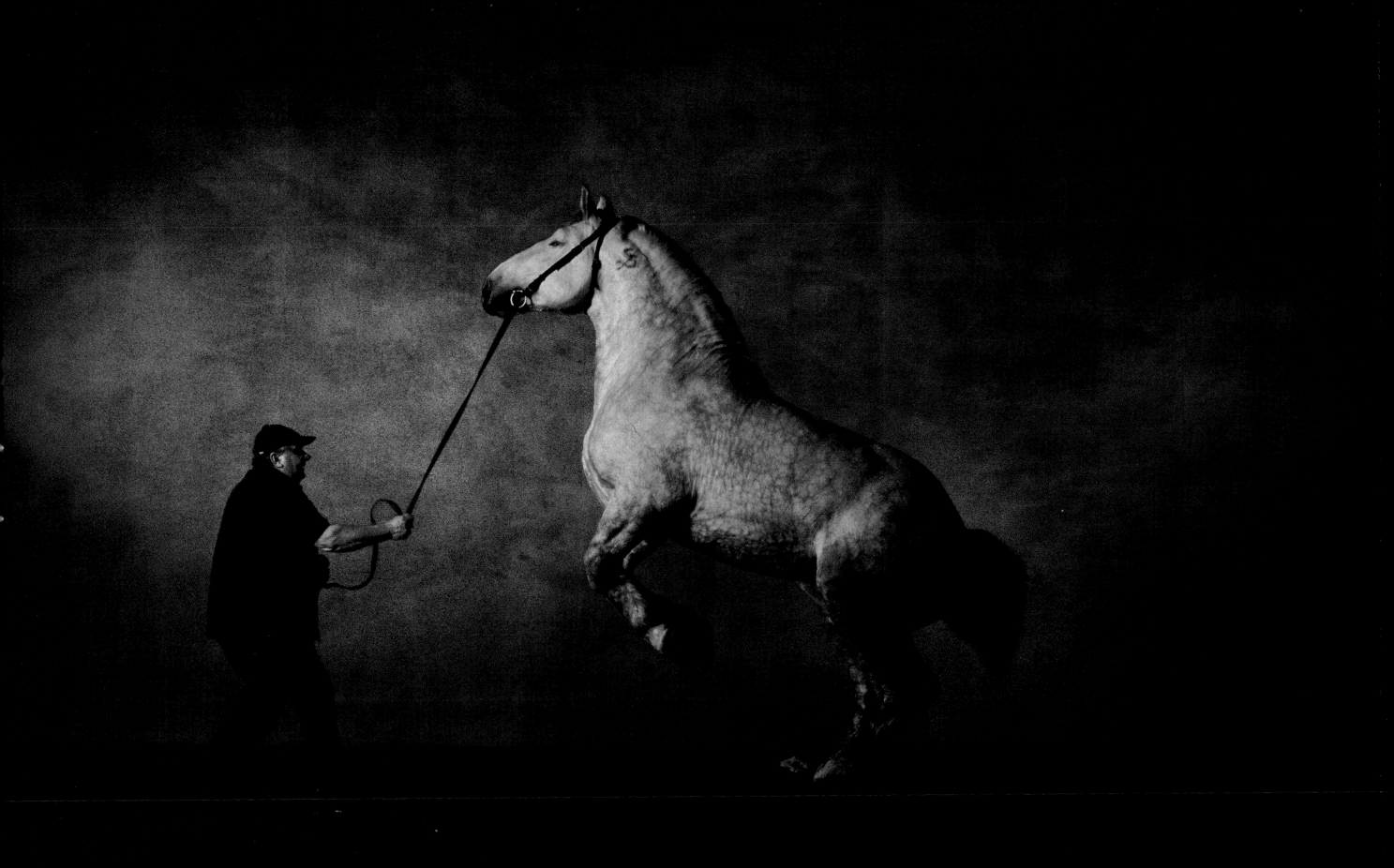

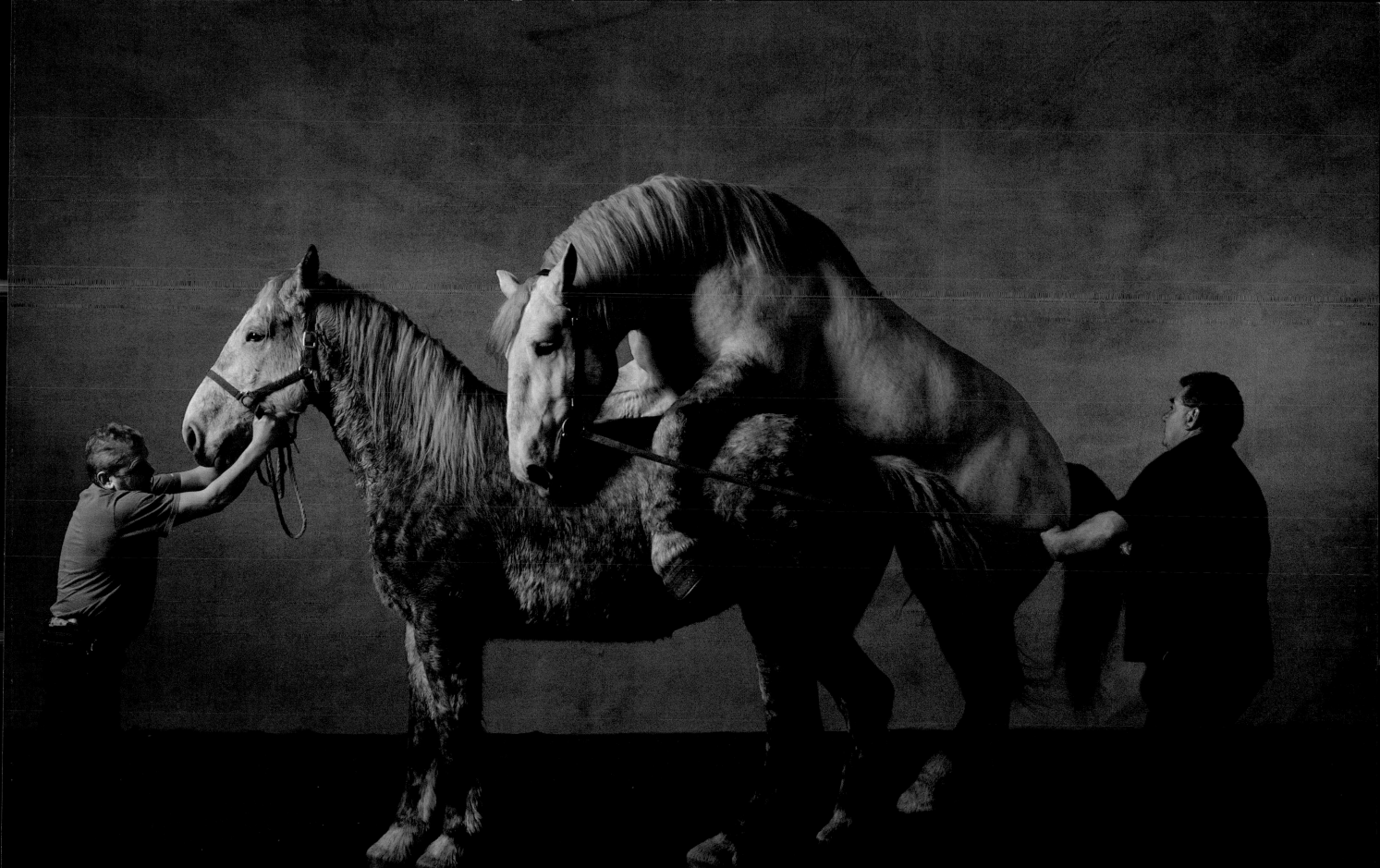

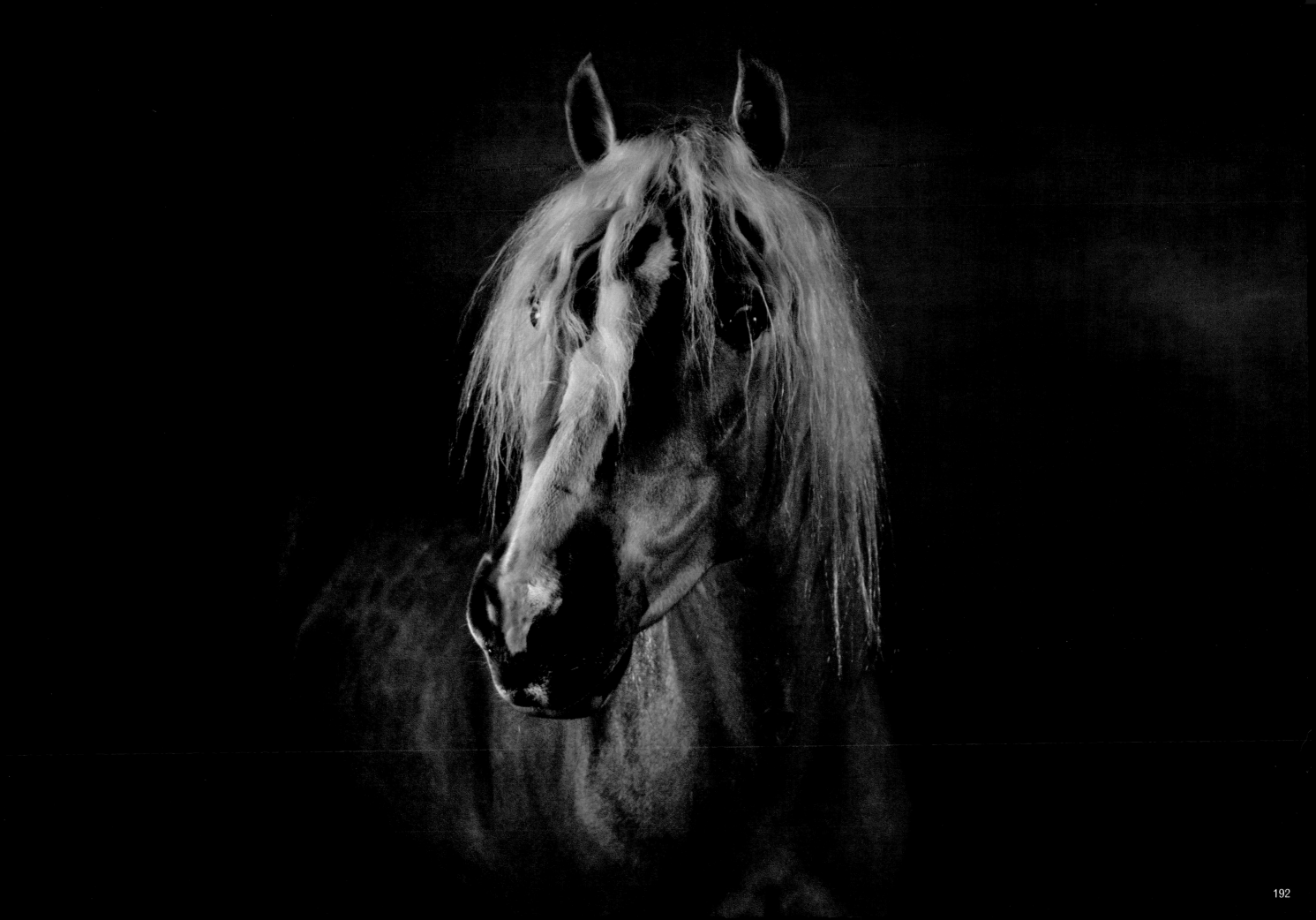

Horse or pony?

How do you define a pony? Is it just a small horse, or can it be defined as a member of the horse family, but different from a horse in the way that the horse itself is different from the ass and the zebra? The answer is that it is a question of height: a horse stands more than 14.2 hh (58 in), whereas anything smaller is considered a pony. The rule is quite simple.

However, take, for example, a purebred Arab of less than 14.2 hh (58 in). Should it be called a horse or a pony? Is a Connemara, a Haflinger or a Merens of more than 14.2 hh (58 in) no longer a pony? Has it suddenly become a horse? And what do you say of an animal that stands 14.2 hh (58 in) at three years old and 14.3 hh (59 in) at four years old? Why do the Bashkirsky and Camargue deserve to be termed "horse," when they are all less than 14.2 hh (58 in)? The difficulty that the cut-off point of height presents is obvious.

Some schools of thought adopt a more pragmatic approach and do not take height into account. Instead, they call a horse a pony when its appearance and temperament are more hardy. It is not a very precise solution, admittedly, but it is a realistic and practical one. According to this logic ponies could therefore be said to be horses that are able to adapt to the challenging environments that are unfavorable to the development of the more refined "true" horse.

Some breeds of pony are able to survive in tropical regions—the African Musey is even immune to the tsetse fly, which is deadly to large horses. Small horses—standing less than 14.2 hh (58 in), and therefore technically ponies—also live in some of the coldest climates in the world. In north Siberia, for example, where the temperature falls sometimes to minus 60 degrees Celsius and where no "normal" horse could survive, the local pony—the Yakut "horse"—copes admirably well, having developed a thick coat that makes it look a little like a bear. The local people make jackets (chapkas) from the hide of the Yakut. Ponies live in all climates and on all terrains throughout the world, from the high altitudes of the Himalayas to swampy regions, forests, moors, steppes and deserts.

In this sense, the pony can be defined as a horse that has succeeded in surviving difficult conditions without the aid of man, which is the crucial factor. While the majority of large horse breeds are the result of selective breeding and crossbreeding, coupled with constant and attentive care, pony breeds owe little to human intervention, but are instead the result of a process of natural selection and evolution.

It follows that miniature horses, such as the Falabella (less than 7.2 hh/30 in), should not be called ponies, and it is even debatable whether they should really be called horses. The Falabella was the result of an Argentinian breeding program that took place at the end of the nineteenth century.

There are as many types of pony as there are different ecologies in the world, each with its own peculiarity of build, size, coat, temperament; nevertheless, there are some shared traits. Some breeds bear a vague resemblance to the prehistoric horse that is sometimes assumed to be their ancestor. Perhaps the willful and wild side that ponies sometimes have can be traced back to this ancient ancestry. They can even be cantankerous, but more often they are simply mischievous. Ponies are robust and tough and normally show great willingness to work. Rarely docile, they are normally full of character and personality.

However, the pony's lot has not always been an easy one. Used in harness and for riding, it was long viewed simply as a beast of burden, though it demanded little in return. By the mid-twentieth century, its status had improved greatly. Ponies often became a symbol, or a rallying point for the land on which they lived, something to be protected as part of a region's heritage. As a result, their fortunes began to change and some of these "country breeds" began to experience success abroad, away from their homeland. Irish ponies were raised in France, Icelandic ponies in Germany, Argentinian ponies in England and Tyrolean ponies in India.

In recent times the pony has become a major player in what is called the democratization or popularization of equestrian sports. When the pony made its appearance in equestrian circles in the 1960s, it enabled children under the age of ten to discover the joys of horse riding at a young age and with relatively little risk. Little girls in particular, who today make up the majority of pony-club members, have contributed much to the modern-day success of the pony.

Here Marion Scali, a horsewoman, riding instructress and journalist, will introduce some of the principal breeds of pony.

192. *Efraïm*, a two-year-old **Avelignese** (the Italian cousin of the Austrian Haflinger), owned by the local forestry authority.

While most breeds of large horse are the result of man's intervention through selective crossbreeding, **ponies** owe their existence and survival to themselves alone.
Adaptable, robust and tough, in just fifty years ponies have seen their status improve beyond all measure. Instead of being exploited as beasts of burden, they are now the beloved playmates of many children, and today many horsemen and women fondly remember learning to ride on their very first pony.

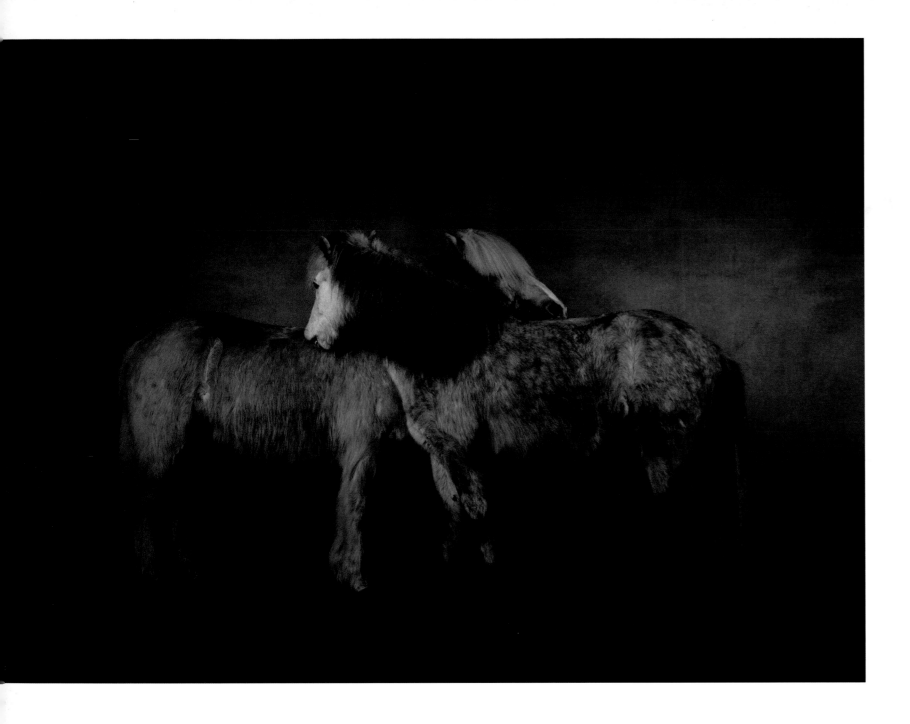

The Icelandic horse: a true performer

All ponies can walk, trot, canter and gallop from the day they are born. Icelandic horses can do even better, boasting two additional paces—*tölt* and *skeid*—which are both a kind of lateral gait that seems to come quite naturally to them. The *tölt* (or "running walk") is a four-beat gait in which one foot is always in contact with the ground, whereas the *skeid* (or "flying pace") is a faster, two-beat gait.

Black, bay or gray, with a thick coat, bright eyes and small ears, the Icelandic horse has a complex ancestry, descended from Celtic ponies from all over northern Europe following the discovery of Iceland by the Vikings in A.D. 795. Less than two hundred years later, Iceland passed a law that forbade the introduction of any foreign animals into the country and, as a consequence, the Icelandic horse has evolved in a vacuum. Today, Icelandic law governing the movement of horses is very strict. No horse that leaves Iceland is allowed to return, even if, for example, it is simply to attend championships held in other European countries, where ponies from the frozen North are now much in vogue. This strategy does have its disadvantages, however: the Icelandic horse is in need of new blood, and Germany is currently breeding some excellent Icelandic stallions.

Often raised in semiliberty, the Icelandic horse is able to withstand extreme temperatures, surviving winter out in the fields. Never broken in before the age of five, it has shattered all records for equine longevity: the oldest recorded age is fifty-seven. Although standing only 13.2 hh (54 in), Icelandic horses can easily carry adults, who enjoy the comfortable ride and are better equipped than children to channel the exuberance to which these horses are sometimes prone. According to local legend, Icelanders became greatly attached to their horses because of their ponies' skill at picking their way home in the small hours, with their charges clinging unsteadily to their thick manes after a night's carousing!

While able to boast little in the way of showjumping skills, Icelandic horses are no strangers to the dressage ring (where special events allow them to show off all their paces) and TREC or endurance riding courses (designed to test the qualities of horse and rider over an outdoor course), but they have been known to abandon these in favour of the racecourse. For the last one hundred and fifty years, races have been organized in Iceland in spring. The most famous of these takes place in Reykjavik on Whit Monday.

194, 195. Icelandic horses *Magni vom Kronshof* (seven years old) and *Ofeigur vom Kronshof* (five years old), owned by Lothar Schenzel.
196, 197. *Gylling*, an **Icelandic** mare (by *Gullhetta* out of *Flygill*), ridden here on the left by Tota (alias Thorunn Thora Rinsdottir) and on the right by Tota and her son. The breed's characteristic high-stepping gait, which is very comfortable for the rider, is unique to the Icelandic Horse. Known as the *tölt*, it is a "running" gait as opposed to a "stepping" (e.g. walk) or "jumping" gait (e.g. trot, amble or gallop).
198–199. The wild beauty of the Icelandic landscape, seen here at Lyngdalsheidi, north of the capital, Reykjavik. Linda Run (aged fourteen) is riding the **Icelandic horse** *Valur*.

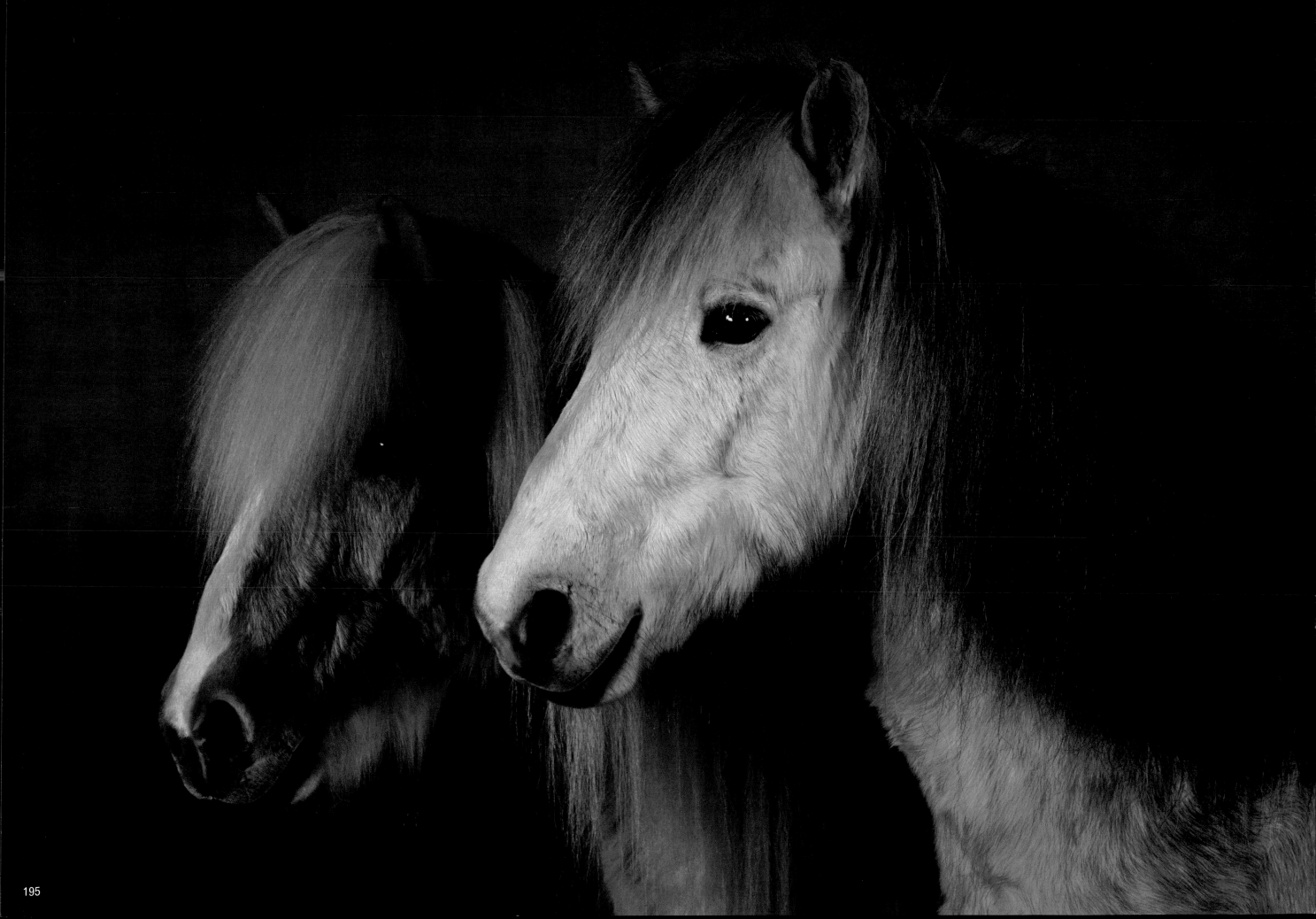

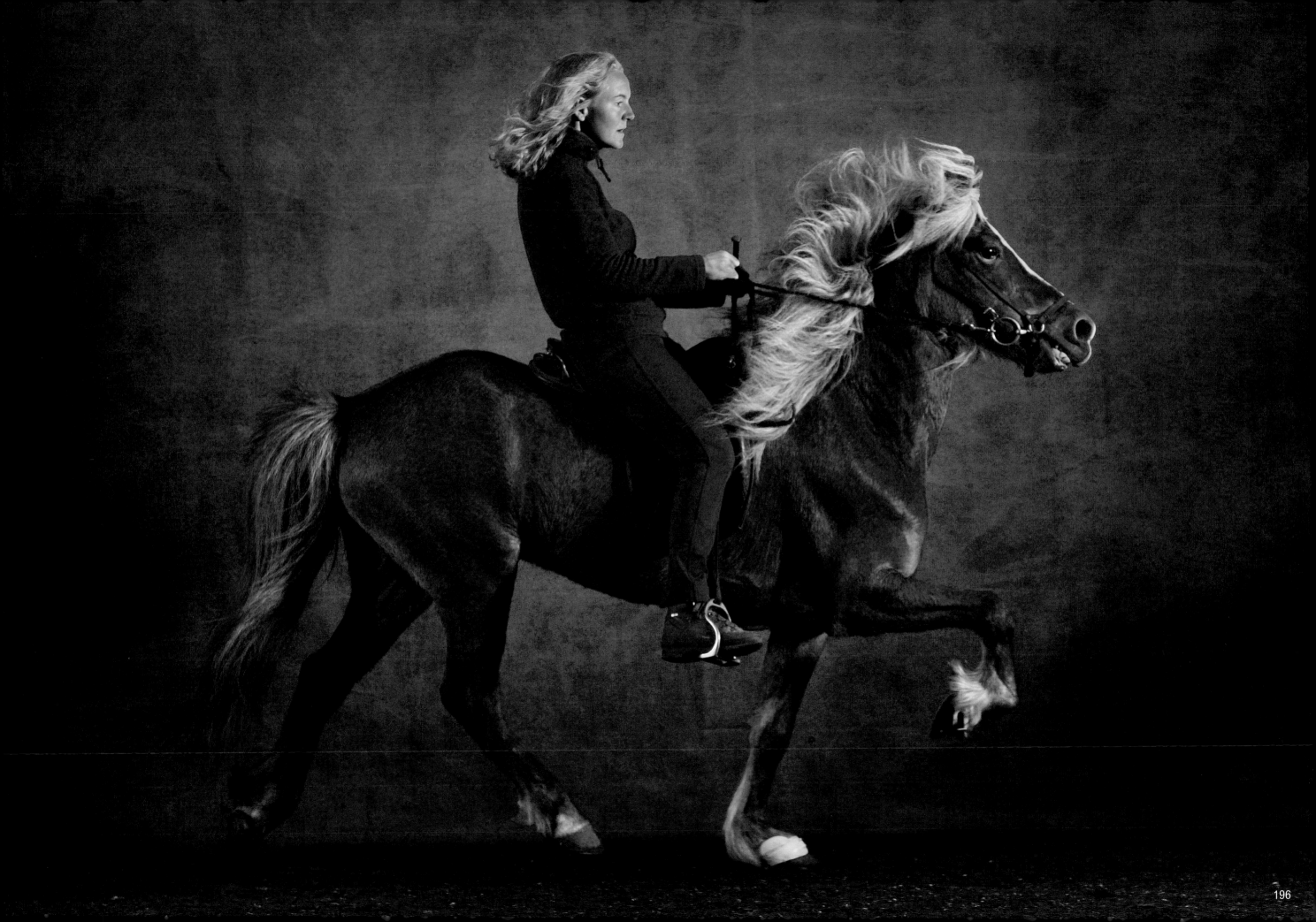

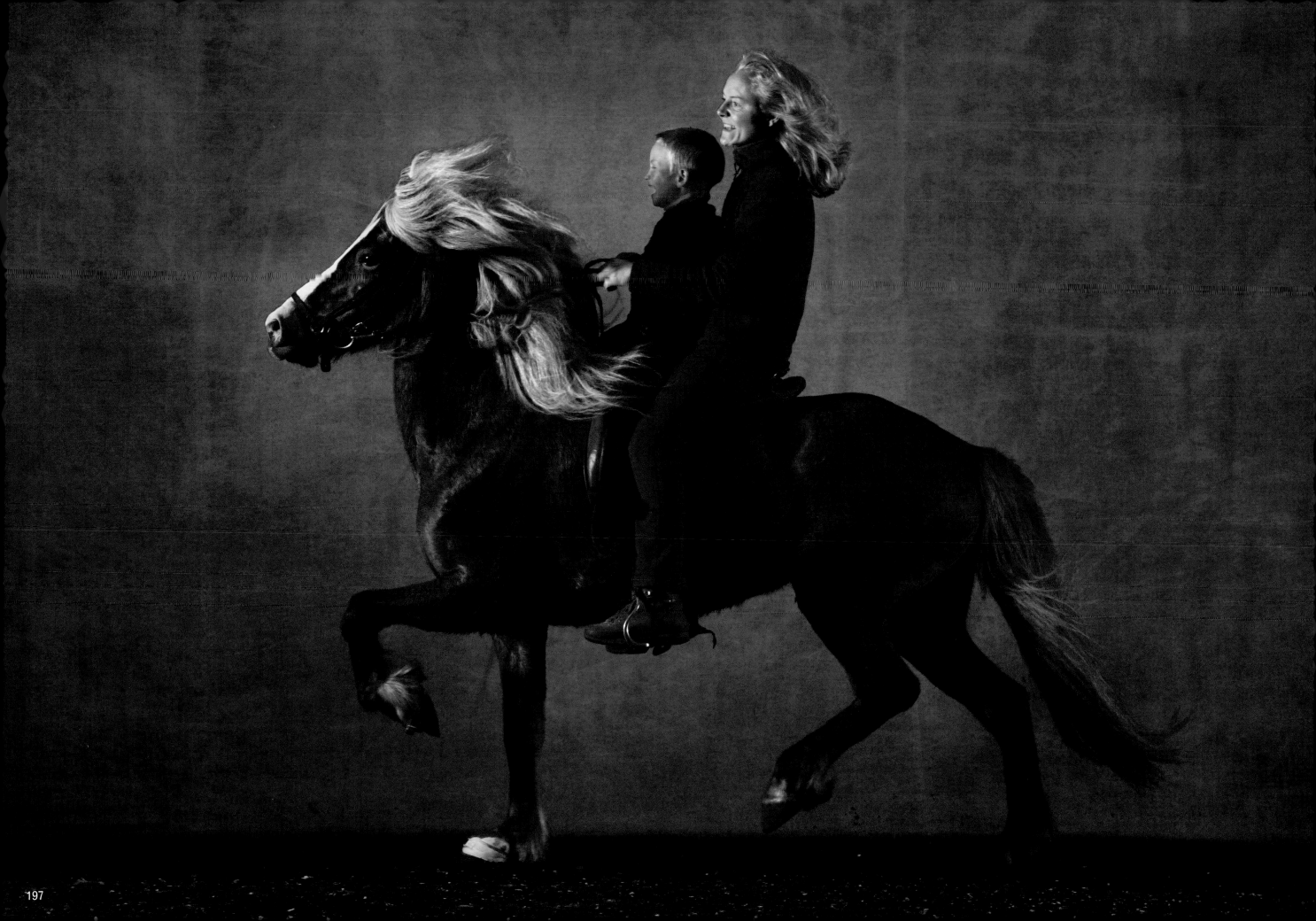

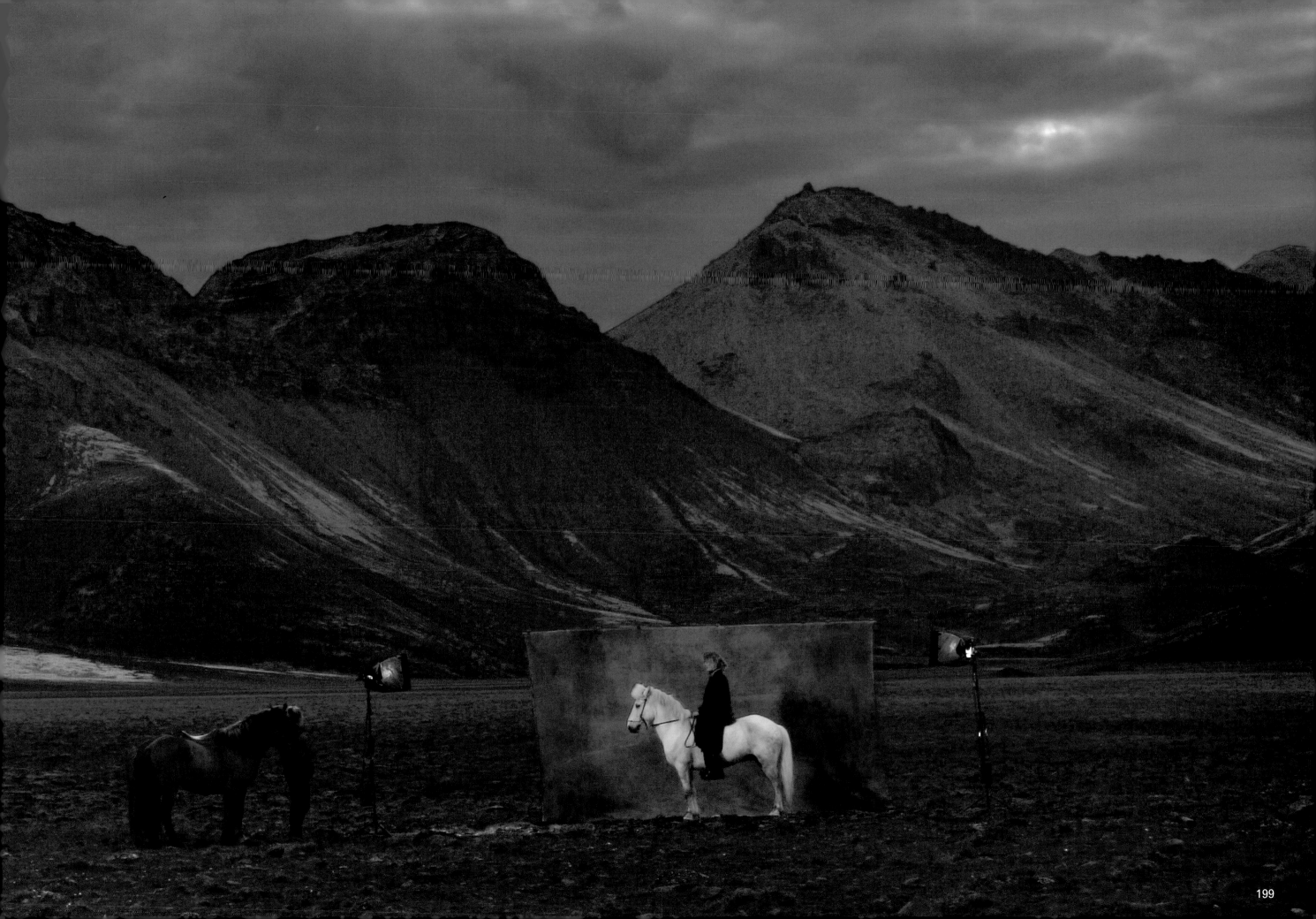

Ireland, the Shetland Islands, Dartmoor, the Dales—in the British Isles the pony is king. Since the Bronze Age, the Shetland Islands, at the northern most extreme of the United Kingdom, have been home to the eponymous tiny pony beloved of small children and known throughout the pony club world in the West as a "Sheltie" or "Shet." Often piebald in color, with its thick mane and tail, soft, shaggy coat, large nostrils and "double" (i.e. cleft) rump, it tends to rank second only to the teddy bear in terms of popularity among children. Independent and playful, though known to bite, it is, paradoxically, the strongest of all breeds in proportion to its size. Nothing fazes the Shetland—it can carry a man of 187 lbs (85 kg) over 62 miles (100 km) or haul a laden wagon in the depths of a mine without losing its good humor. It excels at all equestrian disciplines and can boast that it has borne the showjumping champions of the Western world over their first jumps.

It is not known how this pony arrived in the Shetland Islands. Perhaps the Nordic ponies took advantage of the Ice Age to return to the tundra? Equally intriguing is its diminutive size—it rarely stands higher than 40 in (100 cm). The harsh soil, the cold, the wind, the lack of trees and green fields undoubtedly form part of the explanation, and the Shetland pony sometimes had to eat seaweed in order to survive. It probably received an injection of Arab blood at some point during the Crusades and the medieval trade routes that opened up between Norway and the Shetland Islands almost certainly also influenced the pony's appearance.

The Connemara pony, on the other hand, has a much purer line. Until the arrival of the Celts, it had not been infiltrated by any foreign stock since the British Isles were formed some fifteen million years ago. The first cross-breeding produced the Irish Hobby, the ancestor of the Connemara, a horse so well loved and so much a part of Irish life that it even adorned a postage stamp. The only indigenous horse in the country, the Connemara still lives in semiliberty in the far west of Ireland, in the lakeland region that bears its name.

At one time, every farm had a Connemara for cultivating the land, pulling the farm cart and ferrying the family about the countryside. According to the history books, it was in 1588, when the Spanish Armada was forced to disperse after failing to invade England, that a few Spanish ships were found to have drifted ashore along the Irish coast. Legend has it that the horses on board wooed and conquered some of the local mares, explaining the origins of the delicate features of the present-day Connemara. Originally dun with a dorsal (or eel) stripe and black mane and tail, it is now often gray, black, brown or bay.

By nature the Connemara is the most well-balanced of all ponies and it is also the best showjumper. It excels at polo and has proven to be extremely adept at *haute école*. Consequently, the breed has had its fair share of stars. In 1935, *The Nugget* jumped 7 ft 2.5 in (2.20 m) at the International Horse Show in London, at the age of twenty-two, while *Dundrum*, only 14 hh (56 in), cleared 7 ft (2.13 m). The extraordinary American *Marcus Aurelius*, a cross between Connemara and English Thoroughbred, won the gold medal at the Pan-American Games in 1976. Nor should we forget the incredible *Cannon Ball*, born in 1904, who won the local farmers' race in his region for an amazing sixteen years in a row. This horse traveled 62 miles (100 km) every week to take his master to market—mounting mares as he went. When he died in 1926, he was buried in a grave filled with hay, according to the Irish tradition. His grave can still be seen at Oughterard.

200. *Ted*, a seven-year-old **Connemara** stallion, used as a "teaser" at the Gilltown Stud in County Kildare, Ireland.
201. Fourteen-year-old **Connemara** stallion *Cyrano Pondi* (by *Galway de la Dive* out of *Bambou* and *White Granite* out of *Marble*), owned by Gilles le Moullic.
202. *Ulverscroft Sandstar*, a four-year-old **Shetland** pony, owned by Mrs. P. V. Renwick (England) and presented by the Trott family.
203. *Idole du Tregor*, a twelve-year-old "French" **Shetland** brood mare, owned by Francis Glas (France) and presented by Pamela Mengy.

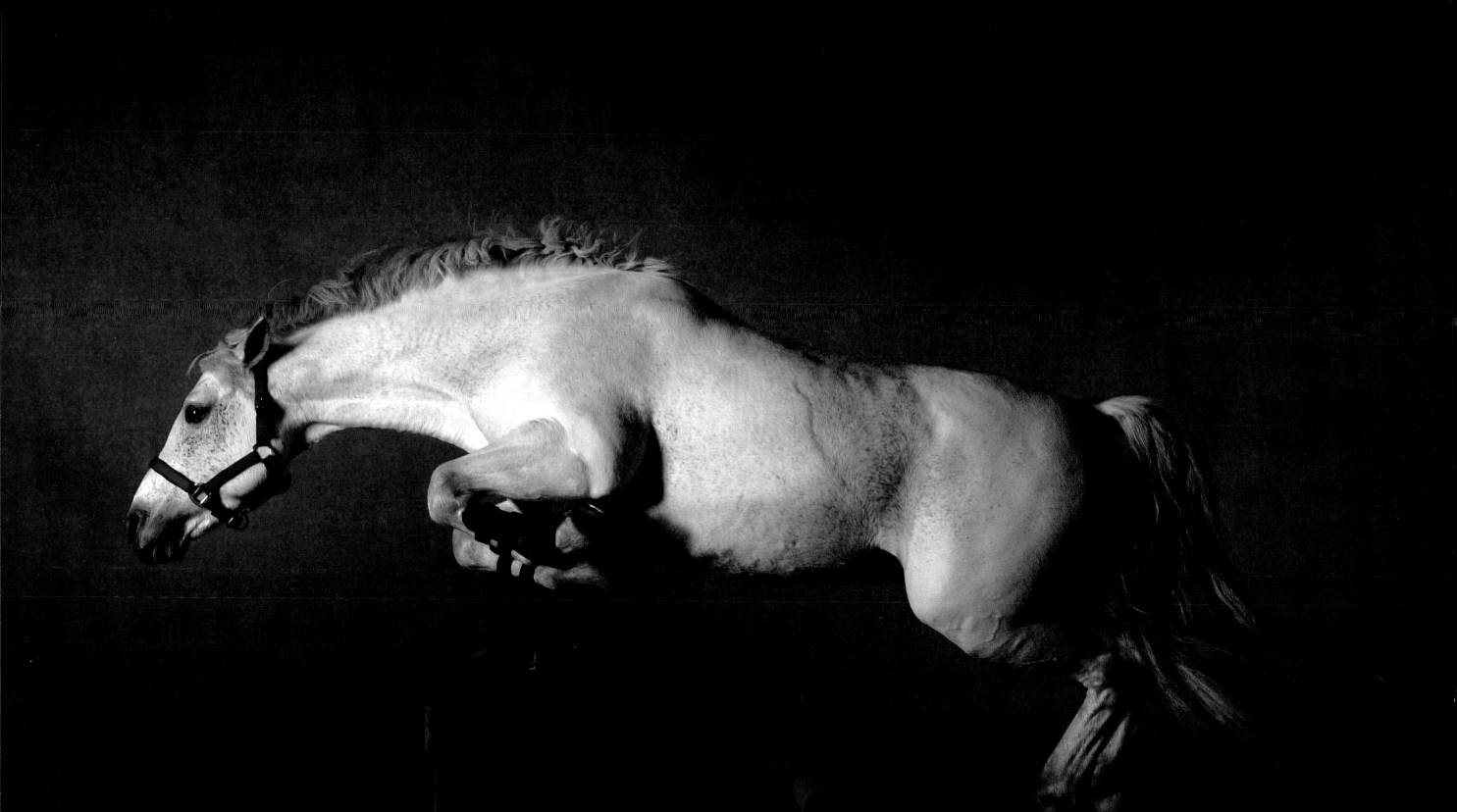

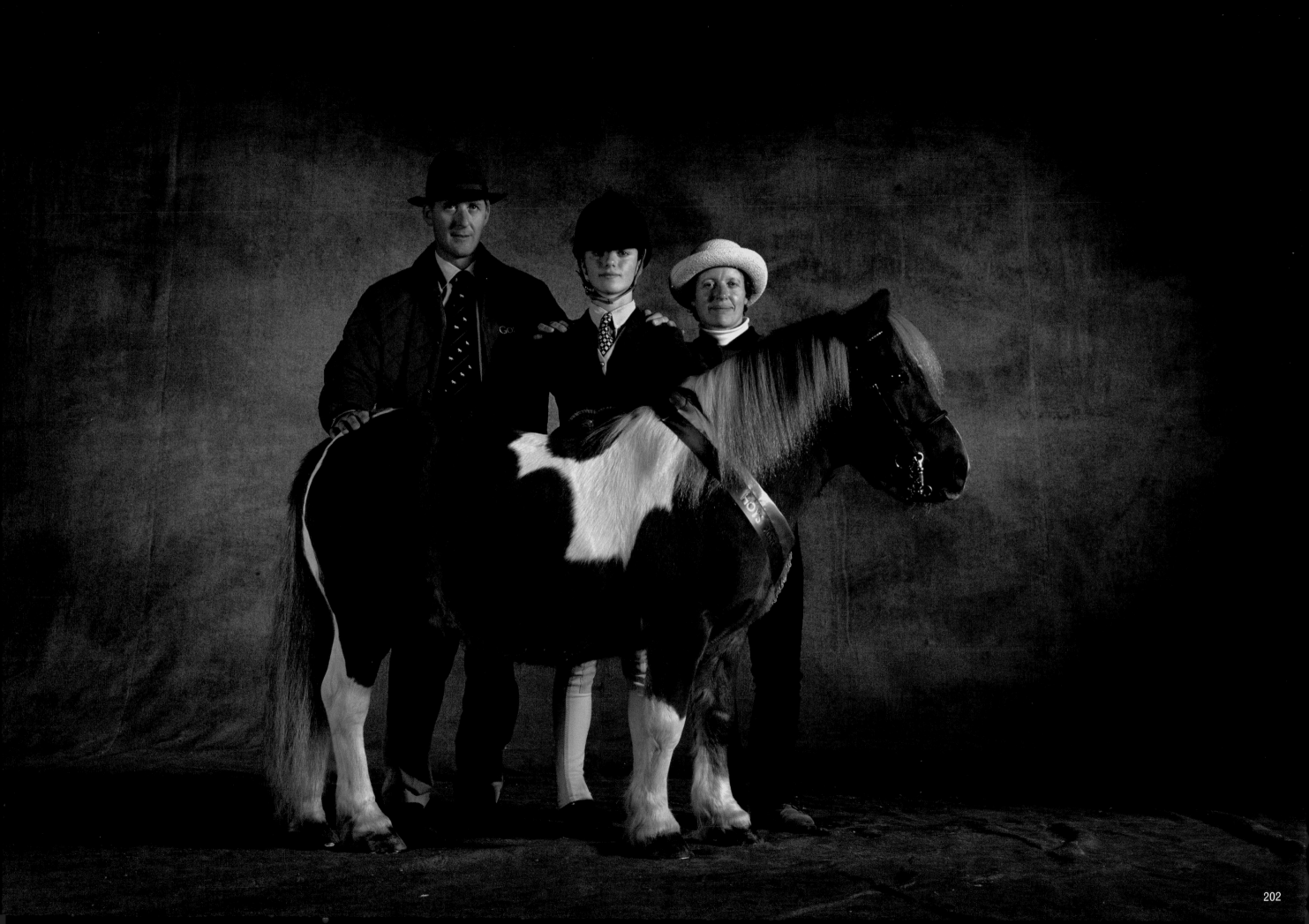

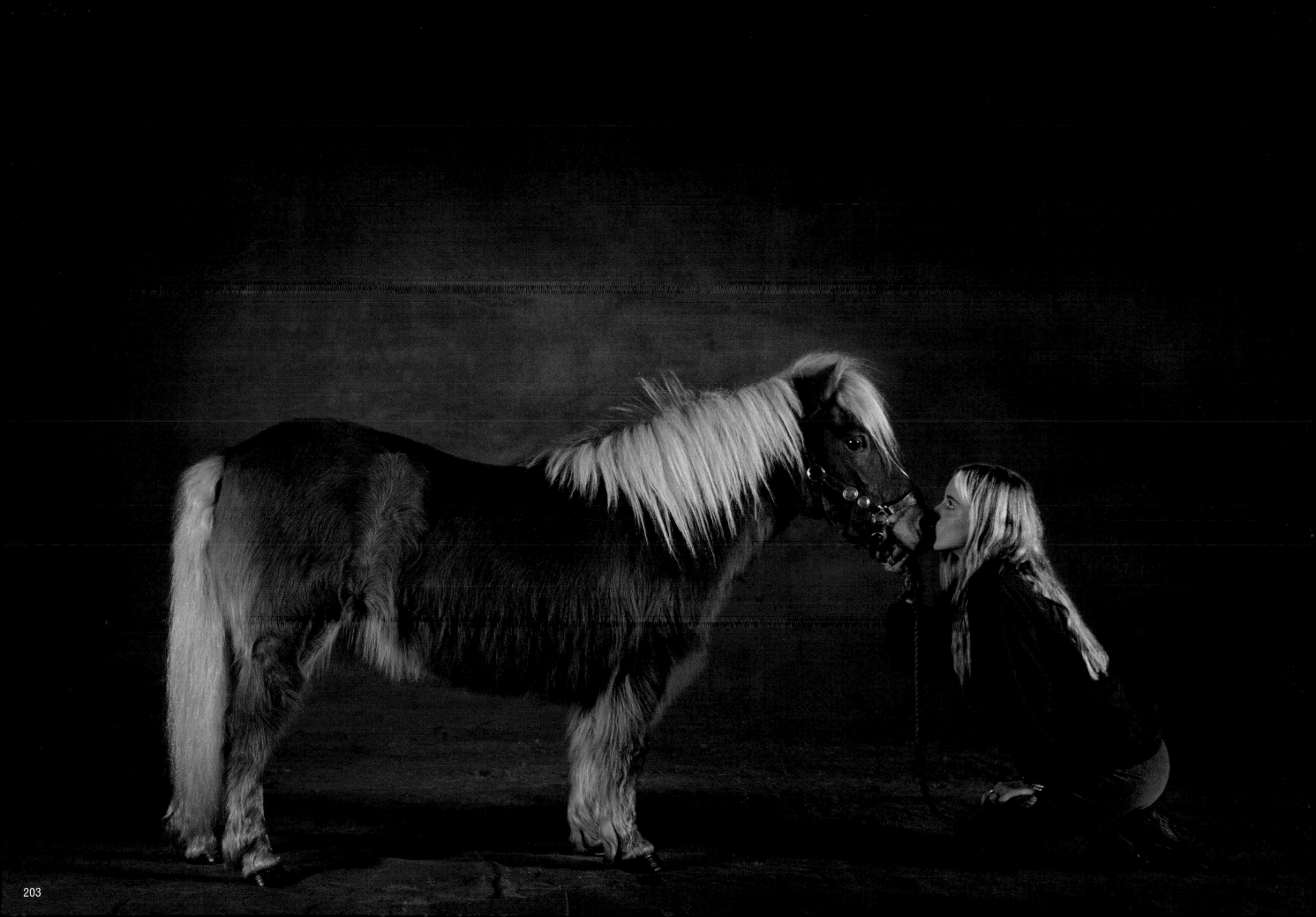

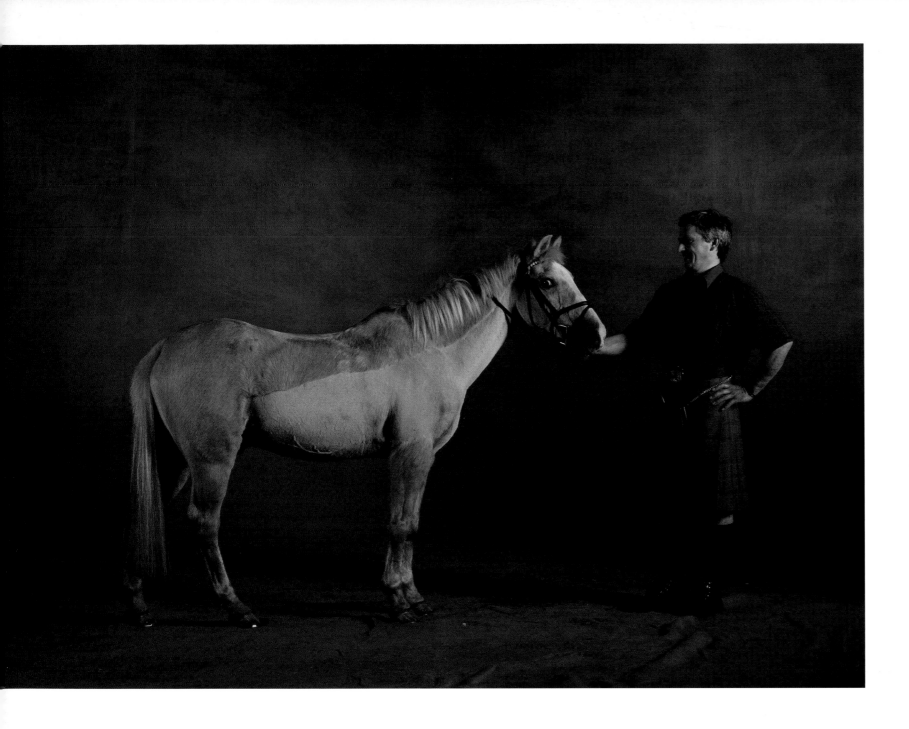

English, Scottish and Welsh ponies: hardy companions

The Welsh pony, the most famous of all British ponies, was very nearly wiped out on a royal whim. King Henry VIII (1491–1547) decided that he wanted to encourage the breeding of warhorses and ordered the slaughter of all mares under 13 hh (52 in). However, some of the mares escaped by taking refuge in the Welsh mountains and, thanks to some Arab stallions that had reverted to the wild after arriving with William the Conqueror five hundred years earlier, the elegant Welsh Mountain pony line was founded. Gentle, hardy and strong, this is the smallest of the Welsh ponies, standing at about 10 hh (40 in). A skillful jumper and a good companion—although a little stubborn—the Welsh Mountain pony is an excellent pony-club mount, ideal for children who are learning to ride.

There are many types of Welsh pony throughout the world, but only four kinds are listed in the stud book: the Welsh Mountain pony; the Welsh pony (Section B), or Thoroughbred Welsh pony; the Section C pony, or Welsh Pony of Cob Type; and the Welsh Cob. The Welsh pony (Section B) was formerly ridden by shepherds but is now used for sport. The Section C pony, standing between 12.3 and 14.1 hh (51–57 in), is the strongest and can carry an adult. Tough and surefooted, it is an ideal trekking or harness pony, doubtless pulling travelers' caravans with much greater willingness than the loads of slate it once transported in the quarries of North Wales. The Welsh Cob, the largest of the breed, which stands up to 15.2 hh (62 in), also worked in the quarries and is a descendant of the ancient Pembrokeshire Welsh pony.

The Highland pony, meanwhile, can boast genes that stretch way back into the mists of time. As its name suggests, it comes from the Highlands of Scotland. Large, tough and strong, it is often gray or dun with zebra markings on its legs and sometimes a dorsal (or eel) stripe on the back. It is very sensible by nature and is often used as a riding-school or trekking pony. It does, however, have something of a nefarious past—before whisky distillation was made legal, Highland ponies made very efficient accomplices to smugglers, enabling them to make a quick getaway before the authorities arrived.

204. James Jackson, from Glasgow (Scotland), presents his **Highland** pony *Cross Bred*, at the Horse of the Year Show 2001, held at Wembley Arena, London.
205. *Jasper de Kergroix*, a five-year-old **Highland** stallion, presented by his owner, Frederic Tamarin, at the Salon d'Agriculture de Paris, 2002.
206. Young Maxwell Knife proudly presents *Cymran Petra*, his eight-year-old **Welsh** pony.
207. Lauren Soanne, aged twelve, bravely presents *Tulira Robuck*, a six-year-old **Welsh** stallion.

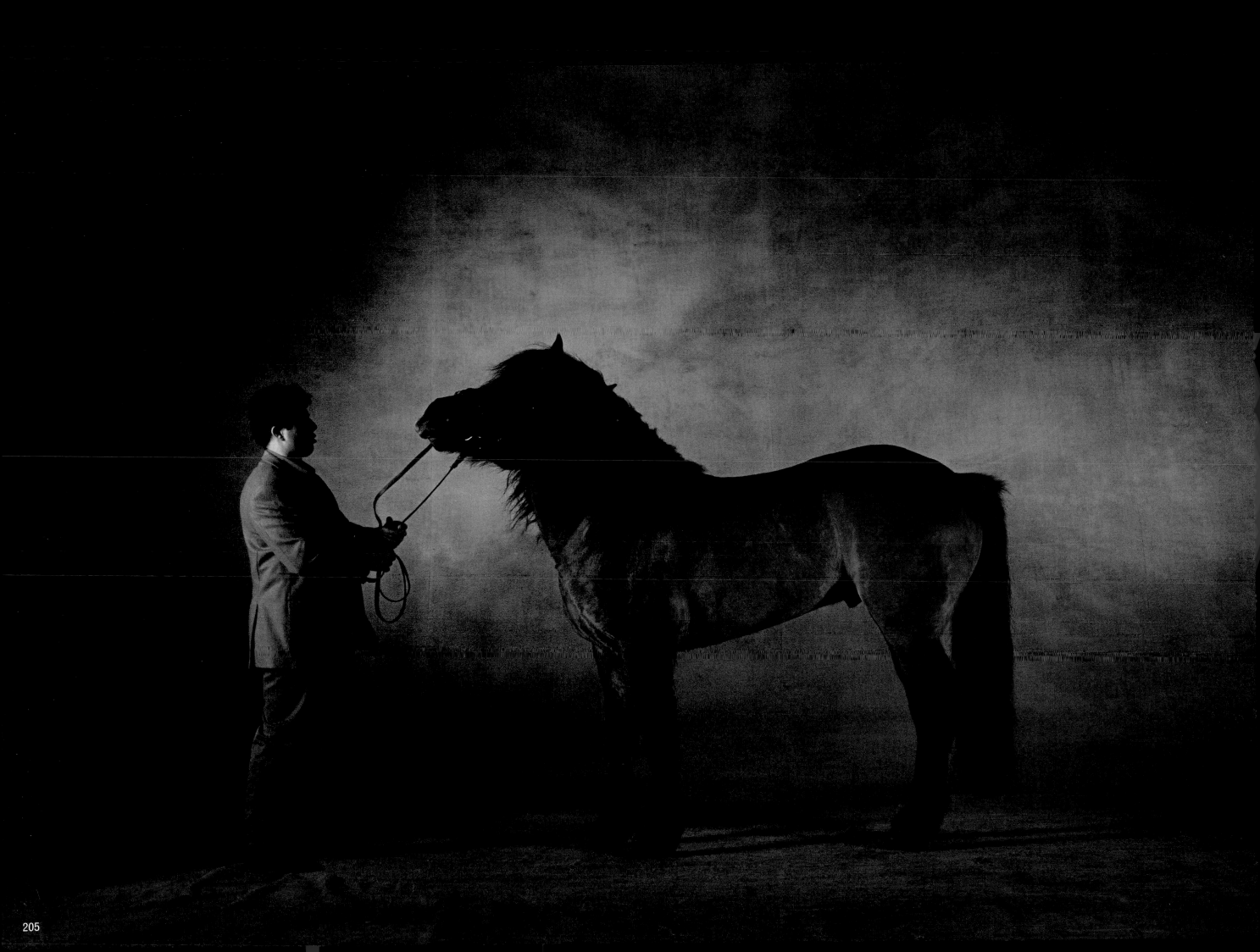

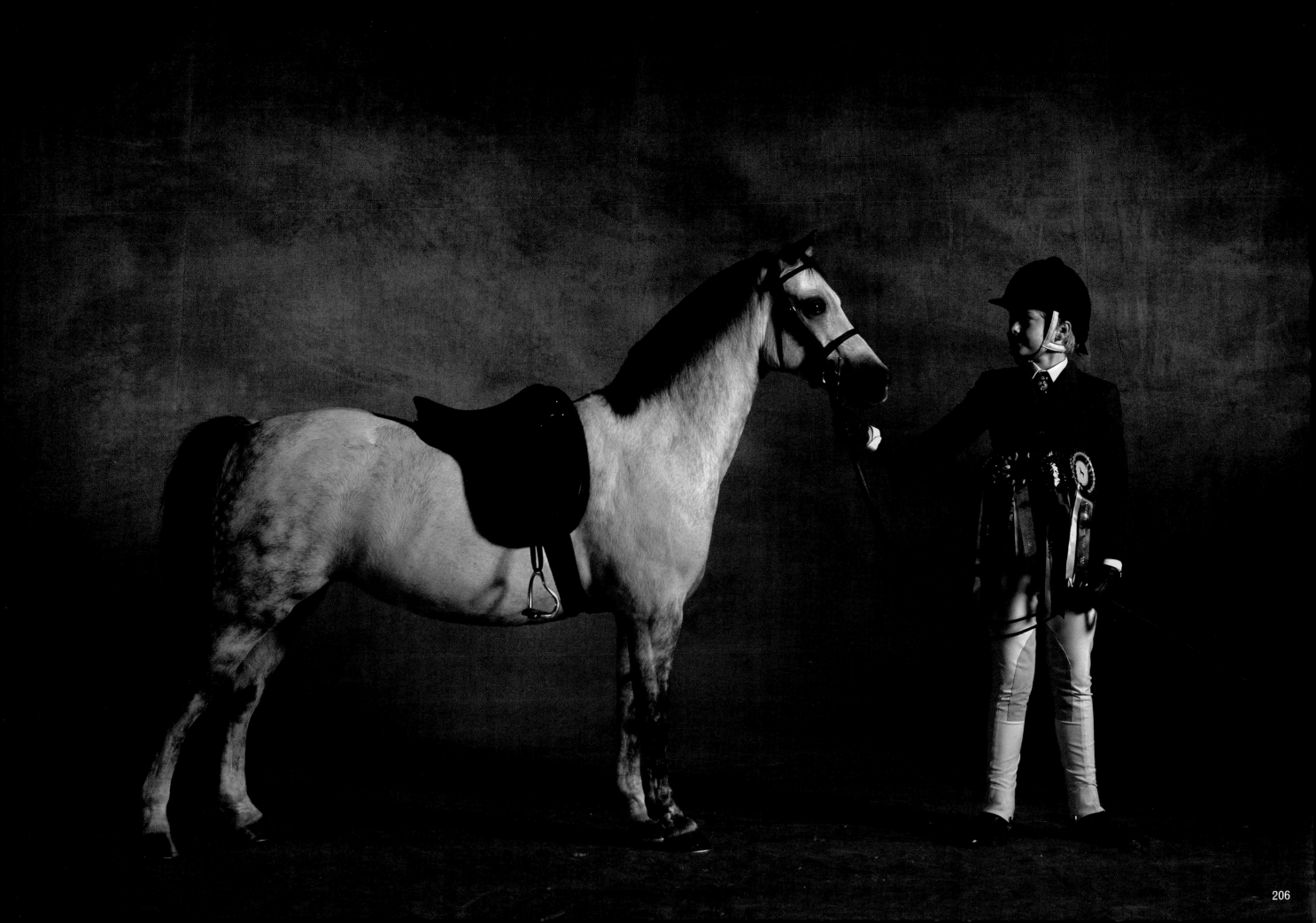

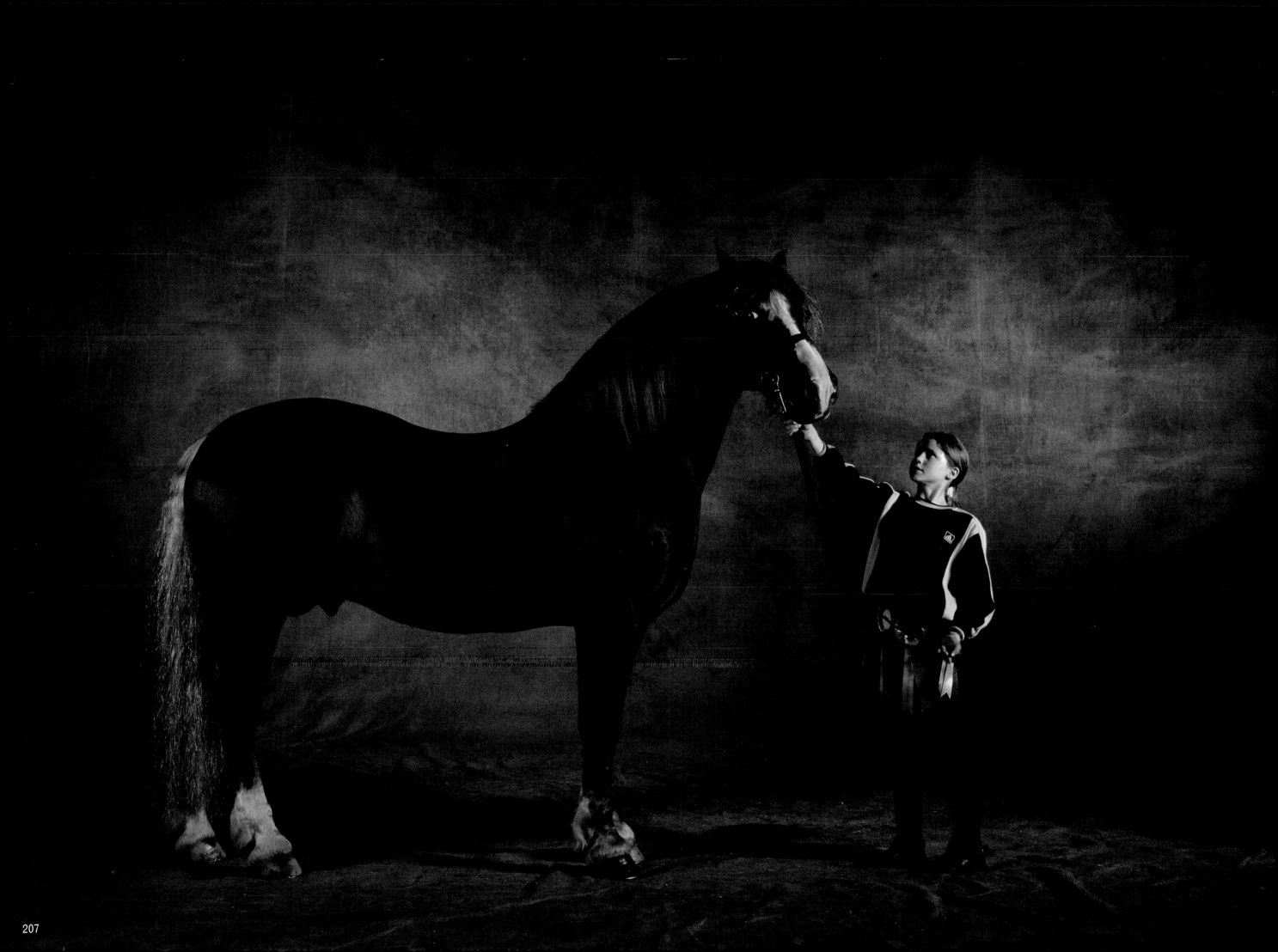

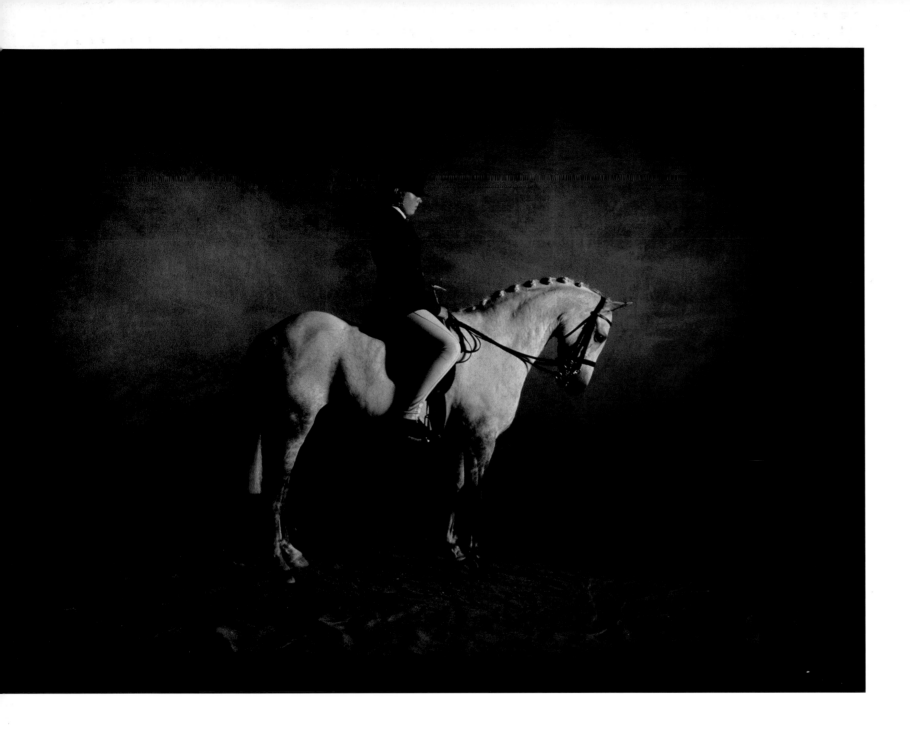

Welsh, Dartmoor, Exmoor and New Forest ponies: a novice's dream

To the south of the Welsh hills and across the Bristol Channel lies Dartmoor in Devon, the wild stretch of moorland that lends its name to a charming little pony, now one of the most common to be found in riding schools. Standing no more than 12.2 hh (50 in), with very small ears and large eyes, Dartmoor ponies are delightful, and owners of mares can be reluctant to be separated from them, thus denying them their chance to foal.

The Welsh Cob played a part in the renaissance of the Dales pony, also known as the "little Friesian" due to its black coat and gait. It is thought that the first Dales ponies were produced at the time of the Roman occupation, by crossing the Celtic ponies from the Yorkshire hills of the northeast of England with Dutch Friesians. In the seventeenth century, Fell ponies—then identical with the Dales but living on the western side of the Pennines—were used as packhorses in the lead mines. In the nineteenth century, Dales mares were mated with a Welsh Cob called *Comet*, very famous for his victories in trotting races. All modern Dales ponies are descended from this line. During both world wars, they were requisitioned by the army, and by 1955 only four fillies were registered in the stud book. Steps were taken to revive the breed, and there are now six hundred Dales ponies living in their birthplace.

The moorland of southwest England is home to the Exmoor pony. Legend has it that some Andalusian blood was added to the line, thanks to a mysterious and mythical dun-colored horse that once roamed the area. Having fulfilled his role and improved one of the oldest pony breeds, *Katerfelto* was subsequently captured, although history does not say whether he was rewarded for his services. Exmoor ponies have all the qualities you could possibly wish for, although they are afraid of dogs.

Farther east, a large tract of heath and woodland on the edge of Hampshire is home to a pony that was forced to witness a change to its habitat in the late eleventh century, when William the Conqueror organized the large-scale planting of trees, naming the area the New Forest. This did not, however, prevent him from meeting an untimely death by falling off his horse. According to another legend, in the eighteenth century the father of *Eclipse*, one of the most famous English Thoroughbreds, covered a New Forest mare (though how this came about is unknown), bringing some pure blood to this placid, careful and gentle animal. Breeding stock and forest ponies still live in the wild on the heath in the New Forest. Long accustomed to the traffic that passes on the roads cut through the forest, they make solid and dependable mounts, ideal for novice riders.

208, 209. *Rosslayne Misty Blue*, an eleven-year-old **Welsh** pony, ridden (on the left) by Harriet, daughter of the owner, Mrs. Jessop (England).
210. *Epson de Kergroix*, a ten-year-old **Dartmoor** stallion owned by Frederic Tamarin (France) and presented by Fabien Bordet.
211. *Townsend Breeze*, an eight-year-old **Fell** pony owned by Mrs. Sweeney (England) and presented by her daughter Cara.

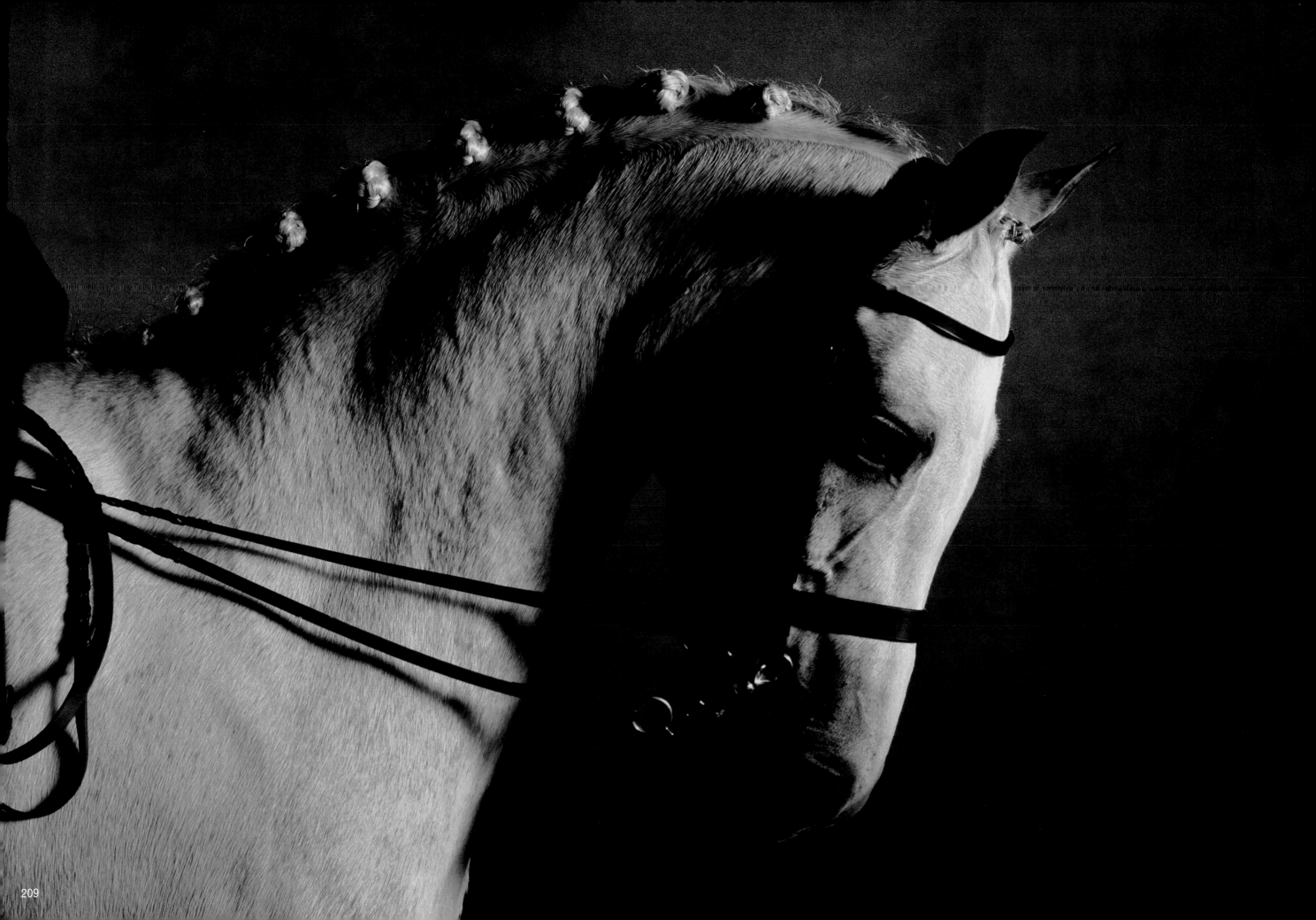

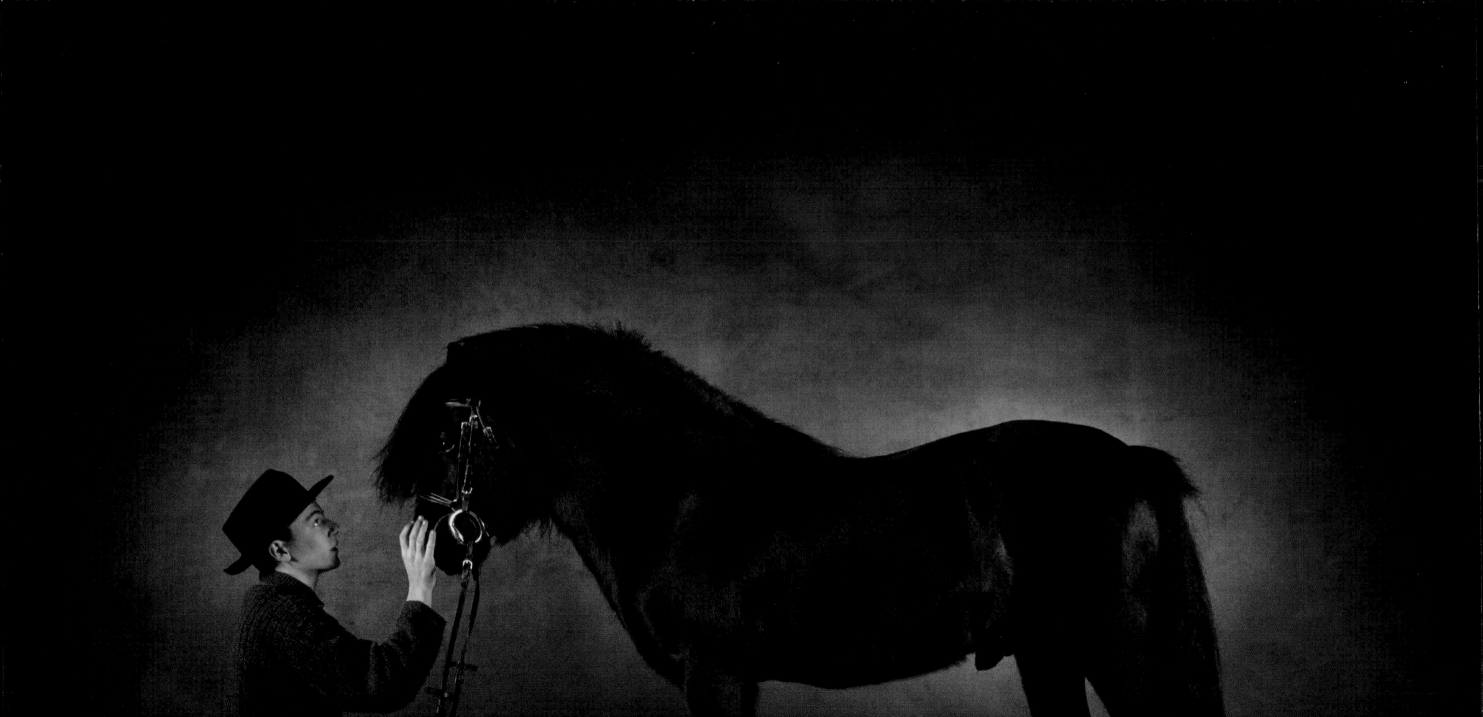

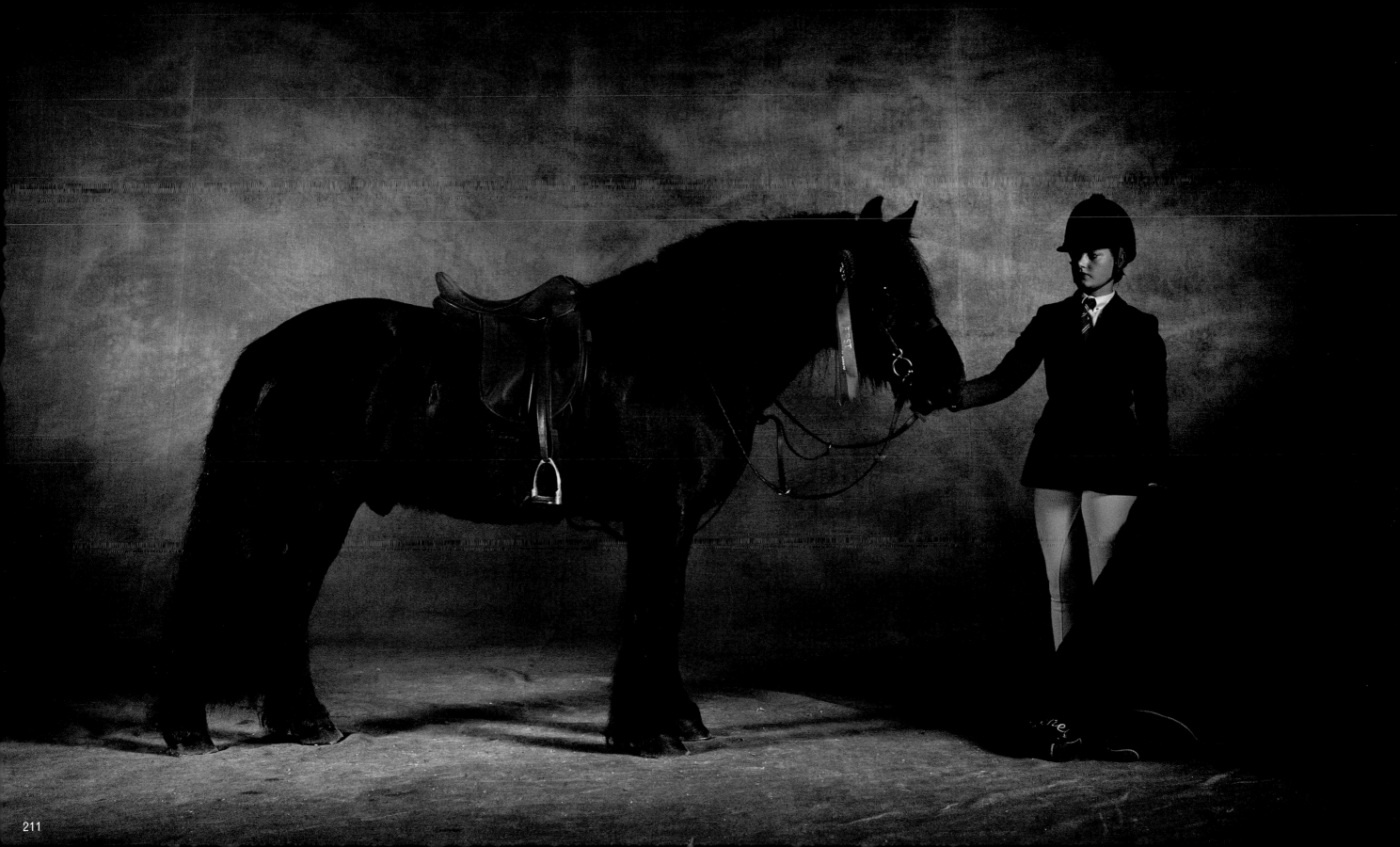

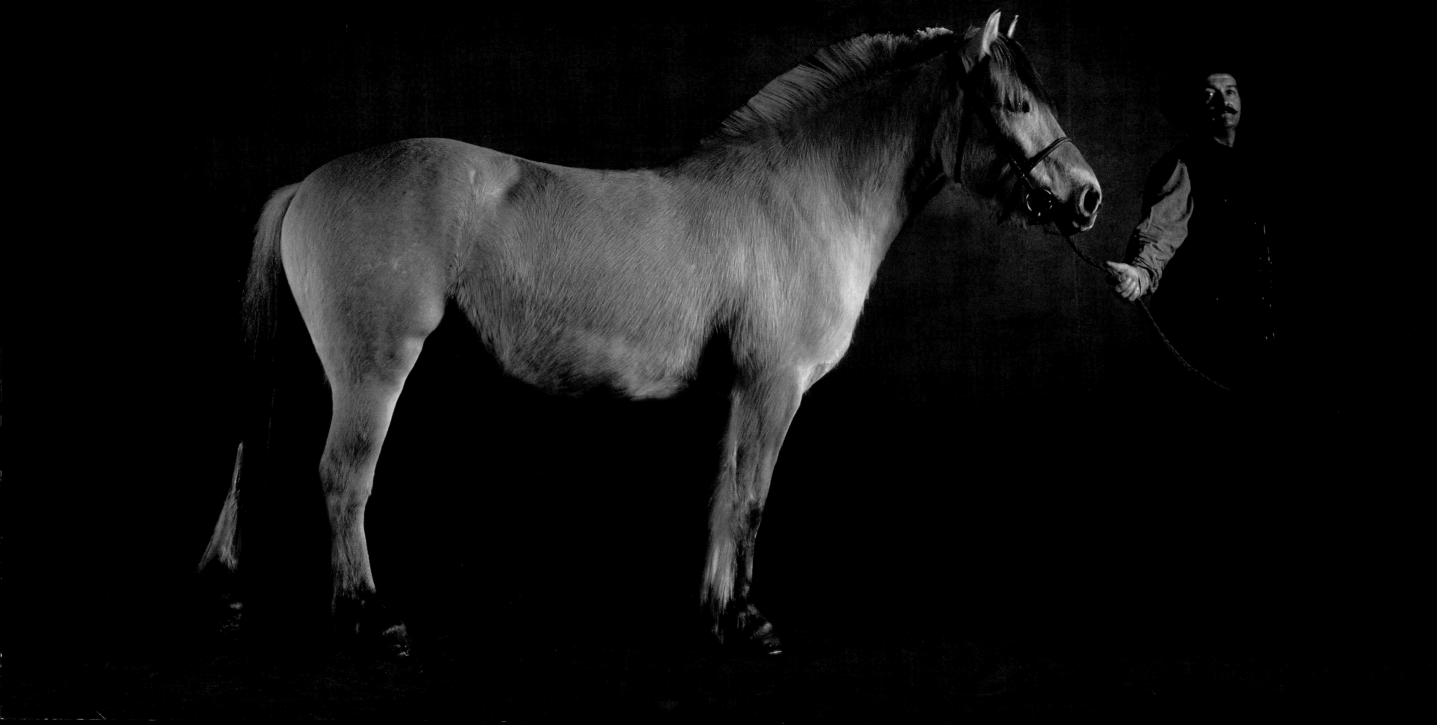

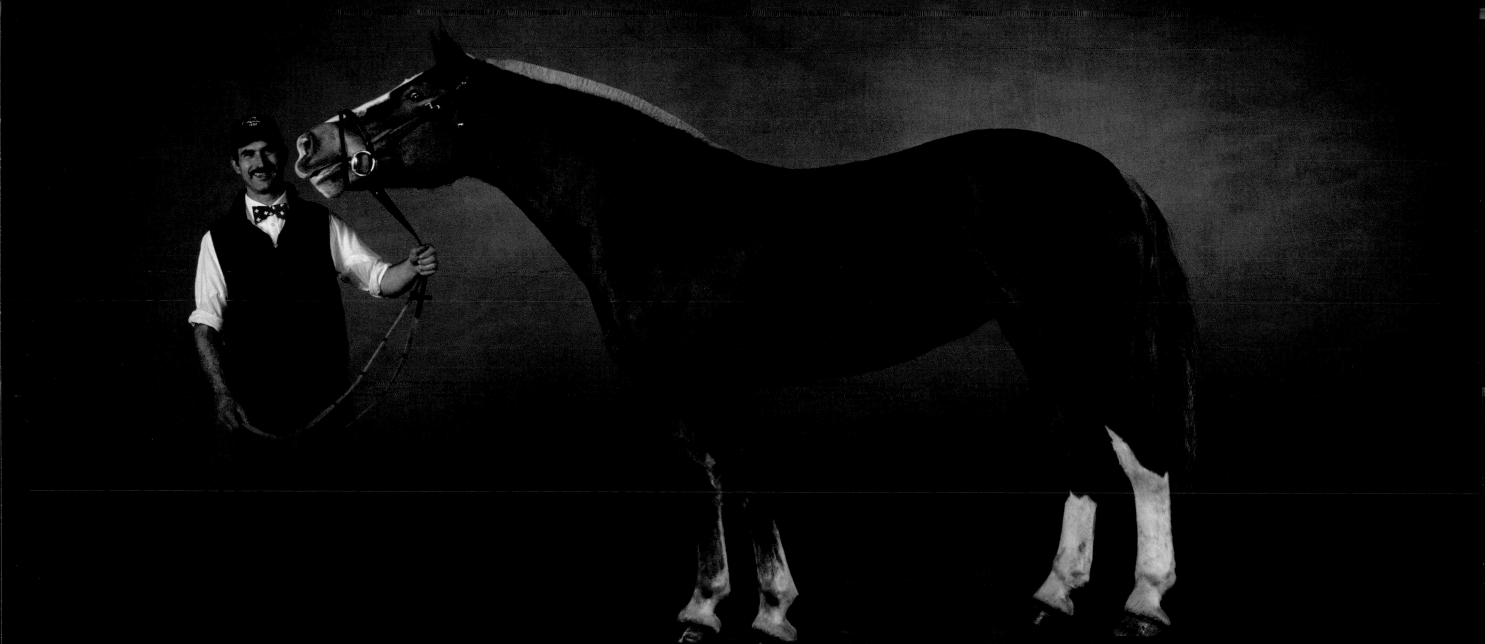

The Fjord: a lucky escape

To envisage the kind of pony that would have existed in the Ice Age, take a look at the Norwegian Fjord, an extremely robust pony whose line has remained essentially pure over the centuries. Besides its dun (characteristically cream or yellow) coat, it has a dorsal (or eel) stripe on its back similar to that of the Asian Tarpan, and remains just as it was in the Viking era, when it was ridden into battle.

Despite this longevity, the Fjord nearly died out as a result of some unlikely crossbreeding in the nineteenth century. There were attempts to make the Fjord first taller, and then fuller in girth, but the results were not very convincing. Fortunately, a few prudent breeders did hang on to their purebred Fjord ponies and were able to bring some order to the breed. Three lines of strong and elegant ponies now dominate it, the descendants of three stallions named *Njal*, *Kare* and *Baronen*.

Standing between 12.3 and 13.3 hh (51–55 in), the Fjord can tackle all kinds of tasks quite happily and is especially suited to agricultural work in areas of Norway in which it is impractical to use motorized vehicles. From working in harness to trick riding and dressage, the Fjord is now found widely across Scandinavia and indeed the whole of Europe, and there are currently some fourteen thousand of these ponies worldwide. Since the Viking era, the tradition has been to keep their mane trimmed, as the epitome of "Fjord style" is to cut the silvery outer mane short enough to allow the black center stripe to show through, giving the illusion of an arched neck like that of a Spanish horse. The thick forelock, however, is left untouched.

212. *Kafka du Camp* (by *Duc d'Ober* out of *Agathe du Moulin*), a four-year-old **Fjord** stallion, presented by his owner, Michel Bousseton (France).
213. *Chanel* (by *Cato* out of *Bacardi*) a six-year-old **Franches-Montagnes** mare (already weighing 1,433 lbs or 650 kg), presented by Richard Olivier.

The Haflinger and the Avelignese: impressive ancestry

An edelweiss encircling the letter "H" is the famous emblem of the Haflinger, the new darling of the equestrian world. Its commercial success can apparently be attributed to just one man, an Austrian who was rescued from the cold by a Haflinger one bitter winter during World War II. Such was his gratitude that he decided to turn the Haflinger into a star. However, the Haflinger is more than just a simple mountain pony: although descended from a heavy Alpine horse and crossed with Asian horses, it can boast a great Thoroughbred among its ancestors. In the nineteenth century, a mare from the area around the village of Hafling was introduced to an Arab stallion, *Folie*. *Folie* was the son of *El Bedavi*, who could also count a Tyrolean mare among his own ancestors. The Emperor Franz-Joseph was bowled over by the little pony with the blond mane and gentle eyes. Nowadays, the surefooted Haflinger is found worldwide and is an excellent family pony, with its chestnut coat and flaxen mane and tail.

Until the age of four, when schooling commences, Haflingers live in semiliberty in the mountains of their birthplace in southern Austria. This upbringing seems to suit them well, as they have been known to live into their forties. Their closest relative is the Avelignese, also a descendant of *Folie*. There are currently some twelve thousand Avelignese in northeastern Italy, Sardinia and Sicily, where they tackle the steep slopes with amazing ease.

Able to withstand both the cold and the heat, Haflingers would certainly have made excellent auxiliary army horses. With this in mind, in 1984 the Indian army acquired five thousand Haflingers for its cavalry, but the venture was not successful and represents the only blip in the breed's illustrious history.

The Swiss, meanwhile, are very proud of their Franches-Montagnes. Every August for the last hundred years, some forty thousand people have attended the horse market and show in Saignelégier, north of Neuchâtel near the French border. Along with traditional displays, harness racing, bareback racing, steeplechases, plus a show with some three hundred horses, and prizes awarded to the local breeders' finest animals, the Franches-Montagnes, or Swiss Draught, is celebrated at these events to the full.

At the end of the nineteenth century, across Switzerland and most of Europe a war was waged between crossbreeding enthusiasts and advocates of strict selective breeding as to the best method to improve this horse. It resulted in the redefinition of the breed's region of origin and therefore a change in status from "Swiss" to "Jura" pony. To make matters worse, the Swiss army refused to have anything to do with the Franches-Montagnes and decided to use foreign horses instead. In 1987, the breeders organized the first Saignelégier horse market and show in response to this. Shortly afterwards, the establishment of a genealogical register for the breed finally introduced a degree of order into the breeders' activities, and the characteristics of the Franches-Montagnes were established. It can be any solid color, dappled or roan but never white (or technically "gray"), which is puzzling, given the number of inns in the region with "White Horse" in their name. Standing between 14.3 and 15.3 hh (59–63 in), with solid joints and hard legs, it is robust, sensible and docile. Used as a saddle and harness horse, it is both light and sturdy, a little more versatile than its French cousin, the Comtois, which lives on the other side of the River Doubs.

Well aware of the breed's fragile and uncertain future, Swiss breeders are attempting to export Franches-Montagnes, emphasizing their excellent nature and aptitude for working in harness.

214, 215. Two Alpine cousins: on the left, *Miss Mariand'I*, a two-year-old **Haflinger** filly owned by Alain Buisson, and on the right, *Efraim*, an **Avelignese** owned by the Italian forestry commission and presented by Massimo Scalacci.

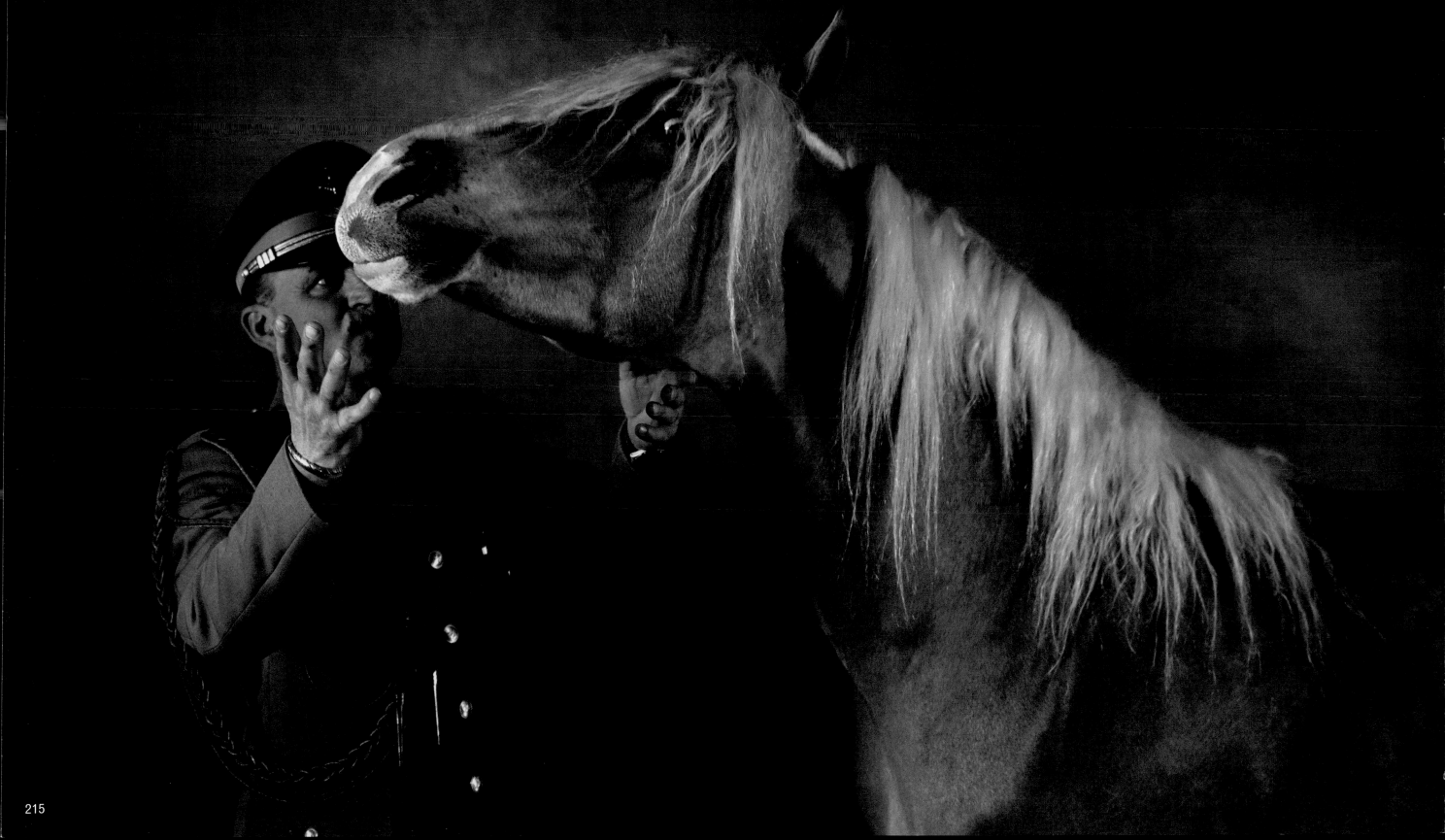

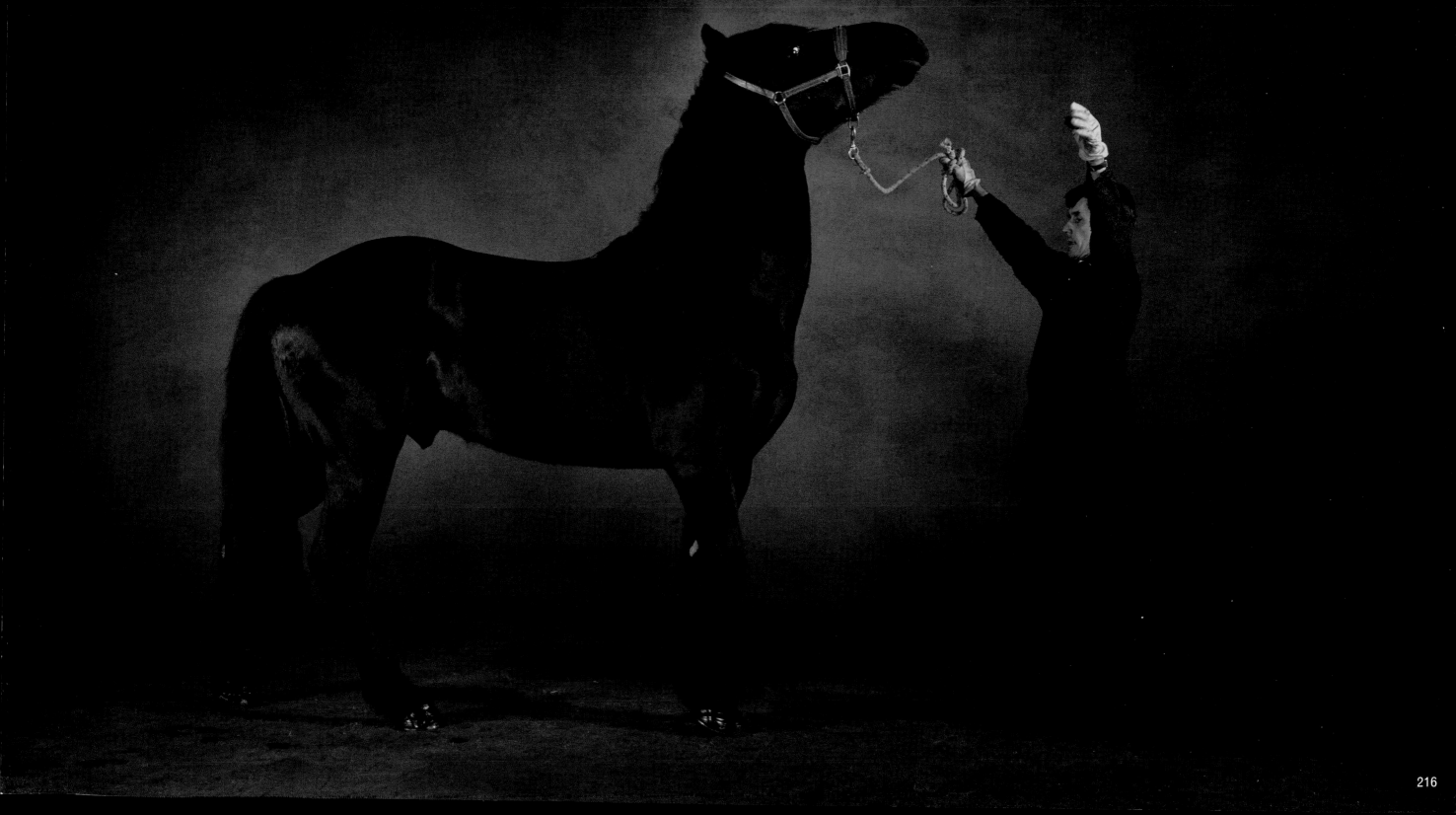

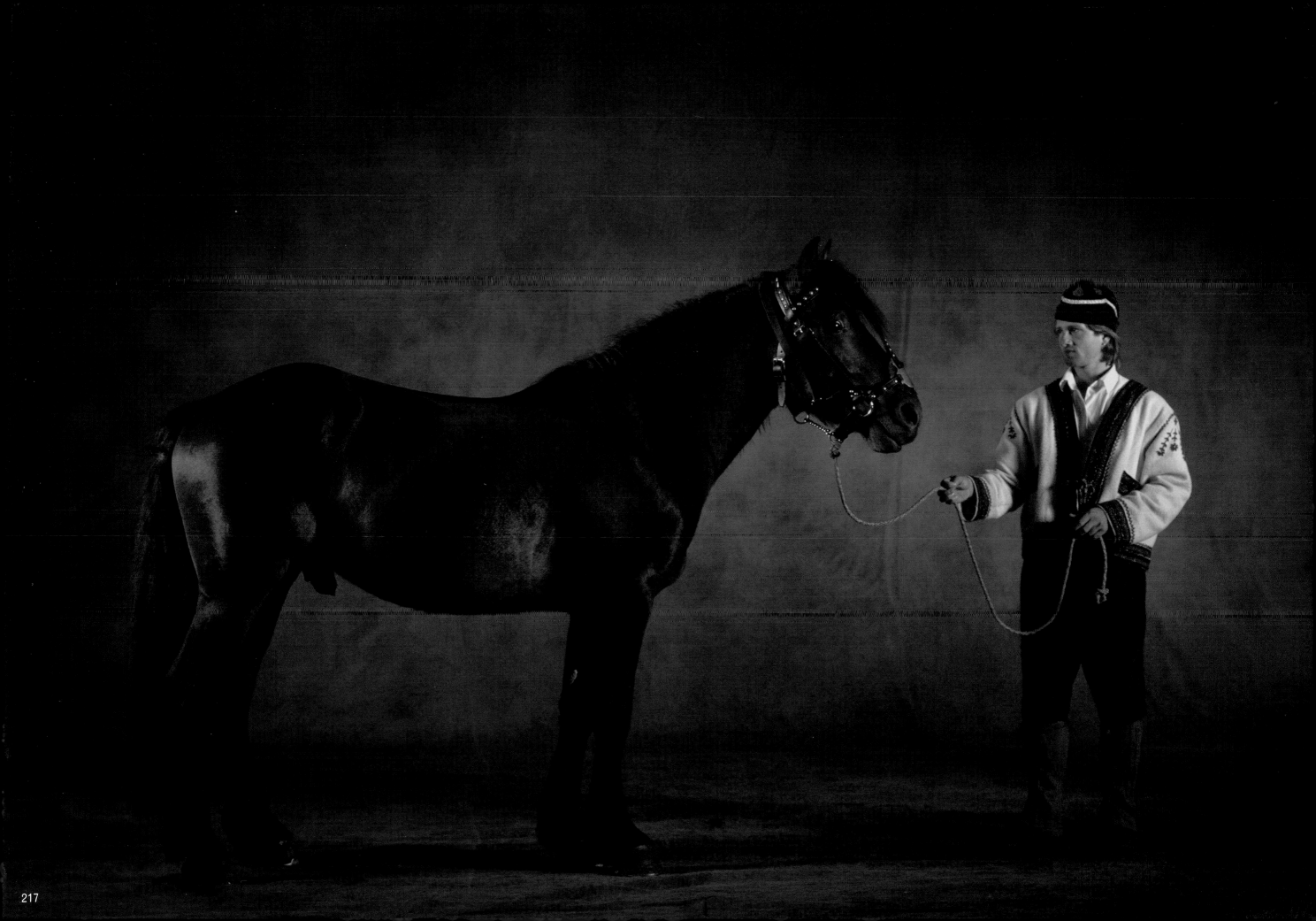

The Merens, the Castillon, the Ariégeois and the Landais are all breeds hailing from the South of France. Fairly small, with dark, or sometimes roan, coats, they often have hairy muzzles, useful when extracting food from prickly shrubs, and are closely related to the Pottok, whose name in Basque means "small horse."

Although now a single administrative region known as the Ariège, until recently Gascony and Languedoc had different cultures, languages and even sheep. It would therefore not be surprising if the horse breeds of the two regions did not differ too, albeit not greatly. Since there was very little communication between these isolated valleys, the breeds were able to retain their own characteristics. People from the region crossed frequently into the Pyrenees, so it is quite possible—as eminent French specialist, breeder and trainer Olivier Courthiade once said—that all the local horses have common Spanish ancestors. This is particularly true of the Navarin, which has now died out. Much prized by horsemen during the eighteenth century, it was somewhat similar to the present-day Pottok.

At a time when horses were valued only for their labor, farmers crossbred their animals according to their needs. This is why the Cerdagne horses, for example, which lived on a high plateau of the eastern Pyrenees and were used for centuries by the military, eventually died out after being crossbred with heavy horses. A similar misfortune befell the Landais pony known as the *poney des pins* (or *lédon*), from the coastal region of the Landes, whose sole living representatives today belong to the family sired by the famous stallion *Jongleur*. His slender frame was passed over by traders at local fairs, in favor of the larger Barthais ponies from the meadows around the Adour. Although never in the rankings in competition at the agricultural shows of the early 1970s, *Jongleur*, an excellent trotting horse, went on to have a dazzling career on the racecourse, thanks to his Parisian owner.

Breathing some new life into these brave, free horses was one of the hobbyhorses, so to speak, of the conservation movement that grew up in the latter part of the twentieth century, with the aim of preserving the old breeds. Some enthusiasts even succeeded in introducing a stud book for the local types.

In 1955 there were fewer than two hundred Barthais ponies, whose bloodline was, by then, much diluted. However, in 1967, with the addition of a little Arab blood and a touch of Welsh, the Landais stud book was born. Generally bay, black or dark brown, with a fine, square head, sound joints and a full tail that brushes the ground but is lifted when the Landais is moving, this pony also made a significant contribution to the stock of the French riding pony, established in 1969.

The Merens was the French trick-riding champion of 1999 and excels in harness. Its gentle nature also makes it ideal for use in horse therapy. A small village horse from the Ariège, it has conquered the whole of Europe in less than fifty years. Thirteen thousand years ago, if the Magdalenian paintings in the Niaux Caves are to be believed, the Merens was of average size, with a velvety black, shaggy coat and long whiskers. Since then, its penchant for eating oak leaves has refined its line and today it cuts an elegant figure compared to the Castillon, a heavier horse from the Ariège.

One story goes that the Castillon originates from Greece, as does the traditional folk costume worn in the high valleys of Bethmale and Biros in the Ariège. In the sixteenth century, having made his fortune in Greece, a Frenchman by the name of Jouanissou is said to have returned to his birthplace, bringing with him Greek livestock (including goats and breeding mares) and cloth. On the other hand, some historians assert that the French king François I (1494–1547) was riding a horse from Biros at the battle of Pavia, on the day he was captured by the Spanish. Nowadays, the Castillon is a good leisure horse, happy to go anywhere. Saved from extinction in the 1980s, its future is now assured—it was recognized as a pure breed by the French Ministry of Agriculture in 1996. With its black mane and tail and chestnut coat, it bridges the gap between the Merens and the Tarbais, a horse that was greatly loved by the hussars.

The Pottok (pronounced "pottiok"), perhaps the best known of the breeds that the conservationists are trying to preserve and the subject of many books, films and scientific papers, at one time must have traversed Europe bearing the warriors of the Visigoths. Over the years, it has become something of a cult horse for the conservationists and now plays a major role in eco-tourism. In Bidarray, in the French Basque country, the Pottok Center organizes guided tours of the Pottok Pyrenean Reserve. Spread over four peaks—the Baigura, the Rhune, the Usu and the Hatza-Mendi—these Basque horses with wide-set eyes and black hooves live in total freedom, just as they have always done, and still look very much as their ancestors did. Unfortunately, the Basque peasants took better care of their sheep than of their horses, which—being unprofitable—were tolerated, but only just, and made to live on poor land. The Pottok's participation in local cultural life is only fairly recent, but it has formed part of the local Basque cuisine for many years. Nowadays, however, they live much more peaceably than their Spanish alter ego, the Galician pony, which is still used for meat.

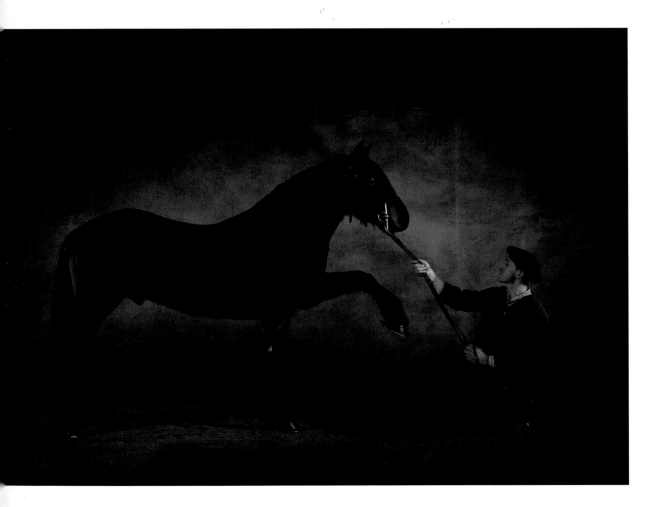

216. *Kenobi de Garosse*, a four-year-old **Merens** stallion, owned by Mr. Bury and presented by Pierre Germain.
217. *Guirantos d'Aulus*, an **Ariégeois** horse presented by Sylvain Salamero.
218. *Kazan des Vieilles*, a four-year-old **Castillon** stallion, owned by Marie-Claude Bernard and presented by Jean-Christophe Goedgebuer.

219. *Judo*, a five-year-old **Pottok** stallion, owned by the Grands Joncs Marins stud farm (Normandy) and presented by Jacomina Daneels.
220. *Viwa Cap de Bosc*, a five-year-old **Landais** mare, owned by Alain Frère and presented by Bérengère Zamora.
221. *Farceur des Contes*, an eleven-year-old **French Saddle Pony** stallion, owned by Michelle Davenet and presented by Véronique Magrin.
222, 223. *Gayrlock de Touvent*, a fourteen-year-old **Henson** (by *Chanell d'Oueux* out of *Artemis de Henson*), owned by Michel Beaufils, and 12-year-old *Enya de Henson* (by *Urus du Sehu* out of *Teriam de Henson*, owned by Michèle Lejeune. The result of a cross between mares from the Somme basin (France) and Fjord stallions (Norway), the Henson is a very versatile breed (used as a saddle horse, in harness or as a pack animal) that has only been recognized very recently (summer 2003).

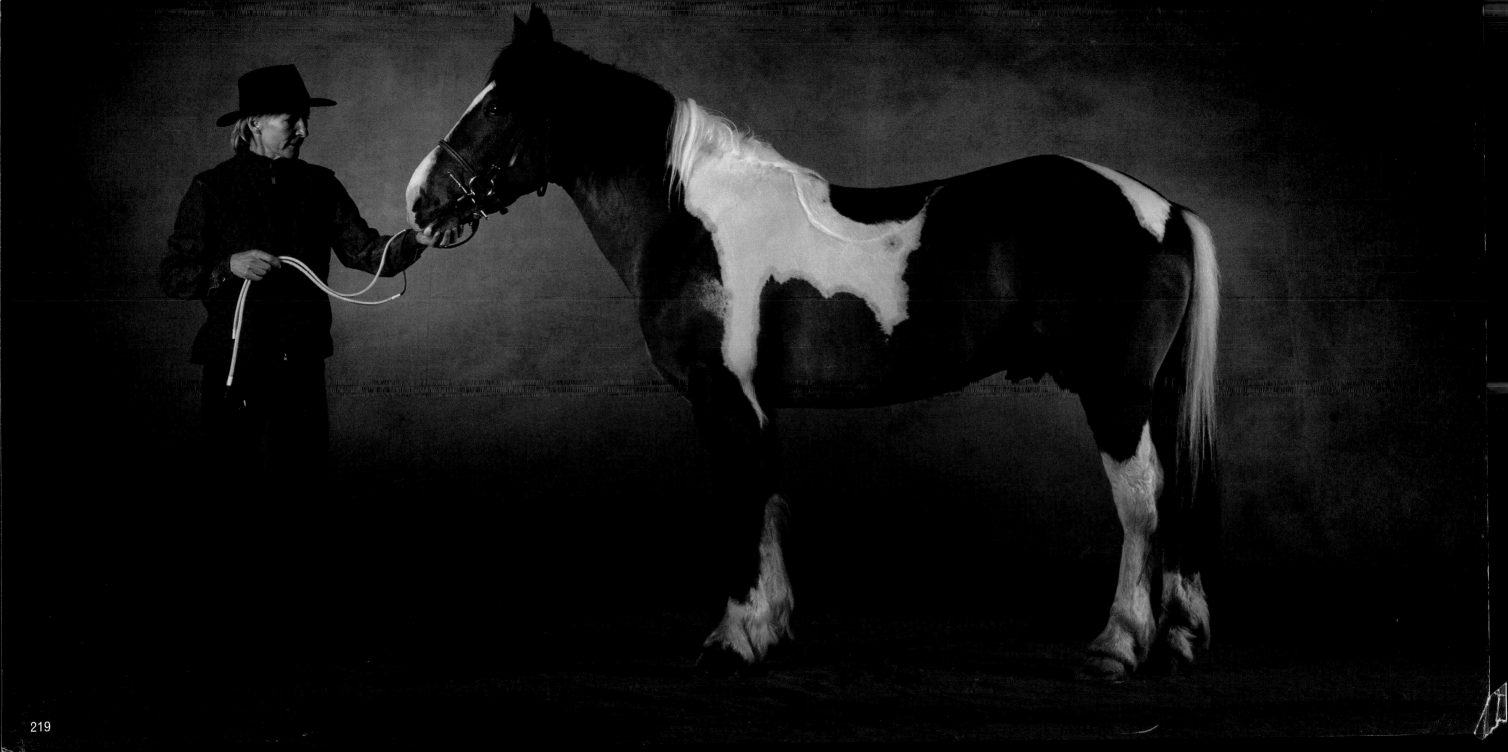

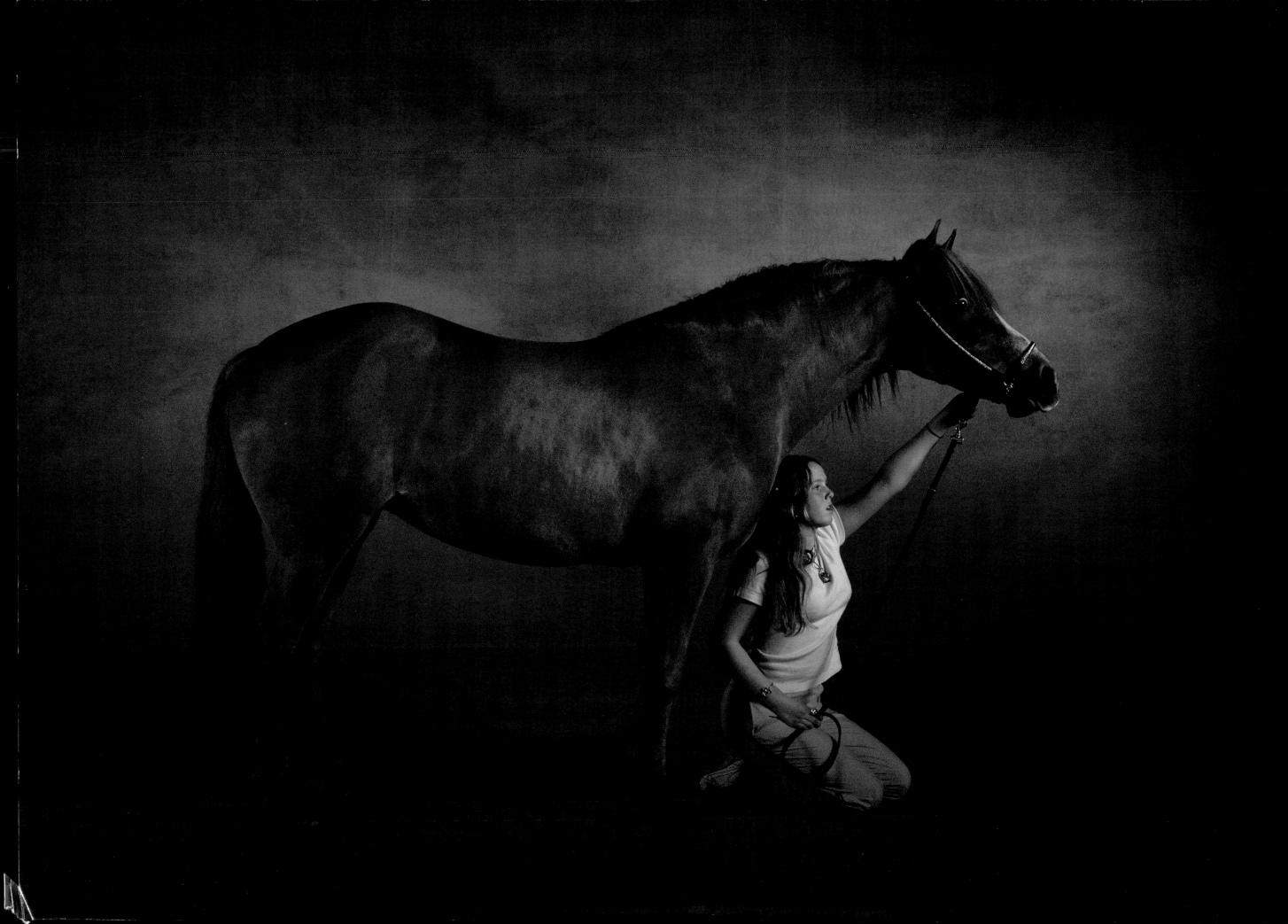

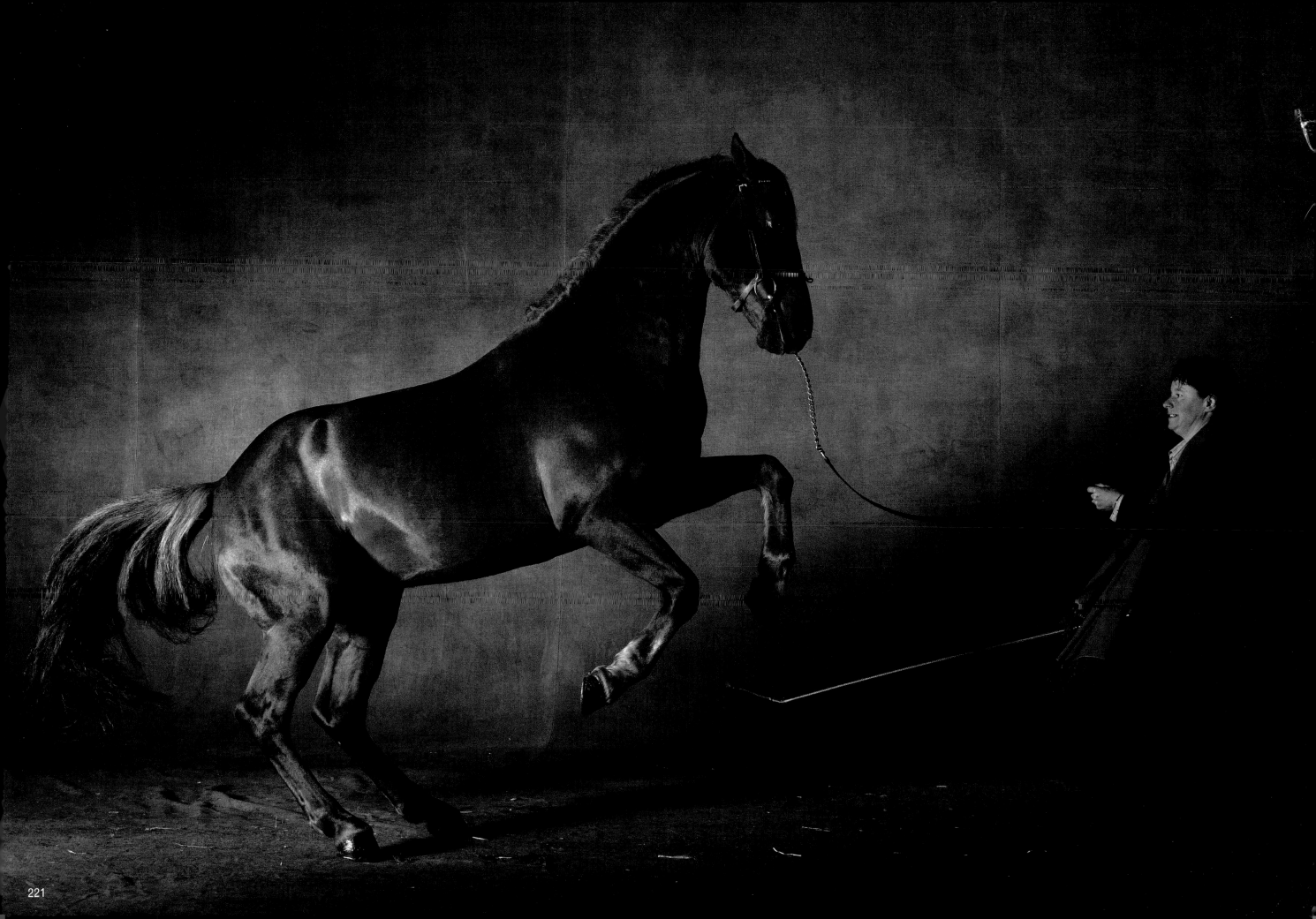

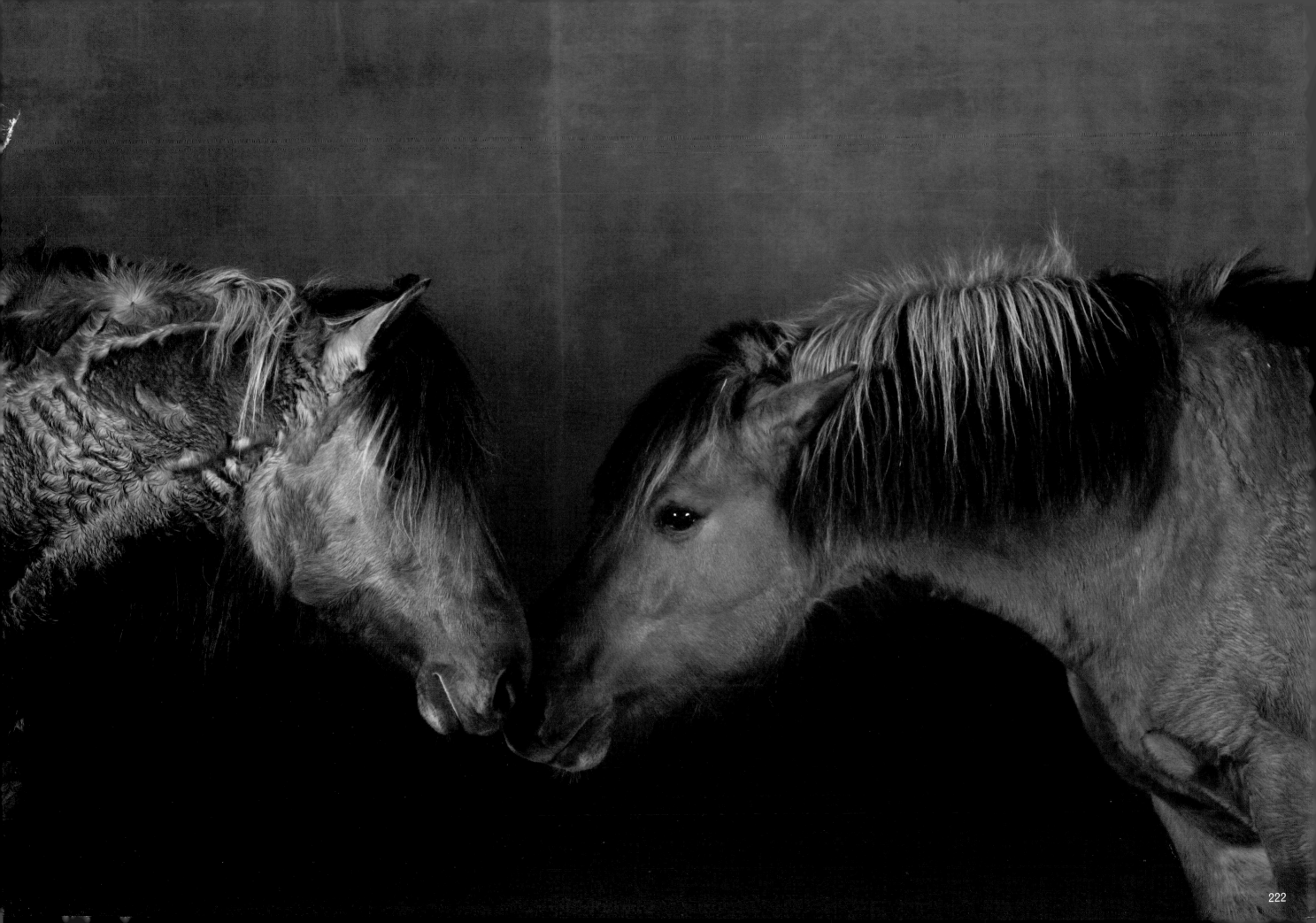

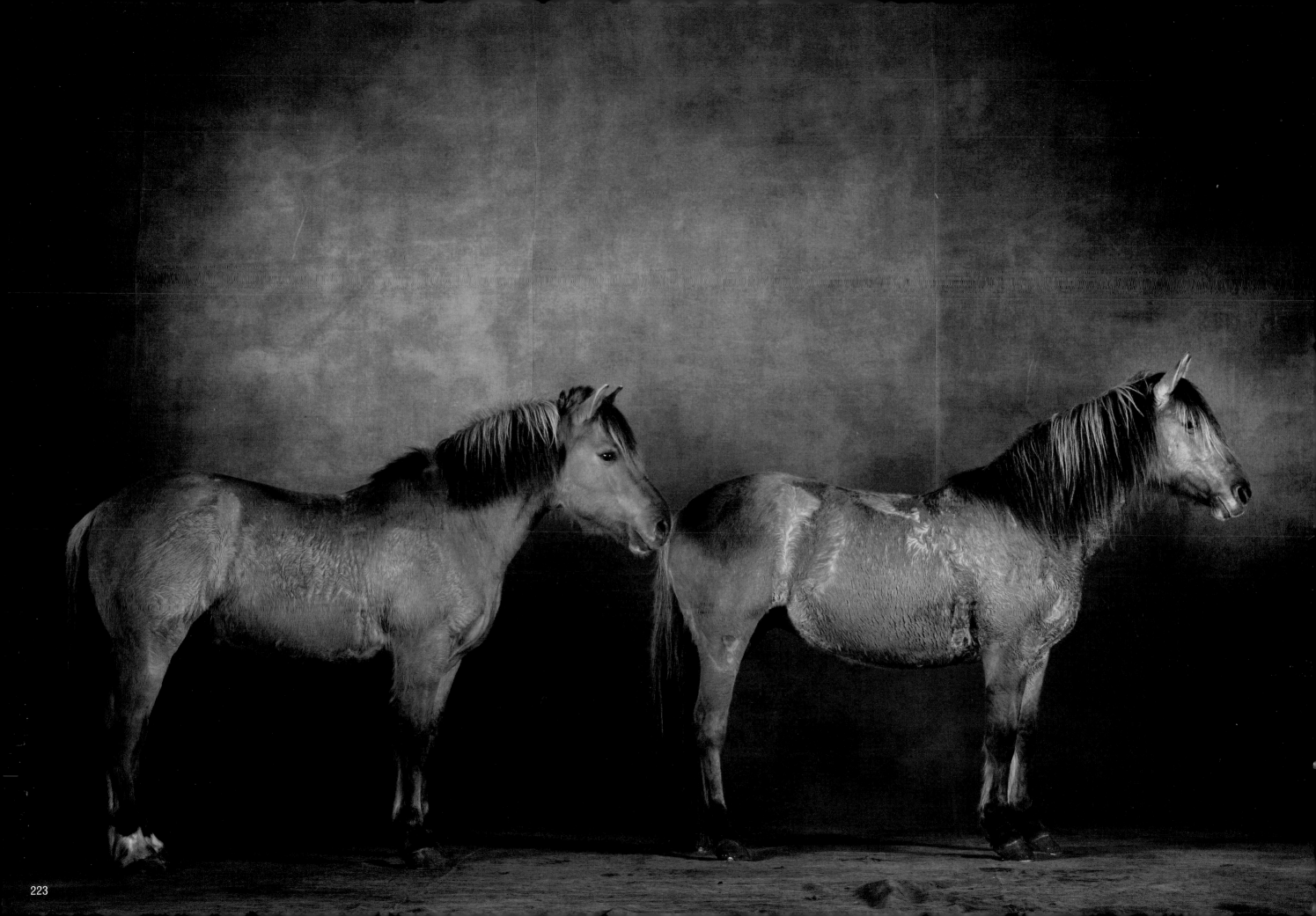

The horse's cousins

The donkey

It may seem somewhat incongruous to find a section devoted to donkeys and mules in a work entitled *Horses*. As they belong to a different species, their inclusion cannot be justified from either a zootechnical or even an aesthetic point of view. They are included here because Yann Arthus-Bertrand loves donkeys and wanted to make them a part of his photographic tribute to horses. At the same time, it was a good opportunity to present a case for the humble donkey, which, despite its long association with man as a beast of burden, should surely be given a place in this book alongside its illustrious cousins.

The large *Equidae* family to which the horse belongs comprises seven different species. The three main groups within the family are the horse, of which there are two species (*E. przewalskii*, *E. caballus*—the domestic horse), the zebra, of which there are three (*E. quagga*, *E. grevyi*, *E. zebra*), and the ass with two species (*E. asinus*—the donkey or African ass, *E. hemionus*—onager or Asiatic ass). The horse species is extraordinarily diverse, but some types of wild ass are either endangered—such as the onager, usually known by its local name (*kiang* in Tibet, *kulan* in Mongolia, *ghorkhar* in India and Pakistan)—or extinct—such as the Syrian wild ass (*E. hemionus hemippus*). The donkey is the domesticated descendant of the African wild ass (*E. asinus*) and/or the Nubian ass (*E. asinus africanus*).

Employed as a beast of burden since as early as 4000 B.C., the donkey is often associated with the biblical lands of the Near and Middle East. According to the well-known anecdote, the Egyptian queen Cleopatra (69–30 B.C.) preserved her legendary beauty by bathing regularly in wild donkey's milk. The donkey's other—and more prestigious—claim to fame is that, along with the ox, it was one of the few animals to witness the birth of Christ and was the animal upon which Jesus chose to ride into Jerusalem.

Even so, the donkey's distinguished past was not taken into account when it first appeared in Europe, at an unspecified but very early point in history. The poor creature became the victim of both physical and verbal abuse and an object of mockery and ridicule, with just one exception—the donkey did earn respect for its prodigious sexual prowess and the exceptional size of the jack's reproductive organ.

Recent years have seen it acquire a newfound and more respectable status in developed countries, where it is no longer used to carry loads or pull carts. In some parts of Europe, donkeys have become ever more popular, especially where children are concerned, and their numbers have increased significantly over the past twenty years. Gone are the days when the donkey's large ears were a symbol of stubbornness and ignorance; instead, they have become an asset, adding to the appeal of an animal that is sometimes kept as a pet. Today, donkey foals can be bought at quite reasonable prices from the many donkey sanctuaries that have sprung up in rural Europe. In some cases, their owners—often unprepared for and sometimes disconcerted by their new pet's behavior—have been obliged to turn them out to pasture or simply use them as "living lawn mowers" for the family's second home. Donkeys are also being used

increasingly in the tourist industry, to carry walkers' backpacks on long-distance hikes, perhaps inspired by the Scottish writer Robert Louis Stevenson's (1850–94) account of his experiences in *Travels with a Donkey in the Cévennes* (1879).

Still, the donkey's improved lot in some parts of the world should not blind us to the fact that it is even more of an endangered species than certain breeds of horses and runs the risk of becoming extinct through lack of use. Overall, worldwide, the donkey population is on the decline, even in those countries (especially North Africa) where it is still relatively widely used. This is a much more serious problem than it would first appear. It is not just a question of declining numbers; entire breeds are disappearing. For example, until relatively recently, each French region had its own "breed" of donkey, so there was a wide variety in size—9.3–14.3 hh (39–59 in), to even 15.3 hh (63 in)—type, color and aptitude. Today, only a few of these "breeds" survive, with numbers in decline. For example, the Poitou (or Poitevin) and Pyrenean breeds number only around three hundred each.

The most picturesque is undoubtedly the Poitevin, a large donkey standing 13.3–15.1 hh (51–61 in), with strong limbs and a thick, dark bay coat. Its reputation is due not only to its striking shaggy and ungroomed appearance but to its quality as breeding stock—Poitou jacks are highly prized throughout the world for the production of mules.

224. *Gamin*, gray **Provence donkey**, with its owners Roland and Marie Pevent.

With the horse unquestionably at its head, the large *Equidae* family comprises a number of species, including zebras and asses...

Among this "herd" of cousins, the donkey, the domesticated descendant of the African wild ass, is more closely related to the horse than any other species. In fact, they are so closely related that they can even be interbred. When a donkey stallion (jackass or jack) is mated with a horse mare, the offspring produced is a mule.

The mule

The mule is the result of an interspecies breeding, produced by crossing a horse mare with a donkey stallion. Surprisingly, the offspring of this pairing retains all the qualities yet none of the defects of its sire and dam. The mule is another example of man's creative ingenuity and our irrepressible desire to transform nature, adapting and controlling it for our own ends.

The mule would not be able to exist without man's intervention, since there are no instances of natural coupling between different species, however closely related. The basic instincts of both horse and donkey have to be overcome in order to persuade them to participate in the reproductive act.

Attempts to cross different species in this way are by no means a recent phenomenon. It is reasonable to suppose that such attempts were made as long ago as the first domestication of these animals, and it is likely that many permutations were tried, although successful results may have been few and far between. In the cattle family (*Bovidae*), bulls have sometimes been successfully crossed with yaks (Mongolia) and in the camel family (*Camelidae*), attempts have been made to cross Arabian camels or dromedaries with Bactrian camels (Turkey). However, it was in the horse family (*Equidae*) that these crosses were the most inventive, as can be seen from old documents referring to a hybrid that was produced by crossing a zebra with a donkey. Today, these zebra-donkey crosses (known as zedonks or zonkeys) are becoming increasingly popular, as is the zebra-horse cross (the zorse), the unlikely sounding cross produced by putting a zebra stallion to a horse mare. Attempts have also been made to cross horse stallions with donkey mares (jennies), but that offspring (the hinny) does not have the same qualities as the mule.

Calmer than the horse and more lively than the donkey, the mule lives longer than the former and is more active than the latter. Its sure-footedness makes it ideally suited to mountainous terrain, while its ability to carry heavy weights makes it an equally good pack and saddle animal. It is also enduring and, whether ridden or in harness, is ideal for covering long distances.

Today the mule, which was widely found and used in Ancient Mesopotamia, is still produced and worked in countries throughout the world. Mules have to be "produced," crossing a good brood mare with a strong jack because, like all hybrids, mules are sterile. If the jack appears reluctant to perform, it is given verbal and, if necessary, manual encouragement. However, sterility is not synonymous with impotence and the virility of the males can be so excessive that, in certain countries, they are automatically castrated.

There is no established standard for mules: their size and colour depends on the choice of sire and dam, especially the dam. Although some breeds of mare are better suited to producing mules than others, in principle any breed can be used. Andalusian mares are used in Spain, Murgeses in Italy and Appaloosas in the United States. About twenty years ago, the Indian army acquired a job lot of Haflinger mares and a Poitou jack with a view to producing mules. According to Pyrenean breeder Olivier Courthiade, who puts Catalonian jacks to Breton mares, Thoroughbred mares were once widely used in mule production. He quotes the example of champion racehorse *Monsieur Piperlin*, winner of the Auteuil Steeplechase in 1901, whose half brother was a mule.

The United States is now the only country in the world where a racehorse would be covered with a donkey. Ever pragmatic, the Americans choose the breed of the dam according to the use to which her offspring are to be put. So, Thoroughbred brood mares are used to produce racing mules, Quarter Horse mares to produce sporting mules, and Percheron or Belgian Draught mares to produce draught mules.

In Europe, where the mule has for some reason never had a very good press, its use is declining dangerously. Fortunately, however, the reverse is happening in the United States, where mules enjoy a good reputation and are increasingly used in a wide variety of areas, from racing and jumping to parades, *haute école*, rodeo and driving (singly, in pairs or in teams of six or even twenty). Mules seem able to adapt to most disciplines. Perhaps one day they will even be used in polo matches, but they really come into their own in the field of endurance and, in events open to both mules and horses, it is not uncommon for the latter to be outperformed by their long-eared cousins.

In America's land of opportunity, some enterprising individuals have even created "mule rental," businesses that hire out pack mules to work on sites that are steeply sloping. Not only are they ideal for this type of terrain, they are also a cheap alternative to other means (such as helicopters) of bringing goods and materials onto these sites. It appears that the entrepreneurs have made quite a "killing."

226. *Jolie*, a six-year-old **Poitou donkey** mare (970 lb/440 kg and 14 hh/56 in; by *Ultime* out of *Voleuse*), was French champion in 2003. She is owned by Jean-Pierre Mariot and presented by Céline and Émilie.

227. *Doly de Cadéac*, a four-year-old **Pyrenean mule** (by *Solide* out of *Venus de Cadéac*), owned by the École des Mulets (Nescus) and presented by Olivier Courthiade.

228. *Kourout*, a four-year-old **Poitevin draught horse** (by *Coquelicot* out of *Aurore*), owned and presented by Jean Clopes. The mares of this breed are sometimes used to produce mules.

229. *Dolly*, a **Poitevin mule** (by *Lizeron*, a Poitou donkey, out of *Victoire*, a Poitevin mare), presented by her owner Jean Richard.

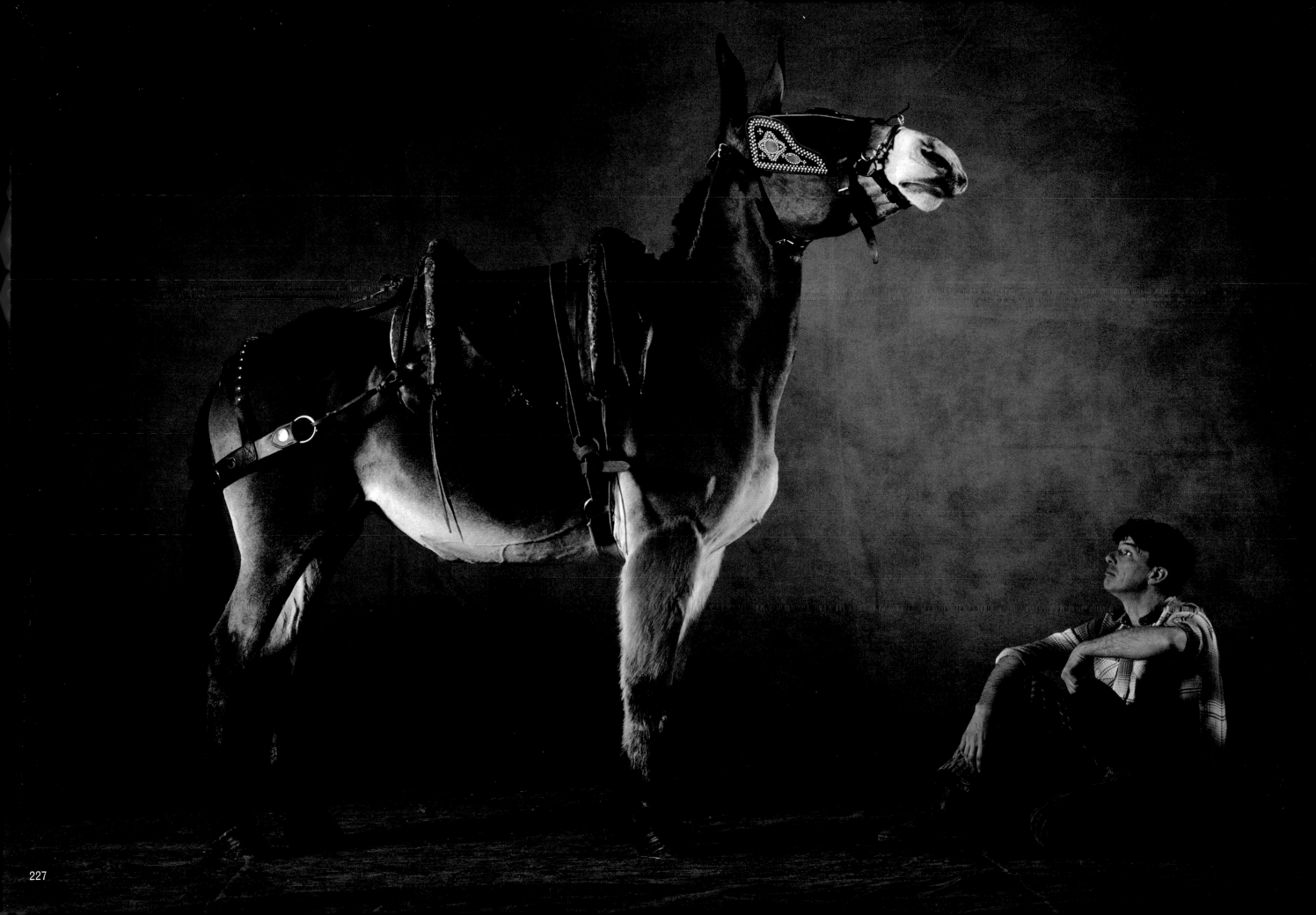

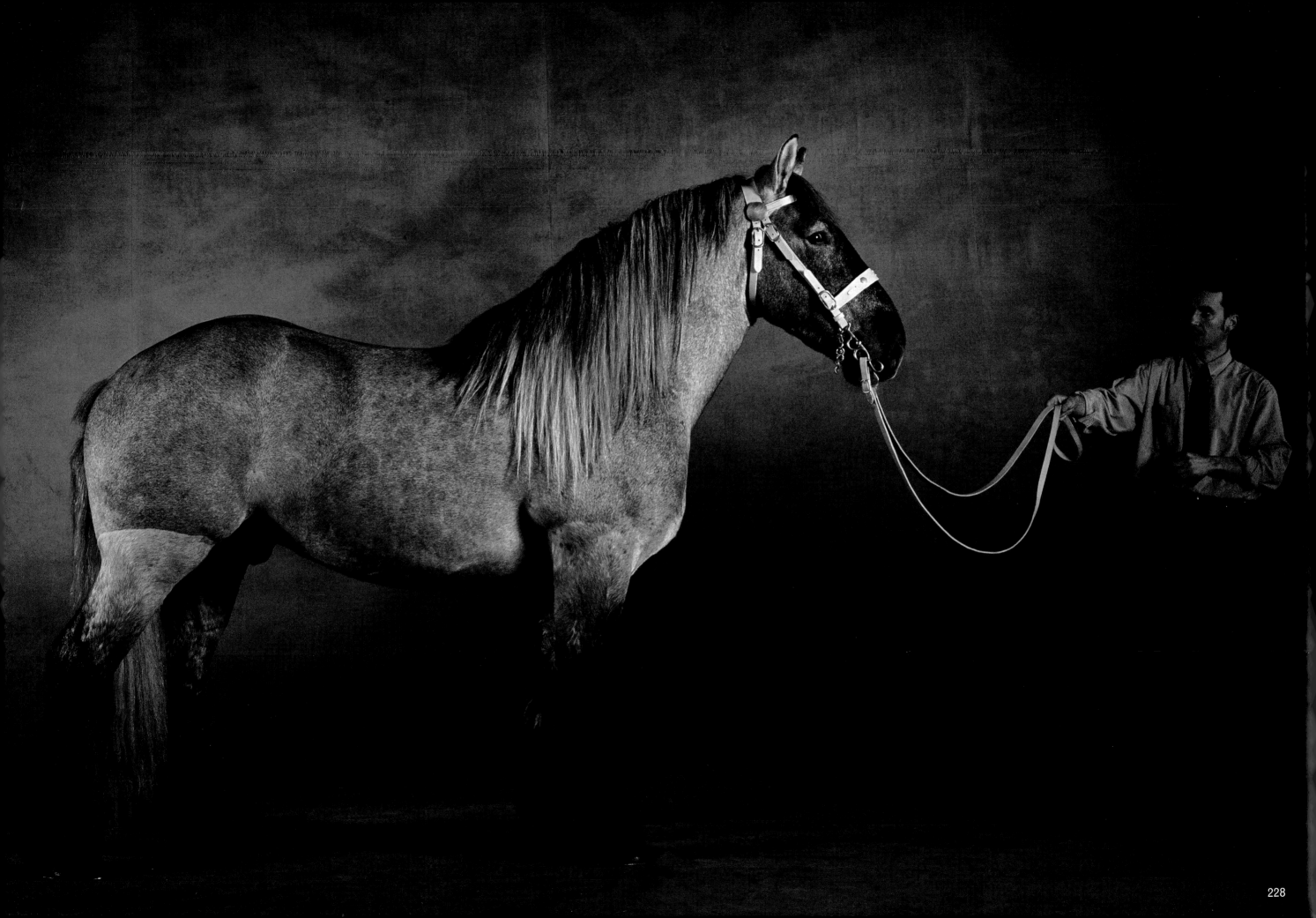

228

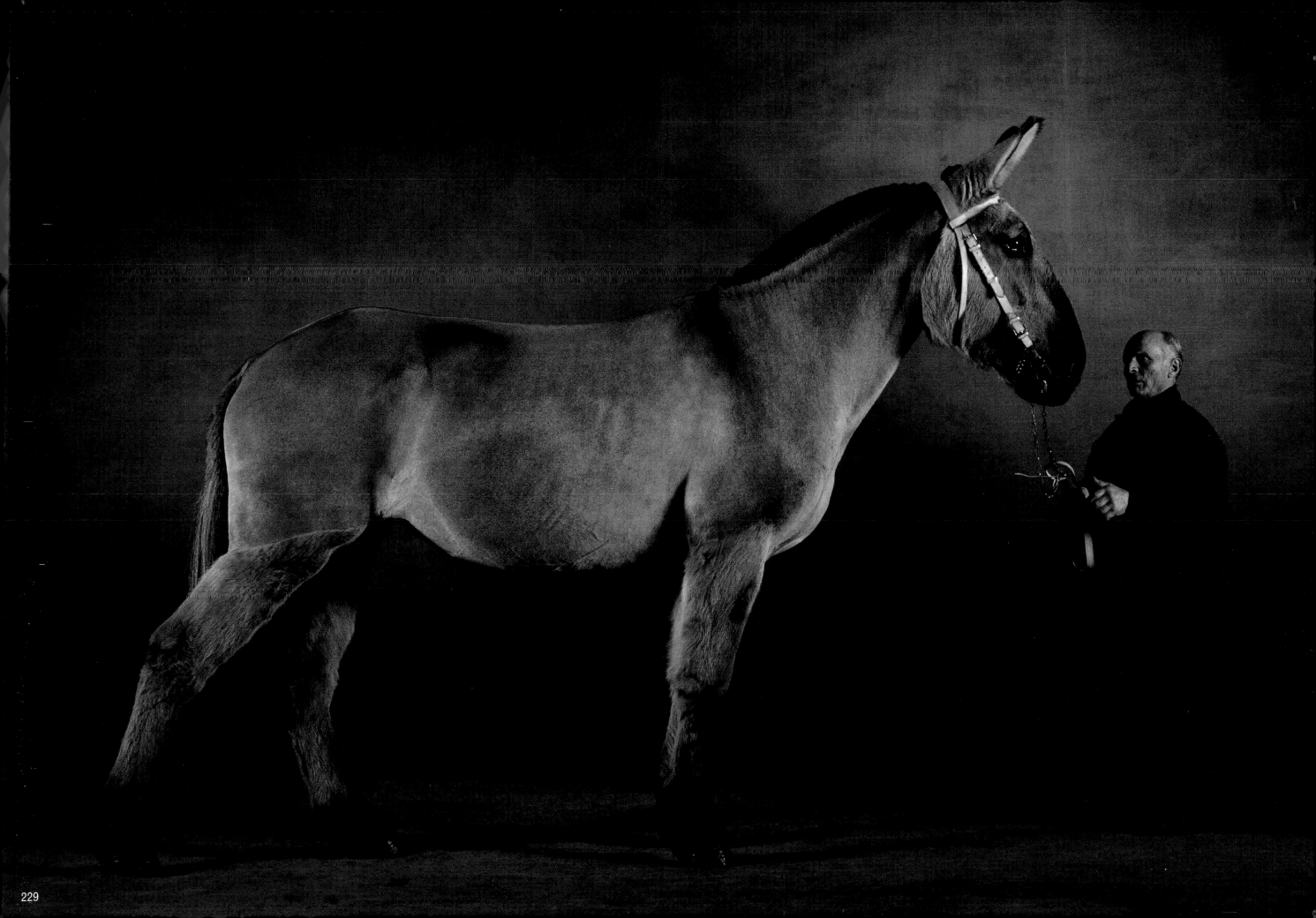

The canvas is not something we invented. It has been used in horse portraits since the earliest days of photography.

On the other side of the canvas...

"You've made the canvas too wet! It'll never dry!" The usual wave of panic swept through the camp before the shoot. The dripping canvas, still soaking wet, was suspended between two poles in the middle of a field in Montana. Everything had to be ready in less than an hour. The memory of this particular shoot at a riding school in France, struggling with a canvas still marked with damp patches, haunts Yann Arthus-Bertrand to this day. We had to resort to hiring a dryer to help us restore the canvas to its proper color.

The canvas or tarpaulin was the key accessory in the traveling photographic studio assembled for each shoot. Wetting the canvas was essential. It was the only way the marks caused by folding it for transport could be erased. However, today, with the aid of the winds across the great American plains, there was no problem, it would be dry in a few minutes. Still, the wind itself presented difficulties, tugging at the canvas and making it fly up. The placid Quarter Horses were not at all disturbed by the flapping canvas, but the lighting equipment was blown over onto the grass, while the cowboys waiting patiently nearby laughed at us doing battle with the wind as we tried to secure the canvas to the ground. They finally came to our aid, resulting in a photo session that was a little more makeshift than we had planned (see the photo above).

In over fifteen countries, some of the most beautiful examples of the equine race have paraded in front of our canvas, or rather canvases. I say "canvases" as, depending on the location, we set up what we termed a 'full studio' or used a canvas in a rather more makeshift affair. The "full studio" version, using a 33 x 33 ft (10 x 10 m) canvas weighing over 88 pounds (40 kg) was used for shoots at horse shows. At the end of just a week of shooting at the shows, we would have an enormous collection of images of the finest representatives of the dozen or so breeds that usually attended them. Setting up the full studio version allowed Yann to get the lighting just right in order to create the atmosphere he wanted to achieve.

Holsteiner, purebred Spanish, Murgese, Maremmana, Arab Berber—we drew up a list of the breeds present at each show to make sure none was missed. We then sought out the best of each breed and tried to persuade their owners to give up some of their valuable time during the busy show week. It was a risky business at times—when we tried to lead four gigantic Friesians to the "studio" through the center of a large crowd, for instance. Over the past fifteen years, the breeders at the Paris Agricultural Show had become accustomed to Yann's presence and were quite happy to participate. The Russian breeders, however—to whom we tried to explain (in Russian) that we wanted them to pose with their horses in our makeshift studio—were somewhat surprised and not a little suspicious. Less so than the British, however, who seemed to expect that they would have to pay for the photograph.

"The Maremmana has pulled out, the Avelignese is coming instead." Françoise and Arnaud started to panic. Instead of the large black horse they were expecting next, a little horse with a dun coat was on the way. All the light settings would have to be changed. Luckily Yann and Françoise have been working together ever since Yann started taking photographs of animals. "Put the front lights at a lower angle, but not on the right, on the left, I know what I mean... or at least Françoise knows what I mean!" Nearly one hour later and Françoise, tireless as ever, is still at it: "Shall we try with the whole family next to the horse? What if we let the horse loose?" People put forward their ideas for giving the photo some life and try to work out the best way for each horse to be positioned. A lifeless image would be useless.

The problem with the full studio version was its sheer bulk. From the Paris Agricultural Show to the Horse of the Year Show at Wembley, or Equitana in Essen, Germany, we managed to transport all the equipment in a camper van and horse trailer. However, things became a little more complicated when the Russian Equiros Show in Moscow began to loom: how could three people, each with 330 lbs (150 kg) of luggage in metal trunks, avoid attracting the suspicion of the Russian customs officers? The Russians did not let us get away with it and confiscated the generators, light boxes and canvas at the airport. Four days of hellish negotiations, sleepless nights and a dozen or so official letters from various people and organizations, and finally the customs officers, who in the end became sympathetic to our cause, received official authorization to release the equipment. The show was opening the next day. We had just one night in which to set up the studio in the barn we had rented, by torchlight. Suspended from beams more than 16 feet (5 m) above the ground, the canvas was fixed in place, with no distracting folds and just in time to capture the soulful eyes of an Akhal-Teke.

Like people, however, horses are an integral part of their surroundings, and confining an animal that symbolizes freedom indoors in order to take a photograph seems to lessen it in some way. On the other hand, the open-air version of the studio—set up in the middle of the countryside—allowed us to convey much more fully the ambience of the life led by the horses and their riders, still, of course, with the famous canvas as a backdrop. The equipment for shooting outside was much lighter and less obtrusive: 330 pounds (150 kg) comprising two solid camera stands, two battery-operated flash units and a smaller version of the canvas (20 x 10 ft/6 x 3 m). All we needed then was a long rod, sturdy enough to hold the canvas. "In Cameroon we secured the canvas with ropes, didn't we?" But in Chile there were no trees. "Bamboo won't hold up the canvas, it's not solid enough—what about the flagpole? Too heavy!" Each shoot was different and brought its own set of problems; we had to be flexible and adapt each time, making do with what was available.

Each outdoor shoot was like creating a *tableau vivant*, with the horse as the principal character against the canvas background. Sometimes, however, the composition became difficult to control, especially with twenty beaming Kyrgyz horsemen standing around the canvas at an altitude of 9,186 feet (2,800 m), with a herd of sheep, two eagles and rain threatening... His eye pressed to the viewfinder, Yann took in the scene, and assumed the role of director: "Sheep to the left more, eagle turn your head towards me—can't he beat his wings? The horse is lifeless—prick up your ears!" "This is terrible"—he despaired—"the horse won't prick up its ears, the sheep have strayed off, the eagle's not looking the right way, the horsemen in the front row are hiding the others." Total disaster and then, finally, the horse deigned to lift an ear thanks to the racket we were making to attract his attention, the horsemen managed to bring the sheep back, the flashbulbs synchronized and the camera worked its magic. "Don't change a thing, that's wonderful!"

We would often keep going until nightfall, when fading light would finally put an end to the shoot. For each successful image, dozens and dozens of compositions were tried out before finding the perfect pose. It was rare for everything to come together at the right time, so we would carry on until that magical moment took place... As the equipment was packed away by torchlight, we tried to remember to collect every last piece, ensure the publication authorizations were signed and take down as many details as possible about the horses and their owners so that later we could accurately match up the images with the subjects. Not an easy task when it was already late at night and everyone was eager to get away at the end of the shoot.

When we explained to our friend Tota in Iceland that we shot from sunrise to nightfall, she chuckled, "But here at this time of the year the sun doesn't really set!" Indeed, at two o'clock in the morning it was more like dusk when we finally decided to end the session for the day.

With racehorses, on the other hand, we had to be quick in order to catch them in front of the canvas between races. The number of these horses ready to pose in front of the canvas was limited. A racehorse needs to save its strength, just like an English Thoroughbred or a trotter. The mood or level of fatigue of the horse often meant we had to call it a day.

However, the concept of the outdoor studio often caused astonishment and did not convince everyone. The Kyrgyz, to whom we showed examples of previous outdoor photographs in order to explain what we wanted to do, smiled faintly. "But where is the final photograph? You will remove the brown canvas for the real photo, won't you? It's not very attractive like that...!"

We had the same reaction from a Frenchman who assisted us with our shoots in Qatar: "Ah, I see you're well organized, you've got a canvas to protect you from the sun—but that must be difficult to remove on the computer!" The last two years of intensive photo shoots were also a technological turning point: we always used digital cameras when shooting at agricultural shows. Viewing the images on the computer screen, we could reach a verdict immediately. "Too strong on the hindquarters! Lower the generators at the back—the spotlight settings on the canvas are not right." The light settings could be checked immediately on the image, as could the position of the horse, the folds of the canvas, which all tended to push perfectionism to extremes... "It's not bad but I think we can do better... let's carry on!" And so we carried on...

"What a shame we didn't go to Lipica for the Lippizans... and what about the Yakut horses? We'll go there this winter." Just as a photo shoot is sometimes never quite finished, a book such as this—the stuff of dreams—will never truly be closed.

Sibylle d'Orgeval

Acknowledgments

I must first and foremost thank Sibylle d'Orgeval, who forced me to finish the book I began more than ten years ago. Without her contagious enthusiasm, her constructive criticism and, above all, her unbelievable energy, this book would not exist. Also Françoise Jacquot, who, for the last fifteen years, has assisted me in my studio work with untailing passion and friendship.

I am very grateful to all the people who have participated in this worldwide equestrian adventure, in particular:

In Africa:
Christian Seignobos and Gérard Roso for their invaluable knowledge of the country and being available to help us; His Excellency Mr. Jacques Courbin, French ambassador to Chad; the embassy services, in particular Ms. Chevalier and Mr. Yann Apert, cultural consul.

Thierry Miallier from RJM Aviation in N'Djamena for his hospitality; ASF and its pilots, Guy Bardet and Bruno Callabat; Evelyne Payen at the Relais de la Porte Mayo (Maroua, Northern Cameroon); and Fagus Voyages.

In Argentina:
Jean-Louis Larivière; the members of the Sociedad Rural Argentina (Argentinian Rural Society) and their president Enrique Crotto; Mr. Carlos Videla; Aerolinas Argentinas; Colette Larivière, Josefina and Ricardo Matho Garat from the *Estrella*; and Sara, Susana and Emilio Jorge Ferro from *La Adela*. Ignacio Corti Maderna, Enrique Baserga, Charles de Ganay, Augusto Salvo, Dudu von Thielmann, Mariano G. Fernandez Alt, Antoinette Huffman, Mercedes Villegas de Larivière, Marina Larivière and Enrique Baserga.

In Belgium:
At the Haras de Ligny stud farm, Rodrigo Pessoa and his team for their Brazilian good humor.

In Chile:
Véronica Besnier, Lucho Weinstein, Italo Zunino for his hospitality and his pisco sour and all the staff at the San Lorenzo farm.

In France:
The Salon International de l'Agriculture (International Agricultural Show) organization for many years of photo shoots: Mr. Patria, president of CENECA; Mr. Shaw, chairman of the Comexpo Paris Executive Committee; Béatrice Collet, director of the Salon International de l'Agriculture and all her team, in particular Catherine Boillereau, Richard Redgen and Sophie Quiniou; Mr. Vallogne, Mr. Laroche, Pierrick David, the animal stewards, particularly Patrice Gourmaud, Dominique Jullien, Germain Breney, Jean-Luc Baudry and of course Daniel Ygé; and Véro and Gillou for their unfailing good humor, without forgetting Claude Lahaye and his assistant, Jeanine Martinez-Munoz, who authorized the first ever shoot at the show.

The organizers of the Foire Agricole de Lessay (Agricultural Fair); Pierre del Porto from Sopexa and Alain Raveneau, Anne-Marie Capdaspe, Nelly Le Pautremat and Antoinette del Negro.

Mario Luraschi and all his team, in particular Fadila and Joëlle Balland for their hospitality at the Ferme de la Chapelle, and for their wonderful professionalism.

The Haras Nationaux (National Stud Farms) headquarters: Les Bréviaires National Stud Farm; Didier Domerg and his team; Le Pin National Stud Farm, its director Bernard Maurel, all his team, in particular Pascal Guimard, Vincent Juillet and Gilles Marnay.

Mr. and Mrs. Katz for their invaluable help; Rodolphe Lacourte and Sebastian Pellon Maison, and Mr. and Mrs. Guy Jonquères d'Oriola at Les Bréviaires.

The Société d'Encouragement du Cheval Français (Society for the Encouragement of French Horses), in particular Isabelle Coltier and Caroline Freu; Océane Andrieu.

The Grosbois Training Center, Sylvain and Michel Devulder, Christophe Walazyc; Mr. Compiègne.

Virginie Bruneau, Jean-Paul Guerlain, Arsène Ronsé, Ms. Flauder.

Gilles Marnay, Jacinthe Giscard d'Estaing and the Triple Galop team, France Galop and especially Mattieu Vincent and Dominique Gabel-Litny for their availability. L'AFASEC and Guy Bonnaventure, Dominique Bœuf and Olivier Peslier and M. Baufils and the Association du Cheval Henson (ACH).

In Germany:
The organizers of the Equitana Show in Essen; Reed Exhibitions, in particular Nathalie Bondetti and Ana Lena Grytz; and Geneviève Teegler from Géo Allemagne for translating.

In Great Britain:
The organizers of the Wembley Horse of the Year Show, in particular Mike Gill and Clare Duncan, Philippe Achache for his friendship and invaluable help, plus his son George, Rosalind Mazzawi, the Royal Agricultural Society (RASE) Organizing Committee, the Royal Show and particularly Miss E. S. Binions (Royal Show Livestock executive).

In Iceland:
Gisli and Bergur Gislason; Thorunn Lara Thorarinsdottir (Tota) and family at Laxnes Farm and Siggi; Ernir Snorrason; Heistheimar Stud Farm and Asta Begga, Gisli; the organizers of the Quinzaine Islandaise (Icelandic Event) in France, Chérif Khaznadar, commissioner general for France and director of the Maison des Cultures du Monde (World Cultures Center) and the Icelandic commissioner Mr. Sveinneinarsson and Stine, Soren, Franck and their energetic team.

In India:
The French embassy in India, the Indian government and the Indian Presidential Guard.

In Ireland:
His Highness Prince Aga Khan; Pat Downes, director of the Irish Stud Farms and Julie White, Camilla Milbank and all the team.
Peter O'Dwyer and Gisèle Scanlon.

In Italy:
Associazione Italiana Allevatori (Italian Breeder's Association) in Rome and its director general Fortunato Tirelli; Andrea Guiliani and the Verona and Fieragricola (Agricultural Fair) organizing committee.

In Kyrgyztan:
Jacqueline Ripart for her unique knowledge of Kyrgyz horses; Rash, his family and Shepherd's Way Trekking; René Cagnat; Idil and Ms. Nessrin from Turkish Airlines.

In Lebanon:
Lucien George, Georges Salem, Nabil Nasrallah and the team from Beirut racecourse.

In Mongolia:
Gaëlle Lacaze; Sanduijav Altantuya, known as Tuyya, and her husband, Badraa Battulga, and the Mongolie Voyages travel agency; His Excellency Mr. Jacques-Olivier Manent, French ambassador to Mongolia, His Excellency Mr. Gotovdjorjiin Louzan, Mongolian Ambassador to France; the Mongolian embassy in France; Mr. Bayalag Erdem Gonchig, cultural attaché; and Mr. Schiilegdamba and Mr. Bat-Erdene from the Mongolian Tourism Board.

In Qatar:
His Highness the emir of Qatar Sheikh Hamad Bin Khalifa Al-Thani; Sheikh Hamad bin Ali Al Thani, director of the Al Shaqab Stud Farm; Willy Oppen and the team at the Al Shaqab Stud Farm; the French embassy in Qatar, particularly Gilles Maareck.

Mr. Hamid Abdelamid, director of the Royal Bouznika Stud Farm (Morocco); Dominique Laubarie; Mr. Richardot de Choisey; and the Roissy (Charles de Gaulle airport, Paris) customs officers for their patience.

In Russia:
Nicolas Bordovskikh; the organizers of the Russian Horse Show "Equiros" at the Sokolniki Exhibition Center in Moscow and in particular the Director Liubov Arkhipova; Alexandre Kvasnikov; Gloria Raad; Olga Siblova; Oleg Gourev; Henrik Holten Hansen; Dinara Bakirova; the French Embassy services in Moscow, the customs officers at Cheremitiévo airport; and Irina and Philippe for translating.

In Senegal:
Sindiély Wade; the Senegalese Red Guard and Captain Djiby Tine; General Pathé Seck, high commander of the Police Force and director of Military Justice; and Jean Poderos, the most African member of the Altitude team.

In Spain:
Don Angel Peralta, Don Rafael Peralta, Immaculada and the team at El Rocio ranch in Puebla del Rio, La Real Maestranza de Caballeria de Sevilla (Royal Order of Chivalry of Seville) for the photographs taken in the Seville bullring and Maria Jesus Buitrago Sivianes.

The Hierro del Bocado breeding farm in Jerez de la Frontera and the farm's blacksmith, the Chartreux monastery in Jerez de la Frontera, Sister Corinne and Don Alfonso Pacheco, Carmen Garcia and Lunwerg Editores, André Viard for his advice and Christina Heeren for her flamenco.

In the United States:
William Kriegel for his hospitality and contagious enthusiasm; all the team at the La Cense Montana ranch and the La Cense de Rochefort-en-Yvelines Stud Farm; Jean Pierre Vergnier; and Lisa Daguett.

Curly Bear Wagner; Bob Black Bull, founder of the Blackfeet Buffalo Horse Coalition.

I also wish to thank:
My successive assistants over many years of shoots: Fabien Dorio, Olivier Jeannin, Eric Lafitte, Denis Lardat, Marc Lavaud, Franck Lechenet, Dominique Llorens, Ambre Mayen, Jean-Philippe Piter, Olivier Pollet, Arnaud Prade, Jean-Paul Thomas.

François Drion, breeder of champions.

Air France, in particular François Brousse and Dominique Gimet, thanks to whom the equipment has been transported to some fifteen countries.

Janjac, in particular Olivier Bigot, Eric Macé, Erwan Sourget, Frédéric Gueguen, Thierry Vançon, Olivier Caron, Hervé Bollard and Eric Thillier for their sleepless nights.

The team at Éditions du Chêne, in particular Joan Le Boru, Philippe Pierrelée and Isabelle Jendron; the Chine studio, Marc Walter and Sabine Arqué.

Lumiphot (Godard Flashes), and especially Gérard Devaucoux for his invaluable technical assistance; Jipe Labo (Norman Flashes), especially Alexandra; Avis-Car Away in Rueil-Malmaison, particularly Philippe and Isabelle Gueugnier; Le Ronchay weaving mill in Luneray for making our canvases, and Sylvie Mitot; the team at Fujifilm France, in particular Marc Héraud and Anissa; Canon, especially Guy d'Assonville, Bernard Thomas and Raphaël; Pentax, Éric Denoulay and Marc Albuisson; Shop Photo Prony; and Pierre Peres Insurance, particularly Émilie. Emmanuel Perrault (Eperrault@wanadoo.fr), who sent us the photograph on page 230.

A list of acknowledgments is never complete. Double thanks to anyone I have forgotten.

—YAB

Index

Boldface page numbers refer to photographs

First published in North America in 2004 by Artisan, a Division of Workman Publishing, Inc., 708 Broadway, New York, New York 10003–9555
www.artisanbooks.com

Original edition © 2003 Éditions du Chêne—Hachette-livre, Paris

Chevaux, written by Jean-Louis Gouraud, photographs by Yann Arthus-Bertrand (www.yannarthusbertrand.org). Translated from the French by Wendy Allatson, Sue Rose, Barbara Souter and Lydia Smith for JMS Books LLP.

Library of Congress Cataloging-in-Publication Data
Arthus-Bertrand, Yann.
[Chevaux. English]
Horses / Yann Arthus-Bertrand ; text, Jean-Louis Gouraud.
 p. cm.
Includes index.
1. Horses—Pictorial works. 2. Horses.
3. Photography of horses. I. Gouraud, Jean-Louis. II. Title.

SF303.A78 2004
636.1'0022'2—dc22

2004046370

Printed in China
10 9 8 7 6 5 4 3 2 1

ISBN 1-57965-274-3

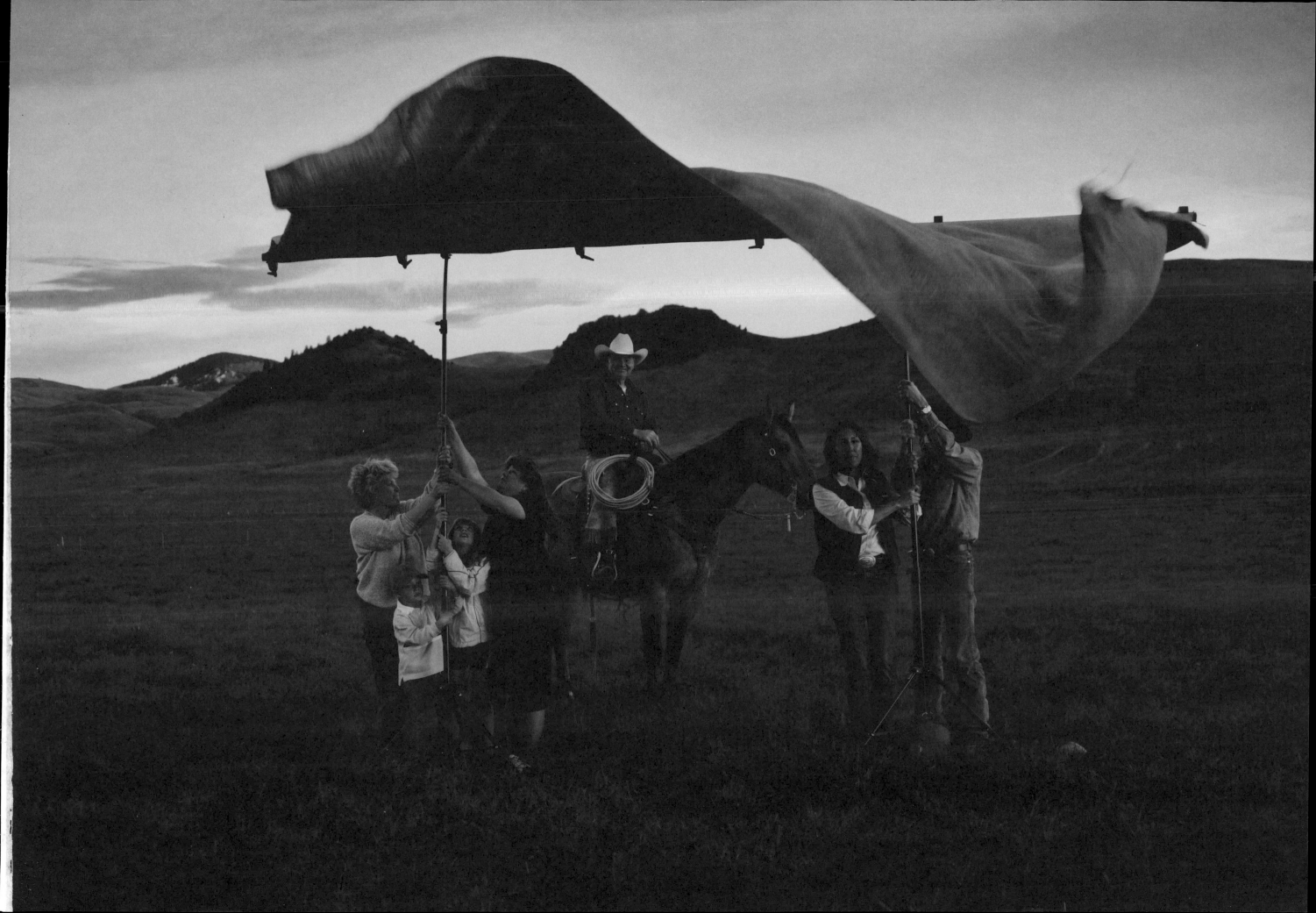

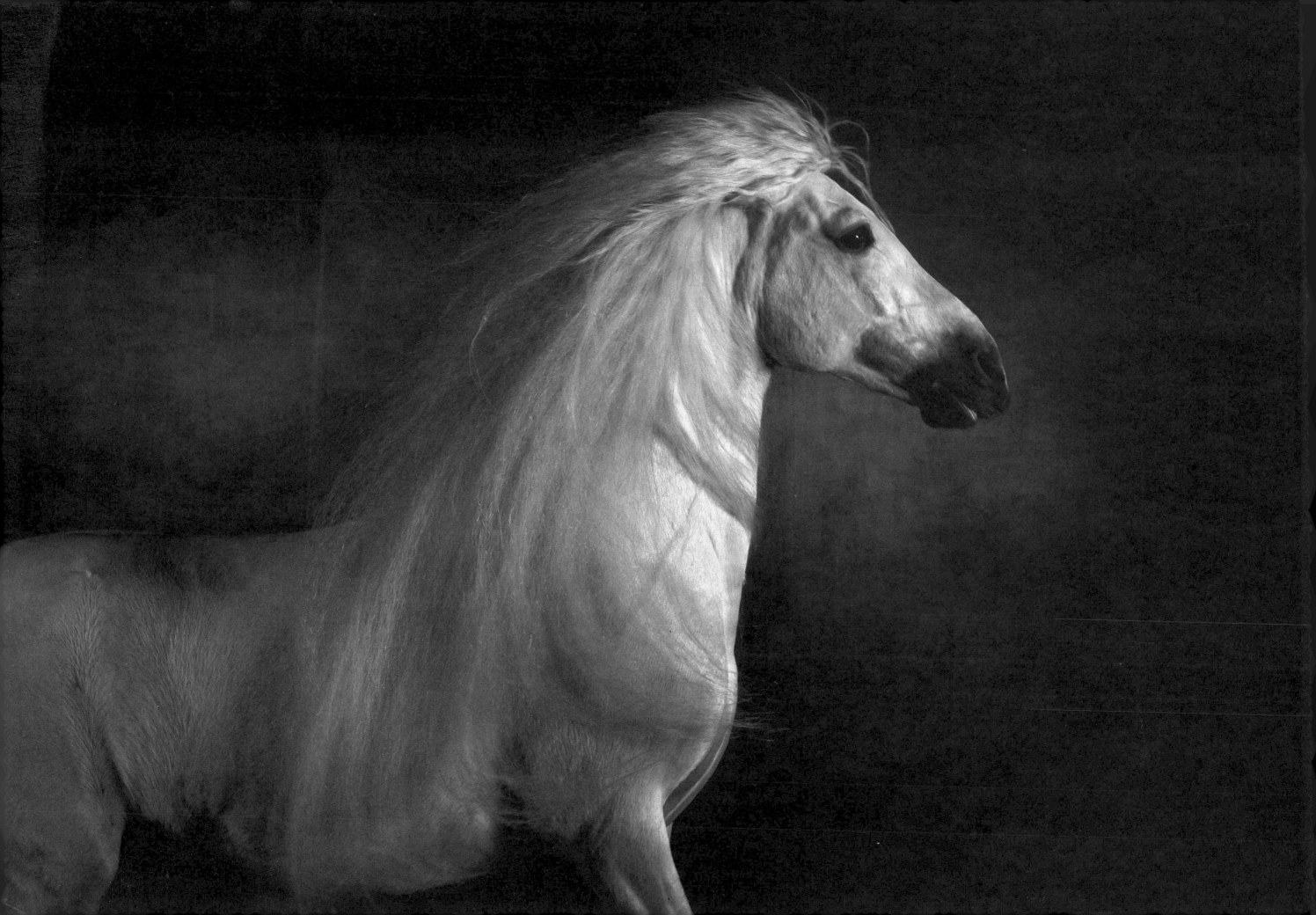